LOVELAND PUBLIC LIBRARY

000547368

D0337361

Withdrawn

7/16/15
$34.95
BNT
AS-14
7/15

MONA LISA
REIMAGINED

Published by Goff Books. An Imprint of ORO Editions
Gordon Goff: Publisher

www.goffbooks.com
info@goffbooks.com

Copyright © Goff Books and Erik Maell, 2015

All rights reserved. No part of this book may be reproduced, stored in a retrieval system, or transmitted in any form or by any means, including electronic, mechanical, photocopying of microfilming, recording, or otherwise (except that copying permitted by Sections 107 and 108 of the U.S. Copyright Law and except by reviewers for the public press) without written permission from the publisher and/or the proper copyright holders.

You must not circulate this book in any other binding or cover and you must impose this same condition on any acquirer.

While every possible effort has been made to publish full and accurate credits for each image included in this volume, sometimes errors of omission or commission may occur. For this the editors are most regretful, but hereby must disclaim any liability.

Graphic Design: Erik Maell Edited by: Ryan Buresh and Evan Morris
Production Assistance: Meghan Martin Text: Erik Maell
Cover Design: Erik Maell and Pablo Mandel

10 9 8 7 6 5 4 3 2 1 First Edition

Library of Congress data available upon request. World Rights: Available

ISBN: 978-1-939621-26-9

Color Separations and Printing: ORO Group Ltd.
Printed in Hong Kong.

International Distribution: www.goffbooks.com/distribution

MONA LISA
REIMAGINED

ERIK MAELL

goff BOOKS

ABOVE: Details from illustrations by (from left to right) Zorikto Dorzhiev, Michael Knight, Naoto Hattori, Fernando Naveiras Garcia, Carlos Cabo, and Kacey Schwartz.
PREVIOUS PAGE: Illustration by Erik Maell.

MONA LISA
REIMAGINED

CONTENTS

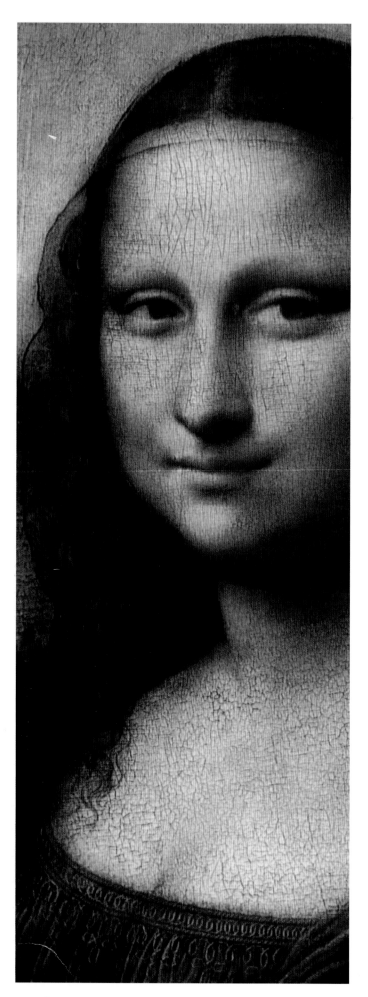

INTRODUCTION

BY ERIK MAELL

Over 8 million people from all over the world flock to the Louvre every year for the opportunity to gaze upon Leonardo da Vinci's beguiling Renaissance masterpiece, *La Gioconda*, more popularly known as "Mona Lisa." It is estimated that approximately 80% of all visitors to the Louvre are there primarily for the purpose of seeing this one painting, sometimes disregarding or outright ignoring the thousands of other famous works of art that populate the expansive museum. What is it about this iconic portrait that continues to mesmerize century after century? Hundreds of prominent books have already been published exhaustively attempting to examine all facets of the painting's creation, influence, mythology, heritage, and mystique. But perhaps one of the most fascinating aspects of Mona Lisa's enduring legacy is the frequency with which this painting has been imitated by other artists. No other painting in history has been reproduced, reinterpreted, parodied, appropriated, and exploited as often as Mona Lisa, and yet there has never before been a book published such as this.

I remember distinctly my first trip to the Louvre, and how the experience of seeing Mona Lisa was more comparable to meeting a celebrity than looking at a piece of art. Essentially, it was impossible to view the painting on its own terms, filtered, without all of the baggage that accompanies it. Even if it were conceivable to somehow know nothing about the painting or its cultural and historical significance, simply being present in the museum and witnessing the frenzy surrounding the painting would be enough to distort one's perspective. After all, there are no other paintings in the Louvre protected by dual panels of bulletproof glass and guarded on either side by security personnel.

Shortly after this experience, I began to explore theories as to why this particular painting had struck a nerve with so many people over the past half-century. I soon became aware of the unusually large number of artists who were compelled to recreate the painting in their own styles. Although many pieces of art have been reinterpreted or parodied by various artists over the years (*American Gothic*, *The Creation of Adam*, *The Scream*, and *Starry Night* are a few of the most frequent examples), no painting in history has come even remotely close to being "reimagined" as often as Mona Lisa. Just what exactly is the mysterious allure of this portrait that has inspired unparalleled levels of imitation? Although many explanations abound, there really can be no definitive answer, as the ambiguity of Mona Lisa is certainly one of the major factors of the painting's indelible appeal. To try too hard to define its enigmatic charm is a bit futile, although admittedly it can be a lot of fun.

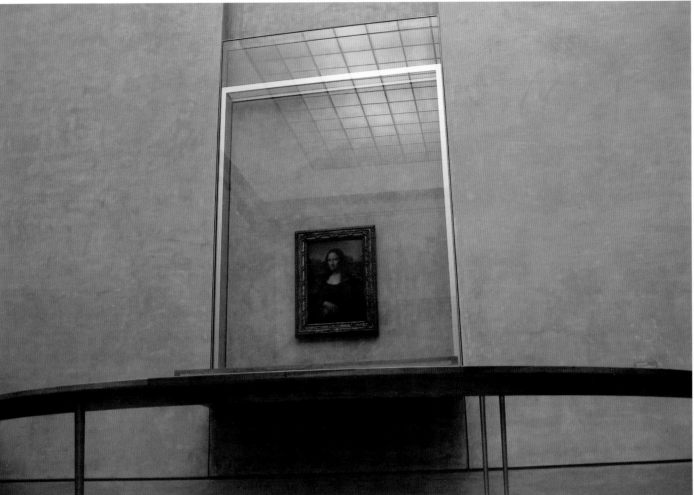

© Cayetano Delgado. All Rights Reserved. Used with Permission.

One of the greatest testaments to the overwhelming popularity of Mona Lisa is the vast number of books that have already been published, and continue to be published, with this iconic portrait as their subject. While there is apparently no limit to the amount of analysis that this painting inspires in writers, artists, poets, scholars, and scientists alike, there is an equally insatiable appetite for such publications from the book-buying public. Every year there are new books released, each attempting to define the painting's mysterious seductiveness or explain its immeasurable appeal and why its idolization has continued to gain propulsion century after century. They have endlessly speculated over the true identity of the woman who posed for the painting (some even suggesting that Leonardo had actually based the portrait on himself while looking in a mirror). Cutting-edge forensic techniques have been utilized to meticulously examine the painting's construction layer by layer. Countless theories exist as to what exactly were the various forces at work conspiring to elevate the painting to its unimaginable level of fame. Perhaps one of the most succinct and thoughtful evaluations of Mona Lisa was offered by Roy McMullen in his 1977 book, *Mona Lisa: The Picture and the Myth*. Mr. McMullen sums up the painting's rich legacy thusly:

"Mona Lisa is without a doubt the most famous work in the entire forty-thousand-year history of the visual arts. It provokes instant shocks of recognition on every continent, reduces the Venus de Milo and the Sistine Chapel to the level of merely local marvels, sells as many postcards as a tropical resort, and stimulates as many amateur detectives as an unresolved international murder mystery. Moreover, it has been famous a remarkably long, almost uninterrupted period. When it was still in Leonardo's studio in Florence, and very probably not yet finished, it was already inspiring imitations. By the middle of the sixteenth century it was being pronounced divine rather than human in its perfection; by the middle of the nineteenth it was a goal for pilgrimages and the object of a cult that mixed romantic religiosity with eroticism and rhetoric. It is decidedly not a painting like other paintings; it might be better described ... as a cross between a universal fetish and a Hollywood-era film star."

Indeed, Mona Lisa is not only a celebrity, but a valuable commodity to be packaged, marketed and sold; a popular brand name product with instant recognizability all across the globe. There is an unstoppable momentum to Mona Lisa's adoration, and, as the myth of this painting continues to grow, its status as an artistic and cultural icon is unlikely to ever be eclipsed. During the past five centuries, literally tens of thousands of Mona Lisa variations have been created by both professionals and amateurs alike, and as civilizations continue to ponder that enigmatic smile, no doubt thousands more will follow.

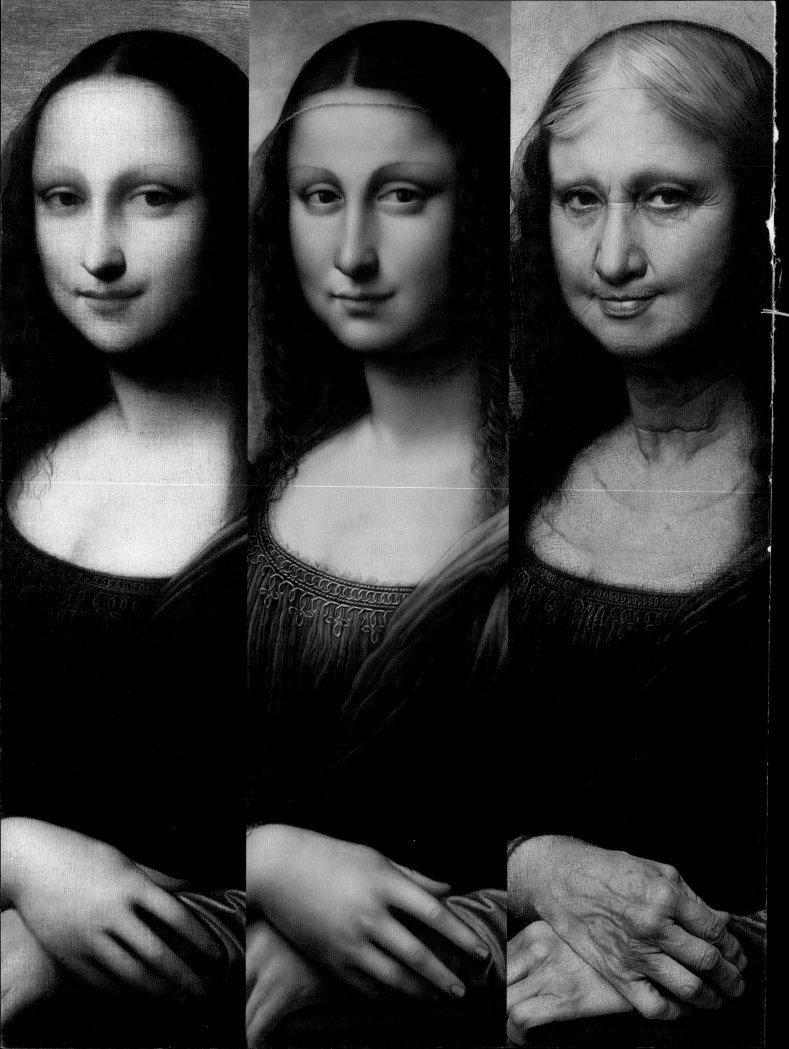

Loveland Public Library
Loveland, CO

RIGHT

Leonardo da Vinci
La Gioconda (Mona Lisa)
Oil on poplar wood panel
53 × 77 cm, 1503-1506

Often described as the archetype of the Renaissance Man, Leonardo da Vinci was an Italian artist whose expertise spanned a significant number of disciplines. He was possibly the most diversely talented person ever to have lived, achieving unprecedented levels of accomplishment as a painter, sculptor, writer, inventor, architect, musician, mathematician, engineer, anatomist, geologist, cartographer, and botanist. Most famous in his oeuvre as a painter is this half-length portrait of a seated woman with an elusive smile on her face. Known today as *La Gioconda*, or *Mona Lisa*, it is believed to have been painted between 1503 and 1506, although work may have continued on it until as late as 1517. There has been much conjecture over the years regarding the identity of the mysterious woman depicted in the painting, with the popular consensus being that it is Lisa del Giocondo (born Lisa Gherardini), the wife of Francesco del Giocondo, a reasonably wealthy silk merchant in Florence, who is believed to have commissioned the portrait. Likely to have started inspiring imitators even before it was finished, Mona Lisa has continued to grow in notoriety during the past five hundred years, reaching unparalleled levels of replication and attaining a celebrity status unsurpassed by even the most glamorous of movie stars.

FOLLOWING PAGES, LEFT

Unknown
Isleworth Mona Lisa
Oil on canvas
Approximately 55.8 x 76.2 cm, Early 16th Century

Named after the London suburb from where it was originally discovered around 1912, the *Isleworth Mona Lisa* has been the source of much controversy and speculation. Considered by some to be a copy of Leonardo's painting dating from sometime in the 16th century, others believe it was a precursor to the Louvre's Mona Lisa, possibly painted in whole or in part by Leonardo da Vinci himself. Art historians, research physicists, restoration experts, and forensic imaging specialists continue to conduct tests on the painting, with their findings often contradicting one another. The painting is now owned by a private international consortium, and its authenticity remains a subject of great debate.

FOLLOWING PAGES, RIGHT

Unknown
La Gioconda, Atelier di Leonardo
(Mona Lisa, Leonardo's Workshop)
Oil on walnut panel
57 × 76.3 cm, 1503-1516

Widely considered to be the earliest known copy of Mona Lisa, this is believed to have been painted simultaneously alongside the original by one of Leonardo da Vinci's pupils, possibly Francesco Melzi or Gian Giacomo Caprotti. Having previously been part of the Spanish Royal Collections, it's been owned by Museo Nacional del Prado in Madrid, Spain, since the museum's opening in 1819. For centuries, it was thought to be an unremarkable 16th- or 17th-century replica, until extensive restoration in 2010 removed the thick black paint which had initially obscured the background landscape. Using infrared technology, conservators were able to carefully observe the details of the underdrawings and underpaintings, and concluded that both Leonardo and the painter of this replica made exactly the same changes at the same time, indicating that the two paintings had been created side-by-side in the same studio. In 2012, this replica was displayed at the Louvre next to the original Mona Lisa as part of a temporary exhibition.

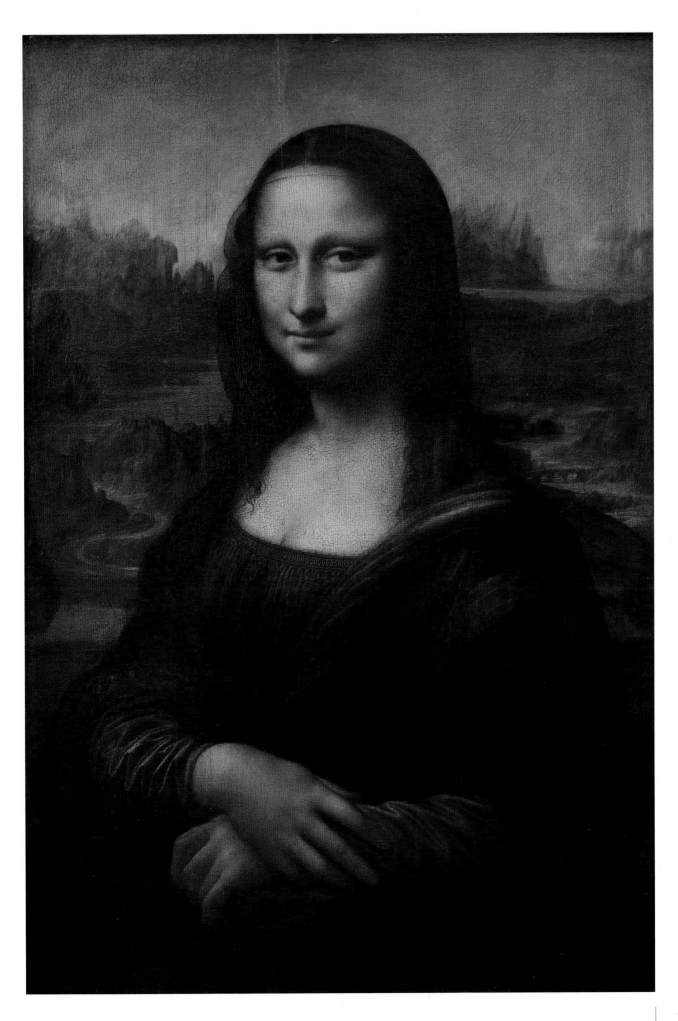

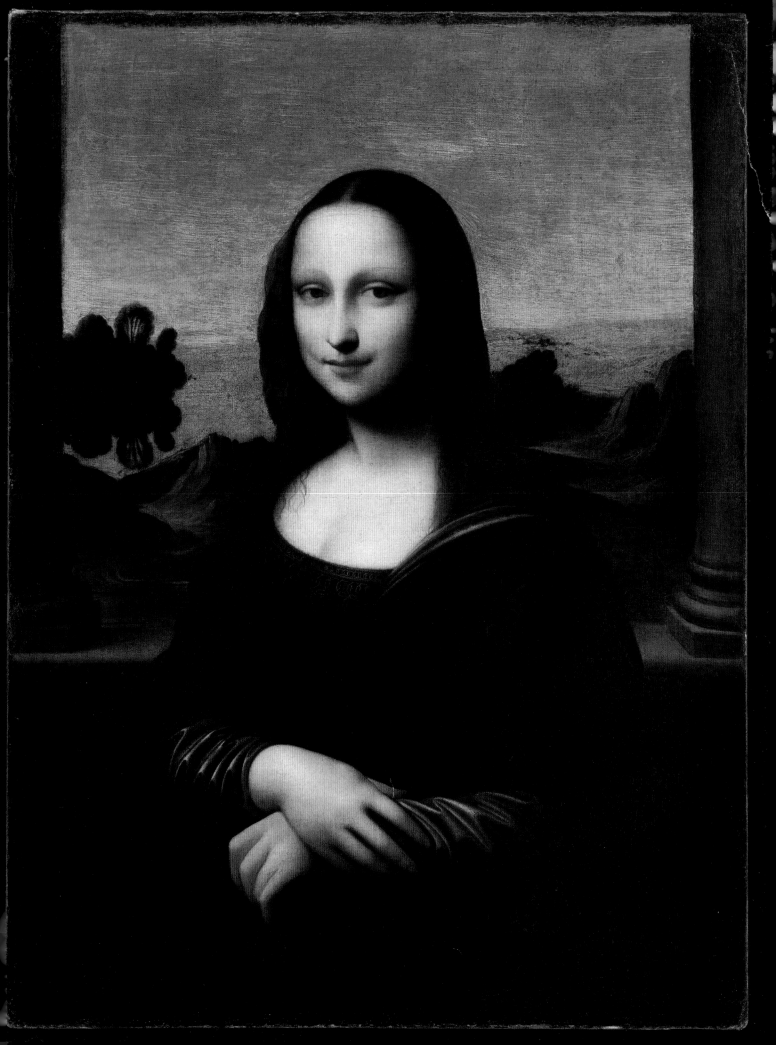

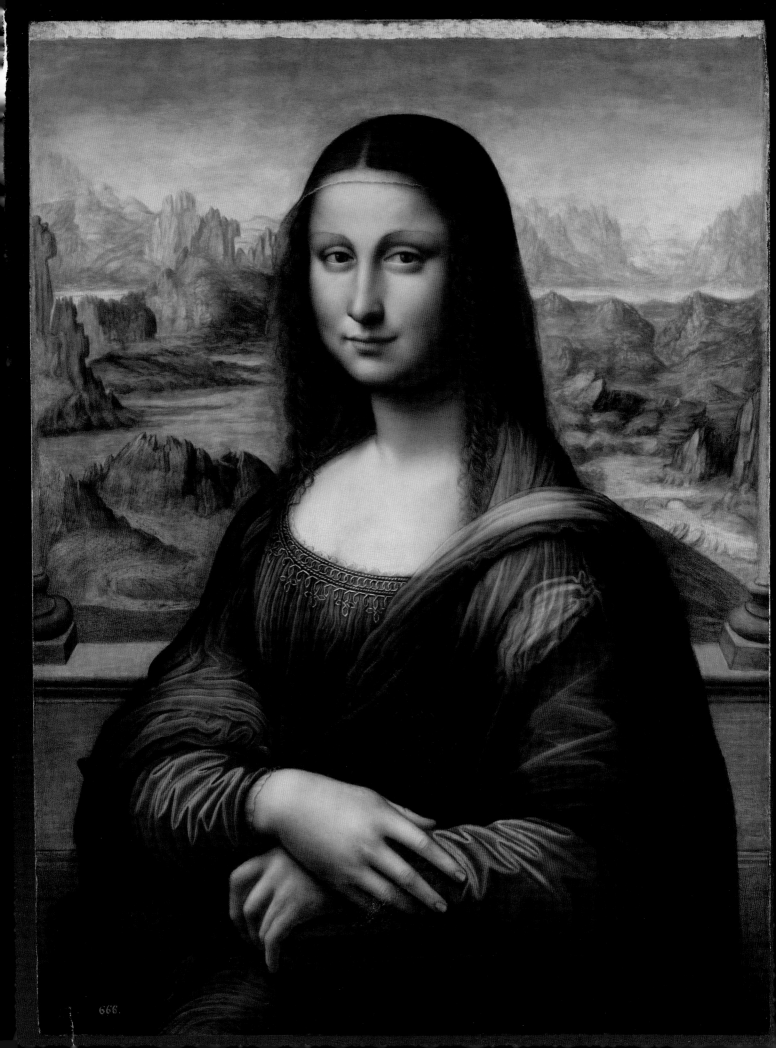

666.

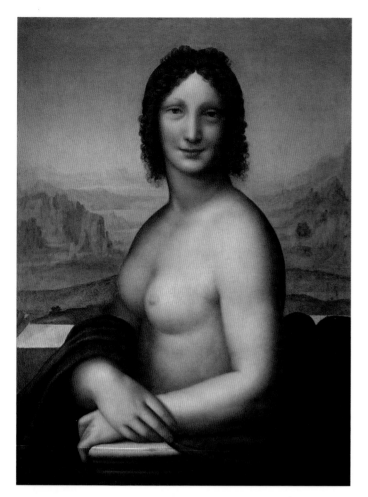

Gian Giacomo Caprotti
Monna Vanna
Oil on panel, 16th Century

Gian Giacomo Caprotti, better known as Andrea Salaì, or simply "Salaì" ("The Little Devil"), was an Italian painter and pupil of Leonardo da Vinci, who, at the age of ten, joined Leonardo's household as his assistant. Although he had been a pickpocket and was generally known as a troublemaker, Salaì remained with Leonardo for over twenty-five years as his student and companion. Under Leonardo's tutelage, Salaì became a competent, though unexceptional, painter and created this nude version of Mona Lisa, which may itself have been partly based on a now-lost nude by Leonardo himself. Salaì's life came to a violent end when he was fatally wounded by a crossbow injury during a duel in 1524.

Jean Ducayer
Portrait of a Woman after Mona Lisa
(AKA Gioconda with Bodice)
Oil on panel, 27.3 x 35 cm, 17th Century

During the 16th and 17th centuries, as Mona Lisa's notoriety was steadily beginning to grow, it became more and more common for artists to adopt in their own work certain styles and techniques reminiscent of Leonardo's painting. Mona Lisa's pose, expression, and sometimes her very likeness were appropriated with increasing frequency, as in this example by French painter Jean Ducayer.

Cesare Maccari
Leonardo che ritrae la Gioconda
(Leonardo Painting the Mona Lisa)
Oil on panel, 128 x 93.5 cm, 19th Century

Cesare Maccari was an Italian painter and sculptor, who regularly worked as a fresco artist in churches, shrines, public palaces, and most famously, the Salone d'Onore of Rome's Palazzo Madama, home of the Italian Senate. He was renowned for his oil paintings of historical events, and in 1863, he was one of the first artists ever to depict a scene of Leonardo da Vinci creating his portrait of Mona Lisa. The painting was awarded the highest honor at the 1865 competition at The Academy of Fine Arts in Siena, Italy. In 1909, while working on a fresco at the Palace of Justice in Rome, Mr. Maccari was struck by paralysis, which ended his career as an artist. He died ten years later.

Eugéne Bataille (AKA Arthur Sapeck)
Mona Lisa fumant la pipe (Mona Lisa Smoking a Pipe)
Photo-relief illustration, 15 x 22 cm, 1887

Popular French prankster Eugéne Bataille, better known by his pseudonym Arthur Sapeck, was a member of many intellectual artist factions of the late 19th century, most famously the short-lived but influential art movement called Les Arts Incohérents. The work of "The Incoherents" was satirical and irreverent, and questioned the traditions of conventional art. Throughout this period, Mr. Bataille achieved greater notoriety for his mischievous antics and outlandish pranks than he did for his work as an illustrator. During his final years, he suffered from psychiatric disorders and was confined to the mental asylum at Clermont-de-l'Oise, where he died in 1891.

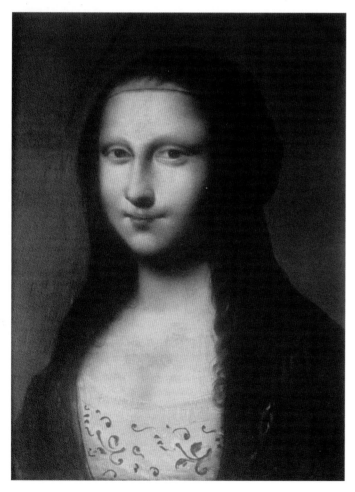

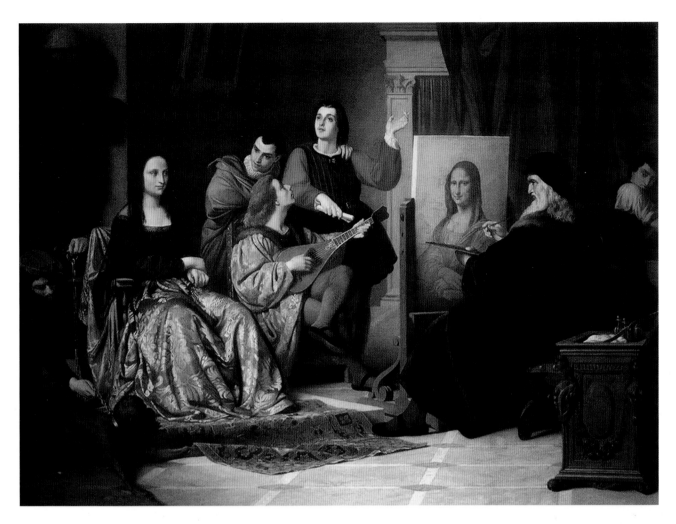

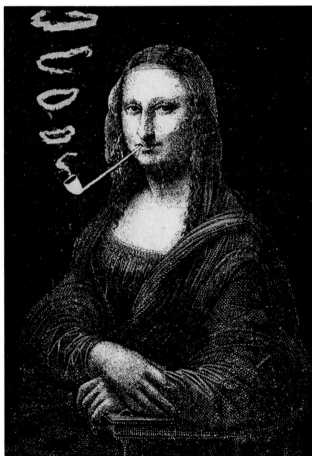

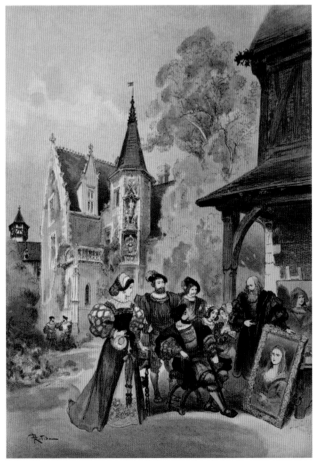

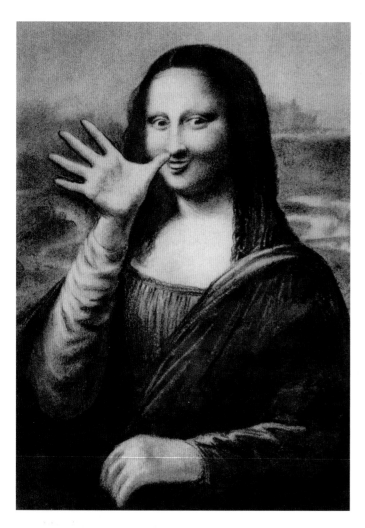

Albert Robida
Leonardo da Vinci presents Mona Lisa to King François I
Watercolor on paper, 32 x 43 cm, 1909

Albert Robida was a French painter, caricaturist, etcher, lithographer, and writer, best remembered for his visionary trilogy of futuristic novels, originally published from 1883 to 1890. In 1909, he created this illustration depicting an event in 1516 at Château du Clos Lucé, a small estate in the city of Amboise, France, which was the residence of Leonardo da Vinci during the final years of his life. After Leonardo's death in 1519, his estate was legally purchased by King François I and Mona Lisa officially became the property of the French Republic. Clos Lucé exists today as an immersive Leonardo da Vinci museum, containing life-size interactive models of his various inventions.

LEFT, TOP
Unknown
c.1911

Mona Lisa made international headlines in 1911 when the painting was stolen from the Louvre. Before being recovered, it was a periodic subject of editorial comic strips and cartoons. One of the most famous and popular parodies during this time showed Mona Lisa thumbing her nose in a defiant gesture of disrespect, mocking anyone who would try to find her. This image was reproduced on postcards, sometimes with the caption "Non, pas au revoir, mais adieu, je vais rire sous d'autres cieux." ("No, not goodbye but farewell, I'll smile in other lands.")

RIGHT, TOP & BOTTOM
Yves Polli
Arrivo della Gioconda a Milano
(Arrival of Mona Lisa in Milan)
Ink on paper, 1913

After being stolen from the Louvre in 1911, the whereabouts of Mona Lisa were unknown for over two years, and many believed it may have been lost forever. Recovered in Italy in December, 1913, the painting was treated like an international celebrity and was sent on an extensive tour of Italian museums before being sent back to Paris. It was first displayed at the Uffizi Gallery in Florence, drawing a sell-out crowd of 30,000 people the first day. It was then transported to Milan in a saloon carriage under strict security precautions. A force of 200 police officers had difficulty preserving order as enthusiastic crowds gathered to view the painting at Brera Gallery. A special medal was coined which featured a portrait of Leonardo da Vinci and the inscription "May Her Divine Smile Ever Shine." As part of the promotional furor surrounding Mona Lisa's tour of the country, Italian artist Yves Polli created these illustrations, which were sold as postcards to memorialize the occasion.

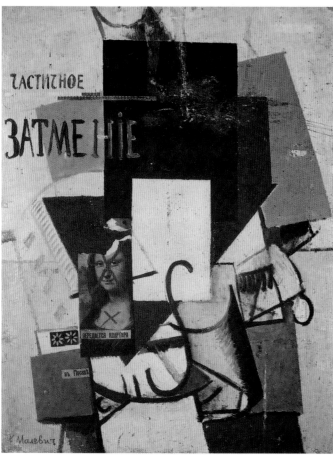

LEFT, BOTTOM
Kazimir Malevich
Composition with Mona Lisa
Oil and collage on canvas, 48.9 x 62.2 cm, 1914

Russian painter and art theoretician Kazimir Malevich was a pioneer of abstract art and the founder of Suprematism: an art movement characterized by the use of basic geometric forms painted in a limited range of colors. As a reaction to all the publicity surrounding Mona Lisa after it had been recovered from Italy, he created *Composition with Mona Lisa*, which featured a reproduction of a portion of the famous painting attached as a collage element. Using bright red paint, he crossed out her portrait, symbolizing his rejection of the painting and all of the attention it was receiving.

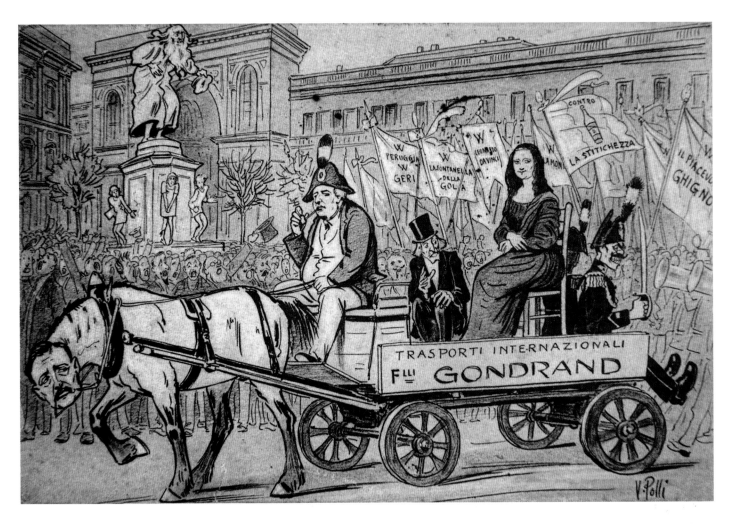

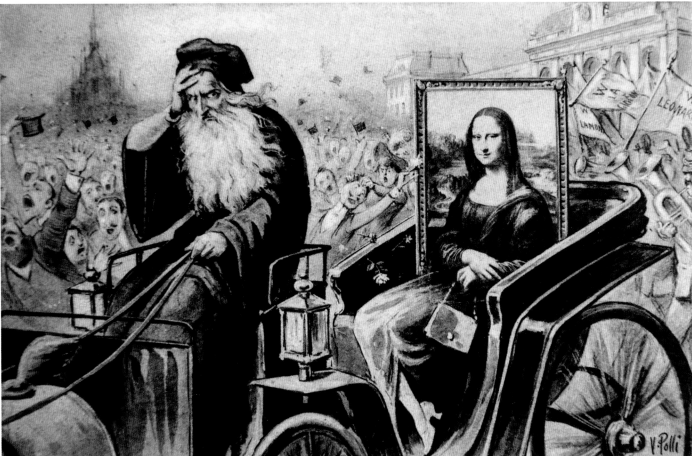

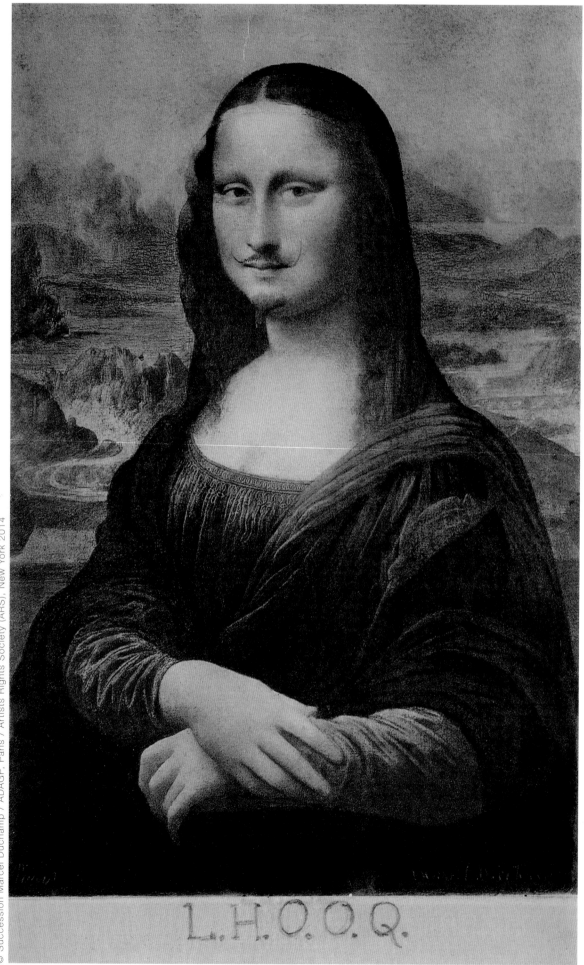

© Succession Marcel Duchamp / ADAGP, Paris / Artists Rights Society (ARS), New York 2014

LEFT

Marcel Duchamp
L.H.O.O.Q.
Mixed media on paper
10.8 x 19.7 cm, 1919

Perhaps one of the most well-known Mona Lisa parodies of all time, French artist Marcel Duchamp's *L.H.O.O.Q.* was partly modeled on Mr. Duchamp's own face, with a mustache and goatee added in pencil. The letters L.H.O.O.Q. sound like "elle a chaud au cul" when read aloud in French: a pun which roughly translates to "she has a hot ass." Throughout his career, Mr. Duchamp created numerous versions of *L.H.O.O.Q.*, all of varying sizes and utilizing different media. He was a pioneer of the movement known as Dadaism, which was characterized by a deliberate irrationality and the rejection of the prevailing standards of art and beauty. As the defaced subject of this piece, Mona Lisa is a symbol of ideal aesthetic beauty, and represents the artist's protest against an oppressive intellectual rigidity in both art and everyday society.

RIGHT, TOP

Fernand Léger
La Joconde aux Clés (Mona Lisa with Keys)
Oil on canvas
72 x 91 cm, 1930

French artist Fernand Léger built his reputation as a painter working in his own form of Cubism, which he had modified to make more figurative and populist. While his painting style varied from decade to decade, his work was consistently graphic, favoring primary colors and bold forms. This is one of his most experimental canvases, one of the few in which he shows the influence from Surrealism. The objects depicted have no support, but rather float in space, as in the works of Joan Miro. Mona Lisa was added to the painting almost as a footnote, after the artist happened to see a postcard of the painting in a shop window and decided that it would be the perfect choice to include as a contrasting element furthest removed from a bunch of keys.

RIGHT, BOTTOM

René Magritte
La Joconde
Oil on canvas
49.5 x 69.5 cm, 1960

René Magritte was a Belgian painter whose humorous and thought-provoking imagery helped shape the Surrealist Art movement. His paintings frequently displayed a collection of ordinary objects placed in an unusual context, giving new meaning to familiar things and challenging the observer's preconditioned perceptions of reality. Among his body of work are a number of Surrealist recreations of other famous paintings, with *La Joconde* being perhaps his most important and best remembered example. Here, he has reproduced several oft-repeated components from his previous work: a spherical metal bell, curtains, and the blue, cloud-filled sky which is prevalent in so many of his paintings. The result is a Mona Lisa that is highly intellectualized and decidedly less representational. He created several different versions of this artwork during the final decade of his life, including a three-dimensional bronze sculpture which was conceived only months before his death in 1967. He had described his art as "visible images which conceal nothing, but are meant to evoke mystery." When asked to explain the meaning behind his work, he replied, "It does not mean anything, because mystery means nothing either, it is unknowable."

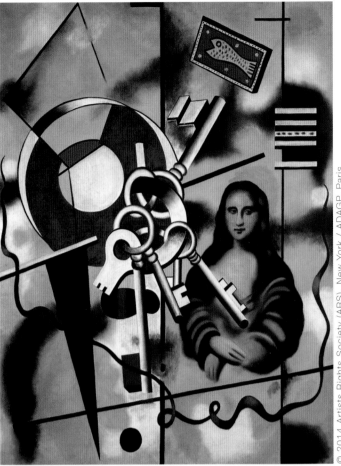

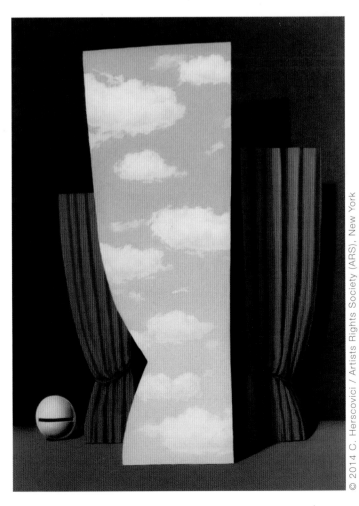

© 2014 Artists Rights Society (ARS), New York / ADAGP, Paris

© 2014 C. Herscovici / Artists Rights Society (ARS), New York

© 2014 The Andy Warhol Foundation for the Visual Arts, Inc. / Artists Rights Society (ARS), New York

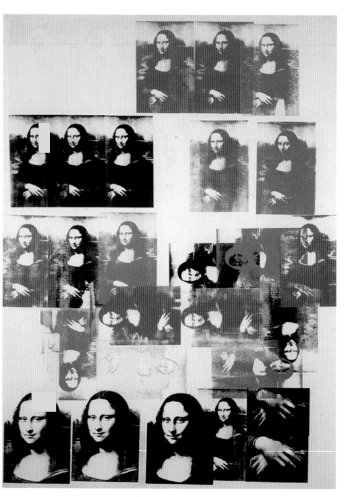

Private Collection / © Look And Learn / Bridgeman Images

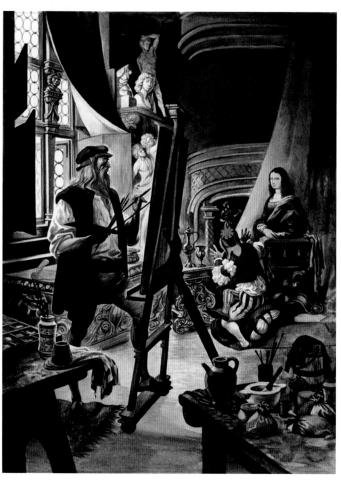

LEFT, TOP
Andy Warhol
Mona Lisa
Serigraph (Silkscreen)
75 x 113 cm, 1963

Andy Warhol was an American artist who was a leading figure in the art movement known as Pop Art. His controversial artwork explored the relationship between artistic expression, celebrity culture, and advertising trends. By taking an artistic masterpiece and reprinting it as though it were a mass-produced commodity, Mr. Warhol suggests that there is no difference between famous works of art and symbols of commerce such as Campbell's Soup cans and Coca-Cola bottles.

LEFT, BOTTOM
Peter Jackson
When They Were Young: Leonardo da Vinci
Watercolor on illustration board
30 x 39 cm, 1966

British artist Peter Jackson was known for his vivid historical illustrations of world-changing events. He created this charming conception of Leonardo da Vinci's studio for an article in *Treasure Magazine*, a British educational periodical aimed at young children.

RIGHT
William T. Wiley
Mona Lisa Wipe Out (AKA Three Wishes)
Paper, wire, canvas, and tape
43 x 61 cm, 1967

Contemporary American artist William T. Wiley is regarded as one of the most innovative, imaginative, and purely creative artists of the late 20th century. For over fifty years, he has been creating meaningful artwork that is controversial, revolutionary, and yet wholly personal and political. Mr. Wiley is one of the very few artists who incorporates overt political content into his works without overstating his case and, more importantly, without having his personal political agenda and topical references overshadow and detract from the work itself.

Courtesy of Yale University Art Gallery,
Janet and Simeon Braguin Fund

LEONARDO DA VINCI, 1452-1509 MONA LISA © 1963 BY KUNSTKREIS LUCERNE PRINTED IN SWITZERLAND Wm. T. Wiley 1967 AN ABRAMS COLOR PRINT

© William T. Wiley, Yale University Art Gallery, Janet and Simeon Braguin Fund

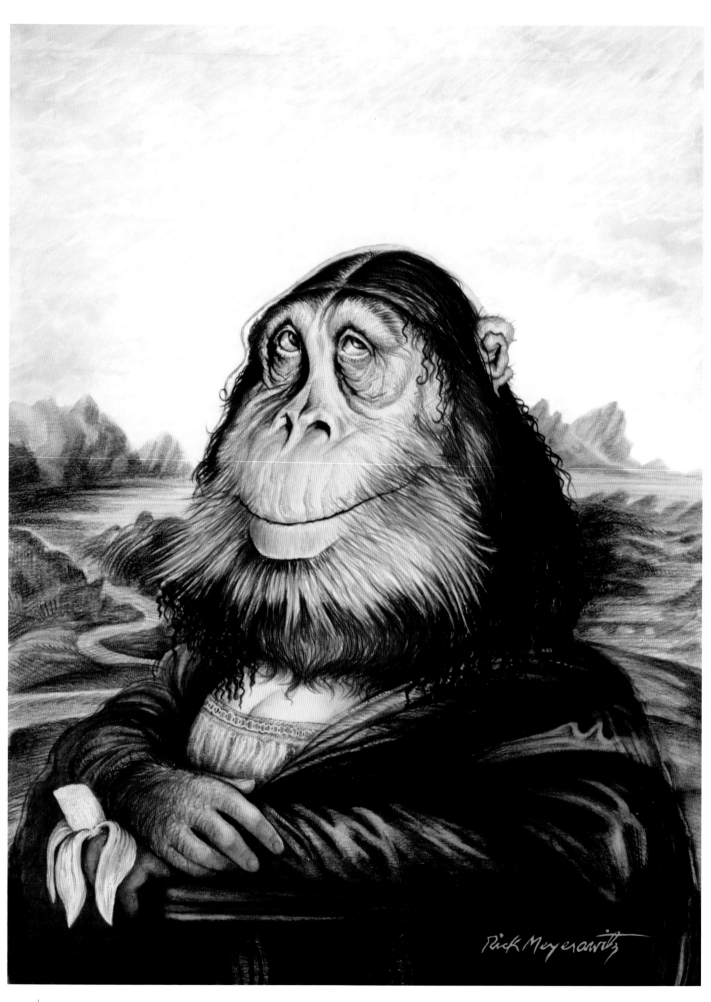

LEFT
Rick Meyerowitz
The Mona Gorilla
Watercolor and colored pencil on paper
57.1 x 81.3 cm, 1971

Bronx native Rick Meyerowitz studied fine arts at Boston University before embarking on his distinguished career as an illustrator. He has created some of the most recognizable images of the seventies, including the iconic poster artwork for the movie *Animal House*, and he holds the distinction of being the most prolific contributor of illustrated articles to the groundbreaking *National Lampoon* magazine. He originally created *The Mona Gorilla* as *National Lampoon* cover artwork to accompany a satirical article, called "The Undiscovered Notebook of Leonardo da Vinci," but the illustration proved so popular it soon became the *National Lampoon* mascot and trademark visual. Over the years, it has often been reprinted on posters and tee-shirts, and reproduced in countless books and publications. Having been described as "one of the enduring icons of American humor," *The Mona Gorilla* is widely regarded as one of the best and most famous Mona Lisa parodies ever made.

RIGHT, TOP
José L. Seligson
Mona Lisa
Watercolor and ink on rice paper
20.3 x 30.5 cm, 1973

Born in Mexico and educated at Instituto Kairós in Brazil, José L. Seligson had a relatively brief, yet vivid, career as an Abstract Expressionist painter. His work emphasized spontaneous and often subconscious creation of subjects that were familiar, though not always instantly recognizable. Of his art, Mr. Seligson had stated, "Every piece is a new experiment, a blank slate given life." The artist passed away in 2013, at the age of forty-nine.

RIGHT, BOTTOM
Mathias Waske
Waske's Mona Lisa
Oil on canvas
80 x 90 cm, 1974

German painter Mathias Waske is one of the most exalted representatives of Modern Realism. His originality, humor, and love of detail have made his farcical paintings highly collectible and established him as one of the most valued contemporary artists in Europe. Mr. Waske attributes his great success to his ability to vacillate between fantasy and realism, and his talent in inviting the spectator to explore and define new limits. Since 1968, the artist has been working as an independent painter and dividing his time between Munich and the South of France. In 2005, a retrospective of his work, entitled *From Mona Lisa to Madonna* was exhibited at KunstHausWien Museum in Vienna.

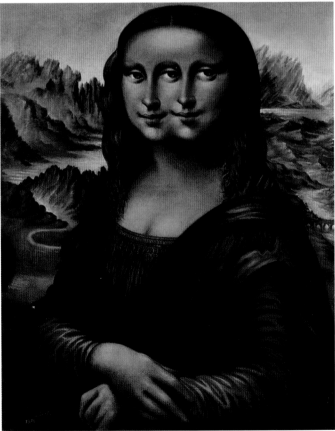

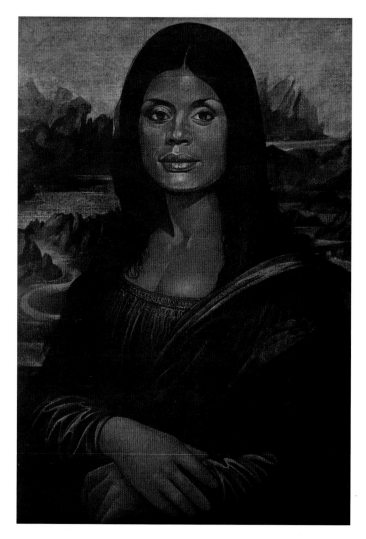

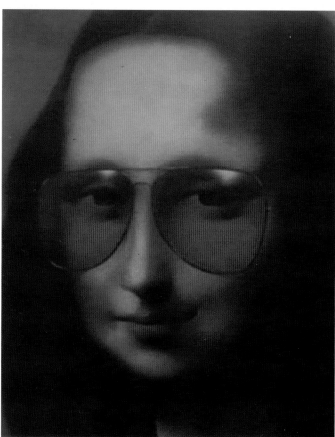

LEFT, TOP
David Dragon
The "Original" Mona Lisa
Acrylic on canvas board, 25.4 x 30.5 cm, 1975

UK-based artist David Dragon began his career in the music industry designing album covers for EMI Records in London. Now a full-time painter and printmaker, it is no surprise that his work continues to draw inspiration from music, film, television, and literature. Blurring the line between fine art and commercial art, his "original" Mona Lisa was created in the mid-seventies as album cover art for the legendary Tamla Motown Label. The album was meant to feature original versions of songs by Motown artists that had been covered by non-Motown artists and gone on to be bigger hits than the originals. Sadly, the album was never released, but *The "Original" Mona Lisa* remains.

LEFT, BOTTOM
Robert E. Amft
Mona
Acrylic on canvas, 152 x 178 cm, 1976

For over seventy-five years, Chicago native Robert E. Amft created a prolific and versatile body of work, which included paintings, sculptures, photographs, and graphic designs. A non-comformist who never followed trends, Mr. Amft was often ahead of his time in creating experimental artwork that would precede later art movements incorporating similar ideals and techniques. Mona Lisa was a frequent subject of his work, and he created dozens of variations on the classic portrait during his long career. Because of his love of his craft, and the wide variety of disciplines in which he worked, Mr. Amft was able to remain active and productive well into his senior years. In 2012, he passed away in South Carolina, at the age of 95.

RIGHT
Siegried Zademack
The Smile of the Mona Lisa
Oil on canvas, 80 x 120 cm, 1979

After training as a window dresser and screen printer, German artist Siegfried Zademack has said that he decided to become a painter as a result of his insatiable desire to express on canvas the outlandish visions contained in his head. His brief experience at an art academy proved unsatisfying, so he decided to educate himself on his own by visiting museums and meticulously studying the techniques of the old masters. Through experimentation, he developed his own expertise with paints, pigments, and solvents, and gradually established a style which he describes as a combination of Italian High Renaissance, European Mannerism, and Surrealism.

FOLLOWING PAGE, LEFT
Jean-Michel Basquiat
Boone
Paper collage, felt-tip pen, and oilstick on hardboard
30.5 x 104 cm, 1983

Jean-Michel Basquiat was an American graffiti artist who rose to great prominence in the eighties, exhibiting his Neo-Expressionist and Primitivist paintings in galleries and museums around the world. He became an instant celebrity in 1982, after selling out his first solo exhibition at Annina Nosei Gallery in New York City. In 1984, he began showing his work at Mary Boone Gallery, and continued until a contentious break with the gallery in 1986. Mr. Basquiat struggled with drug addiction for years before ultimately dying of a heroin overdose in 1988.

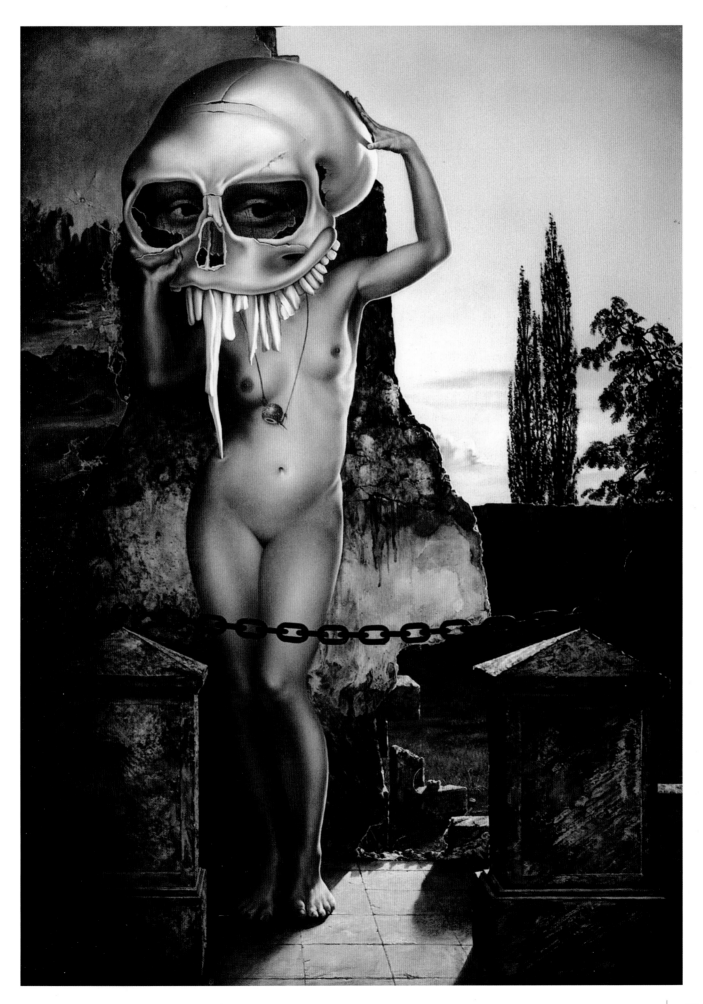

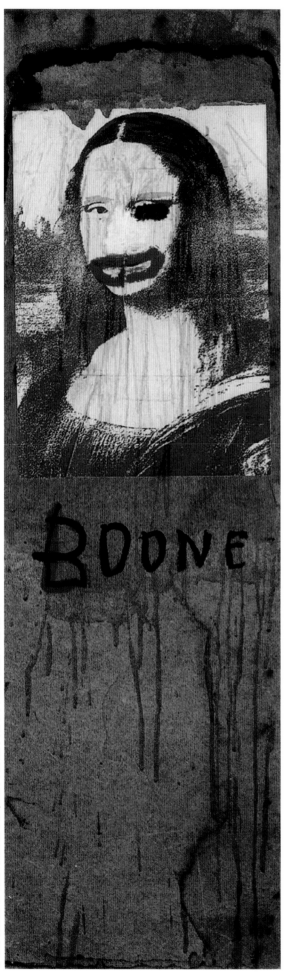

© The Estate of Jean-Michel Basquiat / ADAGP, Paris / ARS, New York 2014

BELOW
John Pound
Mona Loser
Topps Garbage Pail Kids sticker
6.35 x 8.89 cm, 1985

RIGHT
John Pound
Mona Loser
(AKA Phony Lisa)
Acrylic on paper
12.7 x 17.8 cm, 1985

Garbage Pail Kids was a series of trading card stickers originally released in 1985 as a parody of the Cabbage Patch Kids dolls created by Xavier Roberts, which were immensely popular at the time. The stickers were wildly successful and spawned additional series that continued for decades, and led to numerous merchandising tie-ins and even the production of a live-action movie and animated television series. The first run of the cards was painted exclusively by American illustrator and comic book artist John Pound, who continued to contribute artwork for subsequent sets.

Garbage Pail Kids® images used courtesy of The Topps Company, Inc.

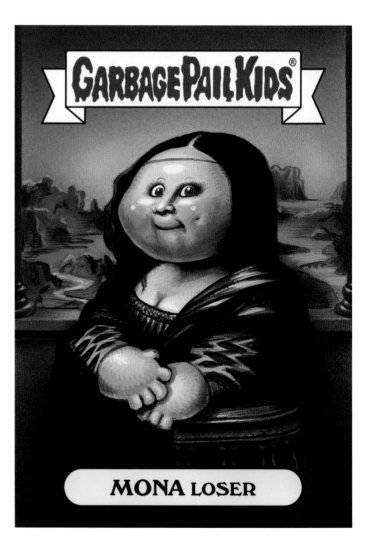

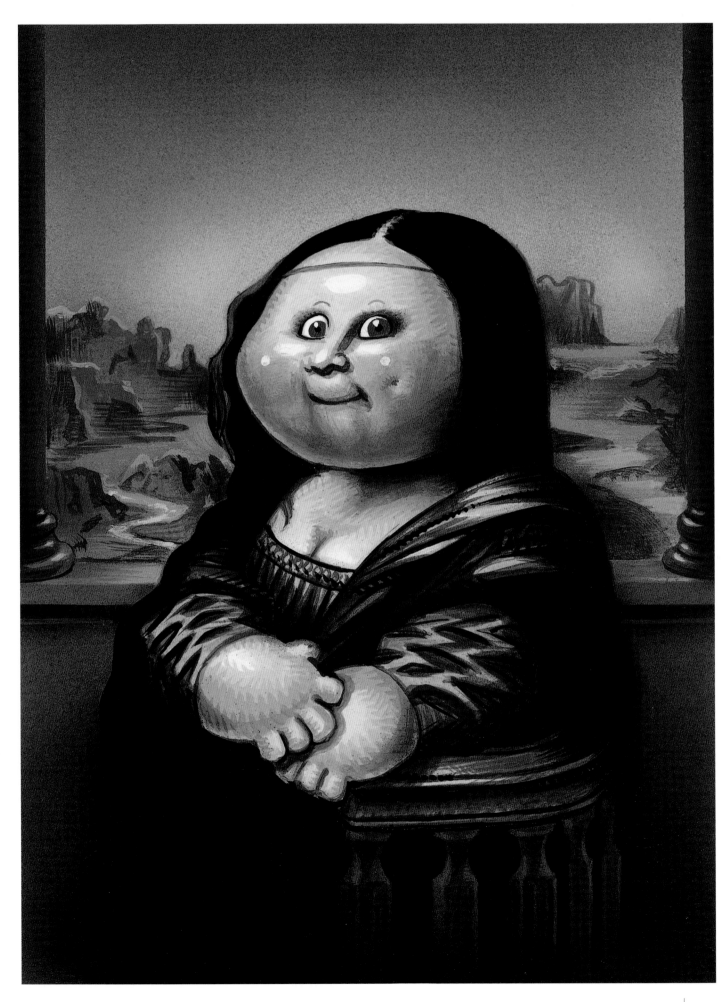

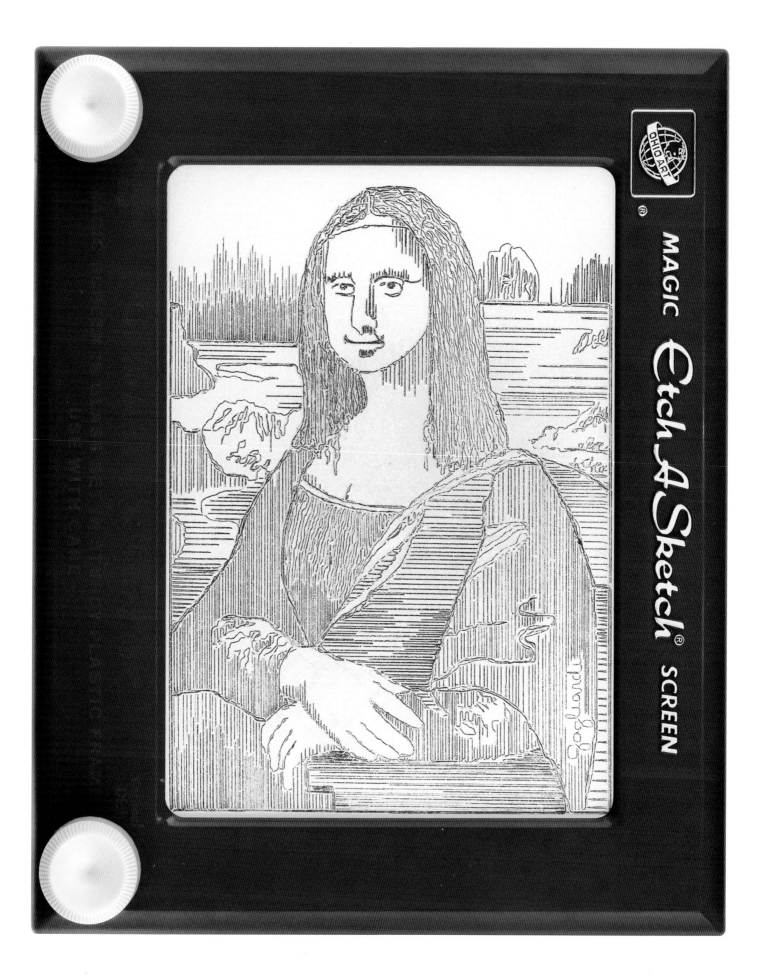

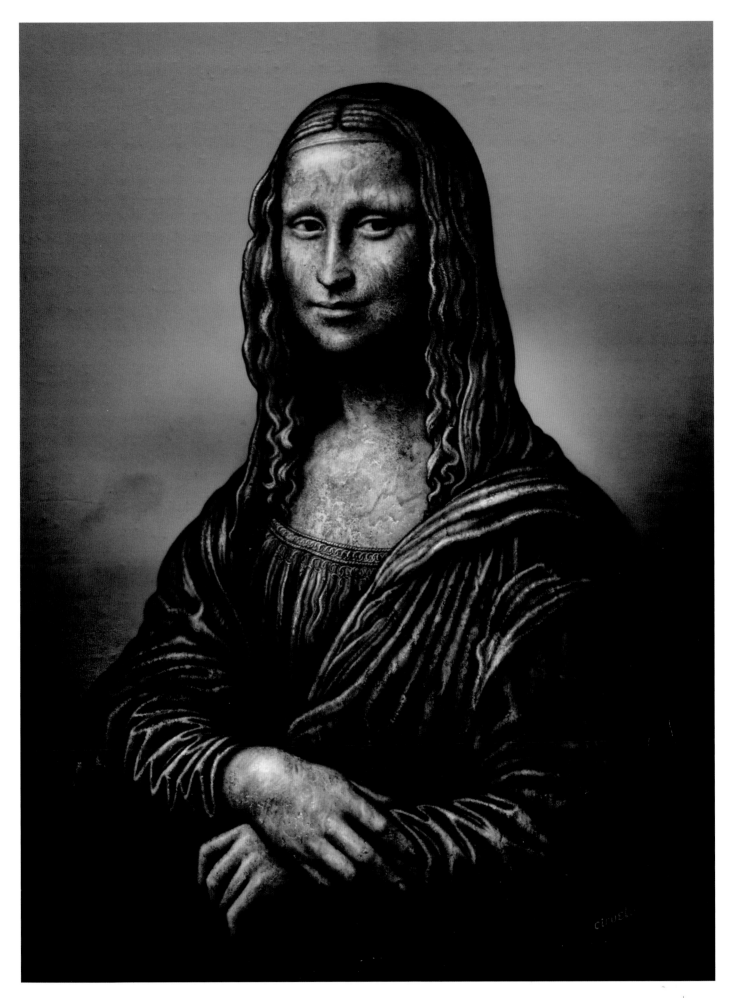

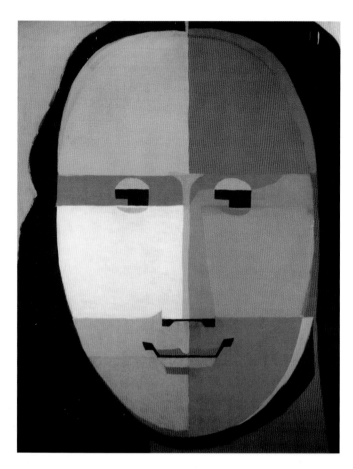

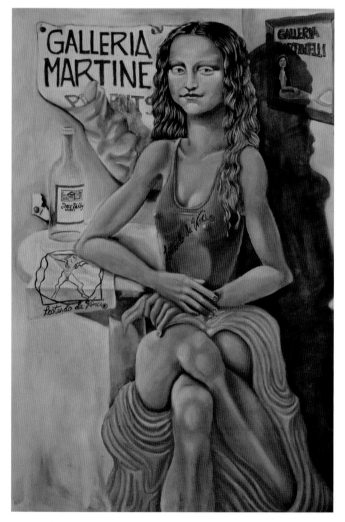

PREVIOUS PAGES, LEFT
Jeff Gagliardi
Mona
Etch-A-Sketch, 20.3 x 25.4 cm, 1986

Anyone who has ever played with an Etch-A-Sketch knows that it is a simple toy to operate, yet extremely challenging to master. Considered to be one of the original Etch-A-Sketch artists, with thirty-five years experience, Jeff Gagliardi has seen his remarkable creations displayed in museums across the United States, and featured in national print and television media such as *People Magazine*, *USA Today*, *Ripley's Believe It Or Not*, and *Good Morning America*. In order to accomplish his Mona Lisa etching, he had to reimagine the portrait in linear form and draw it on its side in order to properly operate the dials. "The work can be very frustrating, as you can imagine. If you mess up in any way, you just gotta shake it and start all over. There are times I've come to the very end and made a mistake, and I'll be honest, you just wanna cry. But, if it were easy, everyone would be doing it." In 2010, he sustained injuries to both of his wrists, which resulted in his being unable to resume creating Etch-A-Sketch artwork. He continues to paint using traditional media and works full-time as a graphic designer in Colorado.

PREVIOUS PAGES, RIGHT
Ciruelo Cabral
Marbled Gioconda
Acrylic and ink on paper, 45.7 x 66 cm, 1986

Born in Buenos Aires, Ciruelo Cabral has become one of the world's most recognizable and in-demand fantasy illustrators. His formal art training was limited to a few courses in drawing and advertising design at the Fernando Fader Art Institute, after which, at the age of eighteen, he immediately found work as an illustrator employed at an advertising agency in Argentina, and a few years later embarked on his career as a fantasy artist. After relocating to Barcelona, he achieved global renown creating book and magazine covers, comic book artwork, and record album covers for clients such as *Heavy Metal Magazine*, Ballantine Books, *Playboy*, Wizards of the Coast, and George Lucas.

LEFT, TOP
Robert E. Amft
Mona
Oil and acrylic on canvas, 138.4 x 179 cm, 1988

American artist Robert E. Amft created numerous versions of Mona Lisa during his long and versatile career, often painting close-up details of her portrait on monumentally large canvases. He experimented with a wide range of techniques and styles, from abstract to figurative, outsider to classic, and mixed-media collages to traditional paintings.

LEFT, BOTTOM
Don Martinelli
20th Century Mona
Oil on canvas, 61 x 91.4 cm, 1988

Born in San Francisco and raised in Los Angeles, Don Martinelli received a Bachelor's Degree in Civil Engineering from Berkeley before eventually relocating to Philadelphia. While he currently earns his keep as a civil engineer with the US Army Corps of Engineers, he continues painting and exhibiting his artwork in national galleries. He populates his canvases with such vivid and intriguing characters that recently the Philly Improv Theater (PHIT) created the improvisational comedy event "An Evening of Scenes Inspired by Don Martinelli," a collection of unrehearsed performances celebrating his artwork.

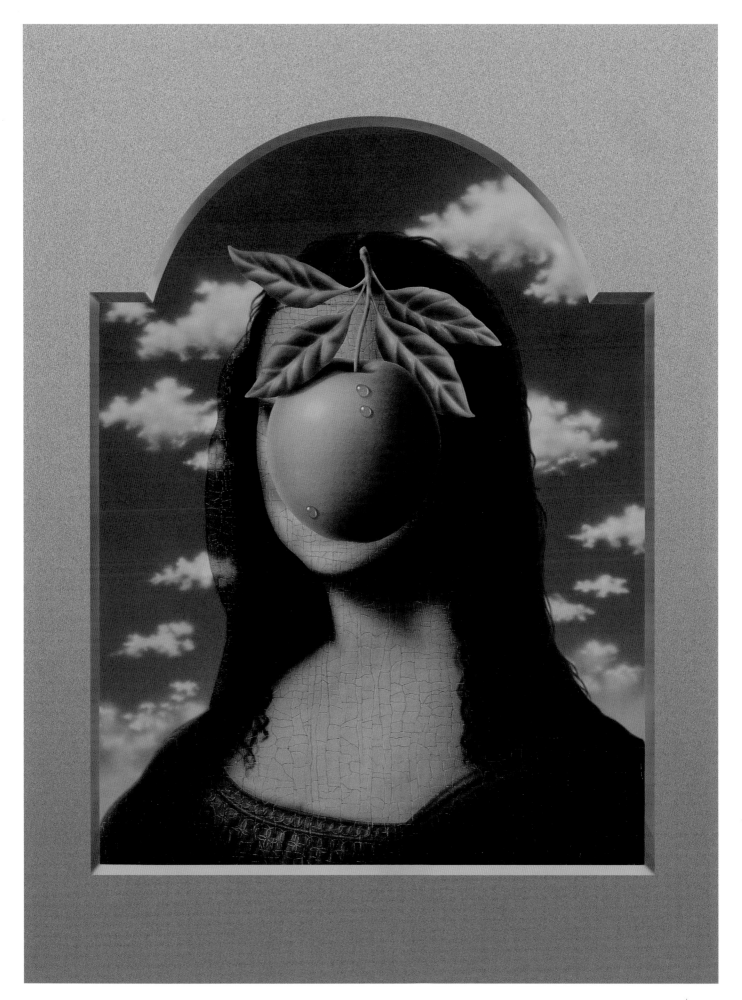

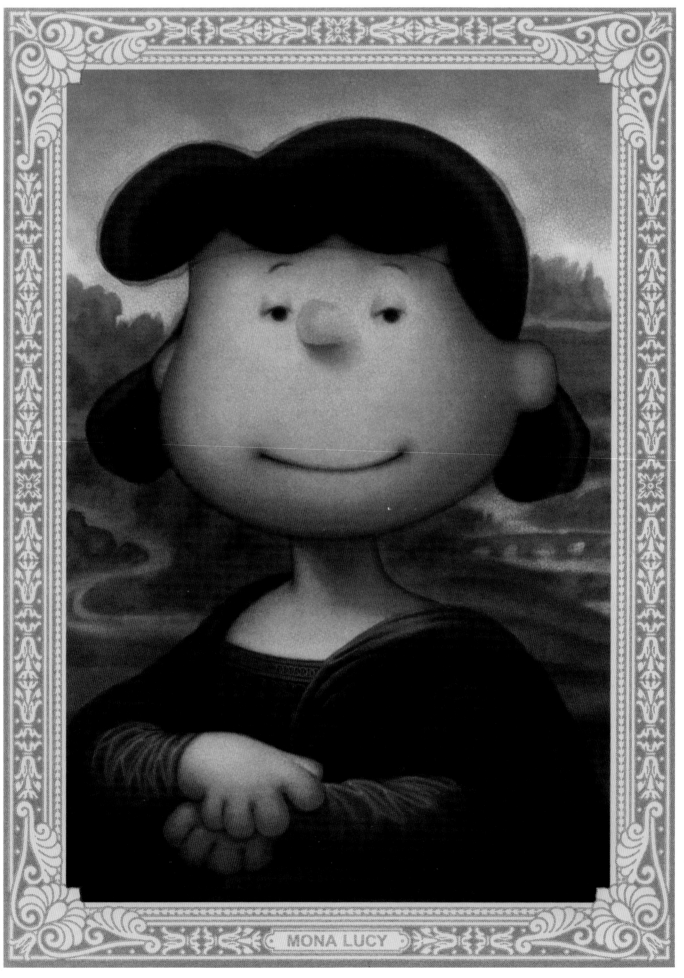

MONA LUCY

© 2014 Peanuts Worldwide LLC. Image provided courtesy of Hallmark Licensing, LLC, Kansas City, Missouri.

PREVIOUS PAGE
Terry Pastor
Magrittalisa
Ink, gouache, and liquid gold leaf on illustration board
30.5 x 40.6 cm, 1988

Although British artist Terry Pastor is probably best known for his work as an illustrator, creating iconic album cover art for entertainers such as David Bowie and The Beach Boys, he has also had a very prosperous career as a fine artist, mounting successful exhibitions of his paintings all over the world. With *Magrittalisa*, he has created a double-homage by combining Leonardo da Vinci's most famous portrait (still recognizable despite having all of her facial features completely hidden) with the cloud-filled blue sky and large, face-obscuring apple made famous in the work of René Magritte.

LEFT
Mark Stephens
Mona Lucy
Oil on board, 53.3 x 76.2 cm, 1989

Working today primarily as a landscape painter, American artist Mark Stephens began his career as an illustrator for Hallmark Cards in Kansas City. In 1989, he was commissioned to create a painting commemorating the sixty-seventh birthday of PEANUTS comic strip creator Charles M. Shulz. It was decided that the painting should spoof Mona Lisa because Mr. Schulz was scheduled to be honored with an exhibition at the Louvre the following year, which marked the fortieth anniversary of PEANUTS. The painting hangs today at Snoopy's Gallery and Gift Shop, across the street from The Charles M. Schulz Museum and Research Center in Santa Rosa, California. A placard hanging with the painting reads: "It is believed that her smile represents the pleasure and joy her creator has brought to millions of people since 1950. Another theory is that she is merely reflecting on a time when she pulled a pigskin away from one of her contemporaries."

Courtesy of Hallmark Licensing, LLC, Kansas City, Missouri.

RIGHT, TOP
Sylvia Long
Mona
Watercolor and Prismacolor pencils, 81.3 x 101.6 cm, 1989

Sylvia Long started her career as a children's book illustrator after reading *Watership Down* by Richard Adams and becoming inspired by the novel's heroic rabbit characters. She collaborated with writer Virginia Grossman to create *Ten Little Rabbits*, a counting book that celebrates Native American culture. She has since illustrated over two dozen more books as well as written her own story, "Hush Little Baby," published in 2002. Her detailed, painterly illustrations have an old-fashioned quality that give her books the feel of classic children's literature from the turn of the century.

RIGHT, BOTTOM
Jacques Poirier
Dos de la Joconde (Back of Mona Lisa)
Oil on wood panel, 73 x 92 cm, 1991

The work of French artist Jacques Poirier is contemplative and humorous, the subjects of his paintings often being still lifes composed of unconventional curiosities displayed in unusual environments. The unexpected setting of this particular painting happens to be the backside of Mona Lisa, and the curious objects are a newspaper, French baguette, cheese, knife, and a bottle of wine, as though someone has stashed their half-eaten lunch behind the painting.

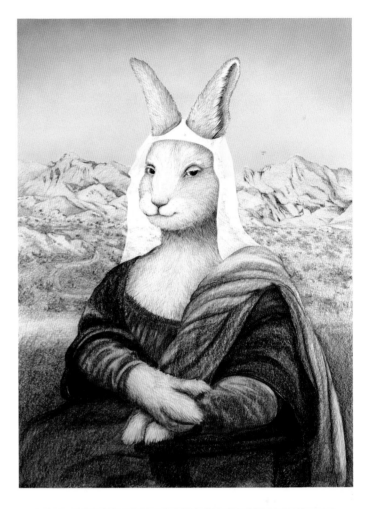

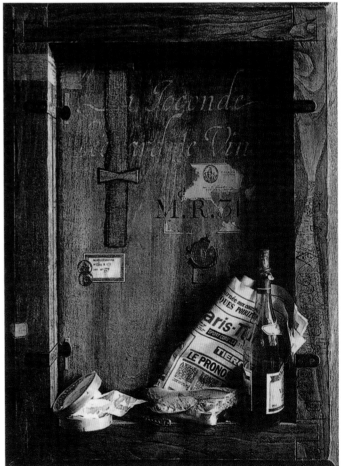

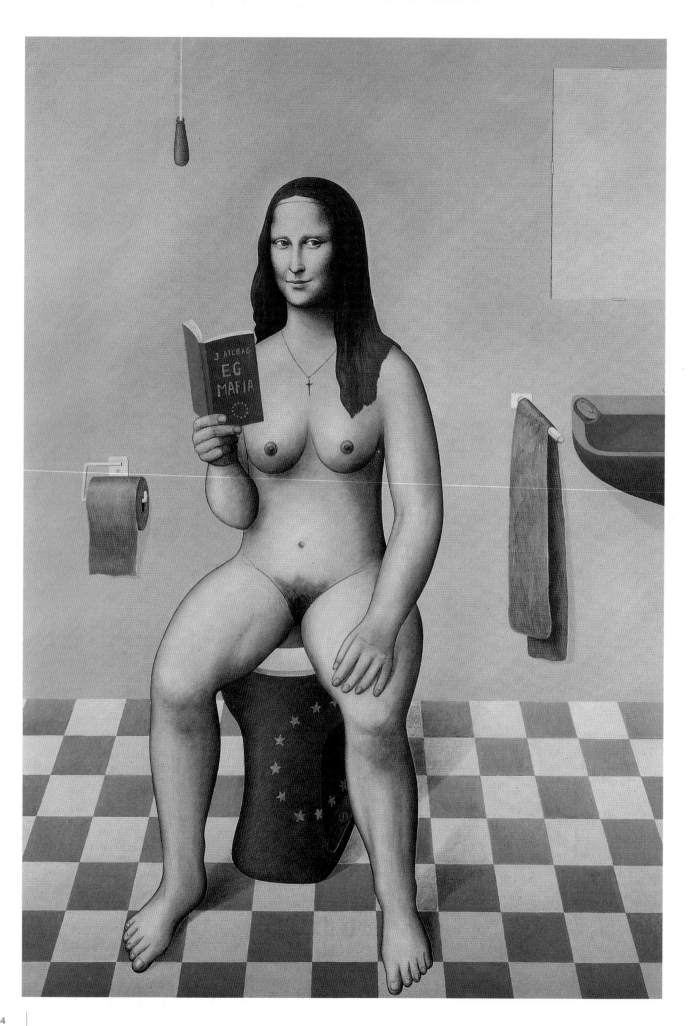

José García y Más

The controversial artwork of Spanish painter José García y Más is often focused on world politics, environmental concerns, and sociological interests. He worked as an engineer in Berlin for nearly a decade before relocating to the island of Usedom in the Baltic Sea to embark on an independent career as a painter. The national and multi-cultural sensitivities in Berlin during this period had been a fruitful source of inspiration for the artist, and he soon developed a reputation for being a very incisive social and political pundit. As the years wore on, having distanced himself from Berlin and thus viewing Germany's capital more objectively, his social criticism began to soften, becoming increasingly humorous and ironic over time, a sharp contrast to the more aggressively accusatory tone of his earlier paintings. The German reunification, tensions between the East and West, and complicated issues of the European community remain important themes throughout his entire body of work.

LEFT
Euro-Mafia
Oil on canvas, 140 x 200 cm, 1991

RIGHT, TOP
Icon of the Cold War
Oil on canvas, 140 x 200 cm, 1992

BELOW, LEFT
Mona Lisa of Leningrad
Oil on canvas, 100 x 135 cm, 1992

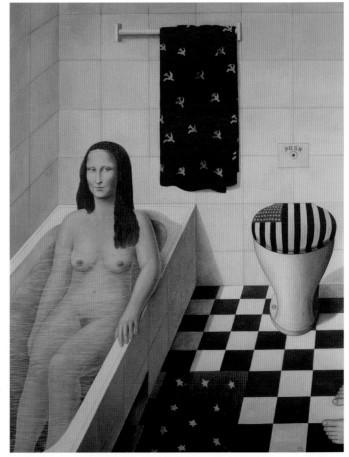

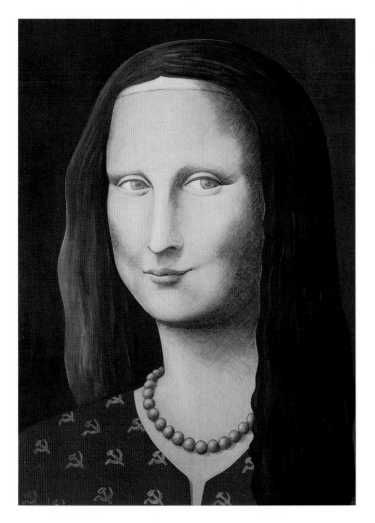

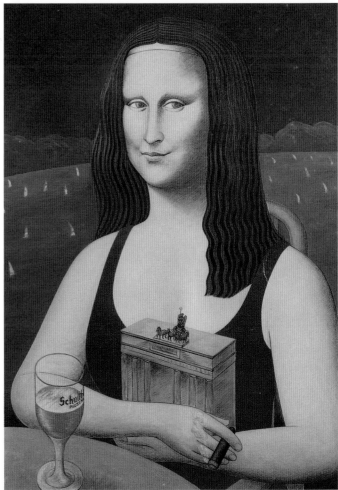

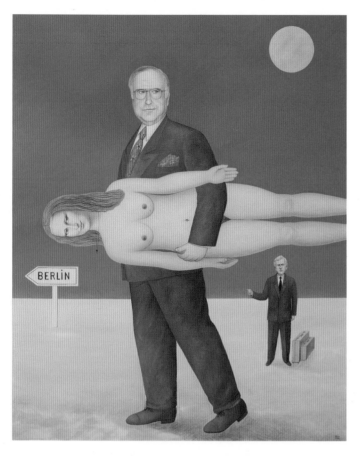

PREVIOUS PAGE, BOTTOM RIGHT
Mona Lisa in Berlin
Oil on canvas
90 x 130 cm, 1992

TOP LEFT
Back to Berlin
Oil on canvas
160 x 200 cm, 1992

BOTTOM LEFT
Top Secret
Oil on canvas
140 x 200 cm, 1992

BOTTOM RIGHT
The Red Garden Chair
Oil on canvas
140 x 200 cm, 1992

FACING PAGE
Mona Lisa I - IV
Oil on canvas
4 canvases, 60 x 85 cm each (120 x 170 cm overall), 1999

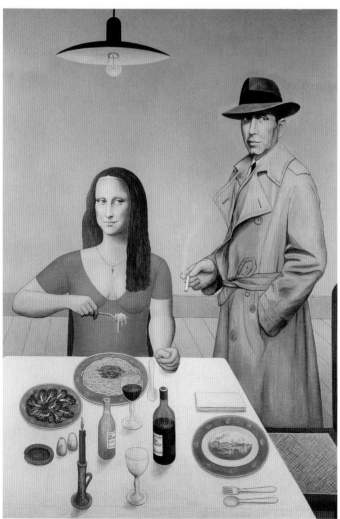

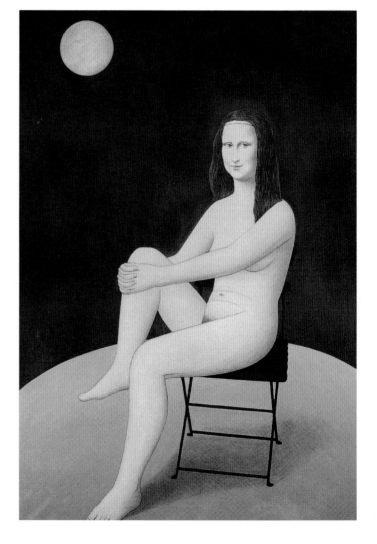

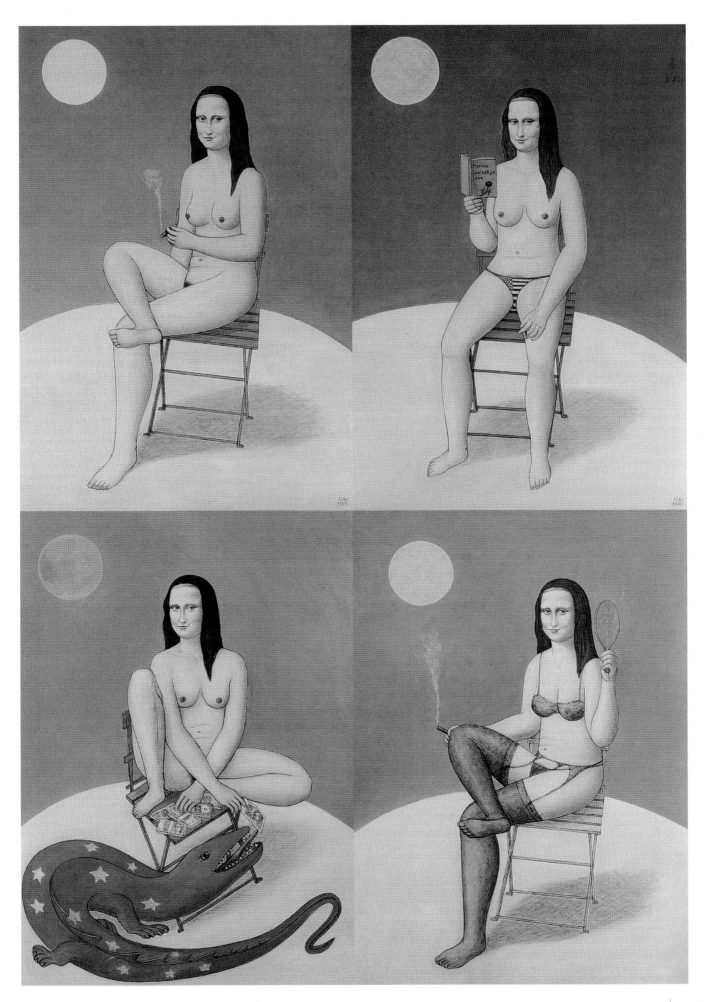

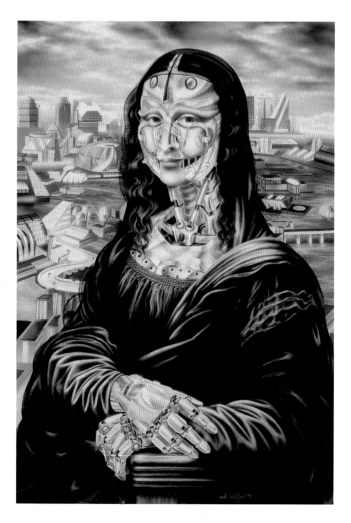

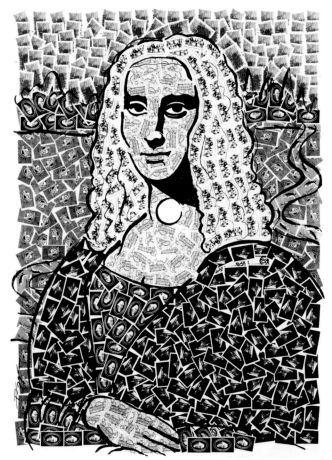

LEFT, TOP
Heidi Taillefer
Multifarious Mona
Oil on board
50.8 x 76.2 cm, 1994

The work of Canadian artist Heidi Taillefer is a fusion of surrealism, contemporary realism, classical allegorical painting, and mythology, combined with popular figurative traditions ranging from Victorian romanticism to science fiction. She addresses eternal issues of the human condition through the lens and language of mechanism, mirroring the ubiquity of technological advancement in the world. In her work, she attempts to marry primordial human essence with the explosive expansion of the machine, as a new paradigm looms close on the horizon and promises a redefinition of what it means to be human.

RIGHT
Siegfried Zademack
Mona Lisa Without Mona Lisa
Oil on canvas
40 x 55 cm, 1994

Another clever painting from German-born Siegfried Zademack, *Mona Lisa Without Mona Lisa* reimagines the famous portrait without actually showing the model herself. In this case, the iconic body posture is emblematic enough to suggest the presence of Mona Lisa, despite the fact that she is not implicitly seen. The shapes of the knight's armored mask give the impression of a laughing face, a shrewd reminder of Mona Lisa's own mysterious "smile which is not actually a smile."

LEFT, BOTTOM
Gregg Palazzolo
Stamped and Branded by Palazzolo
Collage of Palazzolo Brand Stamps and India ink on Mead® Archival Paper
66 x 101.6 cm, 1997

For more than thirty years, veteran advertising executive Gregg Palazzolo has been the owner and chief operating officer of Palazzolo Design Studio in Michigan. He is notorious in the world of advertising for creating "killer work," and has earned the nickname "The Adfather" for his efforts. During his prolific career, he has created logos and brand strategies for more than 5,000 businesses and organizations. His Mona Lisa collage was Palazzolo Design Studio's submission for a national design competition hosted by the Mead® Paper Company, and was awarded first prize in the contest.

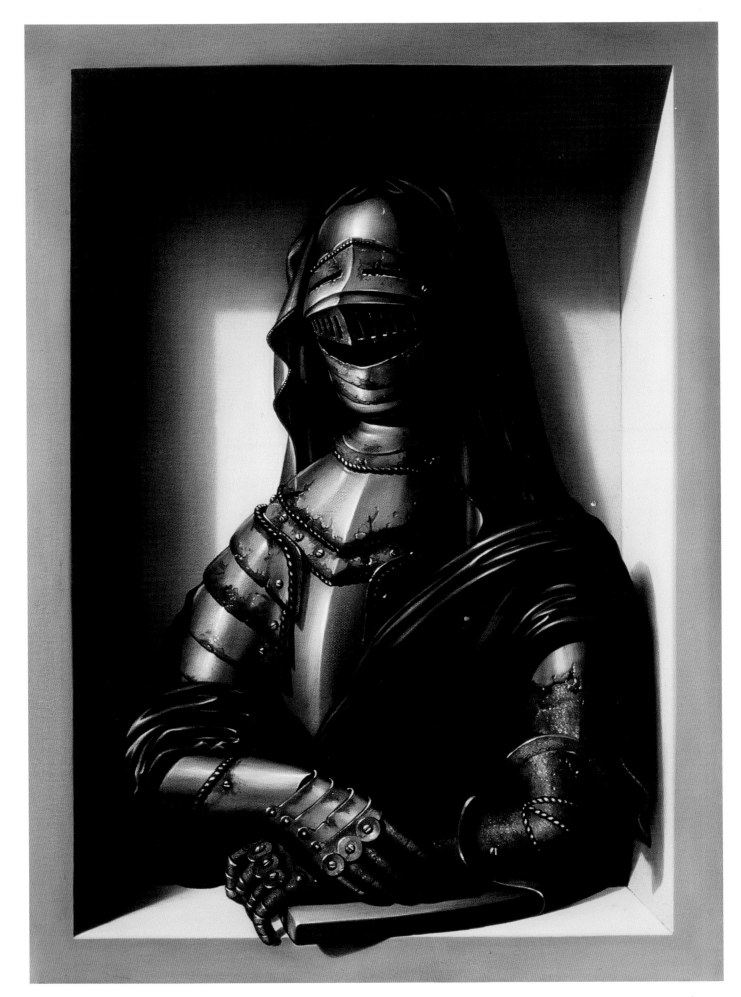

LEFT

Paolo Rui
What Are You Thinking Of?
(Interior illustration from *My Name is Leonardo*)
Acrylic on canvas
24 x 33.5 cm, 1997

BELOW

Paolo Rui
Messer Leonardo and Mona Lisa
(Wraparound cover illustration for *My Name is Leonardo*)
Acrylic on canvas
46.5 x 33.5 cm, 1997

Italian illustrator Paolo Rui created these charming illustrations for *My Name is Leonardo*, a captivating children's book that tells Leonardo da Vinci's life story in a way meant to inspire young readers to apply themselves in different aspects of life. The Italian Renaissance was an extraordinarily exciting time of learning and creativity, and Leonardo was at the forefront as the most famous and diversely talented man of the era. Besides being an artist, he is portrayed as a skilled handyman, who busies himself with any area relating to technical and scientific research. Due to his innate and bursting creativity, he starts many projects, yet finishes just a few, his mind being much quicker than his hands. Mona Lisa's cryptic smile represents some sort of amusing secret she shared with Leonardo, a mystery that remains undeciphered.

"My Name is Leonardo" published by Grimm Press, Taiwan

Joey Nash
Mona Chimp
Oil on canvas
61 x 76.2 cm, 1997

Self-taught Canadian artist Joey Nash began painting in 1979, and was exhibiting in Vancouver galleries within the same year. Known primarily for her wildlife artwork and sensitive animal portraits, she believes that artists are first and foremost storytellers. "My paintings tell stories about people, animals, and nature, but also about me and how I view the world. Wisdom, dignity, life, love and family values are all important themes for my work. The evidence of a life well lived, to be found in a mature face, is always very compelling subject matter for me."

Denis Nuñez Rodriguez
Mona Lisa
Oil on canvas
60 x 90 cm, 1997

Isolation and loneliness are themes frequently explored in the paintings of Cuban artist Denis Nuñez Rodriguez. The seclusion felt by many of his characters seems to be self-imposed, a veiled but voluntary resistance to the beauty of their surrounding environment. His exquisite workmanship and carefully balanced shapes contrast sharply with the harshness of his subjects' internal drama.

FOLLOWING PAGES, LEFT
Philippe Mouchès
Musée d'Ouluvre No. 1
Oil on wood panel
20 x 27 cm, 1997

French painter Philippe Mouchès has mastered the art of the "ambiguous image." For his *Musée d'Ouluvre* series of paintings, he transformed several Louvre masterpieces with this stylistic exercise. His paintings exploit graphic similarities between two or more distinct images, which in turn induces the phenomenon of "multistable perception," or the occurrence of an image being able to simultaneously provide multiple, yet individually stable, perceptions. Careful planning, an extreme sensitivity to details, and the use of illusory contours are all fundamental elements of this highly specialized type of artwork.

In the collection of Olivier Cabiro

FOLLOWING PAGES, RIGHT
Philippe Caza
Joglonde (from Outer Space)
Digital
2700 x 3600 pixels, 1998

Philippe Caza is one of France's most acclaimed science fiction artists. Aside from his extensive portfolio of work in comic books, he has illustrated the book covers of French editions of some of the genre's most celebrated authors, including Isaac Asimov, Jack Vance, Tim Powers, and Roger Zelazny. He also served as production designer on the 1988 animated feature *Gandahar* and co-wrote and designed 2003's *Les enfants de la pluie (The Rain Children)*.

First publication: *Etoiles Vives* #7, France, 1999

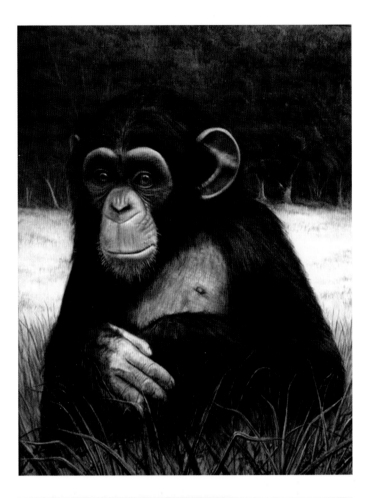

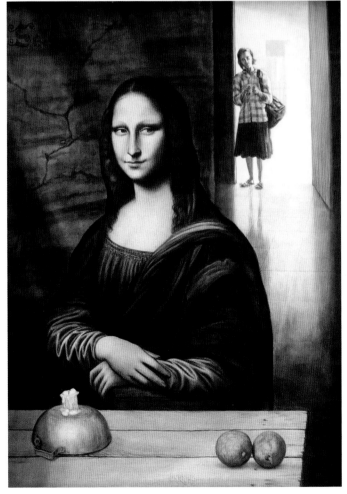

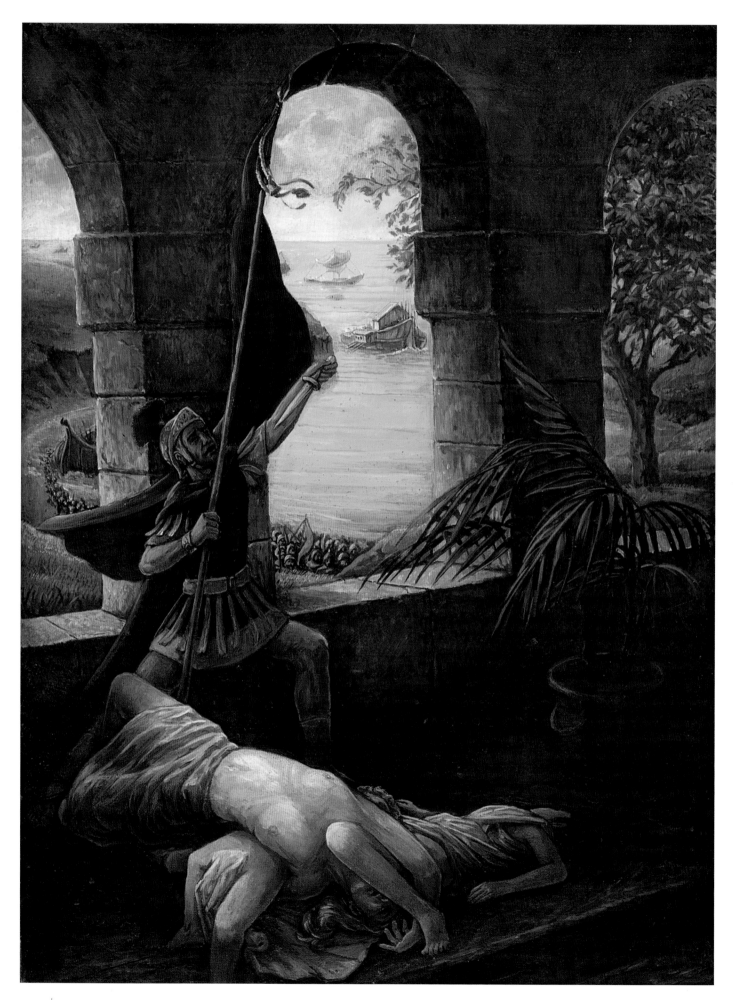

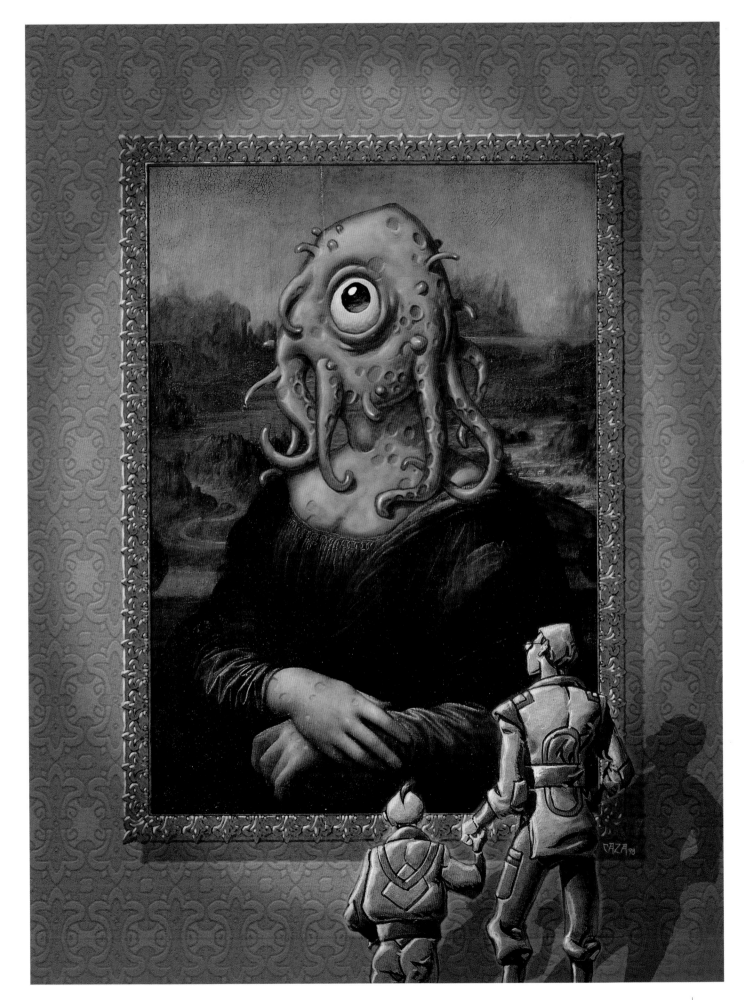

Jeff Nishinaka
Mona Lisa
Paper sculpture, 61 x 45.7 cm, 1998

Los Angeles native Jeff Nishinaka has been a self-taught paper sculptor for over three decades. His vibrant depiction of Mona Lisa was made as part of an advertising campaign for Savin Color Copiers. Remembers the artist, "The tag line was 'Color copiers that transform your documents into works of art.' So I made a fun, colorful paper sculpture."

James W. Sebor
Mona and Monkeys
Acrylic on canvas, 76.2 x 101.6 cm, 1998

The work of American artist James W. Sebor has a strong emphasis on the melding of images with subconscious memories. He describes his art as "warm and damp with jungle humidity and human perspiration generated from curiosity, tears, longing, humor, terror, love, hate - all the emotions that are the building blocks of the psyche." His *Mona and Monkeys* is one of a series of paintings he calls *The Great Invisibles*, a name taken from one of French writer André Breton's essays. "The series is a result of experimentation with negative and positive space. By breaking down an image into two values of black and white, similar to a Rorschach ink blot, one begins to see new

characters and objects that can be redrawn into those shapes. I think it's fair to say that I may have subconsciously equated Mona Lisa to Mother Nature, and by doing so I illustrated a nurturing and maternal place for critters that are cared for and loved."

David Marsh
Tona Lisa
Digital, 2008 x 2840 pixels, 1998

David Marsh
Pantona Lisa
Digital, 2008 x 2840 pixels, 1998

British graphic designer David Marsh founded the design agency Artomattic, which specializes in brand identity and art direction for print advertisements. "As a designer I am constantly working with Adobe products and I noticed that the color swatch picker in Illustrator made beautiful patterns that changed as the size and shape of the pop-up window was altered. This was a eureka moment for me. I started dissecting an image of Mona Lisa into tiny squares, seeing which size worked best in trying to strike the perfect balance between the image being too abstract or too recognizable. The resulting images are difficult to decipher when viewed up close, but becomes more and more evident as you move away. It's an illusion, and as a designer I love visual trickery and the art of playing with images."

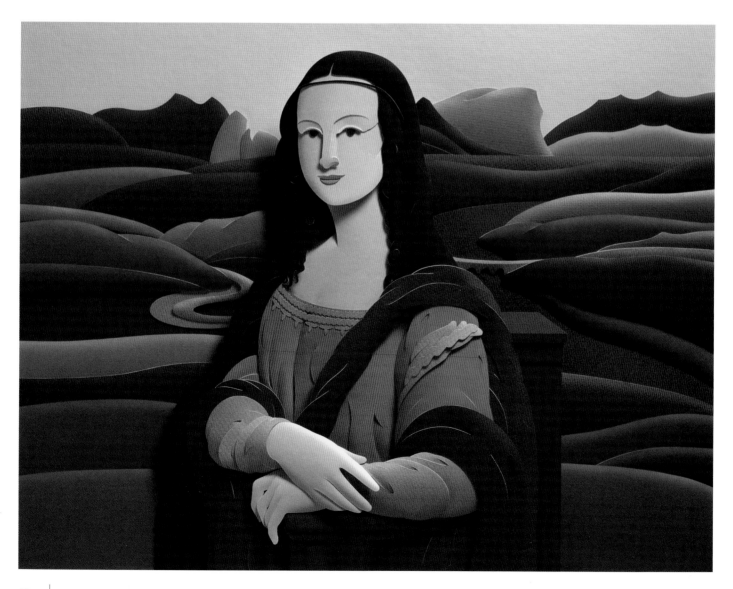

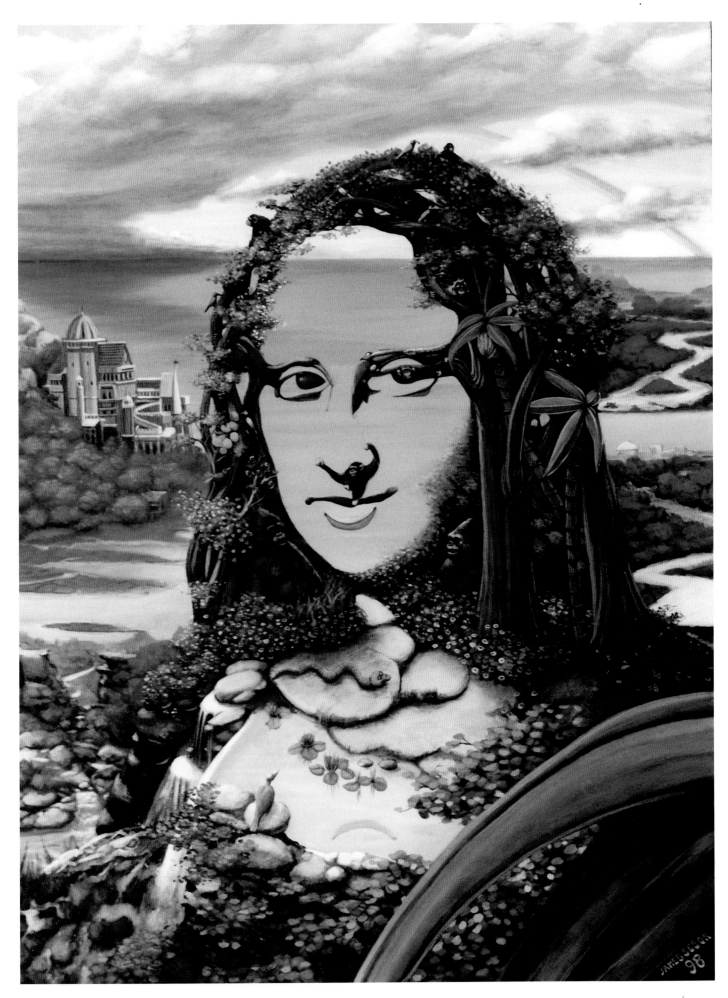

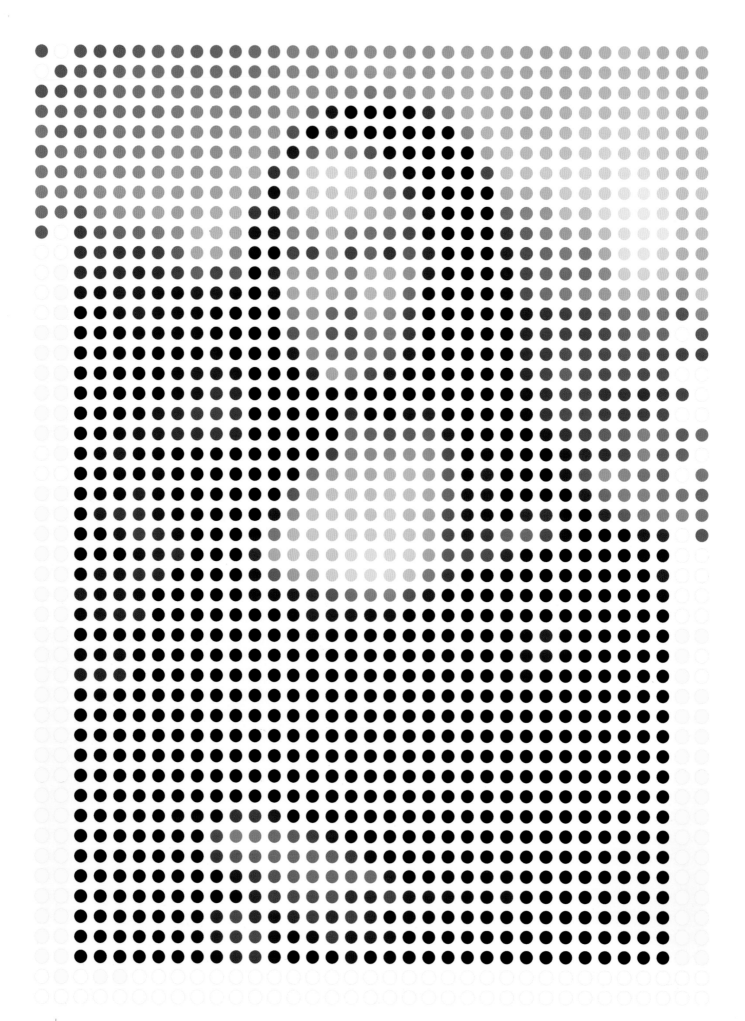

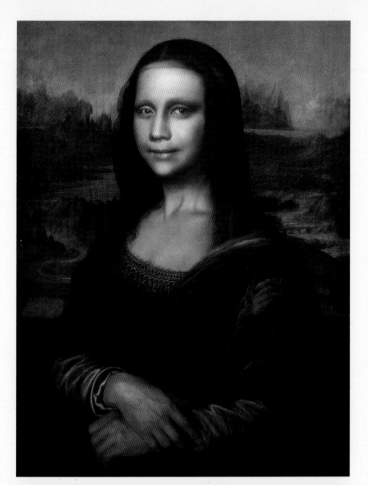

Yasumasa Morimura

Japanese artist Yasumasa Morimura has been working as a conceptual photographer and filmmaker for more than three decades. Through extensive use of props, costumes, makeup, and digital manipulation, he masterfully transforms himself into recognizable subjects, often from the canon of Western culture. In addition to Leonardo da Vinici's classic portrait, Mr. Morimura has based his works on seminal paintings by Frida Kahlo, Vincent Van Gogh, and Diego Velázquez, as well as images culled from historical materials, mass media, and popular culture. The artist's reinvention of iconic photographs and historical masterpieces challenges the associations the viewer has with these subjects, while also commenting on Japan's complex absorption of Western culture. Through his depiction of recognizable female figures, Mr. Morimura subverts the concept of the "male gaze." Within each image, he both challenges the authority of identity and overturns the traditional scope of self-portraiture.

LEFT, TOP
Mona Lisa in Its Origins
Chromogenic print mounted on canvas
54.61 x 77.47 cm, 1998

LEFT, BOTTOM
Mona Lisa in Pregnancy
Chromogenic print mounted on canvas
54.61 x 77.47 cm, 1998

RIGHT
Mona Lisa in the Third Place
Chromogenic print mounted on canvas
54.61 x 77.47 cm, 1998

© Yasumasa Morimura
Courtesy of the artist and Luhring Augustine, New York

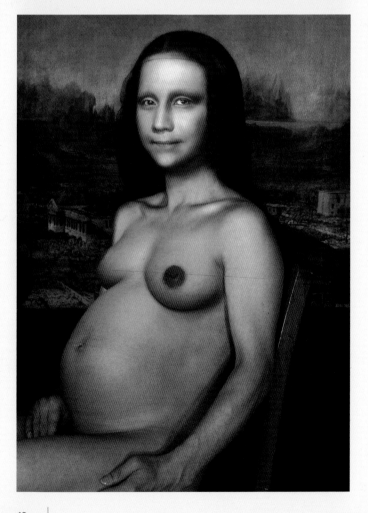

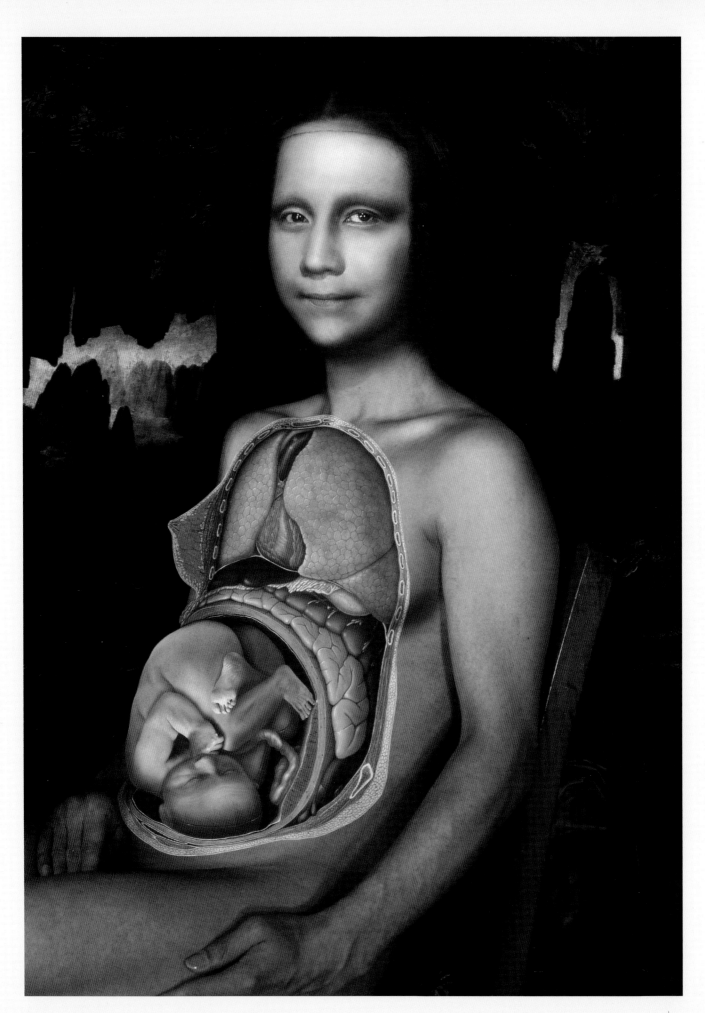

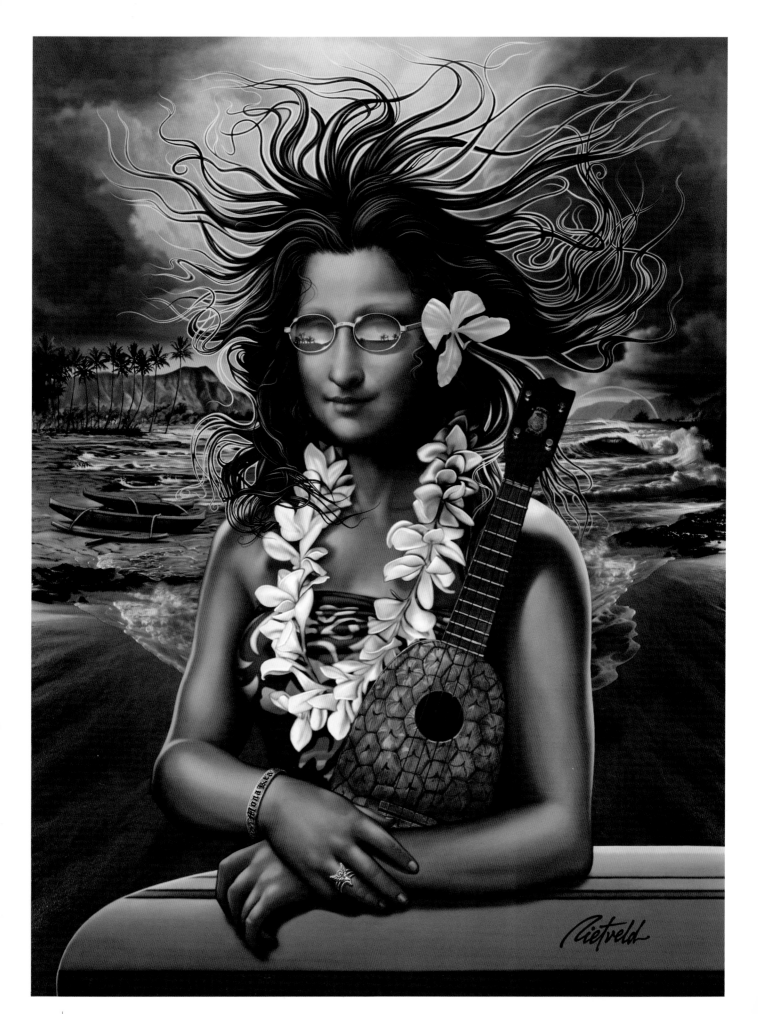

Rick Rietveld
Mona Kea
Mixed media
76.2 x 101.6 cm, 1999

A native of Southern California, illustrator Rick Rietveld co-founded the popular surfwear companies Maui & Sons and Rietveld USA, both of which feature his graphic designs. He describes his artwork as a reaction to his daily experiences ensconced in his passion for surfing and beach lifestyle: "My images tell surfing-related stories of better lands and fairer seas, with lots of adventure, spirituality and beautiful women."

Mark Brill
Klingon Mona Lisa
Acrylic and gouache on illustration board
21.6 x 28 cm, 1999

American illustrator and cartoonist Mark Brill was inspired to create his intergalactic version of Mona Lisa after watching *Star Trek VI: The Undiscovered Country*. One amusing scene in the movie seemed to suggest that William Shakespeare had actually been a Klingon. Says the artist, "I figured that if the Klingons were going to claim Shakespeare as their own, they might as well lay claim to other classic masterworks as well, and the obvious first choice was Mona Lisa."

Heidi Taillefer
Partly Shroudy
Oil on canvas
40.6 x 50.8 cm, 2000

As her work continues to evolve, Canadian painter Heidi Taillefer is constantly driven by the subconscious preoccupations of a mind busily creating associations most of us would choose to ignore. Through her art, she seeks to convey multi-layered levels of meaning and interpretation, and challenges her viewers to sift through the obstacles that may obscure this meaning.

Melinda Copper
Mona Peaches
Acrylic on canvas
40.6 x 50.8 cm, 2000

The portfolio of American artist Melinda Copper is a wonderful collection of Old Master paintings played out in the animal world. She began copying the classic works over twenty years ago, substituting her own pets for the original paintings' human subjects. Of all of her reproductions, she cites *Mona Peaches* as being the most challenging. "Peaches had died as a kitten, and I painted her from the thought of what she might have looked like if she had lived. This is the only time I ever did anything like that." Apart from the demands involved in not having viable references for Peaches, the true difficulty came in trying to replicate Leonardo's famous use of sfumato glazes. "I thought it would be fairly simple and I could just knock it out. It was by far the hardest of any of the paintings I've ever done. After struggling with it for weeks, I decided Leonardo must have been some kind of an alien to be able to paint the way he did."

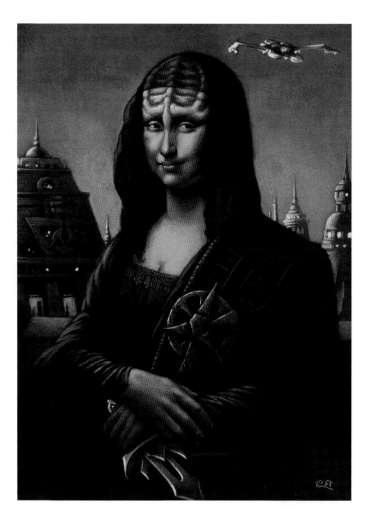

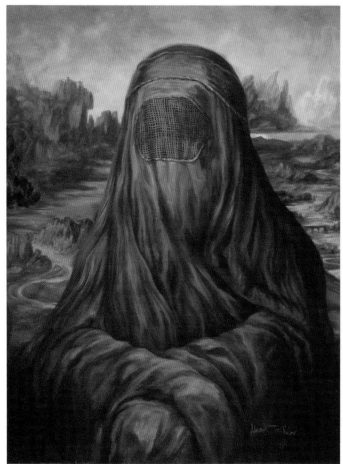

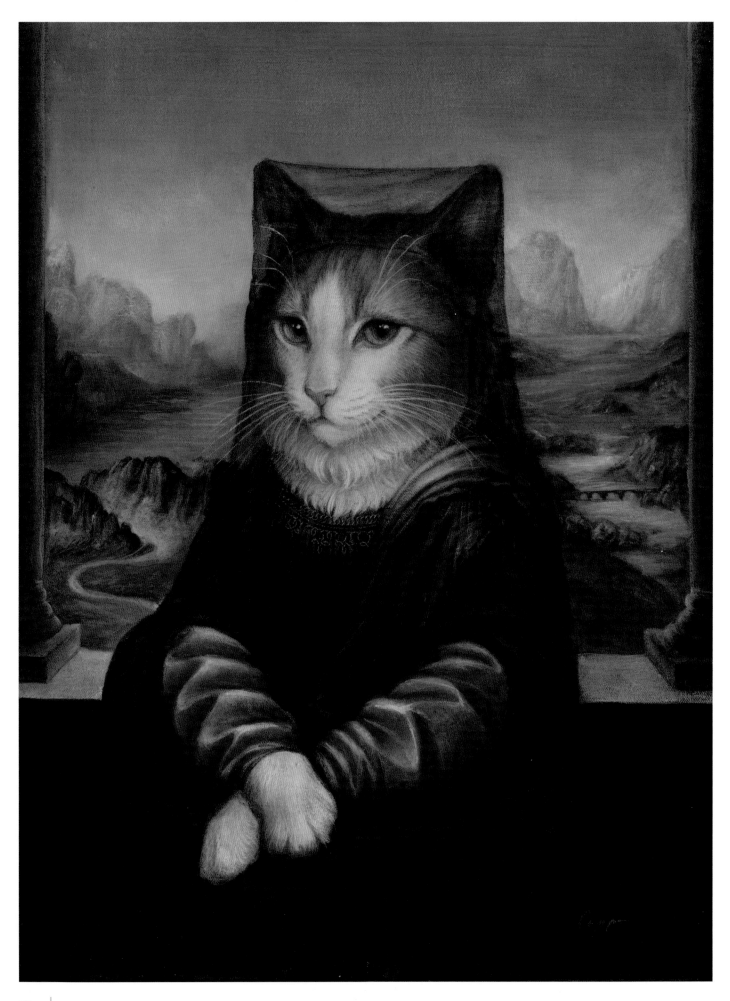

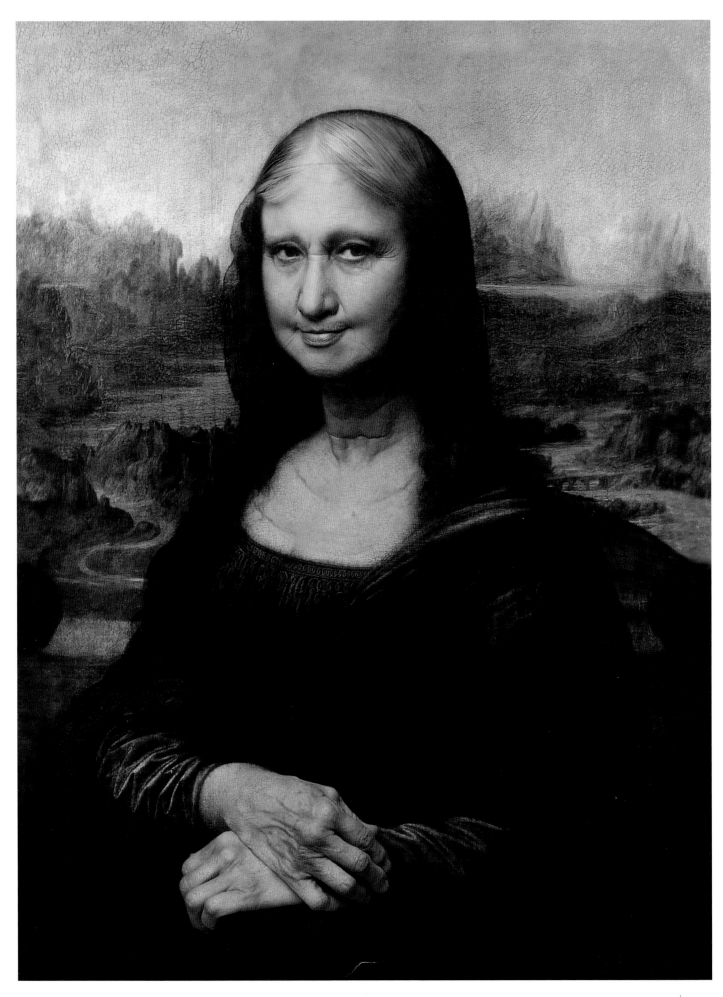

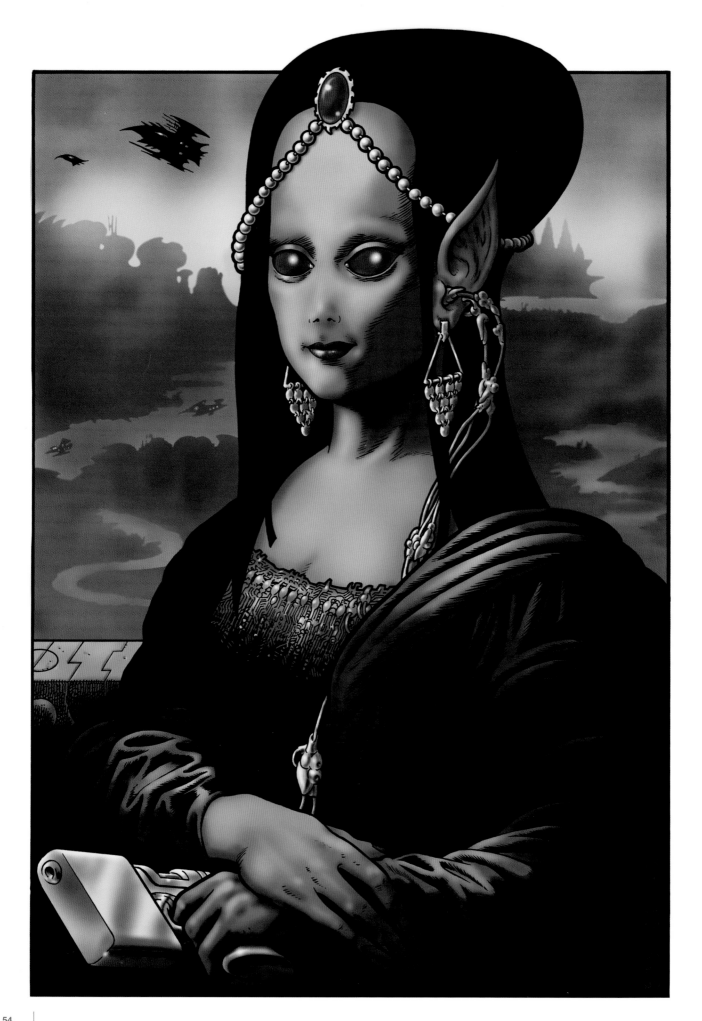

Roberto Weigand and Alex Soletto
Mona Lisa Getting Older
Digital
2070 x 2760 pixels, 2000

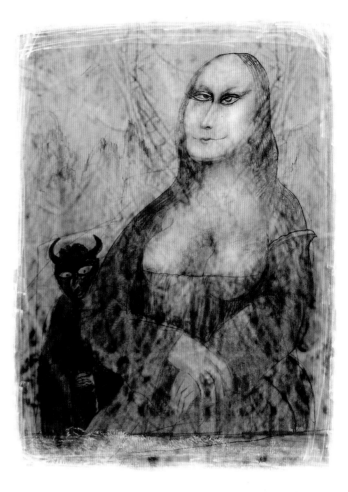

Graphic designer Roberto Weigand and veteran photographer Alex Soletto were working together at Brazilian weekly news magazine *ISTOÉ* when their editors asked them to collaborate on a cover illustration for an article on aging. They carefully selected a model of advanced years who was able to approximate the pose and facial expression of Mona Lisa, and she was photographed by Mr. Soletto. Mr. Weigand then digitally divided the elements of the model's hands and face and carefully overlapped them onto the respective regions of a digital reproduction of the original painting, seamlessly blending everything together to create an approximation of what Mona Lisa may have looked like in her senior years. All of this work was accomplished within one day's time.

LEFT
Bryan Talbot
Gioconda P.I. (AKA Uncommon Mona)
Ink on paper with digital colors
29.7 x 42 cm, 2000

Award-winning British comic book artist and writer Bryan Talbot has been in the business for over thirty years, working on such titles as *Judge Dredd*, *Batman*, *Sandman*, *The Adventures of Luther Arkwright* and its sequel *Heart of Empire*, and the *Grandville* series. He describes the subject of *Gioconda P.I.* as being "from an imaginary parallel world in which aliens live on Earth, side-by-side with humans. She is the lover of Leonardo da Vinci, and she's investigating the brutal murder of the Pope."

RIGHT, TOP
Ilir Pojani
The Temptation of Mona Lisa
Digital
1321 x 1800 pixels, 2000

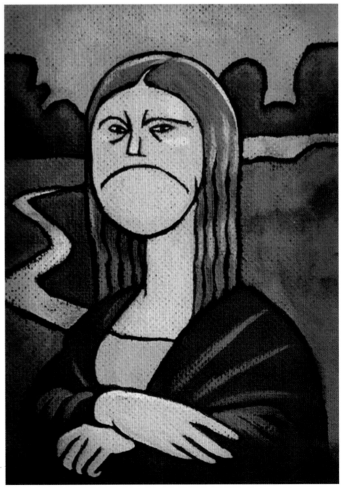

The meaning behind Mona Lisa's enigmatic expression has been a source of speculation for centuries. Albanian born American artist Ilir Pojani interprets her smile as the result of a secret temptation, physically embodied by the shadowy figure of a grinning demon. Says the artist, "I'm always interested in hidden phenomena running wild beneath the surface of the visible material reality. My work aims to visually manifest those perceptions and let them materialize in a representational form. In doing so, I usually raise more questions than I answer, and create more mysteries than I solve."

RIGHT, BOTTOM
Adam Koford
Frowning Lisa
Acrylic on masonite
20.3 x 25.4 cm, 2000

American illustrator Adam Koford works as a video game artist and director of cinematics at Disney Interactive, the digital entertainment division of The Walt Disney Company. His *Frowning Lisa* was inspired by a similar portrait that cartoonist Richard Thompson had painted of Ludwig van Beethoven in 1989.

Paul Gilligan
Dead Man Mopping
Ink brush with digital color
3279 x 3191 pixels, 2000

Canadian cartoonist Paul Gilligan has worked as an illustrator, graphic designer, storyboard artist, and animator, but is probably best known for his syndicated comic strip *Pooch Café*, which is published in nearly 300 newspapers around the world. His *Dead Man Mopping* illustration was created as part of a self-promotional series depicting workplace hardships, this one pertaining to the perils of working late hours.

Patrice Murciano
Mona Lisa (Coubisme Style)
Acrylic on canvas
66 x 100 cm, 2001

Self-taught French artist Patrice Murciano is always experimenting with new media and techniques, constantly evolving over time. He explains that his job is that of a "researcher" and he calls his unique style "NewPop" art or "Pop Grunge." Captivated by art at a very early age, as a child he would take his mother's makeup and apply it to the backs of old rolls of wallpaper abandoned in the attic. "I continue to work with any and all materials that are available to me. Painting, photography, sculpting, filmmaking, fashion design – these are all media that satisfy my quest for meaning."

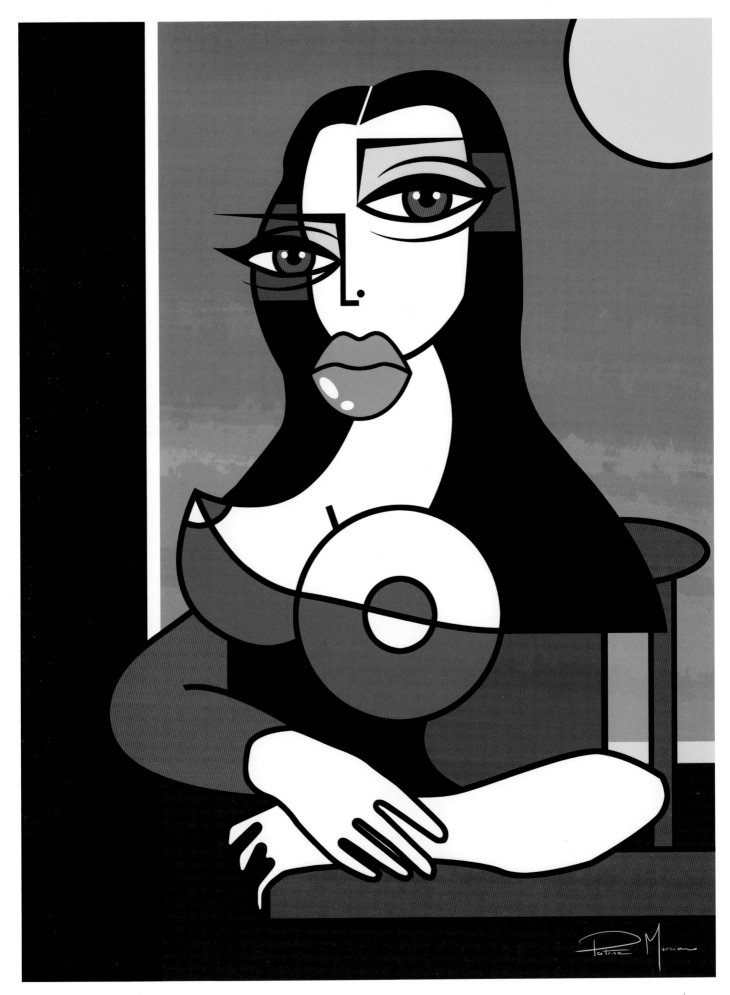

Max Grishkan
In the Eye of the Beholder
Digital mixed media, 2700 x 3600 pixels, 2001

Daniel Blancou
Dona Lisa
Digital, 5906 x 8268 pixels, 2001

Israelian animator and interactive digital designer Max Grishkan has had his animated films screened at festivals across Europe, and through his advertising firm he has mounted innovative, large-scale campaigns for international clients such as Motorola, Renault, Cellcom, and Fox. His furiously energetic rendition of Leonardo da Vinci painting Mona Lisa was created as part of a ten-piece series of digital illustrations called *The Millennium Project*, with each image depicting a crucial, world-changing event that occurred during each century between the years 1000 and 2000. Other images from this series include depictions of philosopher Avicenna from the 10th Century, the construction of the Tower of Pisa during the 13th Century, the beheading of King Charles I in the 17th Century, and the invention of cinema in the late 19th Century.

French comic book artist Daniel Blancou's exhaustively detailed illustration was reproduced as an infuriatingly difficult-to-construct jigsaw puzzle, released by Heye Verlag for the European market. A frenzied whirlwind of controlled chaos, the colorful cartoon features a host of clever inside jokes, including references to several other famous Mona Lisa parodies by artists such as Andy Warhol, Fernando Botero, Marcel Duchamp, and Fernand Léger. In a manner reminiscent of *Where's Waldo?*, the "real" Mona Lisa herself even makes an appearance in the crowd, wearing a blue dress and sitting inconspicuously within a throng of enthusiastic admirers. The entire scene is also a masterful example of an intricate optical illusion known as the "ambiguous image," expertly crafted to give the appearance that this mass of humanity (and sheep) coalesce to form the faint visage of Mona Lisa looming over the proceedings.

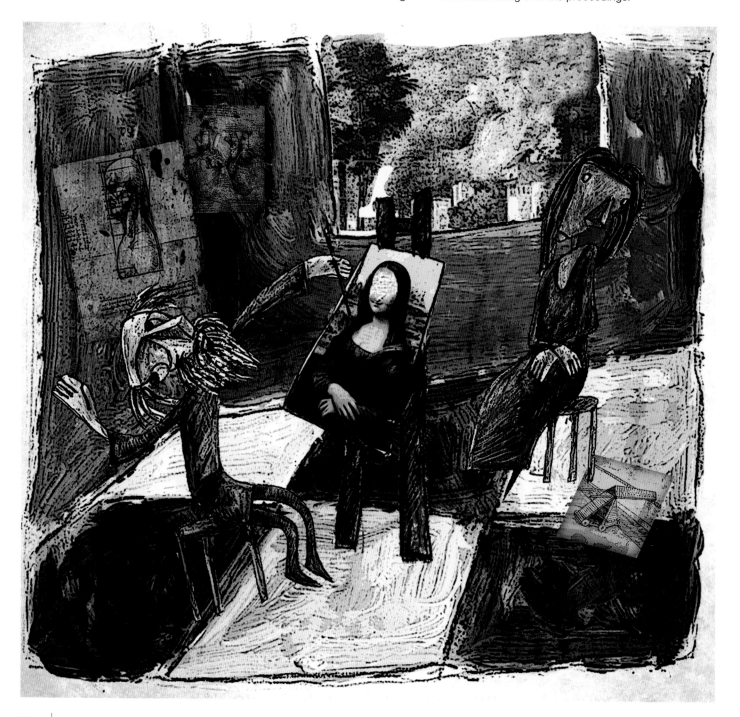

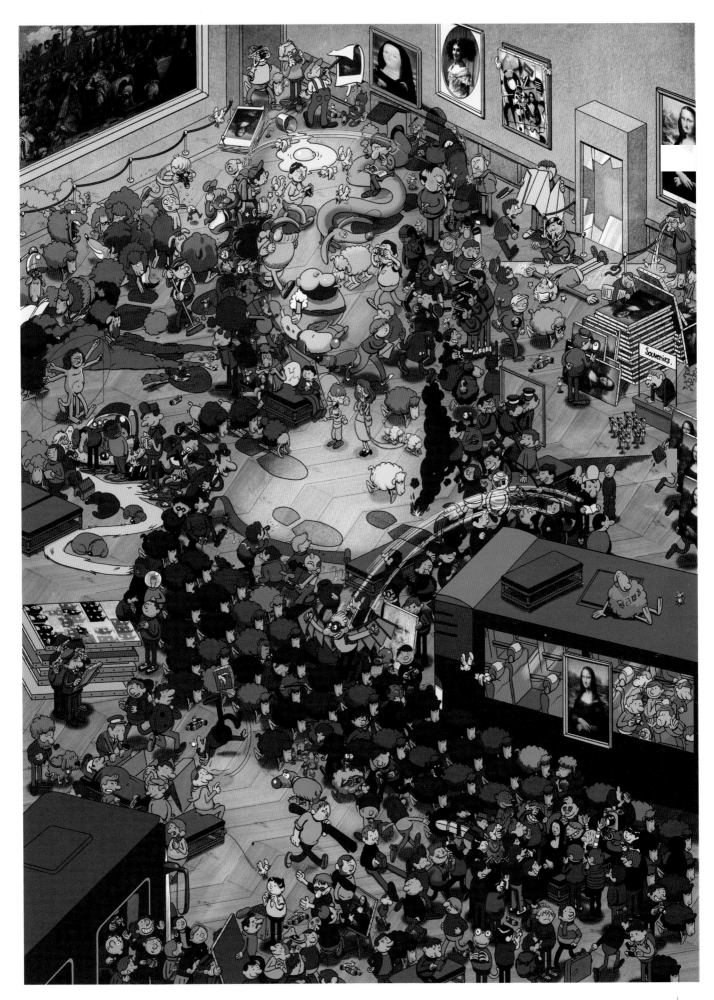

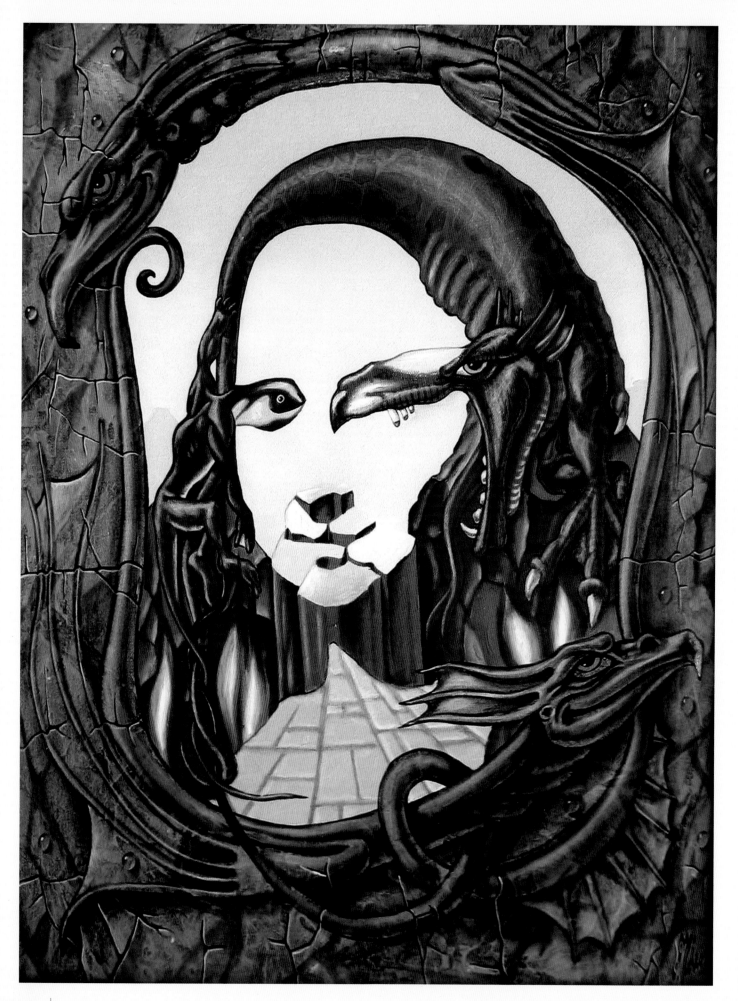

Victor Molev

Russian-born artist Victor Molev began his career as an architect and theater set painter before immigrating to Israel to work as a painter and sculptor. Now living in Canada, he concentrates almost exclusively on easel painting, creating intricately plotted compositions that frequently utilize the optical illusion known as "the ambiguous image." The visage of Mona Lisa appears periodically in his work as a spectral apparition hovering amidst his elaborately designed landscapes. Within these mystifying "portrait-scapes" in which the evident meaning blends into the hidden one, he has created his own artistic language of symbols, signs, and original effects that make his paintings unique and instantly recognizable.

LEFT
Mona Lisa (Fire)
Oil on canvas, 50 x 60 cm, 2001

BELOW, LEFT
Mona Lisa (Love)
Oil on canvas, 71 x 91 cm, 2011

RIGHT, TOP
Mona Lisa (Air)
Oil on canvas, 51 x 61 cm, 2012

RIGHT, BOTTOM
Mona Lisa (Water)
Oil on canvas, 45 x 61 cm, 2014

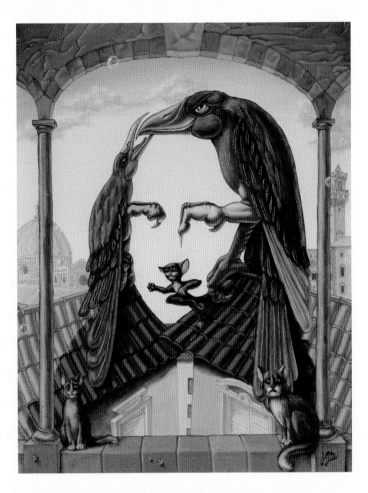

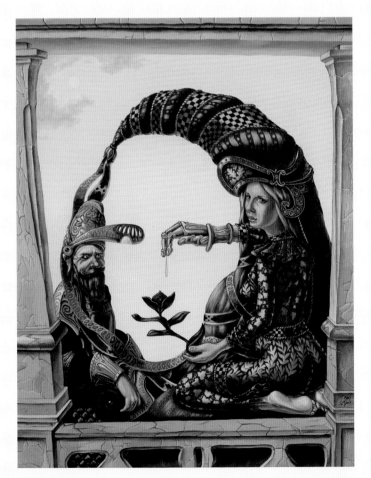

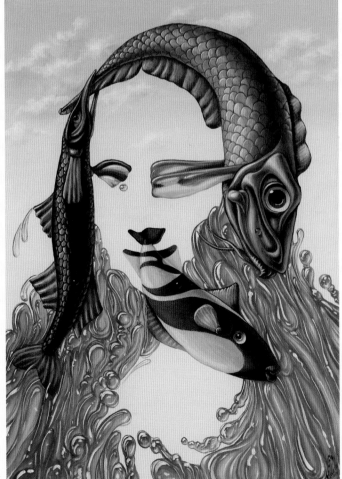

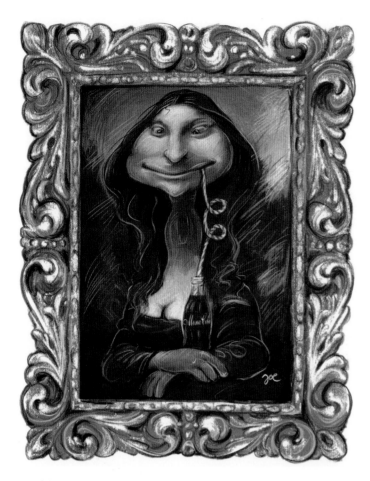

József "Joe" Békési
Mona Cola
Digital, 2325 x 2953 pixels, 2001

Hungarian artist József Békési began his career as a sculptor before turning his attention to cartooning, becoming a staff member of the famous Hungarian satirical magazine *Ludas Matyi*. Today, he is the president of the Hungarian Cartoonist Association and works as a freelance caricaturist, traveling around the world creating amusing portraits.

Ael Lim
Bloom
Crayons on paper, 83 x 128 cm, 2002

Multi-talented Singapore artist Ael Lim does not limit himself to a single discipline or style, instead his work is an assortment of inspiration from all facets of art history and pop culture. Constantly reinventing himself, he currently owns and operates Imagine Tattoo Studio, and describes being a tattoo artist as his greatest passion to date.

Daniel Lienhard
The Shoes of Mona Lisa
Digital, 1451 x 2024 pixels, 2002

Daniel Lienhard
Series: Mona Lisa Over the Years

Mona Lisa: One Year Old
Digital, 1600 x 1086 pixels, 2002

Mona Lisa: Five Years Old
Digital, 1600 x 1086 pixels, 2002

Mona Lisa: Ten Years Old
Digital, 1600 x 1086 pixels, 2002

Mona Lisa: Twenty Years Old
Digital, 1600 x 1086 pixels, 2002

Mona Lisa: Forty Years Old
Digital, 1600 x 1086 pixels, 2002

Mona Lisa: Sixty Years Old
Digital, 1600 x 1086 pixels, 2002

Swiss illustrator and three-dimensional digital designer Daniel Lienhard has been running his own design studio in Switzerland for over thirty years. During that time, Mona Lisa has been a recurrent muse in both his personal artwork and his commissioned projects. *The Shoes of Mona Lisa* offers a rare glimpse of the model in repose, possibly taking a break from her arduous task of sitting for Leonardo, while still exhibiting that same picture-perfect style she is famous for. The affectionate tribute series *Mona Lisa Over the Years* is an ambitious look at Mona Lisa from childhood to old age, and displays Mr. Lienhard's deft ability to convey poignancy without becoming overly sentimental.

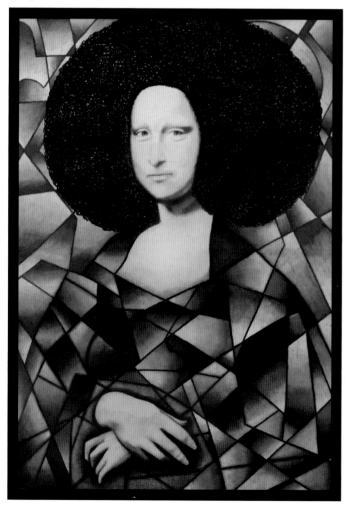

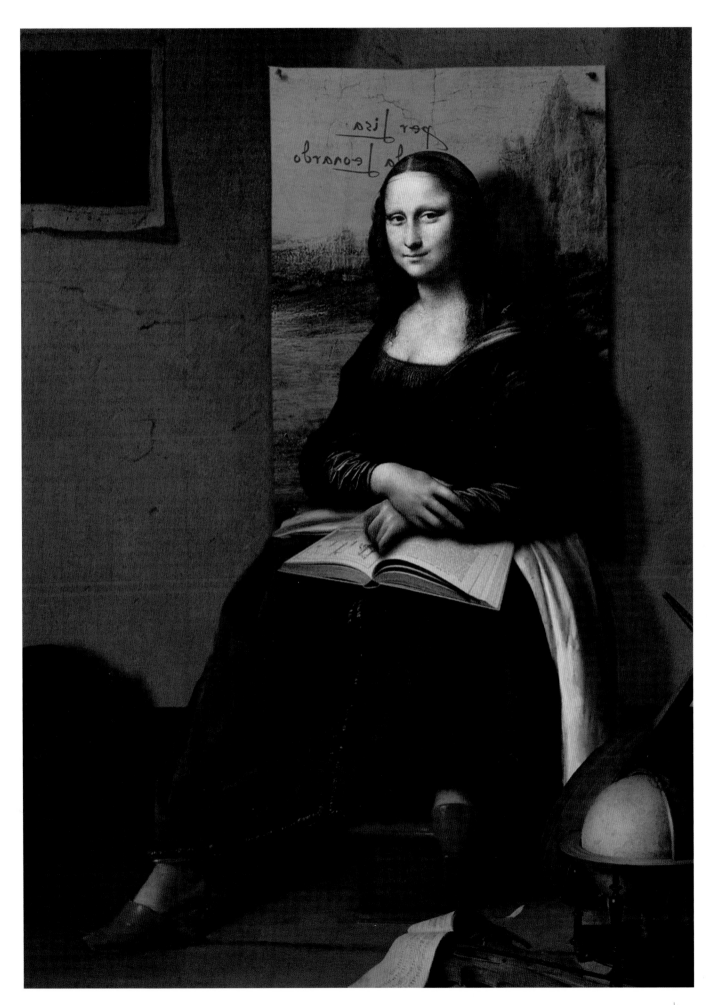

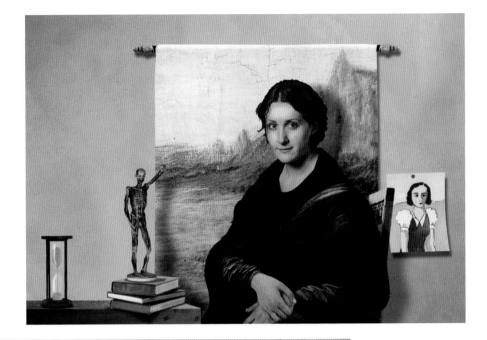

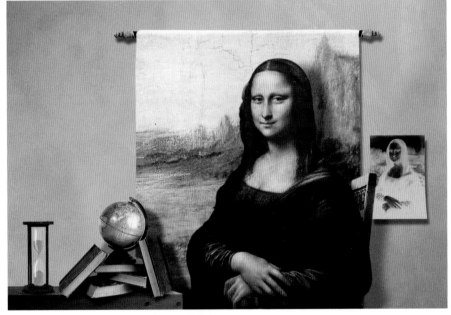

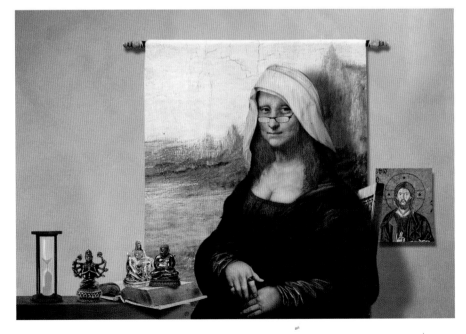

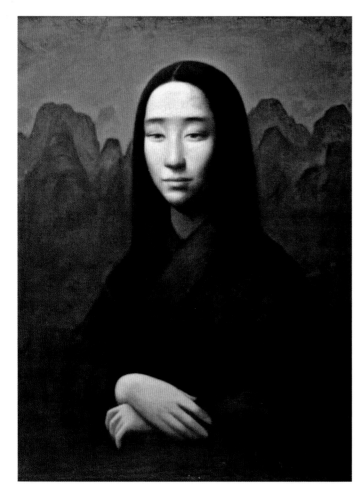

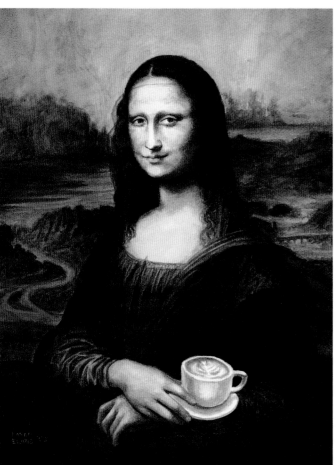

Yin Xin
After Mona Lisa
Acrylic on canvas, 160 x 200 cm, 2002

The work of Paris-based Chinese painter Yin Xin is a fusion of Western techniques with Eastern aesthetics, grounded in tradition, yet independent and free from classic artistic trends. His *After Master* series consists of reproductions of famous works by artists such as Édouard Manet, Diego Velázquez, and Sandro Botticelli, with the subjects of those paintings replaced by Asians.

Richard Rownak
Mona
Digital, 43.2 x 55.9 cm, 2003

American digital artist and photographer Richard Rownak creates contemporary Pop Art portraits using Adobe Photoshop combined with a process he developed called "Scantography," a result of his experimentation with a flatbed scanner.

Karen Eland
Mona Latte
Coffee and water on paper, 5.8 x 61 cm, 2003

Oregon-based artist Karen Eland has become a master of creating delicate pieces of art utilizing non-traditional painting media such as coffee and, more recently, beer. "I came up with the idea while watching rich, red-brown espresso pouring into my cup. It suddenly occured to me that I could take my passion for coffee to a deeper level. So I dipped my brush and began painting, and to my delight, it worked beautifully."

Linda Bark'karie
Bona Lisa
Acrylic on canvas, 28 x 35.5 cm, 2003

Inspired by her fascination with the Dias de los Muertos celebrations, American artist Linda Bark'karie created *La Vida de Muerte (The Life of Death)*, a series of paintings which, as she explains, "explore the parallels between the skeleton being the foundation of our physical being, and the soul being the foundation of who we are."

Ludmila Kalmaeva
Dedicated to Leonardo da Vinci
Oil on canvas, 50 x 70 cm, 2003

Originally from Belarus and now living in the Netherlands, painter Ludmila Kalmaeva reimagines Mona Lisa as a lavatory attendant as part of her taboo-breaking series of paintings depicting famous figures from classical art transposed to modern public washrooms.

Hans Doller
Mona Mia
Oil on canvas, 55 x 75 cm, 2003

German-born painter Hans Doller describes his artwork as "humanity in progress", and explores this theme through his aggressive use of bold color and striking, yet harmonic, compositions.

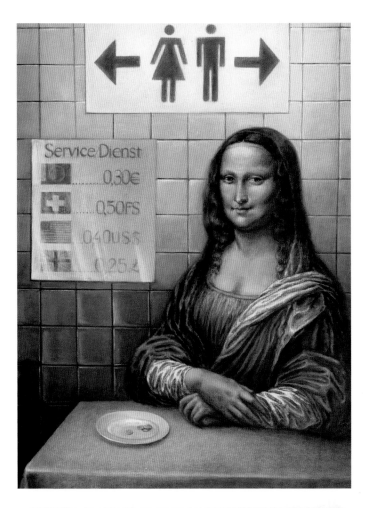

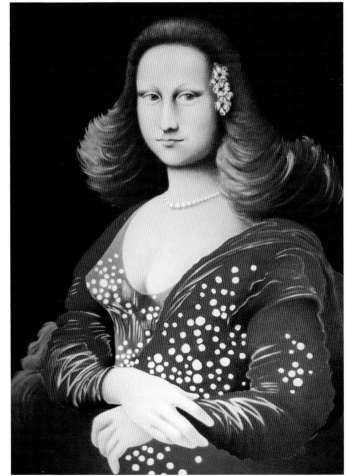

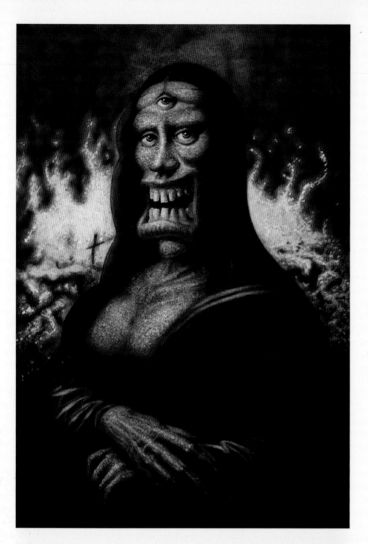

Naoto Hattori

Though his work is often mistaken for digital art, celebrated Japanese artist Naoto Hattori creates all of his surrealistic visions with traditional media, most frequently acrylic on canvas. Says the extremely prolific artist, "I've been creating an imaginary world within my mind ever since I was a child. My vision is like a dream, whether it's a sweet dream, a nightmare, or just a very bizarre dream. I try not to label it or think about what it is supposed to be, I just take it as it is and paint whatever I see in my mind with no compromise." This fantastical imagery can be found throughout his extraordinary oeuvre, which is the fruit of his ambition to increase awareness in stream-of-conscious creativity.

LEFT, TOP
Untitled
Watercolor on board
28 x 35.5 cm, 1998

LEFT, BOTTOM
Sweet Dreams
Acrylic on canvas
61 x 76.2 cm, 2000

RIGHT
Untitled
Acrylic on canvas
40.6 x 50.8 cm, 2000

FOLLOWING PAGE, TOP LEFT
Maternity
Acrylic on canvas
40.6 x 50.8 cm, 2003

FOLLOWING PAGE, TOP RIGHT
The Enigma
Acrylic on canvas
40.6 x 50.8 cm, 2003

FOLLOWING PAGE, BOTTOM LEFT
Watcher
Acrylic on canvas
40.6 x 50.8 cm, 2003

FOLLOWING PAGE, BOTTOM RIGHT
Geisha
Acrylic on canvas
40.6 x 50.8 cm, 2003

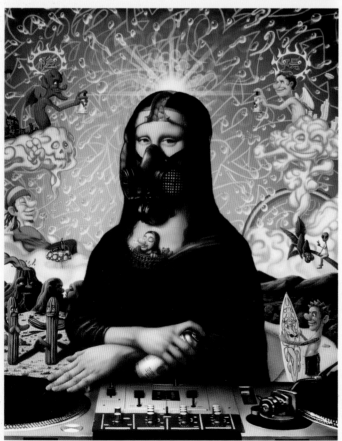

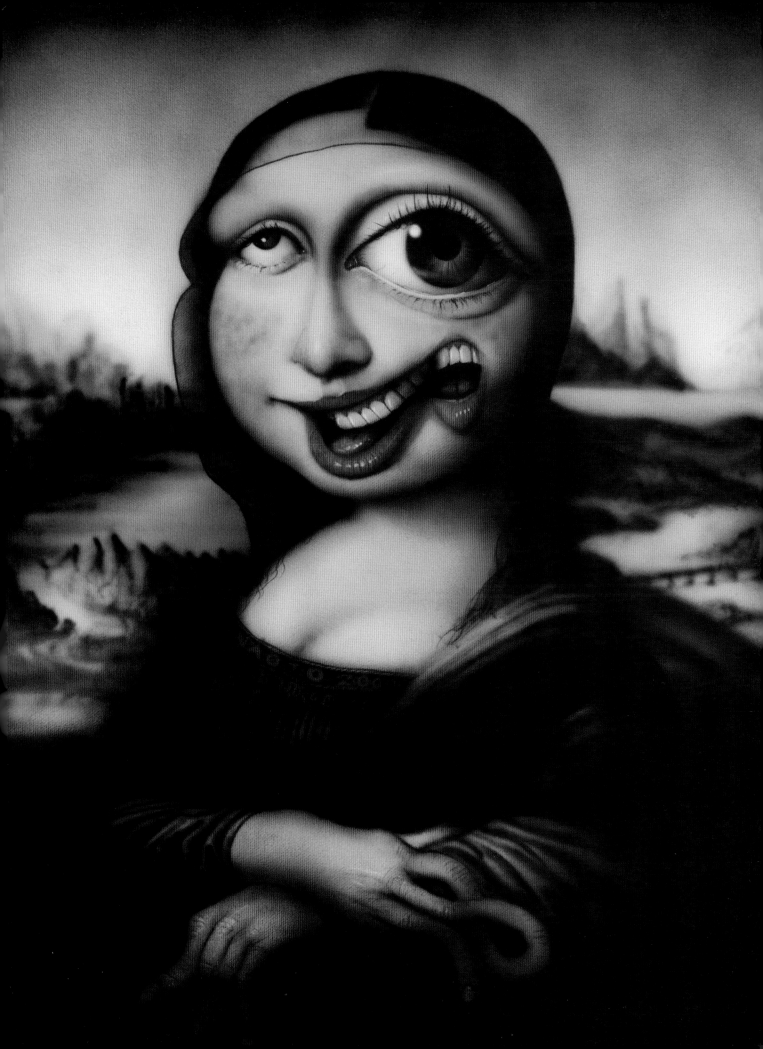

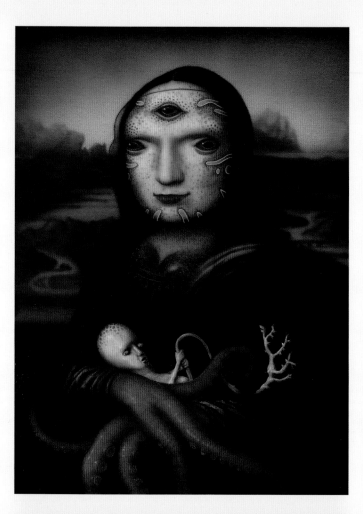

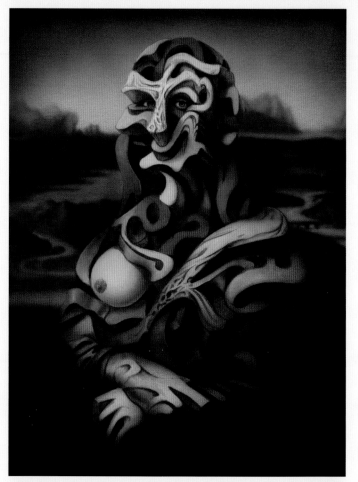

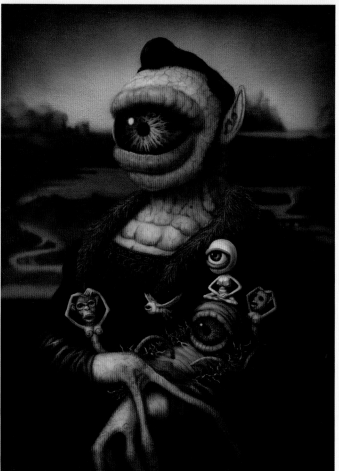

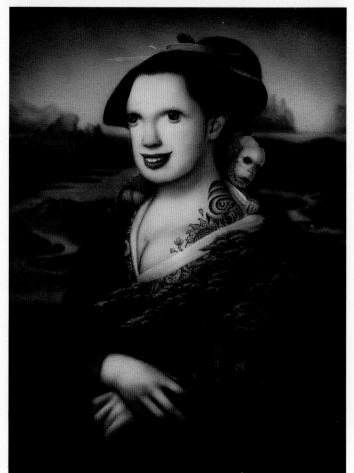

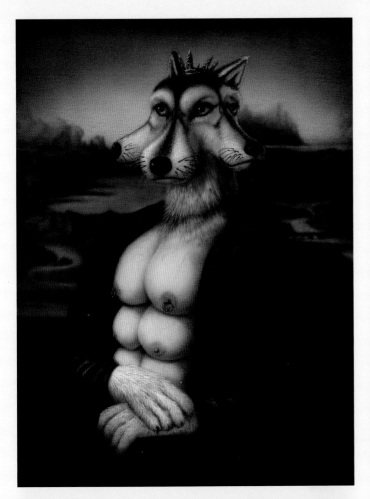 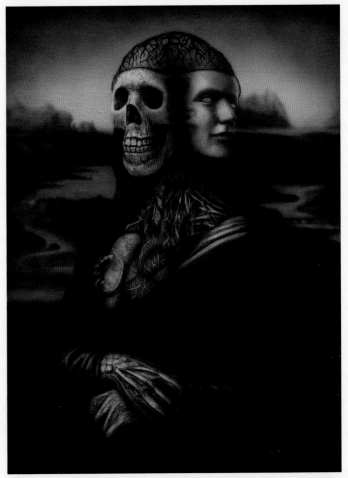

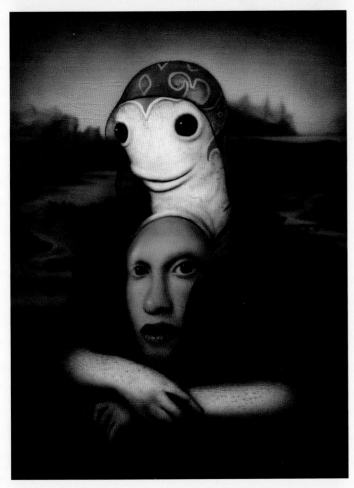 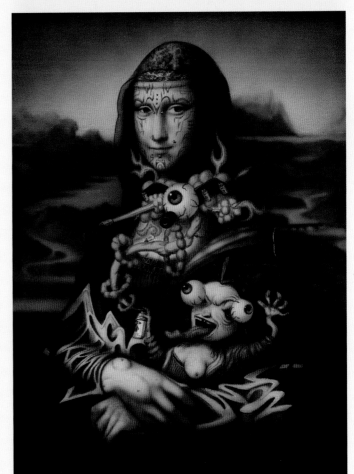

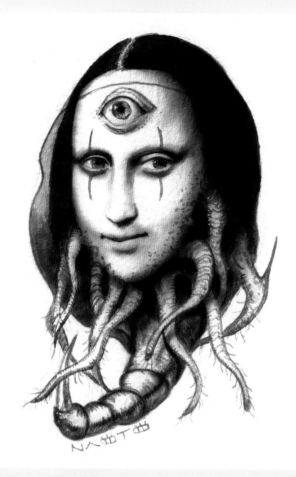

PREVIOUS PAGE, TOP LEFT
Bow Wow Bitch
Acrylic on canvas
40.6 x 50.8 cm, 2003

PREVIOUS PAGE, TOP RIGHT
Skinless
Acrylic on canvas
40.6 x 50.8 cm, 2003

PREVIOUS PAGE, BOTTOM LEFT
Fabrication
Acrylic on canvas
40.6 x 50.8 cm, 2003

PREVIOUS PAGE, BOTTOM RIGHT
Bombing
Acrylic on canvas
40.6 x 50.8 cm, 2003

LEFT, TOP
Virus 022
Acrylic on paper
17.8 x 25.4 cm, 2003

LEFT, BOTTOM
Enigma
Acrylic on board
20.3 x 27.3 cm, 2006

RIGHT
Notorious BI-AT-CH
Acrylic on board
35.5 x 50.8 cm, 2006

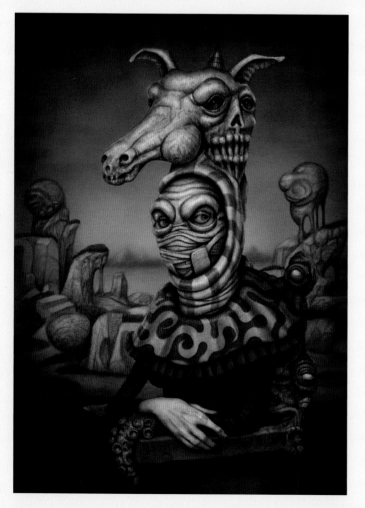

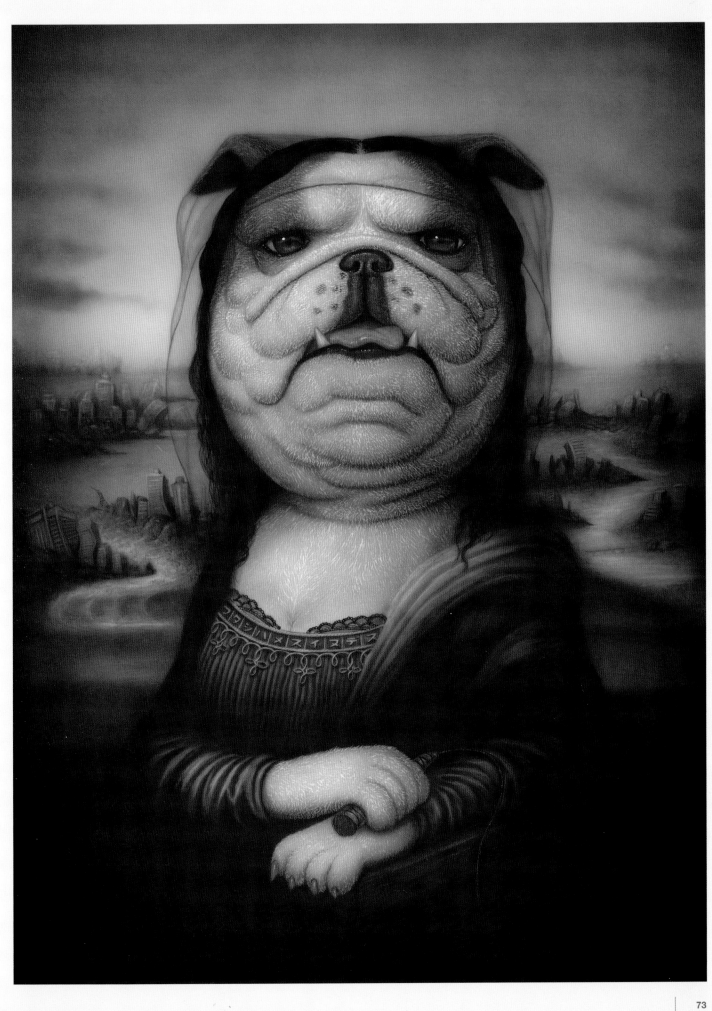

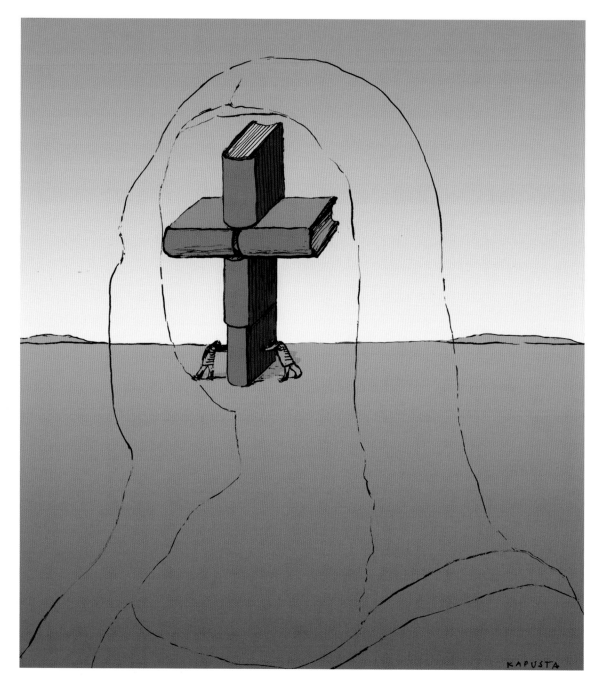

ABOVE

Janusz Kapusta
Mona Lisa Code
Brush and ink on paper, digital color
22.9 x 25.4 cm, 2004

Born in Poland, Janusz Kapusta has resided in New York City since 1981, where he has worked as an author, illustrator, graphic designer, theatrical set designer, and fine artist. In 2000, he discovered new and previously unknown principles of the "golden ratio" (AKA the "divine proportion"), a mathematical concept used extensively by Leonardo da Vinci in his work. Mr. Kapusta has presented his groundbreaking findings at mathematical conferences nationwide, and in scientific periodicals in the United States and Japan. His work as a fine artist can be found in the collections of many museums and galleries around the world, including the Museum of Modern Art in New York. *His Mona Lisa Code* was an editorial illustration created for a magazine article written at the height of the controversy surrounding Dan Brown's 2003 novel, *The Da Vinci Code*.

Courtesy of Illustration Source

RIGHT

Randy Martinez
Star Wars Art Gallery
Watercolor and colored pencil on illustration board
38.1 x 50.8 cm, 2004

One of today's most popular entertainment illustrators, Randy Martinez has been an officially licensed artist for Lucasfilm since 1999. His *Star Wars Art Gallery* illustration was created for *Star Wars Insider*, the official bi-monthly magazine of the popular franchise. To accurately replicate the styles of each of the artists represented in the gallery, Mr. Martinez carefully studied the work of masters such as Pablo Picasso, Vincent Van Gogh, Edgar Degas, and, of course, Leonardo da Vinci. The end result is a vibrant, astute, and very memorable mash-up, filled with inside jokes and clever visual puns. It is also one of the few Star Wars illustrations of the era to feature a likeness of George Lucas. Explains the artist, "At the time it was strictly forbidden to put Lucas in an official piece of art, particularly in a humorous context. But in this case, Lucasfilm liked it and they approved it."

Courtesy of Lucasfilm Ltd.

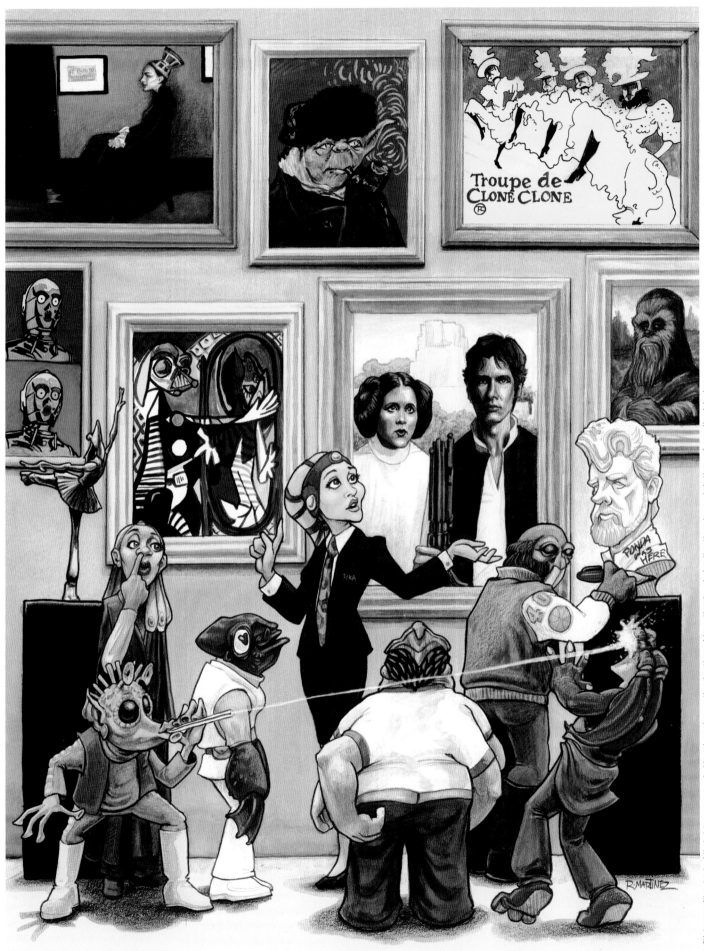

Troupe de
CLONE CLONE

© & ™ Lucasfilm Ltd. All rights reserved. Used under authorization. Unauthorized duplication is a violation of applicable law.

BELOW
Jonathan Godoy Nava
Mona Lisa's Secret
Pencil and ink on paper, digital colors
3600 x 2832 pixels, 2004

Mexican illustrator Jonathan Godoy Nava created this cartoon for the Latin American edition of *Maxim Magazine*, to accompany an article satirizing love triangles. Leonardo da Vinci has discovered that his beloved Gioconda has been given a gift, a nude sculpture from Michelangelo. In his jealous fury, Leonardo has threatened to destroy the statue with a mallet. What he doesn't realize is that the figure itself is actually the secret lover of Gioconda, hiding underneath layers of alabaster makeup.

RIGHT
Jeffrey Batchelor
The Girl in the Window
Oil and graphite on canvas-laminated panel
121.9 x 152.4 cm, 2004

A native of Rocky Mount, North Carolina, Jeffrey Batchelor worked as a theatrical scenic painter for many years before embarking on his career as a fine artist. He achieves extraordinary levels of detail with his time-consuming and labor-intensive painting techniques, the end result of his efforts being a degree of almost otherworldly ultra-realism.

Of his complex and highly symbolic painting, Mr. Batchelor says, "I love the fragmented pieces of objects once present but now gone, because the elements they leave behind are much like the way we humans collect our intellect, laying one thing over another, building a collage of emotions and imagery for which details often fade into oblivion."

FOLLOWING PAGE
Seward Johnson
A Reason to Smile
Bronze and mixed media
106.68 x 142.24 x 106.68 cm, 2004

Following an early career as a painter, American sculptor Seward Johnson turned his attention to three-dimensional art, and has since created nearly 500 life-size cast bronze figures that are featured in private collections and museums all over the world, as well as in public spaces such as Rockefeller Center in New York City, Sir Winston Churchill Square in Edmonton, Canada, and Utsubo Park in Osaka, Japan. Many of his sculptures depict ordinary people engaged in normal, everyday activities. Others, such as *A Reason to Smile*, are part of his *Icons Revisited* series, which takes already existing and recognizable masterworks and reappropriates their subject matter into ordinary, publicly accessible environments.

© 2004 The Sculpture Foundation, Inc. (www.sculpturefoundation.org)

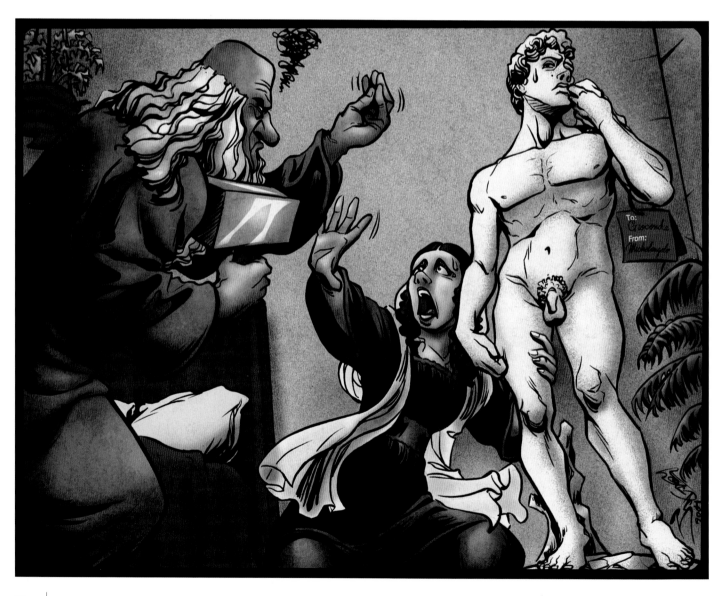

© 2004 The Sculpture Foundation, Inc. (www.sculpturefoundation.org)

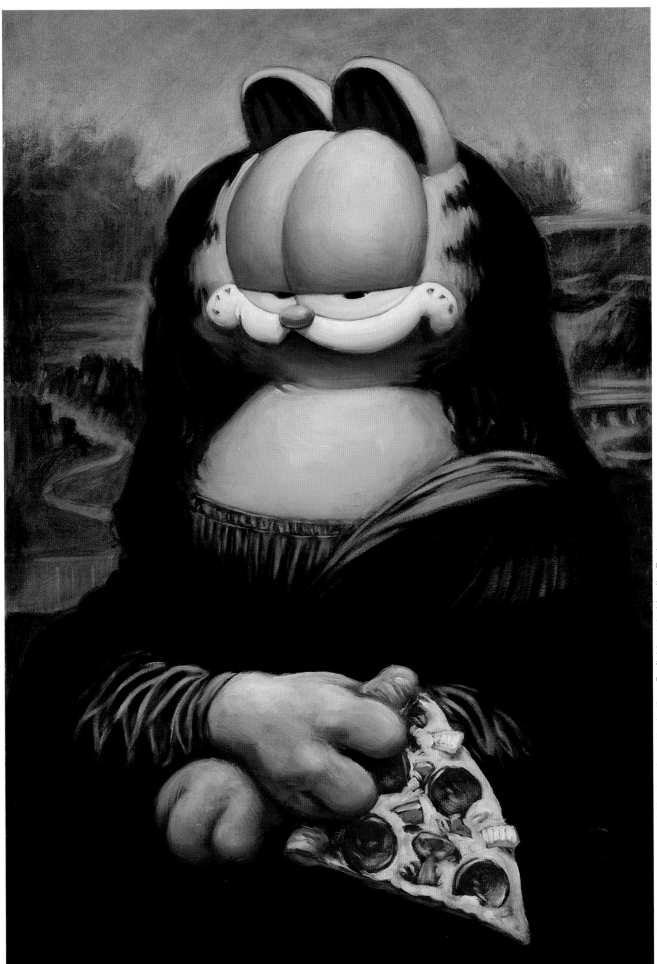

© PAWS Inc. All rights reserved. Used under authorization. Garfield created by Jim Davis.

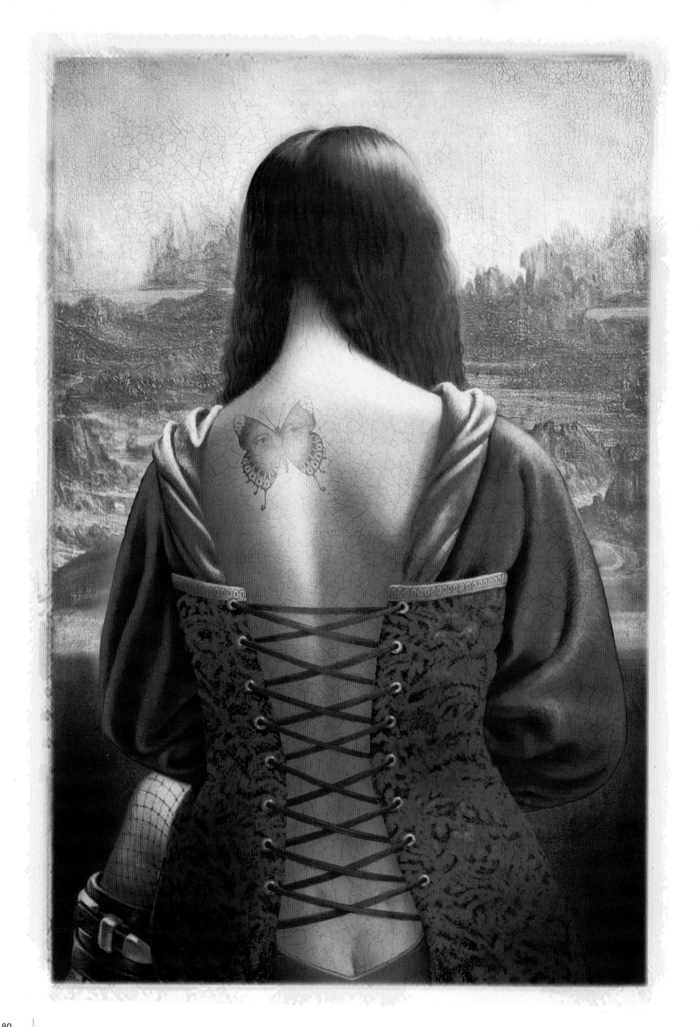

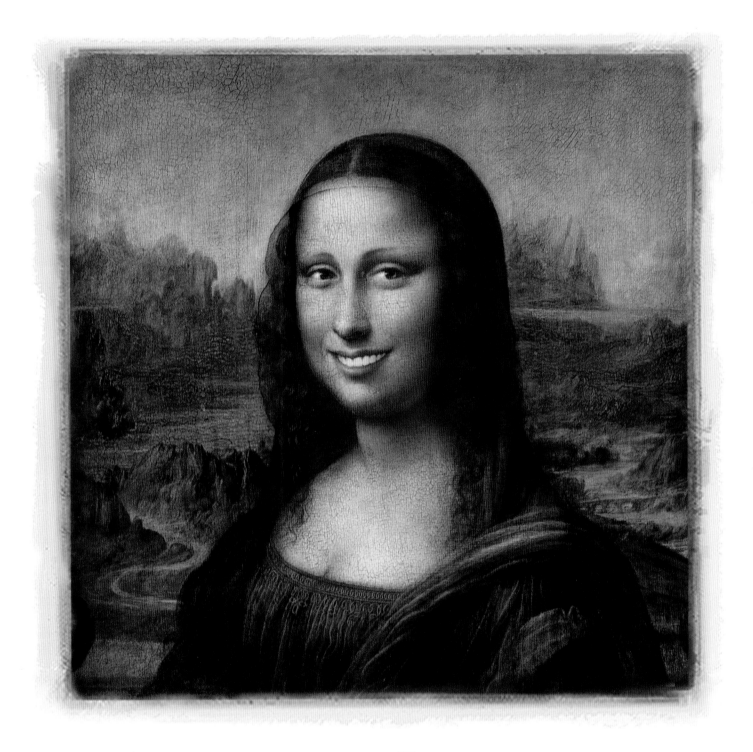

PREVIOUS PAGE
Mike Fentz
Mona Pizza
Oil on canvas, 50.8 x 76.2 cm, 2005

Created by American cartoonist Jim Davis in 1978, the Garfield comic strip is currently syndicated in over 2,500 newspapers and journals, holding the Guinness World Record for being the world's most widely syndicated comic. For nearly three decades, American artist Mike Fentz was the head illustrator in the licensing department of Paws, Inc., the company founded in 1981 to support Garfield licensing rights. During his tenure there, Mr. Fentz designed and illustrated children's books, posters, greeting cards, and calendars. His character designs were also instrumental in the pre-production development of Garfield for his first CGI/live-action motion picture, *Garfield: The Movie*.

Garfield created by Jim Davis.
Courtesy of Paws, Inc.

LEFT
Matt Zumbo
The Back of the Mona Lisa
Graphite and digital mixed media, 2700 x 3900 pixels, 2005

ABOVE
Matt Zumbo
Smiling Mona
Digital mixed media, 3600 x 3600 pixels, 2011

American illustrator Matt Zumbo has been creating artwork for clients such as CBS Television, Phillip Morris, RJR Nabisco, Koss Corporation, and *Fortune Magazine*, among many others. His work has been included in the Society of Illustrators Annual Exhibition in New York, and he has frequently been invited to teach and lecture at the Milwaukee Institute of Art and Design. His mastery of technical skills and unique, humorous twists on subject matter have earned him a highly respected national reputation.

View of the installation at Ljubljana Print Biennale in 2005

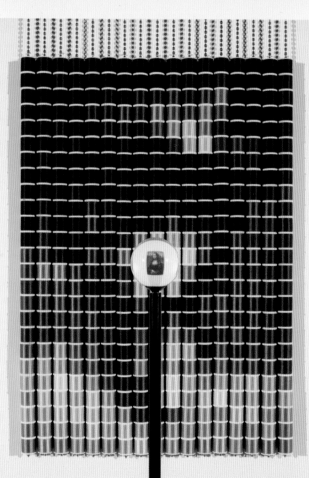

Devorah Sperber

New York installation artist Devorah Sperber has garnered international attention for her remarkably complicated optical illusions. Some of her installations have involved using thousands of spools of thread hung from the ceiling to create pixelated versions of iconic works of art and famous figures from popular culture. The hanging spools of thread appear as a colorful abstraction to the naked eye, but when viewed through a clear acrylic sphere positioned in front of the assemblage, the image is rotated 180 degrees to its correct orientation. The lens functions like the human eye and brain, simultaneously inverting and focusing the arrangement of shapes into a recognizable reproduction of the image. Ms. Sperber's astonishing creations have delighted and confounded spectators in traveling exhibitions and permanent installations across the globe.

LEFT, TOP
After the Mona Lisa 1
425 spools of thread, aluminum ball chain and
hanging apparatus, clear acrylic viewing sphere, metal stand
53.34 x 76.2 cm (thread spools only), 2005

RIGHT
After the Mona Lisa 2
5,184 spools of thread, stainless-steel ball chain and
hanging apparatus, clear acrylic viewing sphere, metal stand
218.44 x 215.9 cm (thread spools only), 2005

LEFT, BOTTOM
After the Mona Lisa 3
425 spools of thread, stainless-steel ball chain and
hanging apparatus, clear acrylic viewing sphere, metal stand
53.34 x 76.2 cm (thread spools only), 2006

FOLLOWING PAGES, LEFT
After the Mona Lisa 4
875 spools of thread, stainless-steel ball chain and
hanging apparatus, clear acrylic viewing sphere, metal stand
78.74 x 104.14 cm (thread spools only), 2006

FOLLOWING PAGES, RIGHT
After the Mona Lisa 6 (Anamorphic Mona)
2,002 spools of thread, stainless-steel ball chain and
hanging apparatus, stainless-steel hemispherical mirror
132.72 x 214.63 x 88.9 cm, 2007

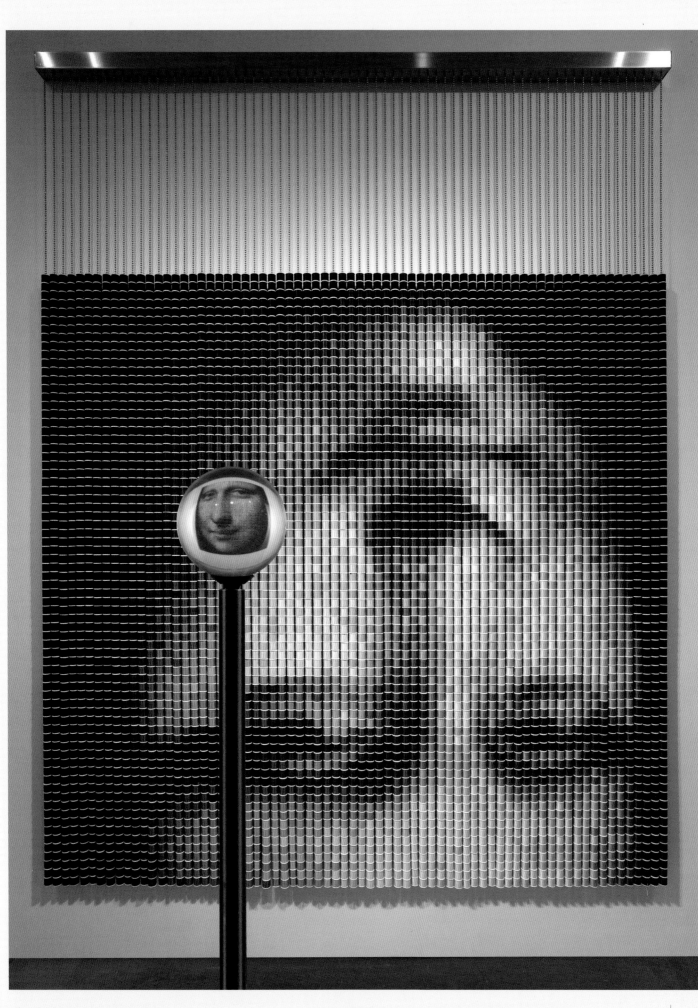

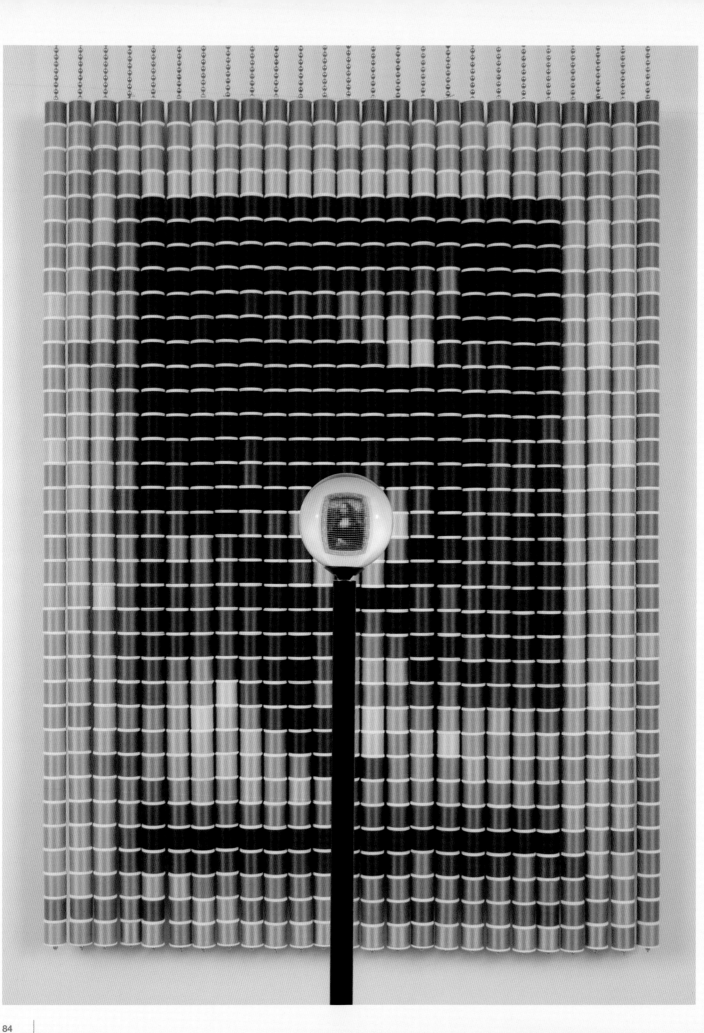

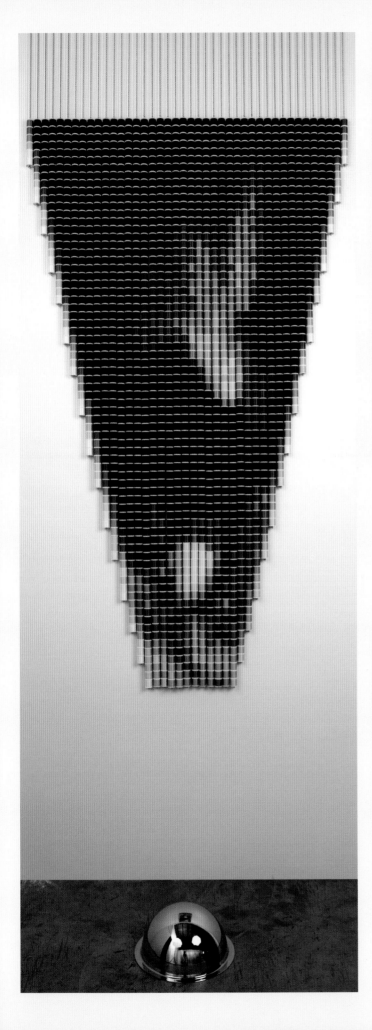

Bernard Dumaine
The Mona Lisa Was Stolen!
Digital
2253 x 3000 pixels, 2005

Bernard Dumaine is a French artist best known for his work in photorealistic styles and for his background designs for television cartoons. He currently works primarily in digital media, as in this clever illustration, which makes reference to when Mona Lisa was famously stolen by Louvre employee and self-described "Italian patriot" Vincenzo Peruggia in 1911. The painting remained in Mr. Peruggia's possession for over two years before it was eventually recovered and returned to Paris.

RIGHT

Invader
Rubik Mona Lisa
330 plastic Rubik's Cubes mounted on board
82.5 x 121 x 5.5 cm, 2005

Invader is the pseudonym of a prominent French urban artist whose work is inspired by the crude pixelation of 1970's 8-bit video games. Adopting his alias from the "Space Invaders" arcade game, Invader's distinctive work can be seen in highly visible public locations in more than sixty cities in thirty countries. He believes that museums and galleries are not accessible to everyone, so he deliberately installs his artwork at street level for ordinary citizens to enjoy on a daily basis. For the past decade, he has also been constructing indoor mosaics using stacks of Rubik's Cubes in a technique he calls "Rubikcubism." Invader remains incognito, and guards his anonymity by pixelating his own face or wearing a mask while conducting interviews. He claims that only a few people know his real identity, and that even his parents think he works as a tiler in the construction industry.

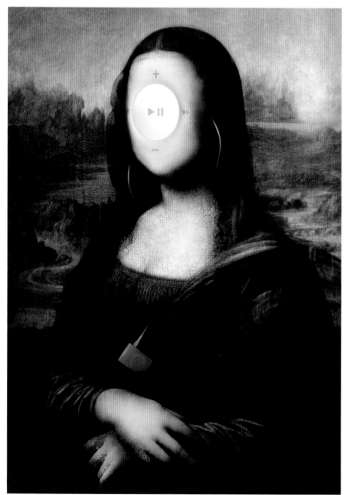

LEFT, BOTTOM

Travis Hammond
Mona Lisa iPod
Digital
2700 x 4200 pixels, 2006

Previously working as a graphic designer, Annapolis native Travis Hammond has recently turned his attention to music, creating hip-hop instrumentals mixed with guitar distortion and a heavy influence of classic keyboard sounds. In his digital illustration *Mona Lisa iPod* he has combined both of his passions by fusing together two iconic symbols: Apple's immensely popular portable media player, and the most famous painting in world history.

FOLLOWING PAGE

Rick Nass
Moooona Lisa
Colored pencil and acrylic on Canson paper
38.1 x 50.8 cm, 2006

American illustrator Rick Nass was commissioned by The Wisconsin Milk Marketing Board to combine Mona Lisa with a Holstein cow for an advertising campaign promoting Wisconsin cheeses. The original painting still hangs proudly at the WMMB corporate headquarters in Madison.

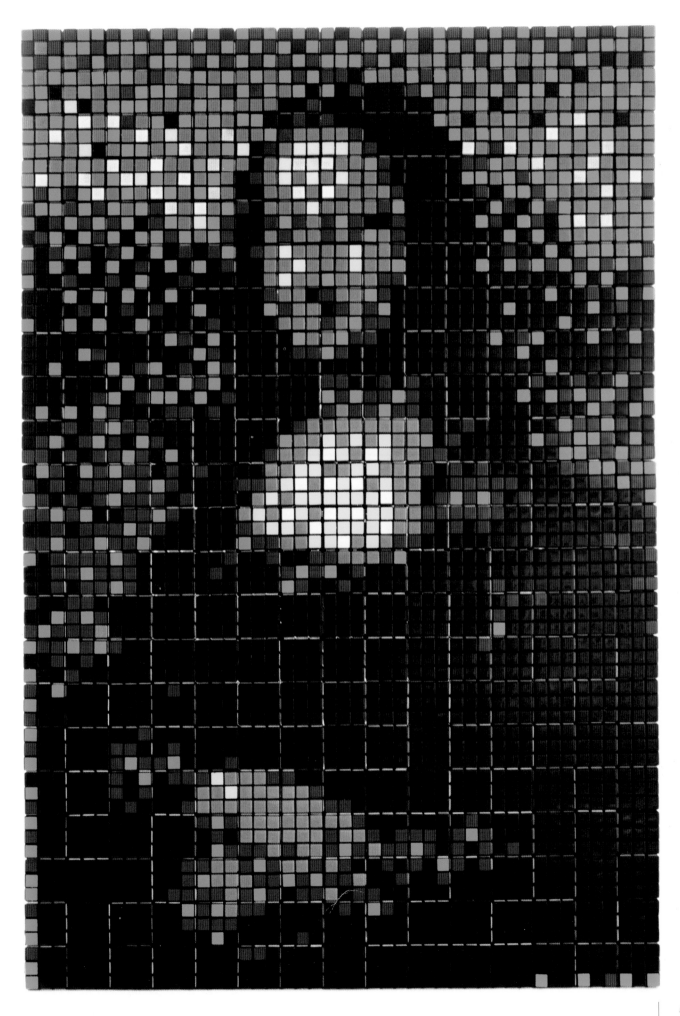

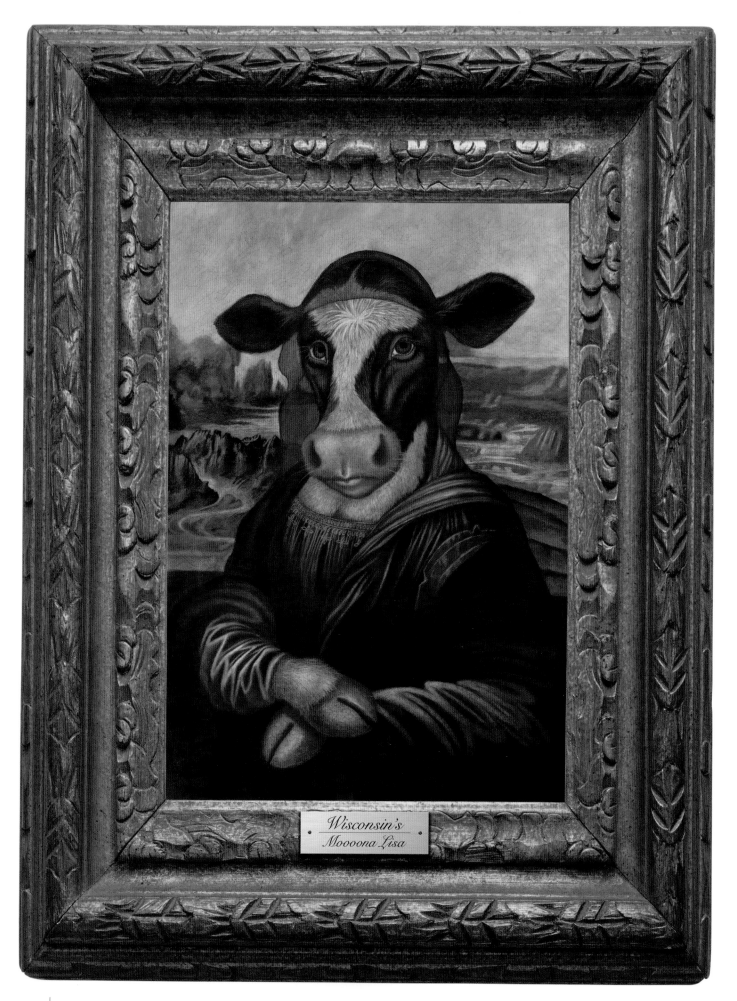

RIGHT, TOP
Gopal Swami Khetanchi
Devashree
Oil on canvas, 61 x 91.4 cm, 2006

RIGHT, BOTTOM
Gopal Swami Khetanchi
Bani-Thani
Oil on canvas, 50.8 x 76.2 cm, 2006

Born and raised in Rajasthan in Western India, Gopal Swami Khetanchi's artwork has journeyed through many different phases during his career, finally culminating into a sophisticated assimilation of tradition and modernity. His appreciation of India's rich and colorful history remains evident throughout his paintings, particularly his admiration of brave warriors and his fondness for the unparalleled beauty of Rajput women, as referenced in his Mona Lisa reinterpretations.

FOLLOWING PAGE, TOP LEFT
David Ho
Mona Lisa
Digital, 3600 x 4320 pixels, 2006

Chinese-American artist David Ho creates his dark and surrealistic illustrations exclusively with the use of digital technology, describing his Macintosh computer as "a playpen where inhibitions, imagination, madness, fears and anger run wild in a frolicking orgy of psychobliss." His intensely ominous artwork has received numerous awards and has been exhibited in galleries, museums, and visual art centers all around the world.

FOLLOWING PAGE, TOP RIGHT
Ray Troll
The Da Vinci Cod
Pen and ink with digital color, 20.3 x 25.4 cm, 2006

Born in upstate New York and now based in Alaska, artist Ray Troll has successfully created his own specialized genre of art, blending ichthyology, paleontology, and razor-sharp wit in his humorous and scientifically accurate illustrations of fish, fossils, and dinosaurs. He has exhibited in all of the major science museums across America, and has had his work published in over a dozen books.

FOLLOWING PAGE, BOTTOM LEFT
Leonardo Petrucci
Gioconda
Acrylic on wood panel, 120 x 180 cm, 2006

A unique example of the optical illusion known as "the ambiguous image", Italian painter Leonardo Petrucci created this illusive portrait of Mona Lisa when he was only seventeen years old. The background was inspired by the actual landscape of his home in Tuscany, which is coincidentally also the homeland of Leonardo da Vinci.

FOLLOWING PAGE, BOTTOM RIGHT
Giana Pisacano Eden
Mona Lisa
Sculpted clay and oil paint, 33 x 45.7 x 20.3 cm, 2006

A native of Long Beach, New York, Giana Eden has over three decades of experience as a production potter. Her designs have been displayed extensively in national art galleries and gift shops, and have appeared in publications such as *The New York Times*, *Vogue*, *The Atlanta Journal Constitution*, and *Cosmopolitan*.

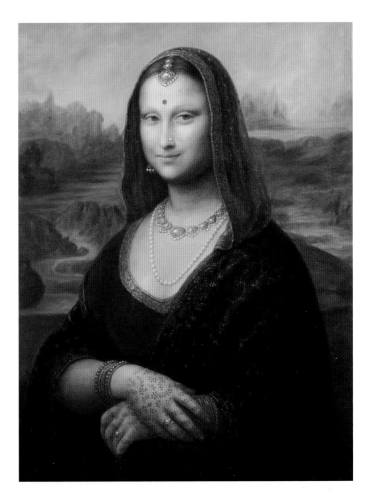

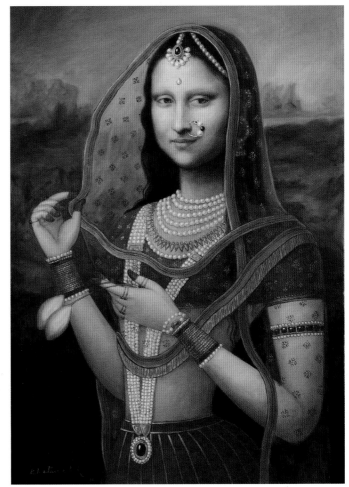

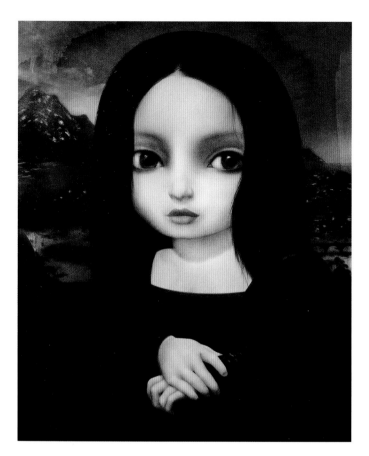

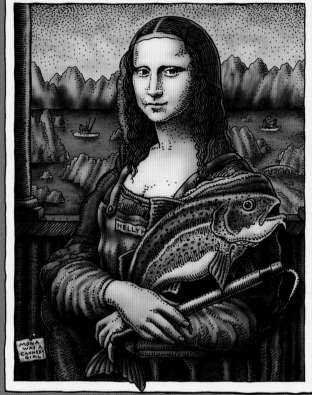

THE DAVINCI COD

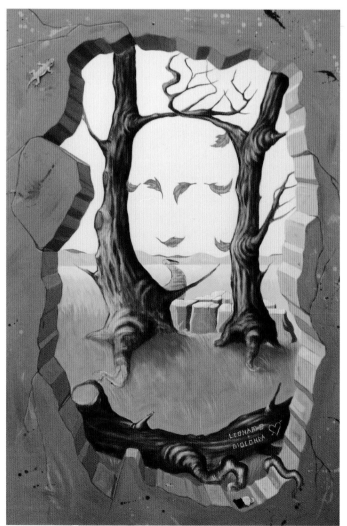

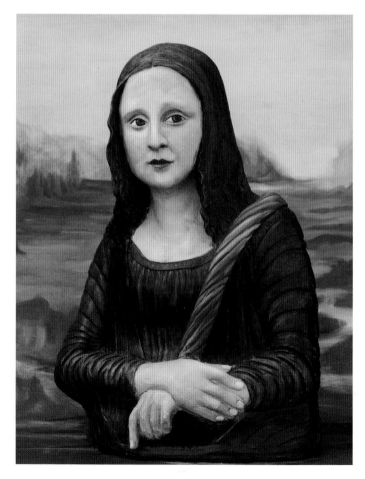

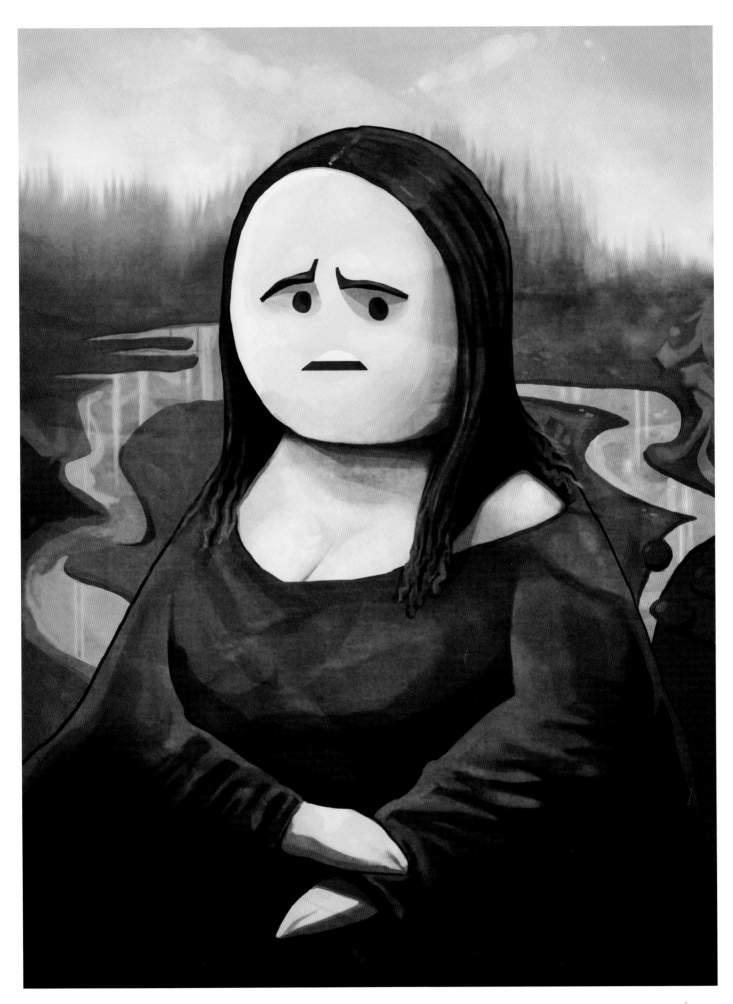

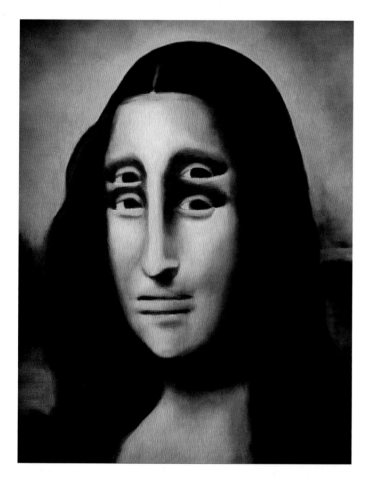

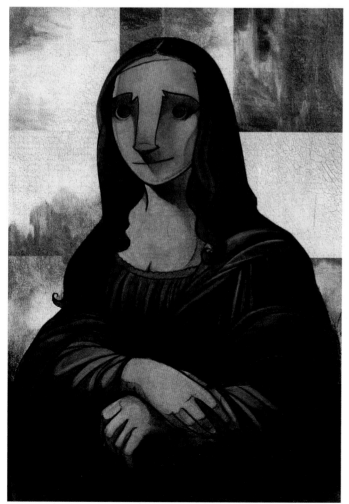

PREVIOUS PAGE
Pavel Zuk
Mona Lisa, My Style
Digital
2700 x 3600 pixels, 2006

Once a talented illustrator and graphic designer, Russian artist Pavel Zuk has since turned his attention to music, playing jazz piano, composing orchestral and symphonic arrangements, and scoring the soundtracks for animated movies. His robust rendition of Mona Lisa is an enduring memento from his former vocation.

LEFT, TOP
Kelly Hutchison
Moanin' Lisa
Oil on canvas board
30.5 x 40.6 cm, 2006

Better known under the pseudonym "Dark Vomit," Texas-born Kelly Hutchison began his career as an artist after rummaging through garbage to find junk to sell at local swap meets. He discovered that by painting on these found objects, he increased their value and was able to sell them at higher prices as objects of art. His work has since exploded in the Southern California art scene, and he has created art for album covers, tee-shirts, posters, book covers, video games, and skateboard decks.

LEFT, BOTTOM
Morgan O'Brien
Mona Lisa - Well, Kind of ...
Mixed media and collage on white card
21 x 29.7 cm, 2006

Trained as an animator at Dún Laoghaire Institute of Art, Irish artist Morgan O'Brien now works extensively in the fields of pre-production animation, illustration, and graphic design, primarily focusing on visual media projects created specifically for pre-adolescent audiences. His personal work has been exhibited in galleries throughout Ireland, and draws upon the innocence and beauty of childhood life while taking inspiration from nature and the extraordinary world around him.

RIGHT
Giulio Iurissevich
Mona Lisa
Mixed media
21 x 29.7 cm, 2006

Driven by instinct and passion, Italian urban artist and graphic designer Giulio Iurissevich views Mona Lisa as a symbol of human nature at its best, created by a man possessed by an infinite intelligence. He believes this symbol, however, has been diluted in the modern era, and is constantly evolving but inevitably decaying in an apocalyptic landscape of consumerism and status obsession.

FOLLOWING PAGE
Kazuki Kikuchi
Mona Lisa Origami
Paper sculptures mounted on wood panel
51.5 x 72.8 cm, 2006

Japanese illustrator Kazuki Kikuchi used tweezers to fold each of the 910 individual rose-shaped paper sculptures that create the foundation for his mosaic Mona Lisa portrait. The entire production period lasted nearly a year, with each flower requiring approximately half an hour to create.

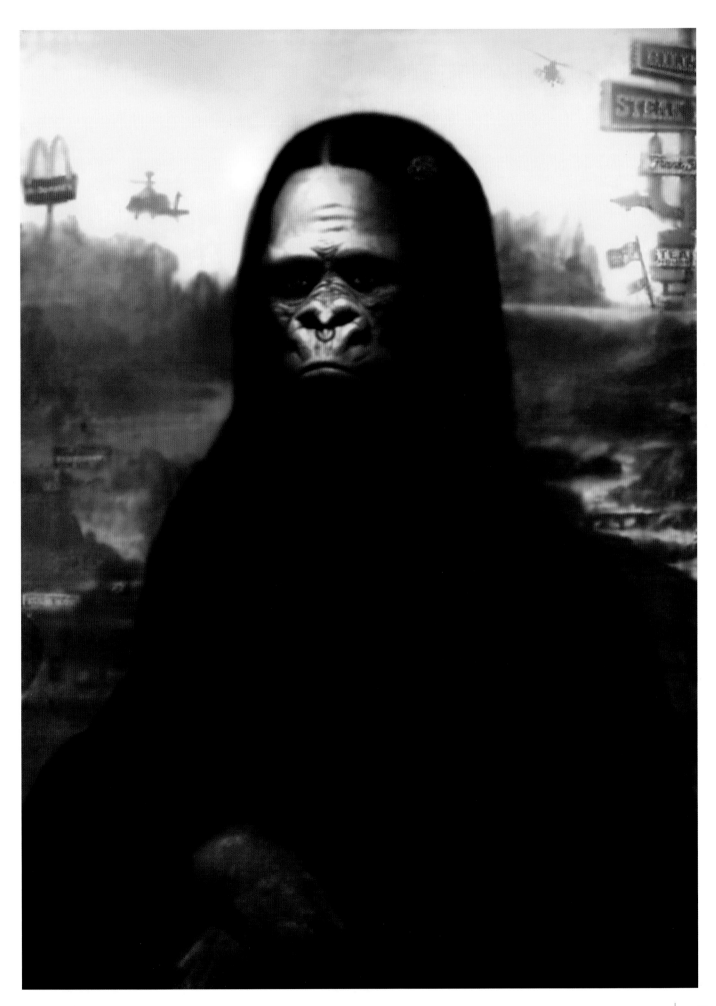

Jean-Jacques Montegnies
Mona Lisa is Cold
Oil on canvas, 61 x 91.4 cm, 2006

The work of French artist Jean-Jacques Montegnies is a clever interplay of light, texture, color, and design that reflects his keen observation and warm sentimentality. His veiled rendition of Mona Lisa remains instantly recognizable even though she is almost completely concealed by drapery.

Christopher Dombres
Original is Dead. Long Live the Copy!
Screen print on paper, 45 x 64 cm, 2006

Dividing his time between England and France, graphic designer Christopher Dombres claims no copyright on any of his art, and encourages others to download and reappropriate his work in any way that they choose. "I don't believe in the concept of original art as the first and only of its kind. Any given creation is the result of cumulative knowledge, not divine inspiration. Like science, art builds upon itself. We wouldn't have Andy Warhol if we hadn't had Pablo Picasso and we wouldn't have modern art if we hadn't had Renaissance art. Imitation, not invention, is what has produced our current culture and civilization. Man is guided by the law of least effort. It is faster and easier to copy than to invent, and it is because we understand that, that we have managed to dominate all other species."

Mark Wagner
Money Lisa
Currency collage
55.88 x 81.28 cm, 2006

Mark Wagner
Elective Surgery
Currency collage
30.48 x 40.64 cm, 2009

Innovative American artist Mark Wagner works in a variety of media, but is best known for his series of meticulously constructed collages made from pieces of dollar bills reassembled to form portraits of politicians and cultural figures. Estimating that he has cut up approximately $10,000 in currency throughout his career, Mr. Wagner finds that the taboo of destroying money makes people pay attention to his work in a way that they would not were he to use any other kind of paper as a medium. "Money elicits high emotions; it's something people worry about and fight over. Perceived value affects a person's judgment, and that's something that attracted me to Mona Lisa. The painting seems to be famous because it is valuable and valuable because it is famous. She's also a touchstone to comment on the nature of beauty itself. My versions of her are admittedly monstrous, as are most attempts to apply beauty from the outside or impose values artificially."

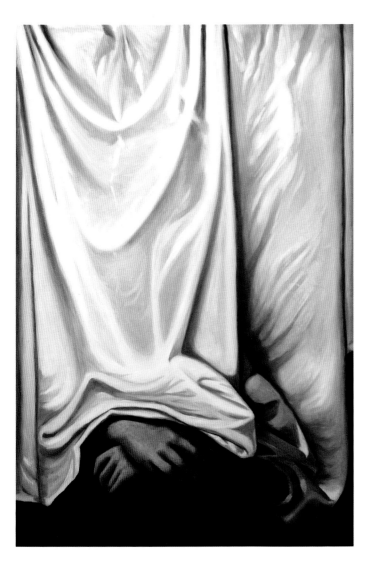

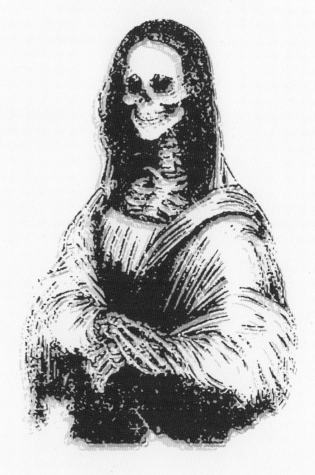

Original is dead. Long live the copy!

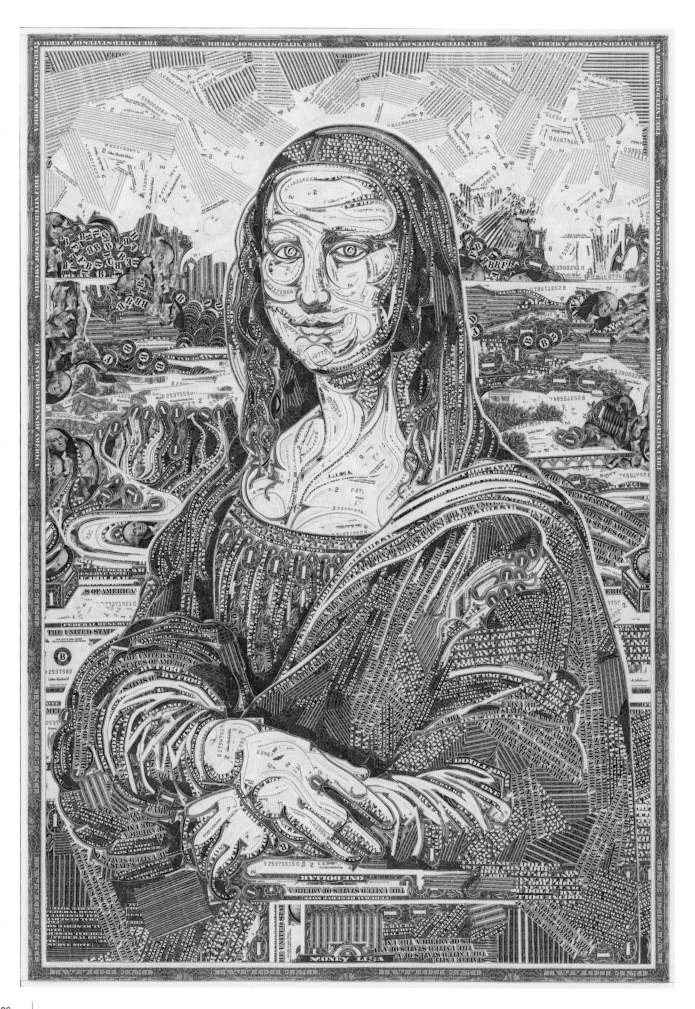

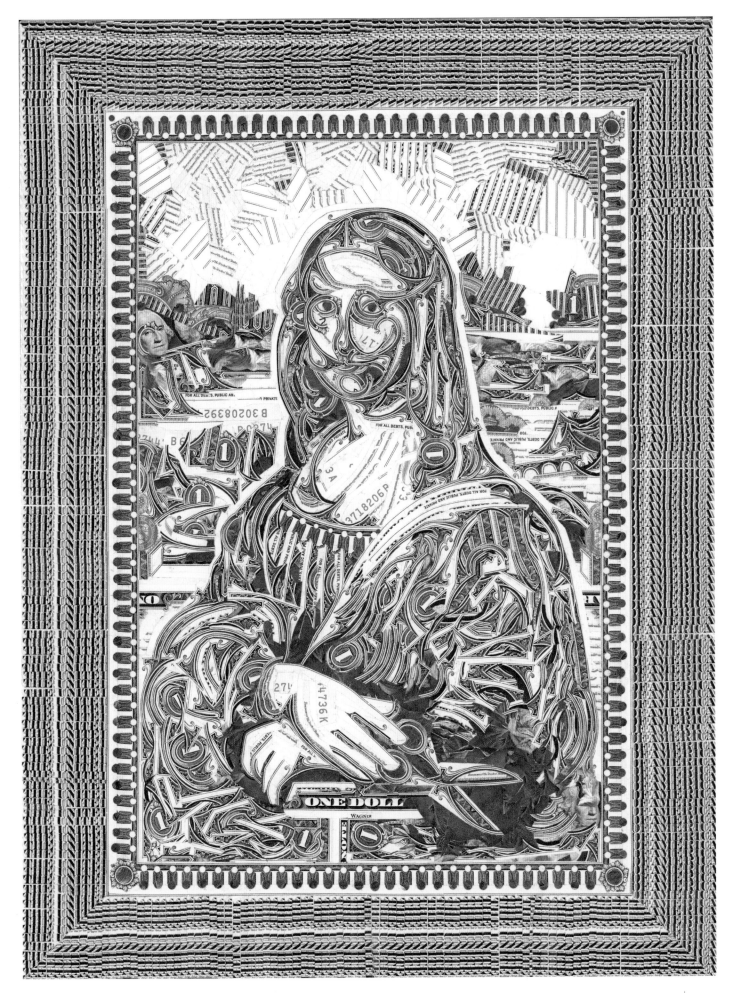

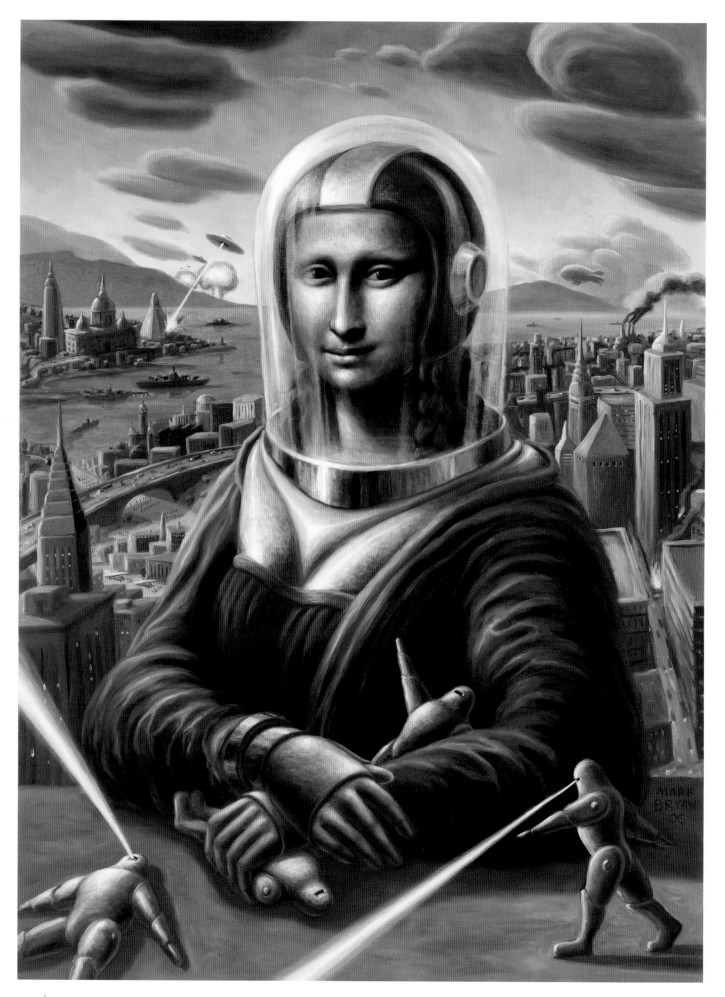

Mark Bryan
Mona and the Metal Men
Oil on panel
81.28 x 111.76 cm, 2006

As a child of the fifties and sixties, American artist Mark Bryan could not avoid soaking up the pop culture and angst of the era. He was fascinated by cheesy science fiction and horror movies, superhero comics, *MAD Magazine*, *The Twilight Zone* television series, and the Surrealist paintings of Salvador Dalí. All of these influences, combined with the "duck and cover" mentality of the Red Scare, shaped his young psyche and at an early age he discovered art as a way to deal with and make sense of the world. "I don't spend a lot of time planning my paintings. One image seems to lead to another like going down a corridor and opening doors to see what's there. I try to allow the pictures to make their way to the canvas on their own, often changing them significantly as I work. Not knowing where they will end up makes the process fun and intriguing. This painting began quite differently but eventually morphed into a futuristic version of Mona Lisa in a somewhat disconcerting world."

Steve Sack
Mona Condoleeza
Oil on canvas
30.5 x 45.7 cm, 2006

A native of Saint Paul, Minnesota, Steve Sack is the Pulitzer Prize–winning editorial cartoonist for the *Minneapolis Star Tribune*. His *Mona Condoleeza* illustration was part of a series of a dozen oil painting parodies satirizing the policies of the George W. Bush administration.

Alfredo Rossi
Mona Geisha Lisa
Digital vector illustration
2700 x 3600 pixels, 2007

Italian graphic designer Alfredo Rossi constantly strives to create the maximum effect with the minimum of information in his work, seeking perfection by continually subtracting rather than adding design elements. His simple yet elegant rendition of Mona Lisa speaks to his personal aesthetic, and is representative of a particular devotion he has to the Asian female figure, which epitomizes, to him, the ultimate expression of sensuality.

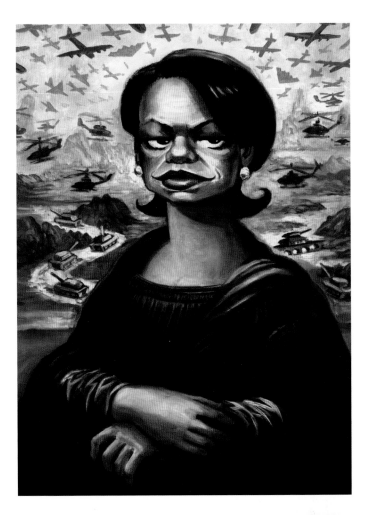

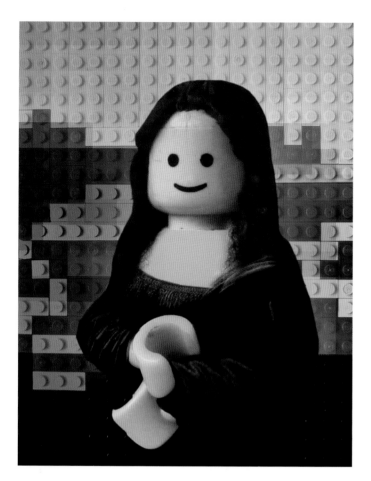

Marco Pece
LEGO® Mona Lisa
Digital photograph
3543 x 5316 pixels, 2007

Working under the alias "Udronotto," Italian mixed media artist Marco Pece uses plastic LEGO® building bricks to reconstruct classic paintings and famous scenes from movies and literature. Once completed, his three-dimensional replicas are photographed and then broken down to be reused for future projects. The resulting photograph becomes his work of art, and is the only evidence that remains of his whole creative process.

Phillip Bannigan
Mona
Digital
2400 x 3200 pixels, 2007

The illustrations of Australian graphic designer Phillip Bannigan are fascinating examples of Op Art, or Optical art, and seem to live and breathe with life of their own. His dynamic visuals appear to be nothing more than graphic abstractions of dots when viewed at close range, but as the viewer moves farther away from the image, the visage of his intended subject gradually begins to materialize, as if by magic. The effect is achieved as a result of perception, and occurs as the mind attempts to reconfigure the harsh and discordant patterns into something recognizable.

Luis Peres
Leo & Mona
Watercolor and colored pencils with digital embellishments
29.7 x 42 cm, 2007

Portuguese illustrator and graphic designer Luis Peres was commissioned to create this painting for a children's encyclopedia of science, and it was to be featured in a chapter specifically about Leonardo da Vinci. The unusual reverse perspective was chosen in an effort to present the scene in a unique way that had not previously been shown, and the cartoon style was meant to appeal to young readers. Actual reproductions of some of Leonardo's most famous works were added digitally. Although the encyclopedia project was eventually cancelled, this image has been used for numerous other posters and book covers over the years, and has proved to be one of the most popular and well-received images in his portfolio.

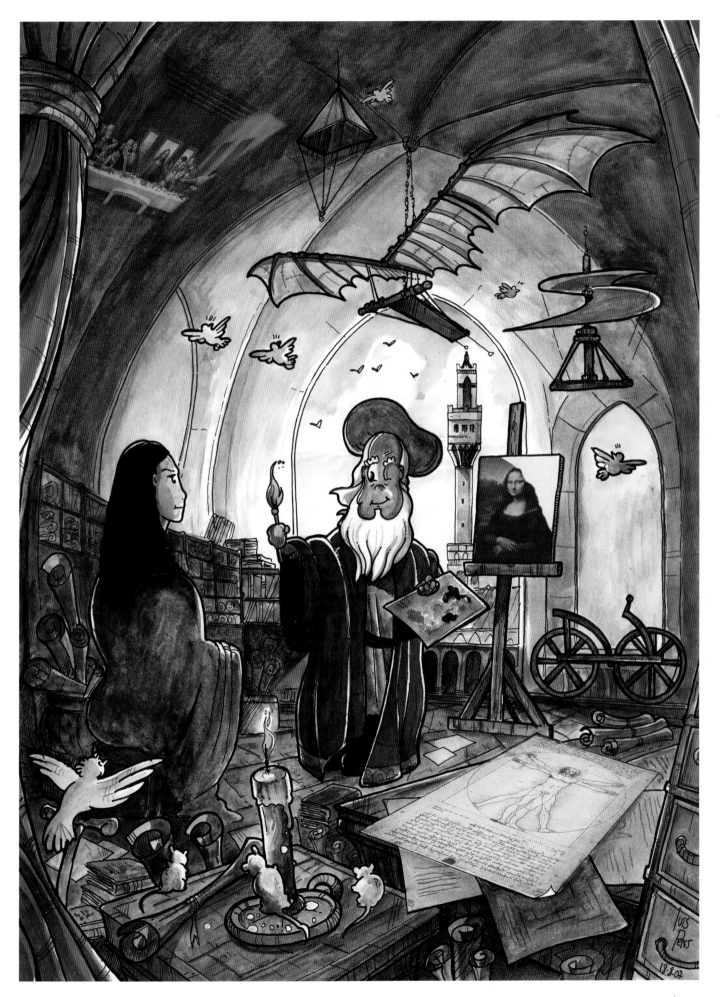

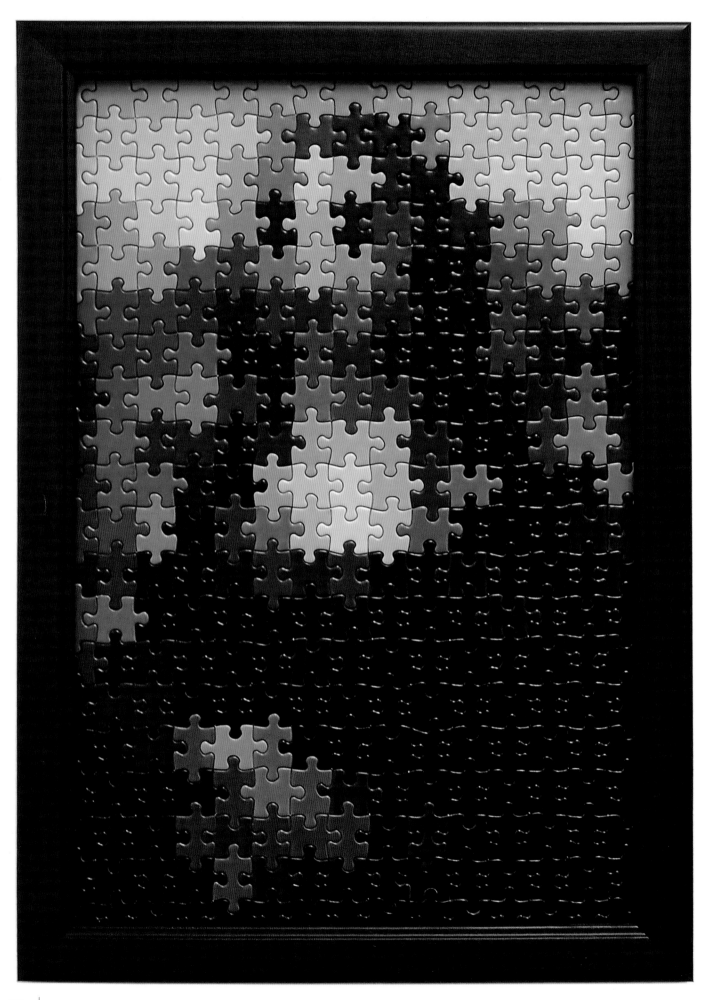

LEFT
Iichiro Tanaka
300 Pieces La Gioconda
Printed jigsaw puzzle in wooden frame
30 x 40 cm, 2007

In an effort to bring a fresh perspective to a painting that had been reproduced thousands of times before, Japanese artist Iichiro Tanaka printed bright swatches of color onto jigsaw puzzle pieces to assemble a decorative mosaic unlike any other. Simultaneously familiar and obscure, his colorful abstraction was put on display at the Tokyo National Museum, the largest art museum in Japan.

RIGHT, TOP
Valéry Vécu Quitard
L'Automate ("The Automaton Dummy")
Oil on canvas
65 x 92 cm, 2007

Favorite subjects of French painter Valéry Vécu Quitard include the illustration of fairy tales, fables, historical anecdotes, and pop culture iconography. He describes his highly symbolic depiction of Mona Lisa as "a mechanical woman reaching out to her creator via a cleverly designed system of gears and racks integrated within her. Her surface texture is painted to simulate a smooth, milky complexion imitating the most-perfect skin tone, with a brown, wavy wig surrounding the head and covered with a veil of chiffon. Her eyes move through a complex internal mechanism that always guides their focus directly to her master, while an unspeaking and unchanging smile is frozen on her face." The fly resting on her chest is a traditional symbol representing death and decay, and in this case is meant to herald not only the inevitable disintegration of the automated dummy, but of beauty itself.

RIGHT, BOTTOM
Corey Wolfe
Mona Bear
Oil on illustration board
40.6 x 50.8 cm, 2007

During his thirty years as an illustrator, self-taught American artist Corey Wolfe has created over 1,200 images for The Walt Disney Company, including artwork for DVD covers, advertisements, and books. He has also worked for a high-profile list of clients such as Mattel, Hasbro, Hanna-Barbera, Pepsi-Cola, Universal Studios, Warner Bros., McDonald's, and Wizards of the Coast. His *Mona Bear* painting was created as a personal project while taking a break from commissioned work. "It may have started out as just a fun little digression, but I soon realized that a lot could be learned by copying a master. The ability to mix colors is an art form in itself, and I learned plenty while mixing and painting the background. After spending so much time working for companies like Disney and Mattel, it was a joy to paint with subtle colors instead of being bombarded with the often heard mantras 'make it brighter', and 'make the colors pop more'."

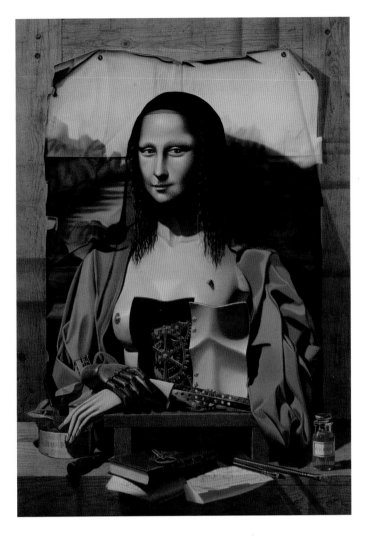

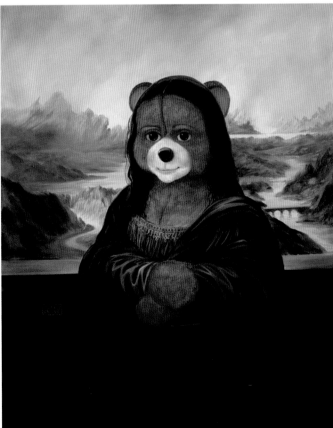

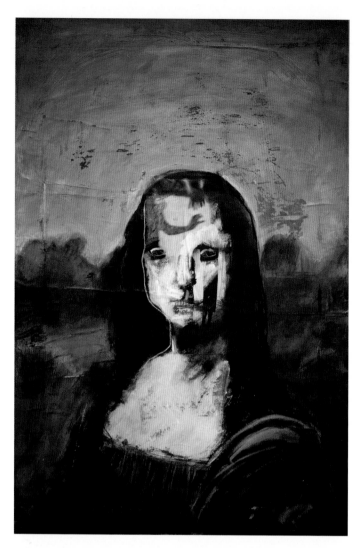

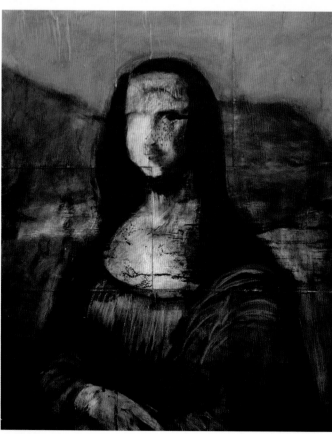

Rai Escalé

The corruptions and violence in Rai Escalé's dark paintings may be personal, but also come from a collective subconscious shared by all human beings. His horrific art alternates between shocking and disturbing, but remains deeply insightful as he makes statements on the freakishness of consumerism and beauty culture. He pursues, in his work, the nature of phantasmagorical human alternations, and evokes some of the discomfort one has when facing others. His Mona Lisa series was created as part of an exhibition that was meant to take place in a small chapel near Barcelona, but unfortunately the event was never realized. Says the artist, "Now, most of these paintings are sold and spread all over the world. I still have my favorite one displayed in my home; it's the only one of my paintings that my wife allows!"

LEFT, TOP
Gio Menacing Shadow
Collage, solvent, pencil, and ink mounted on canvas
54 x 81 cm, 2007

LEFT, BOTTOM
Gio Policrom
Collage, solvent, pencil, and ink mounted on canvas
60 x 73 cm, 2007

RIGHT
Gio Punk
Collage, solvent, pencil, and ink mounted on cardboard
41 x 60 cm, 2007

FOLLOWING PAGE, TOP LEFT
Gio Gray
Collage, solvent, pencil, and ink mounted on wood
60 x 73 cm, 2007

FOLLOWING PAGE, TOP RIGHT
Gio Mechanic
Collage, solvent, pencil, and ink mounted on wood
60 x 73 cm, 2007

FOLLOWING PAGE, BOTTOM LEFT
Gio Piruli
Collage, solvent, pencil, and ink mounted on canvas
65 x 98 cm, 2007

FOLLOWING PAGE, BOTTOM RIGHT
Gio Giant
Collage, solvent, pencil, and ink mounted on wood
65 x 98 cm, 2007

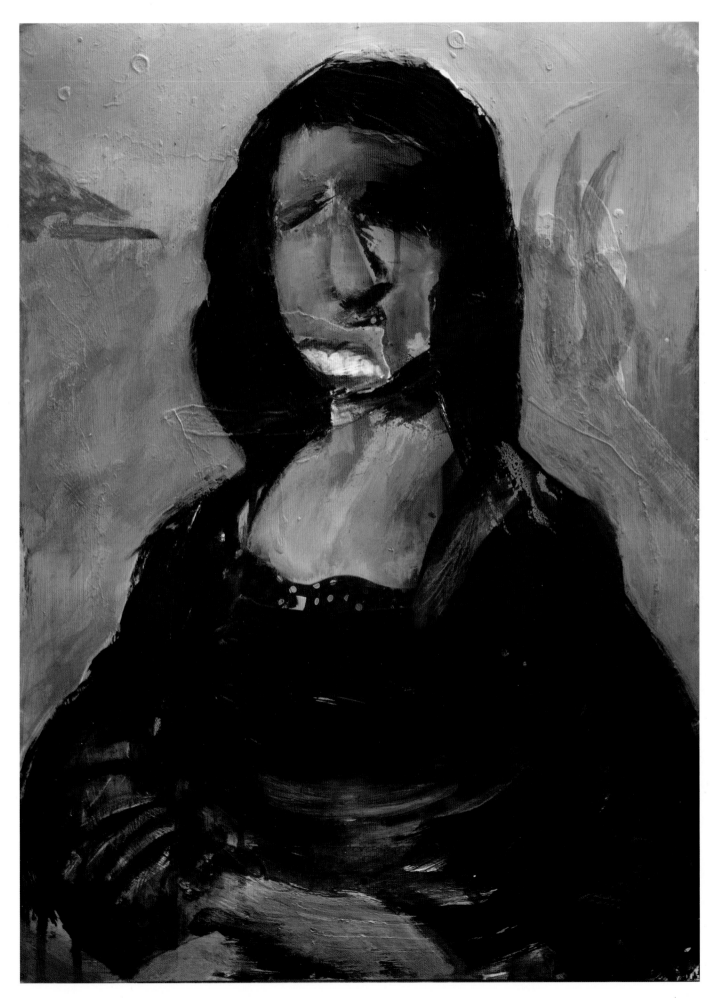

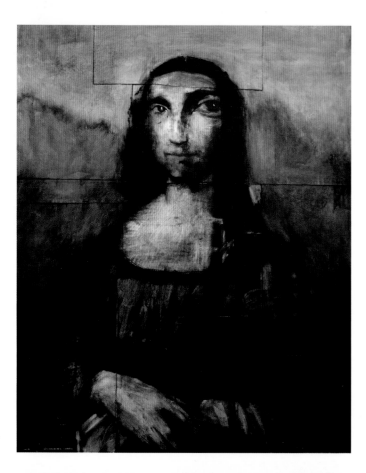
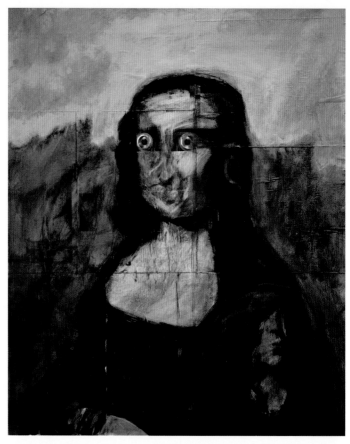
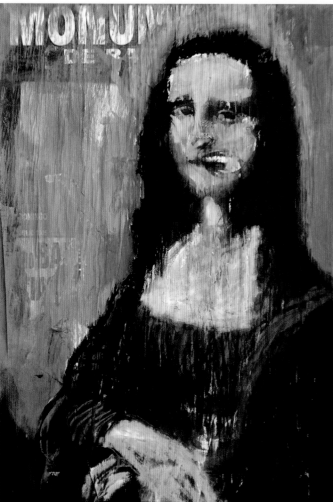
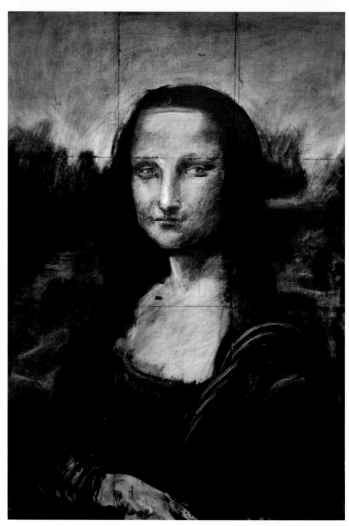

RIGHT, TOP
Gio Fashion
Collage, solvent, pencil, and ink mounted on wood
60 x 73 cm, 2007

BELOW, LEFT
Gio Man
Collage, solvent, pencil, and ink mounted on canvas
60 x 81 cm, 2007

BELOW, RIGHT
Gio Buggie
Collage, solvent, pencil, and ink mounted on cardboard
41 x 60 cm, 2007

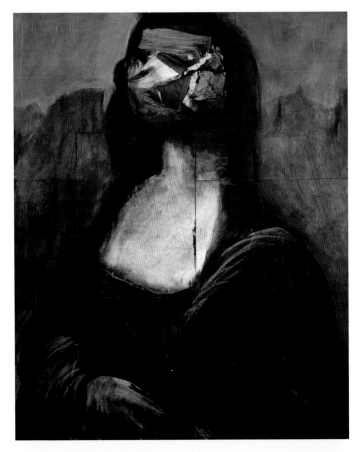

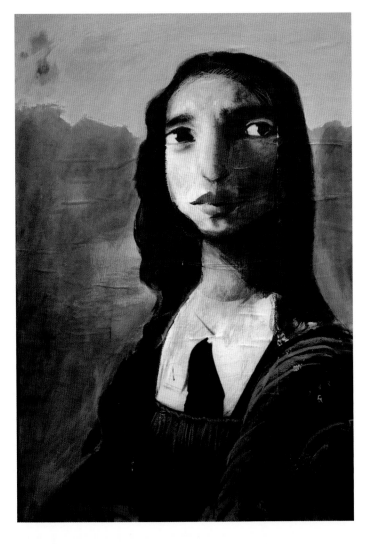

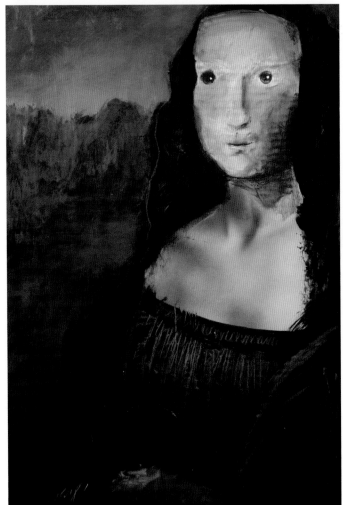

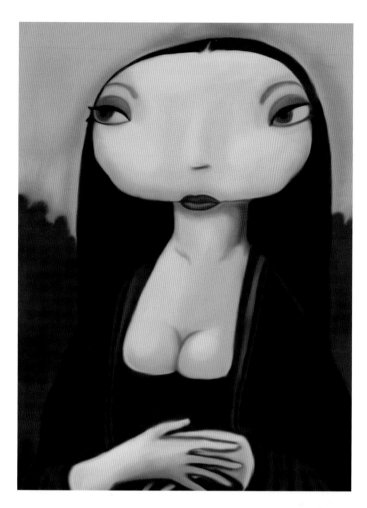

Fabio Rex
La Gioconda Reworked
Digital, 341 x 500 pixels, 2007

Brazilian illustrator Fabio Rex makes his living as a graphic designer, but describes his occupation as "daydreamer." In addition to Mona Lisa, he's brought his unique imagination to restylings of classic works such as Grant Wood's *American Gothic*, Gustav Klimt's *The Kiss*, and most irreverently, Frida Kahlo's *Self-Portrait with Monkeys*.

LEFT, BOTTOM
David Russell Talbott
15,000-H-200 (Quinze mille ache deux cent)
Acrylic on canvas, 45.7 x 61 cm, 2007

In 2007, California-based artist David Russell Talbott was invited to participate in a Mona Lisa tribute show at Strychnin Gallery in Berlin. "I mentioned the exhibition to a local San Diego art critic, and he scoffed, 'After Duchamp drew a mustache on Mona Lisa for his famous L.H.O.O.Q. series, no one could ever top that.' Taking that as a challenge, I decided to spoof both pieces of art. Instead of painting an actual mustache on the figure, I used the word 'mustache' in the background, separating the letters in the middle because I thought the notion that she 'must ache' gave another dimension to what Mona Lisa might be thinking. The title is also a parody of Duchamp's original. The letters 'L.H.O.O.Q.' when spoken aloud in French, is a sexual allusion to Mona Lisa's 'hot ass.' My title '15,000-H-200' when spoken in French sounds vaguely like 'Kiss my ass, Duchamp'."

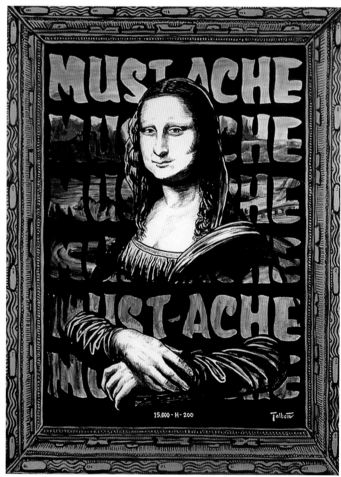

RIGHT
Zorikto Dorzhiev
Gioconda-Khatun
Oil on canvas, 55 x 80 cm, 2007

Nomadic Buryat life is the primary subject of the paintings by Russian artist Zorikto Dorzhiev. His visceral and dynamic images of warriors on horseback pay tribute to his Buryat heritage, but he is equally adept at portraying sensuous females, as in his iconic *Gioconda-Khatun*, dubbed *The Madonna of the Steppes* in reference to its background depicting the lush grasslands of a Mongolian landscape.

FOLLOWING PAGE, TOP LEFT
Mike Bell
Ramona
Acrylic on canvas, 45.7 x 61 cm, 2007

The work of New Jersey native Mike Bell blends an aura of nostalgia and humor, combining inspiration from sources including Japanese cartoons, vintage toys, carnivalesque images, and punk rock. The juxtaposition of counterculture imagery with modern influences is the blueprint for his eclectic canvases. Self-described as a "true lowbrow painter," he creates in his work a world that is illusionistic as well as cartoony, sometimes blurring the distinction between the two.

FOLLOWING PAGE, BOTTOM LEFT
Anke Feuchtenberger
Mona Lisa Selbdritt
Charcoal on canvas, 60 x 80 cm, 2008

The work of German comic book artist Anke Feuchtenberger is a haunting mixture of nightmare and fairytale. She has developed a very particular and recognizable style, with her illustrations often depicting naked, childlike creatures with huge heads, wandering through strange, dreamlike landscapes.

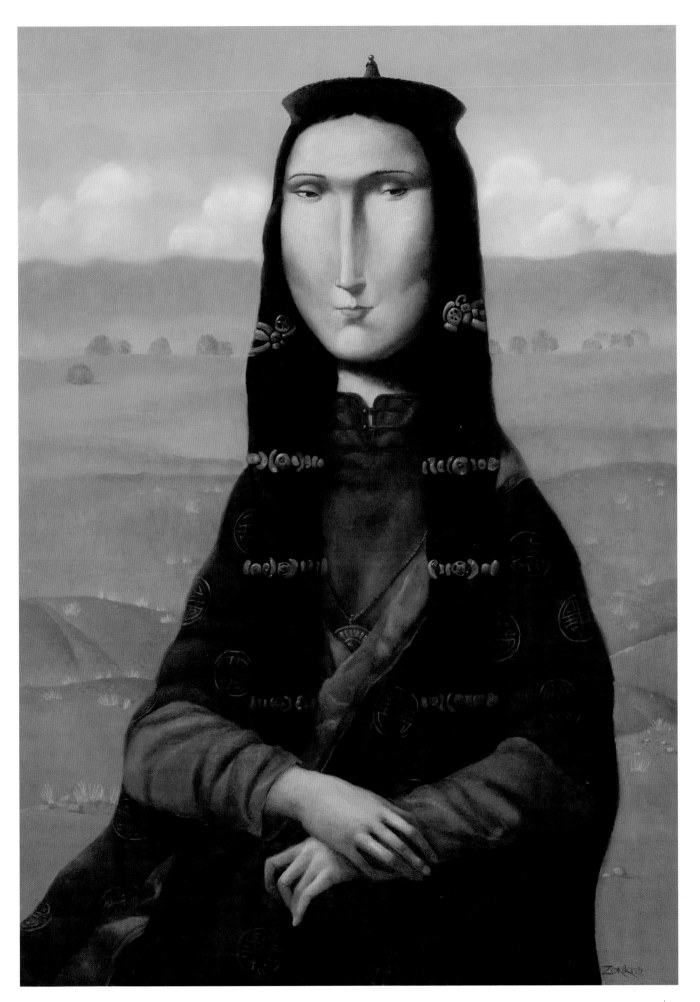

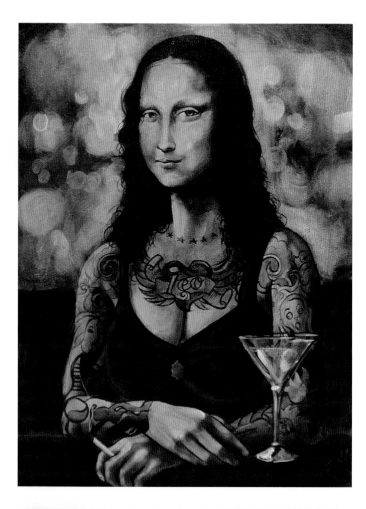

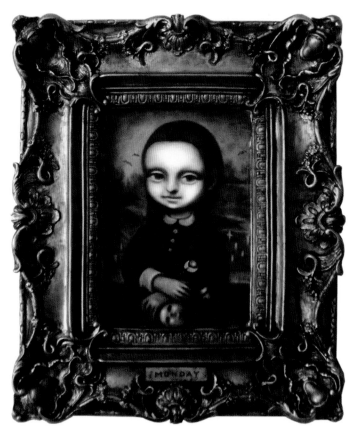

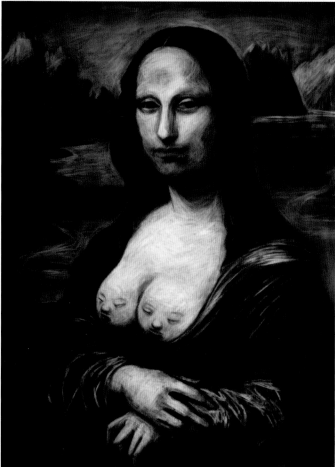

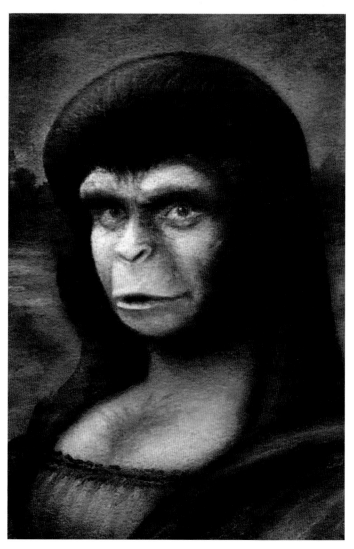

Bethany Marchman
Monday
Oil on paper
20.32 x 25.4 cm framed, 2007

Bethany Marchman
Monkey Lisa
Oil and resin on paper
16.51 x 25.4 cm, 2008

Atlanta-based artist Bethany Marchman plays with influences from both classical art and modern culture to create Pop Surrealist paintings that are sometimes funny, sometimes sad, but always engaging. Explains the artist, "They are reflections of the awkward changes we experience as individuals and as a society, while questioning whether or not growth is synonymous with improvement." The influence of Leonardo da Vinci has emerged more than once in her charmingly eerie creations. With her pigtails, headless doll, and graveyard backdrop, *Monday* is an homage not only to the Renaissance master, but also to the Wednesday Addams character from *The Addams Family*. This piece was exhibited at Strychnin Gallery in Berlin, during their 2008 "Mona Lisa" show. *Monkey Lisa* was created a year later for a *Planet of the Apes*-themed exhibition at an art gallery in Atlanta, with chimpanzee psychologist and veterinarian Dr. Zira now standing in as the muse.

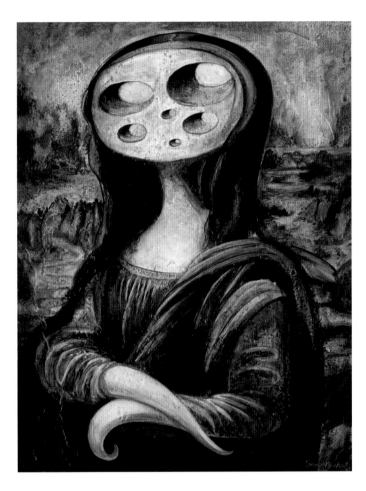

RIGHT, TOP
Snow Mack
Mona Cheesa
Oil on canvas
30.5 x 40.6 cm, 2007

Born in Tokyo and now living in Los Angeles, versatile artist Snow Mack has worked as a digital matte painter on motion pictures such as *Apollo 13*, *Titanic*, *What Dreams May Come*, and *Fight Club*. In recent years, she has focused her attention on fine art, and has kept busy exhibiting her paintings in galleries across the United States. An ongoing narrative in her work involves a psychic race of "Cheeseheads," who communicate telepathically and travel through space from their home world of Planet Cheese. The main character of the series, Star Map Kid, is separated from his family and becomes stranded on Earth. He feels like an outsider until he discovers depictions of Cheeseheads in artwork from around the world, and realizes that his kind has visited Earth before. *Mona Cheesa* is one such piece of evidence, and it helps Star Map Kid find the courage to continue his mission, repair his spaceship, and eventually rescue his parents.

RIGHT, BOTTOM
Mike R. Baker
A Little Golden Book's Mona Lisa
Gouache on paper
8.89 x 13.97 cm, 2007

Although American children's book writer and illustrator Mike R. Baker had early aspirations to become a fireman, an astronaut, a forest ranger, and a pirate, he eventually discovered that drawing was very good therapy and there was nothing else that he enjoyed quite as much. His Mona Lisa painting was part of a group of illustrations depicting famous figures from pop culture rendered in the distinctive style of the popular series of Little Golden Books.

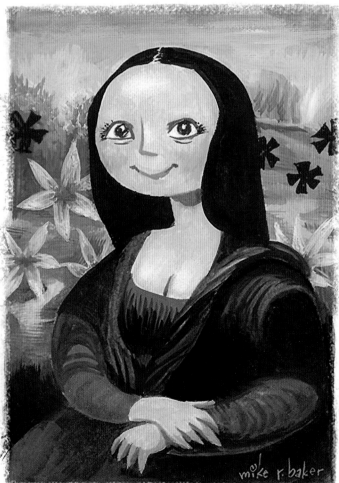

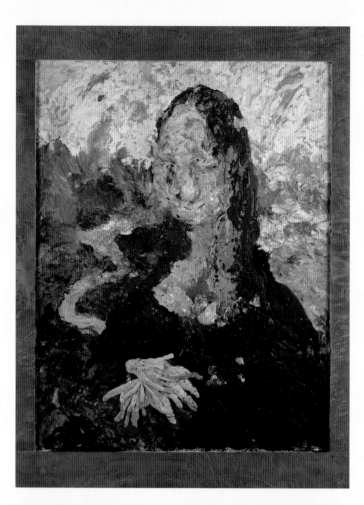

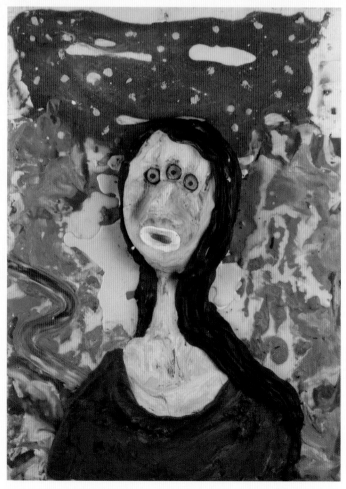

Gelitin

Gelitin (formerly known as Gelatin) is a group of four artists from Vienna, Austria. They first met each other in 1978, when all were attending a summer camp, and have been playing and working together ever since. They are internationally known for creating elaborate art events in the tradition of Relational Aesthetics. Over the years, they have collaboratively produced dozens of variations on Mona Lisa, utilizing plasticine clay to sculpt their colorful creations.

LEFT, TOP
Mona Lisa
Plasticine on wood
135 x 190 x 5 cm, 2008

LEFT, BOTTOM
Mona Lisa
Plasticine on wood
37 x 51.5 x 7 cm, 2008

RIGHT
Mona Lisa
Plasticine on wood
44 x 47 x 3 cm, 2008

FOLLOWING PAGE, TOP LEFT
Mona Lisa
Plasticine on wood
57 x 69.7 x 5 cm, 2010
Courtesy of Carlson Gallery, London

FOLLOWING PAGE, TOP RIGHT
Mona Lisa
Plasticine on wood
103 x 135.5 x 6 cm, 2010

FOLLOWING PAGE, BOTTOM LEFT
Mona Lisa
Plasticine on wood
56.7 x 77.5 x 9 cm, 2010
Courtesy of Carlson Gallery, London

FOLLOWING PAGE, BOTTOM RIGHT
Mona Lisa
Plasticine on wood
42 x 67.5 x 11 cm, 2010
Courtesy of Galerie Meyer Kainer, Vienna

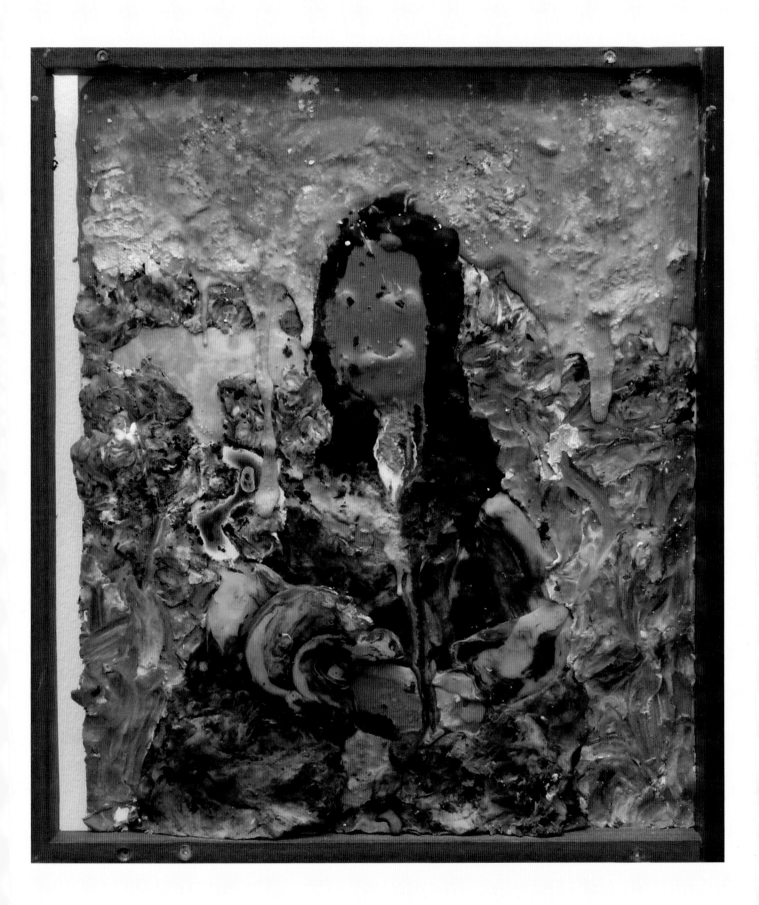

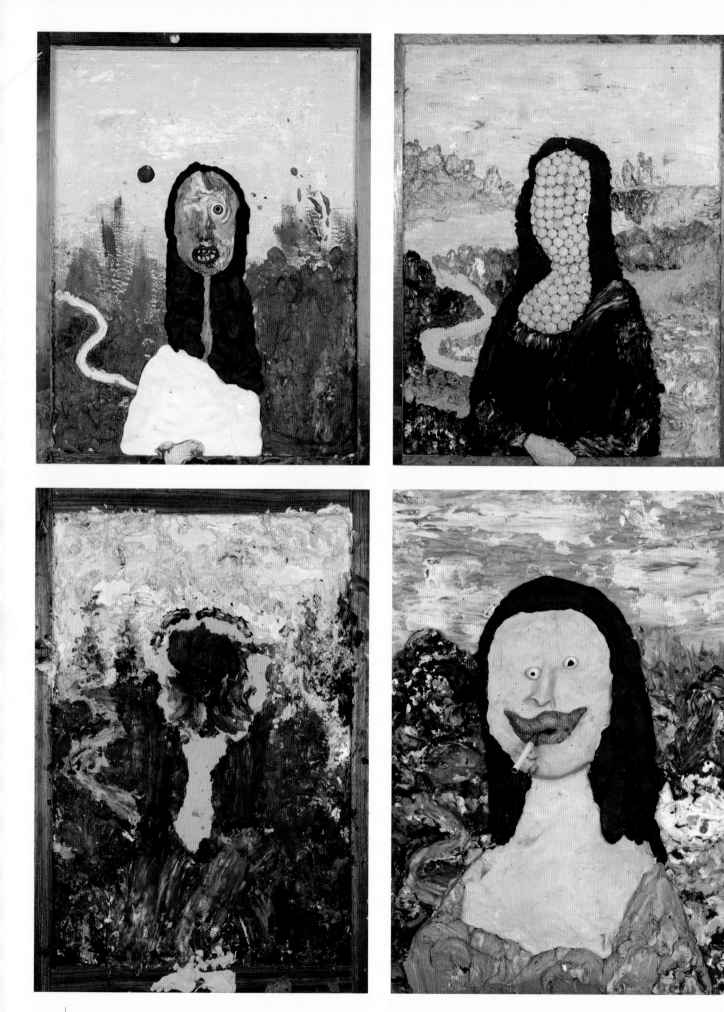

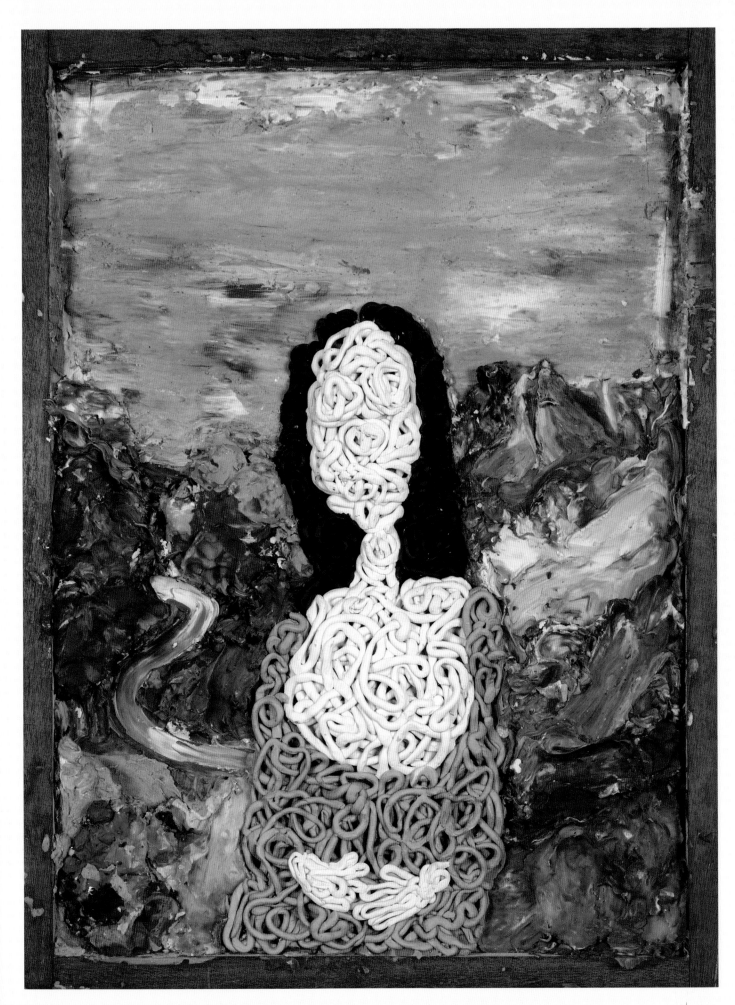

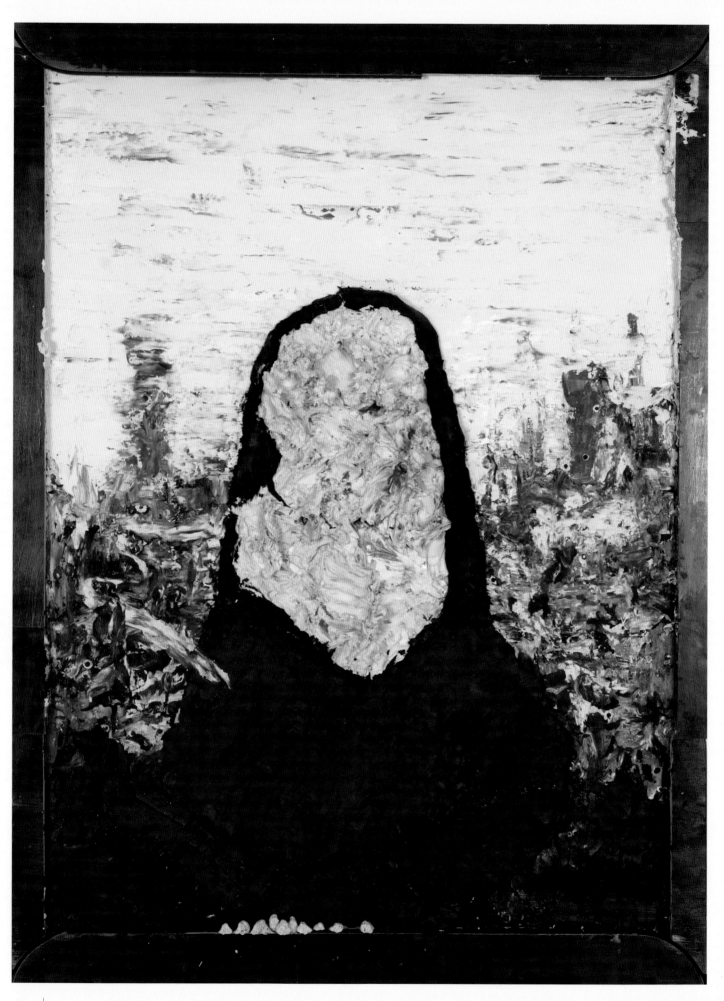

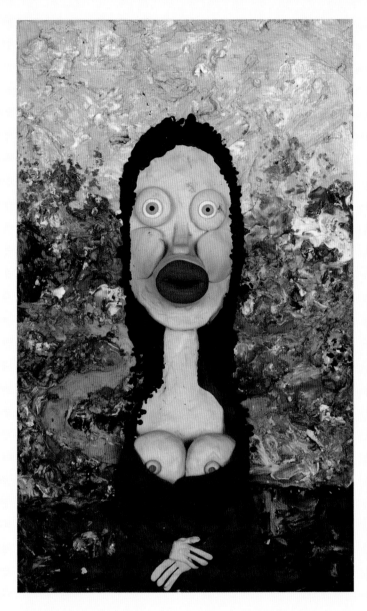 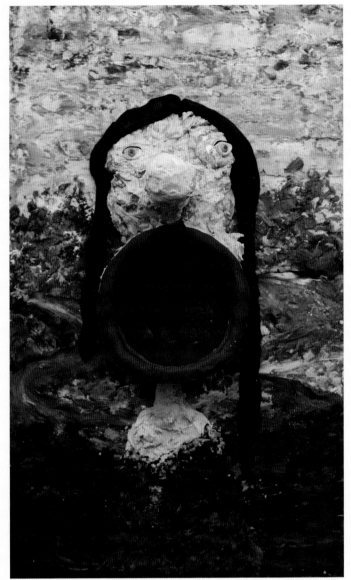

PREVIOUS PAGE
Mona Lisa
Plasticine on wood
47 x 62 x 4.5 cm, 2010
Courtesy of Carlson Gallery, London

LEFT
Mona Lisa
Plasticine on wood
96.4 x 131.3 x 10.5 cm, 2010
Courtesy of Carlson Gallery, London

ABOVE, LEFT
Mona Lisa
Plasticine on wood
42 x 69.5 x 13 cm, 2010

ABOVE, RIGHT
Mona Lisa
Plasticine on wood
55 x 90 x 50 cm, 2011
Courtesy of Tim Van Laere Gallery, Antwerp

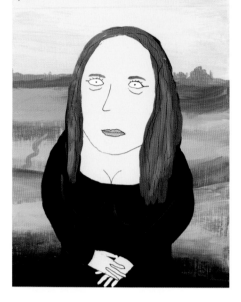

MONALISA MADE IN CHINA

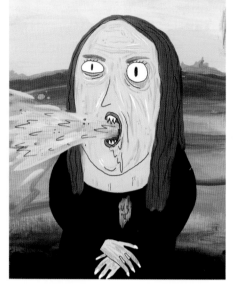

MONALISA - THE EXORCIST

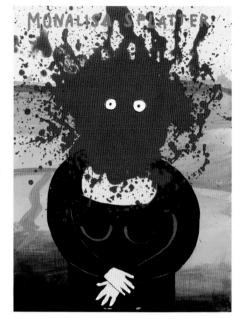

MONALISA SPLATTER

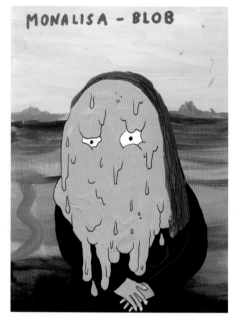

MONALISA - BLOB

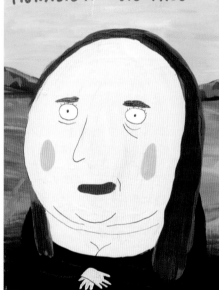

MONALISA - BIG FACE

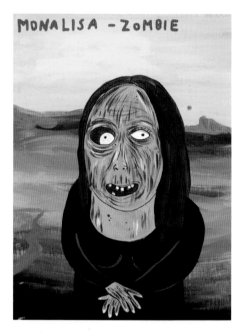

MONALISA - ZOMBIE

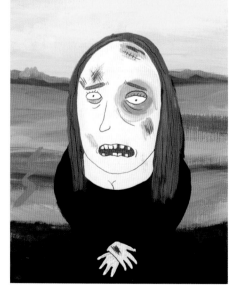

MONALISA K.O.

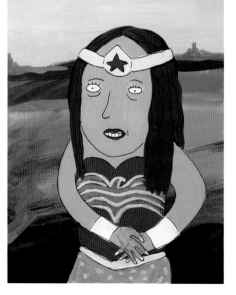

MONALISA - WONDER WOMAN

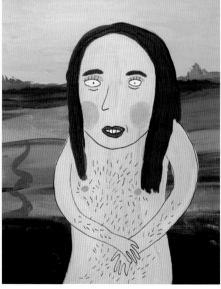

MONALISA - TRANS

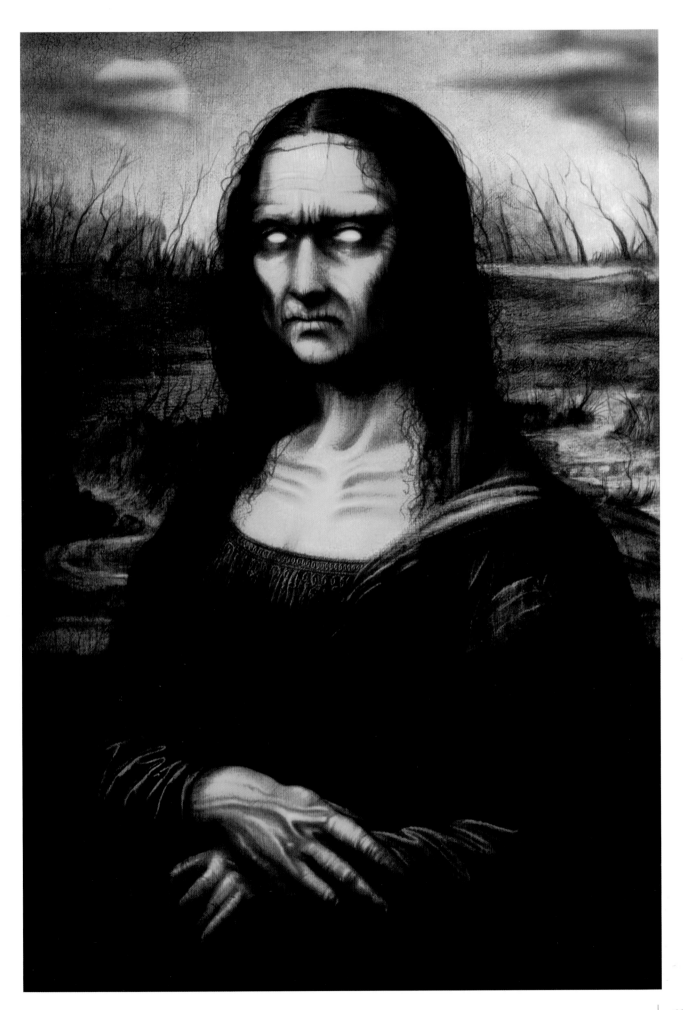

Laurina Paperina
Mona Lisa's Faces
Mixed media on wood
Series of 9 paintings, 15 x 21 cm each, 2008

Italian multimedia artist Laurina Paperina created her series of Mona Lisa variations for *Money Lisa*, a 2008 group exhibition held at MondoPOP Gallery in Rome.

Rigoberto "Rigo" Velez
Zombie Mona Lisa
Digital, 2550 x 3300 pixels, 2008

American artist Rigo Velez works predominantly as a digital illustrator, usually designing children's books and products, but occasionally taking a detour into more macabre and ghoulish territory with illustrations such as his *Zombie Mona Lisa*.

Janet Chui
Japanese Mona Lisa
Watercolor and collage on paper, 6.35 x 8.89 cm, 2008

Janet Chui is a freelance fantasy artist and illustrator living in Singapore. She created her miniature watercolor as a collectible ACEO (Art Cards, Editions and Originals), with collage elements added from scraps of Japanese wrapping paper.

Dave Wilder
Montana Lisa
Watercolor
35.5 x 50.8 cm, 2008

Working from his studio near Sedona, Arizona, California native Dave Wilder creates paintings that dare to challenge the conventions of traditional Western art. With a potent brew of humor, surrealism, and kitschy Southwestern imagery, his artwork depicts American folklore and mythology through the lens of a post-modernist sensibility.

Stanton D. Ewert
Woman Sitting by the Window
Colored pencils on illustration board
69.85 x 95.25 cm, 2008

Self-taught American artist Stan Ewert spent six months illustrating his finely rendered and exhaustively detailed interpretation of Leonardo da Vinci's studio. While originally conceived as a recreation of just the portrait itself, the concept of expanding the view to include the subject's surroundings came as an afterthought. "I had not yet cut my drawing board down to a finished size, and on a whim I started sketching pieces of furniture and other items placed around her. It ended up being a tight fit, and she comes off as a bit large inside the room, but since Mona Lisa has the presence to overpower any room she's in, I guess it's appropriate."

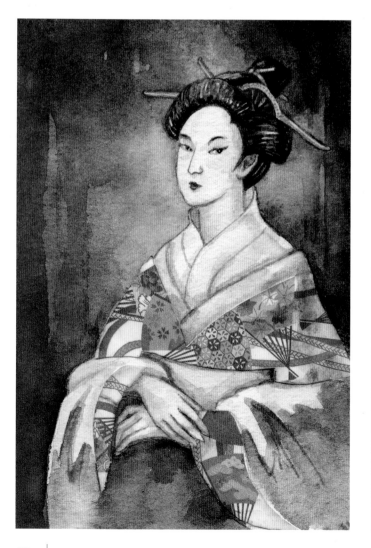

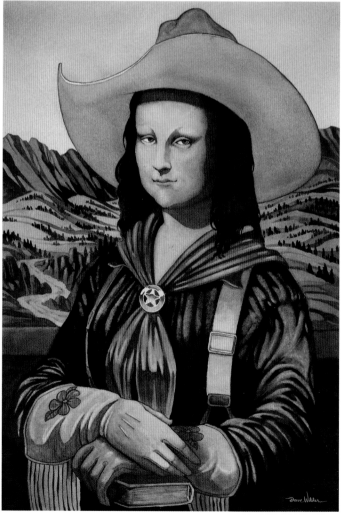

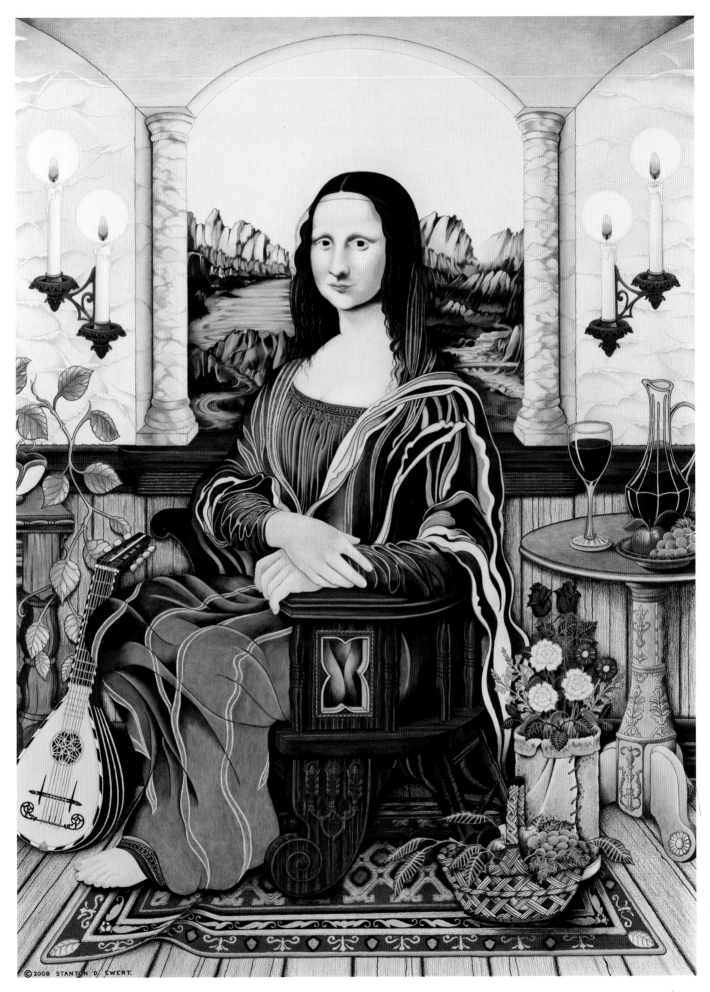

© 2008 STANTON D. EWERT.

Duane Hammond
Onamay Isalay
Pastel on paper
21.6 x 21.6 cm, 2008

After forty years as an award-winning art director and founder of his own graphic design agency, New Hampshire native Duane Hammond launched his *Pigs in a Poke* collection, a series of portraits depicting pigs engaged in humorous and satirical poses and situations. His parodies have been published in two separate *Pigs in a Poke* books, and have been reproduced as prints, stationery, mugs, and magnets, available in galleries and giftshops nationwide.

Mohamed Sami
Nosa Lisa
Digital
3004 x 3810 pixels, 2008

Egyptian artist Mohamed Sami has over twenty years of experience in illustration, character design, editorial cartoons, animation, and educational public service advertisements. He is founder and managing director of Samistudio, an illustration and animation studio based in Cairo. His *Nosa Lisa* was a personal project created on a whim in-between commissioned work.

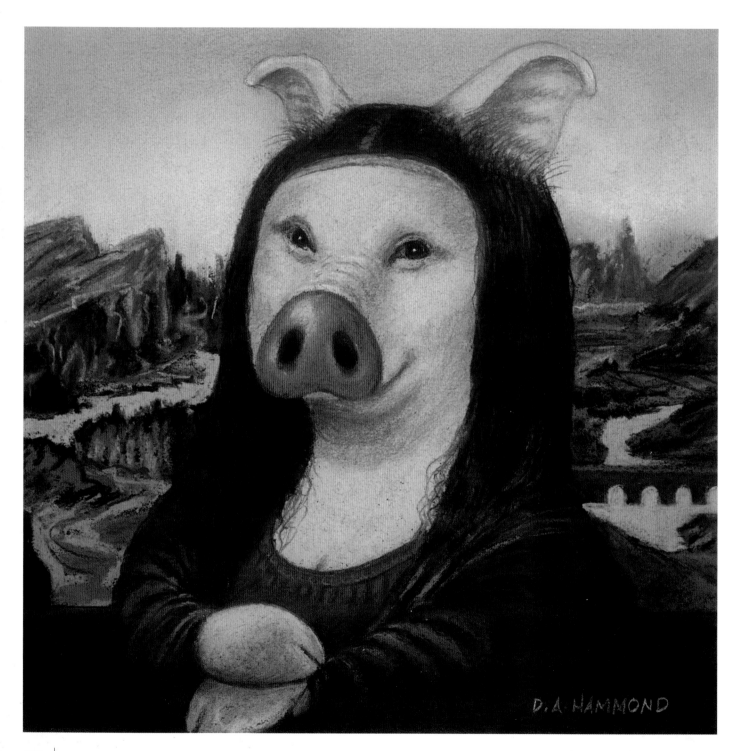

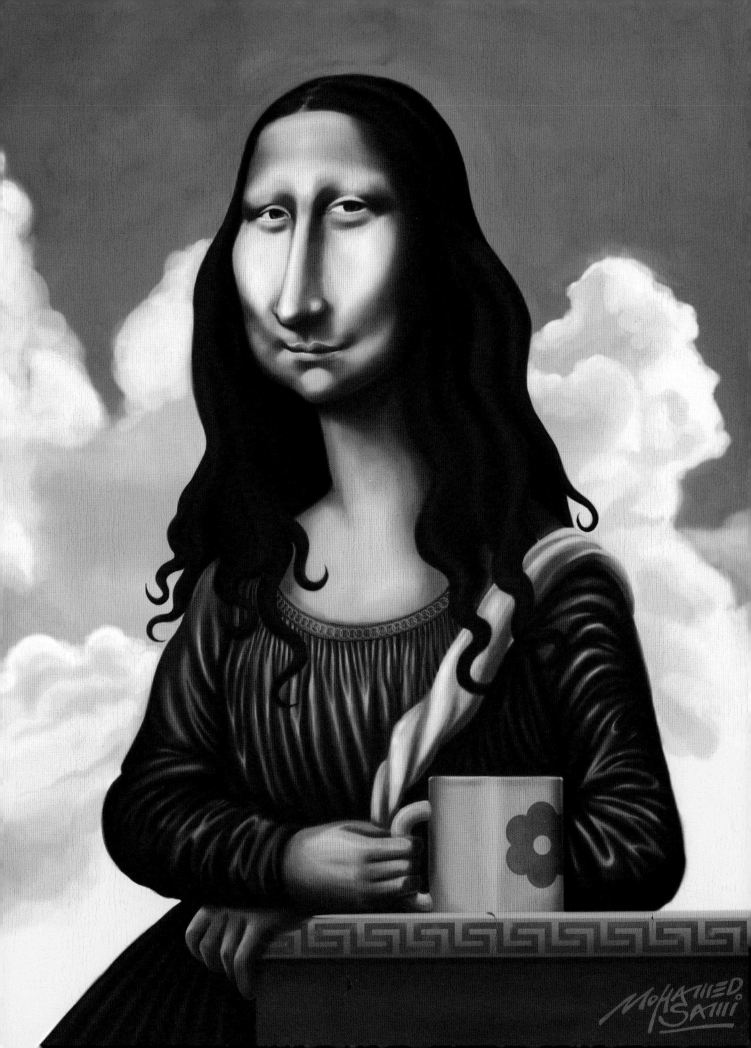

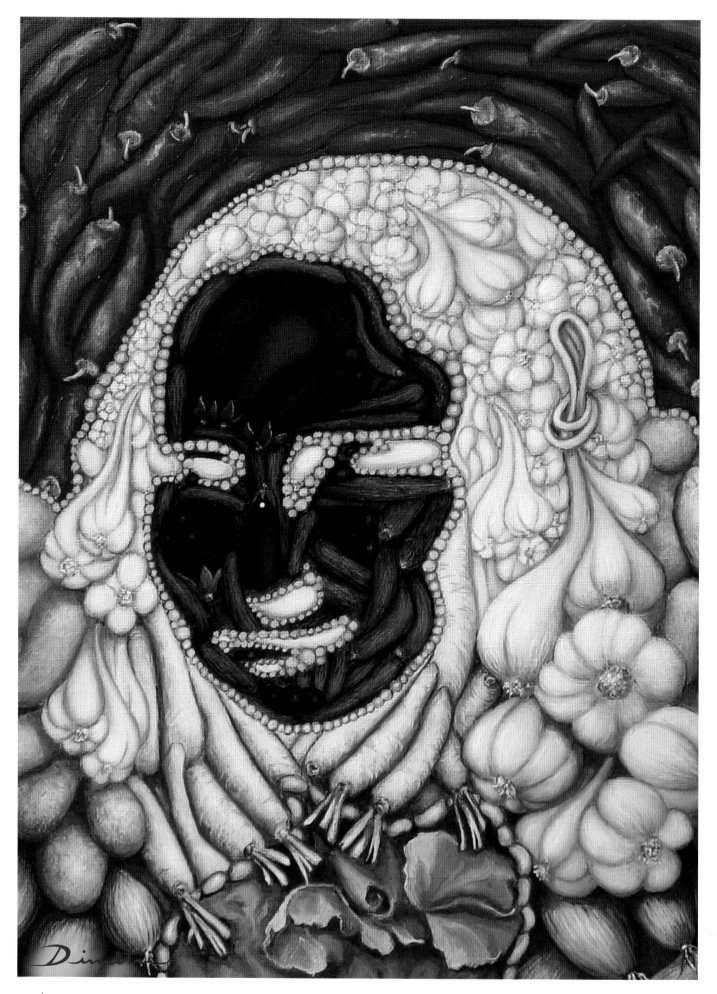

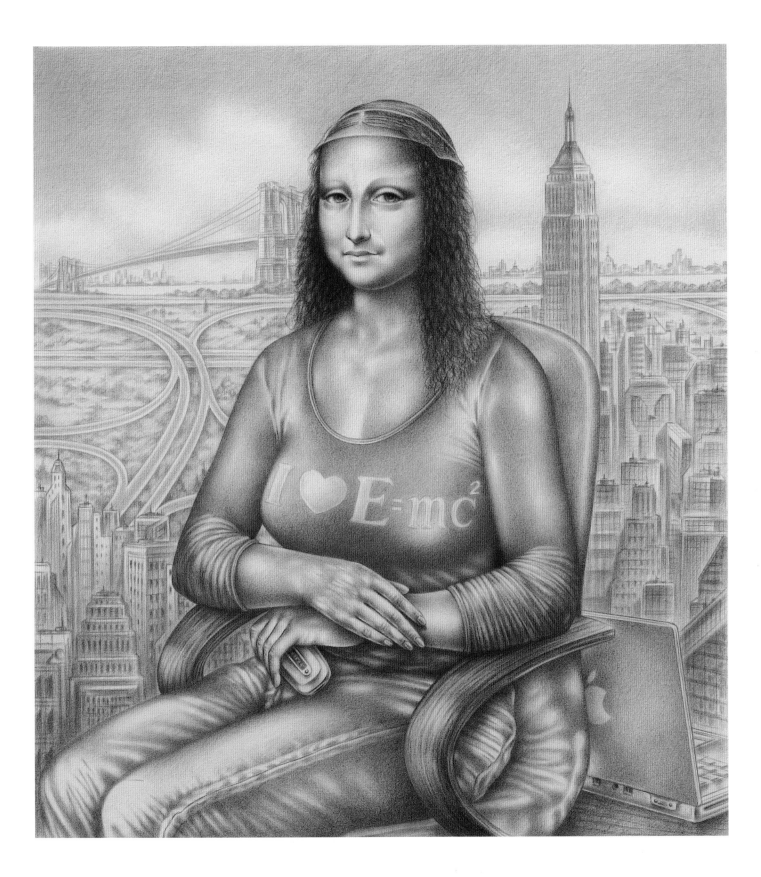

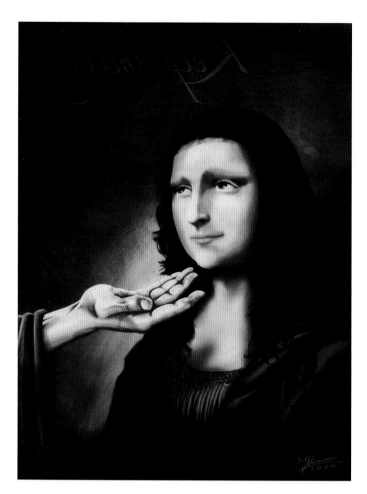

PREVIOUS PAGES, LEFT

Dimitri Parant
Mona Lisa After-Image
Oil on canvas, 33 x 41 cm, 2008

Master of distorted perspectives, French painter Dimitri Parant is a fascinating and unclassifiable artist who draws his technique from archaic experiments of ancient masters. An expert on methods such as anamorphosis and anaglyph three-dimensional paintings, Mr. Dimitri has developed his own optical illusion: the Virtual After-Image painting, which utilizes a theory known as "persistence of vision." The after-image effect is achieved by staring intently for thirty seconds at the white dot near the center of his painting, then closing your eyes for ten seconds. This should produce an after-image of Mona Lisa's face floating in front of your eyes.

PREVIOUS PAGES, RIGHT

André Pijet
Metamorphic Impressions: Mona Lisa
Colored pencil on raw canvas, 83 x 90 cm, 2008

For the past three decades, Poland native André Pijet has been living in Quebec, working as a painter, illustrator, and cartoonist. Inspired by the epic narrative poem "Metamorphoses," Ovid's mythological history of the world, Mr. Pijet created his own epic series, *Metamorphic Impressions*, a collection of large-scale images in which he transposed famous figures throughout history into modern settings.

LEFT, TOP

Francesco Necci
Keep Smiling
Digital, 2480 x 3508 pixels, 2008

Italian illustrator, graphic designer, and comic book artist Francesco Necci explains that he views his illustrations as snapshots of life: "I try to seize the hidden moments behind famous events, whether they were real or imagined. With *Keep Smiling* I have envisioned the birth of Leonardo's masterpiece. I don't believe he would have made a single brushstroke until first obtaining the perfect smile."

LEFT, BOTTOM

Alice Pasquini
Under Lisa
Oil on canvas, 50 x 70 cm, 2008

Alice Pasquini is a visual artist from Rome who works as an illustrator, set designer, and painter. She is interested in creating art about people and their relationships, representing human feelings, and exploring different points of view. She especially likes depicting strong and independent women in her work. Here, she offers a rare glimpse "behind the curtain" of a popular female icon. In the lower right corner of the painting, Ms. Pasquini has signed her name in reverse, as an homage to the "mirror writing" often employed by Leonardo da Vinci in his personal notes.

RIGHT

Timo Grubing
Mona Lisa Rat
Ink on paper with digital enhancements, 21 x 29.7 cm, 2008

German children's book illustrator Timo Grubing created his Mona Lisa variant for the gaming company Projekt Kopfkino to promote their upcoming role-playing game *Ratten! (Rats!)*. In the game, players inhabit the role of rodents with special abilities and fight against monsters and other rat tribes in an abandoned shopping mall.

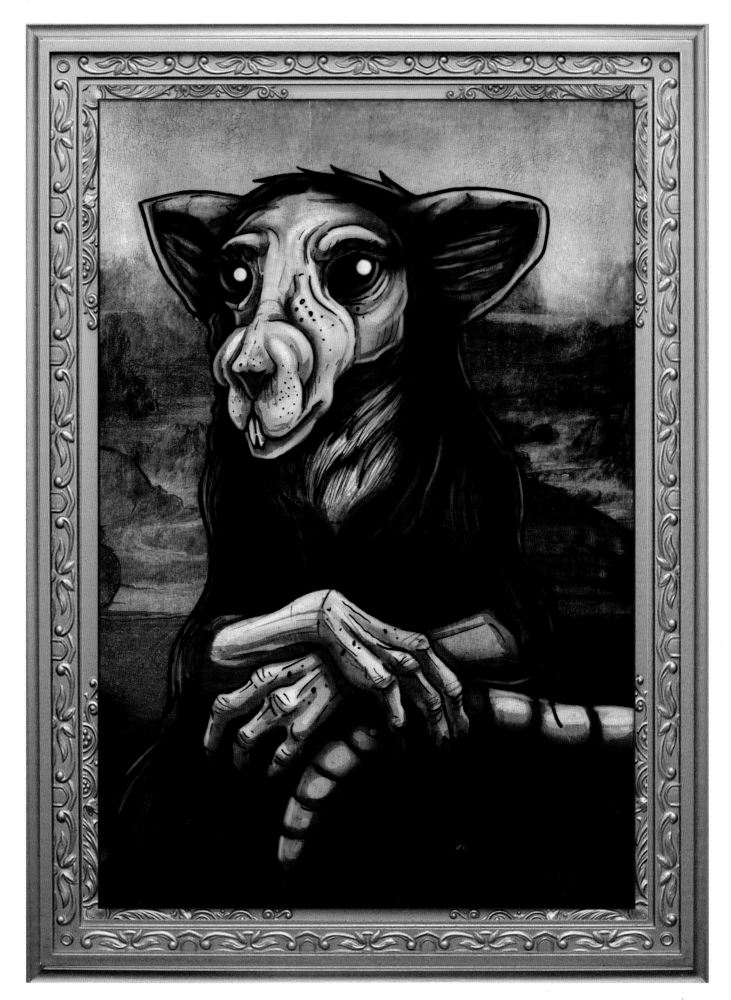

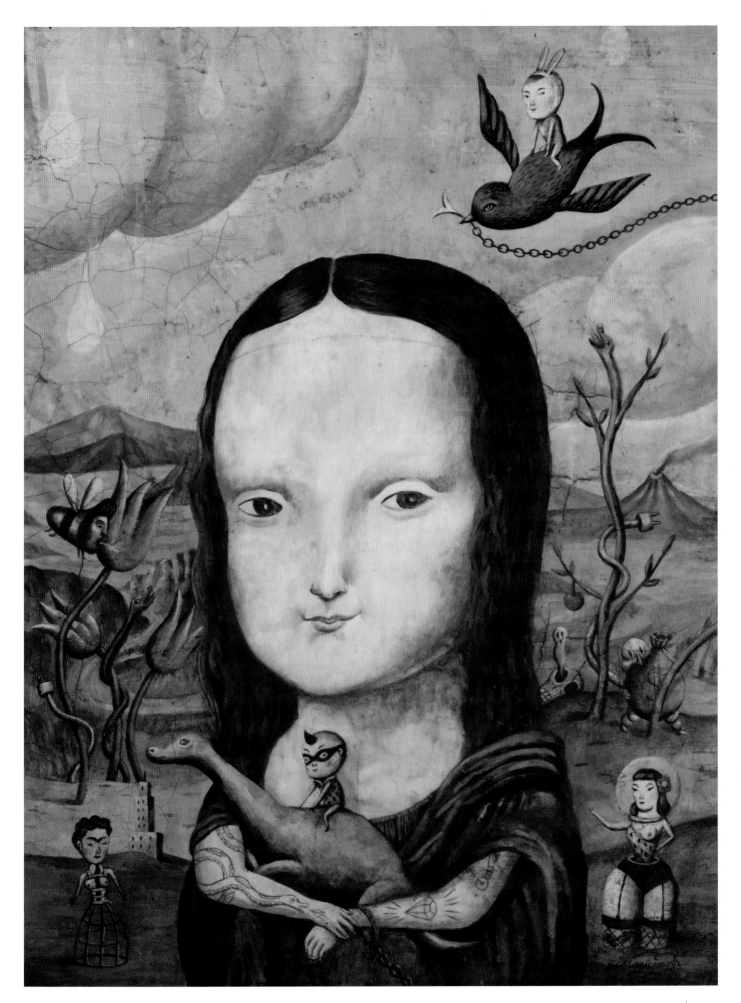

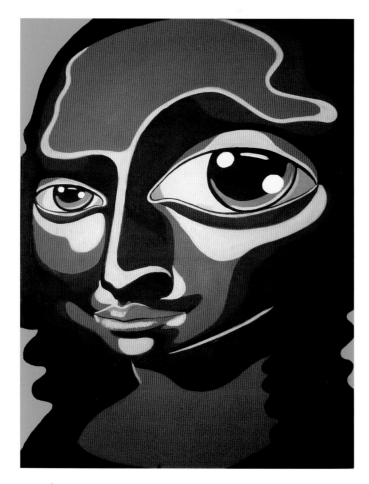

Naoshi
The Hills of Mona Lisa
(AKA May Tomorrow Be Another Good Day)
Sand on art board, 51.5 x72.8 cm, 2008

Japanese artist Naoshi is a modern practitioner of the very specialized art of Sunae, or "sand art". Using colorful grains of shiny sand, she creates dreamlike scenes of surreal characters inhabiting outlandish worlds, experiencing everyday emotions such as joy, sorrow, love, and anxiety.

Sergio Mora
La Moralisa
Acrylic on canvas, 50 x 70 cm, 2008

The Surrealistic paintings of Spanish artist Sergio Mora transport his viewers to strange, circus-like worlds, complete with mythological creatures, iconographic symbols, beautiful monsters, and grotesque fantasies. The artist, who sometimes signs his work as "Magicomora," delves deep into his subconscious to extract surprising and sometimes disturbing visuals that celebrate the simple joy of imagination.

Syoichiro Nishimoto
Line (Gioconda 2008)
Oil on paper, 50.8 x 66 cm, 2008

The work of Japanese painter and digital graphic designer Syoichiro Nishimoto is fascinating in its simplicity and astounding in its power. He constantly subverts expectations by creating images that both confound the mind and stimulate the senses.

Zelda Bomba
Gioconda
Acrylic on canvas, 50 x 70 cm, 2008

Although French painter Zelda Bomba had lived near Clos Lucé in Amboise, France, where Leonardo da Vinci spent the final years of his life, she had never given any thought to reproducing his artwork in her own style until years later, when living in Rome, she was approached by MondoPOP Gallery to participate in a group exhibition with Mona Lisa as the theme. Her bold, expressive style and dynamic use of color helped Ms. Bomba's unique interpretation become one of the most hypnotic and memorable pieces from the show.

Carlos Cabo
Pixelated Monalisa
Digital, 5906 x 8268 pixels, 2008

Spanish graphic designer Carlos Cabo has always been interested in Generative art, a system that allows an approach to abstraction using mathematical formulas and the development of computer programs, in which a random component sometimes determines the final result. For this work, the process was a bit more manual, with the artist creating several mosaics of varying pixel sizes, then combining them into a single image and redrawing them in vector format to allow an upscale in size without loss of quality. The resulting image has an abstract or random appearance when viewed at close range, but becomes instantly recognizable if reproduced in smaller dimensions or when seen from a distance.

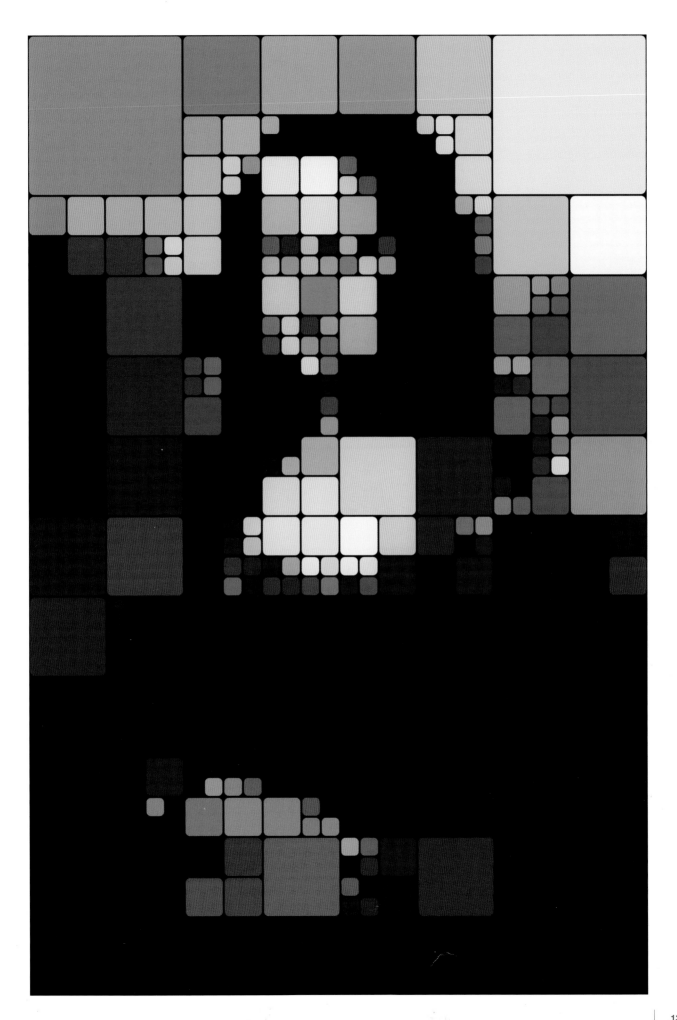

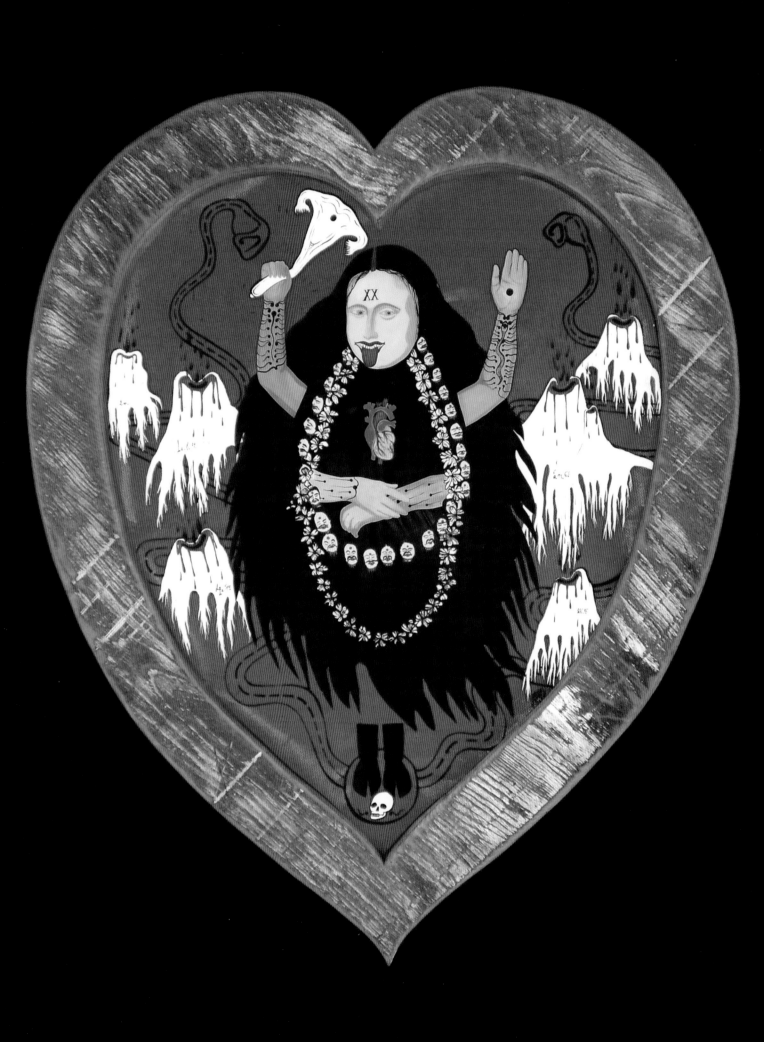

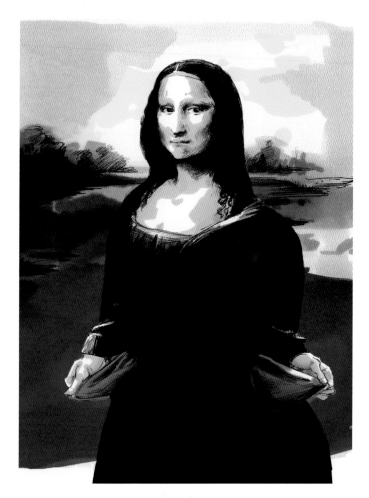

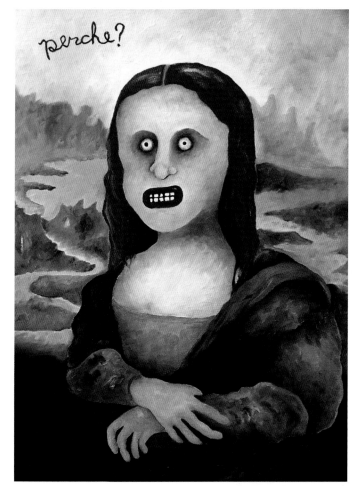

Allegra Corbo
Mona Kali Sa
Mixed media (acrylic, paper, wood), 70 x 90 cm, 2008

Italian painter Allegra Corbo fuses Mona Lisa with the Hindu goddess Kāli in an expressive painting rich with spirituality. Kāli is generally associated with empowerment, and is the personification of divine feminine creative power, representing Mona Lisa's uncontested reign as the most famous painting in history.

Ian Currie
Paint by Numbers (AKA Matrix Mona)
Digital, 1388 x 2135 pixels, 2008

Inspired by the groundbreaking visual effects of the motion picture *The Matrix*, UK-based graphic designer Ian Currie utilized the movie's distinctive "digital rain" to recreate Mona Lisa. The downward-flowing green numerical characters are used in the movie to represent the computer code of the simulated reality world of the Matrix. Mr. Currie also created an animated version of this illustration, which more closely approximates the look and feel of the effect as it originally appeared throughout *The Matrix* movie trilogy.

Jenny Adam
Poor Mona Lisa - No Money for Culture
Ballpoint pen, markers on paper with digital enhancements
21 x 29.7 cm, 2009

German illustrator and industrial designer Jenny Adam created this image for a small student newspaper in Mainz, as cover artwork accompanying an article concerning recent budget cuts that had been made for local cultural and artistic institutions. "The editors had asked me to draw a begging Mona Lisa, but I convinced them that begging would not suit her. Instead I chose to draw her with empty pockets, but still standing straight and proud."

Leigh Cooney
Why Am I Famous?
Oil on canvas, 40.6 x 50.8 cm, 2009

Irish-born Canadian artist Leigh Cooney is a self-taught painter who describes his work as Neo-Folk art. Uncomfortable with academic ideas of composition, color use, and symbolism, he painted *Why Am I Famous?* after visiting the Louvre and fighting the crowds to get close enough to look at Mona Lisa. Ultimately underwhelmed, he started questioning the whole idea of what makes art "good" or "bad." "I decided I would paint Mona Lisa based on my observation, and she herself would be wondering why she's so beloved."

James A. Larson
Mona Alek
Ink and watercolor on paper with digital enhancements
53.3 x 76.2 cm, 2009

American art student James A. Larson created this portrait of one of his classmates as a college assignment to recreate Mona Lisa in his own personal style.

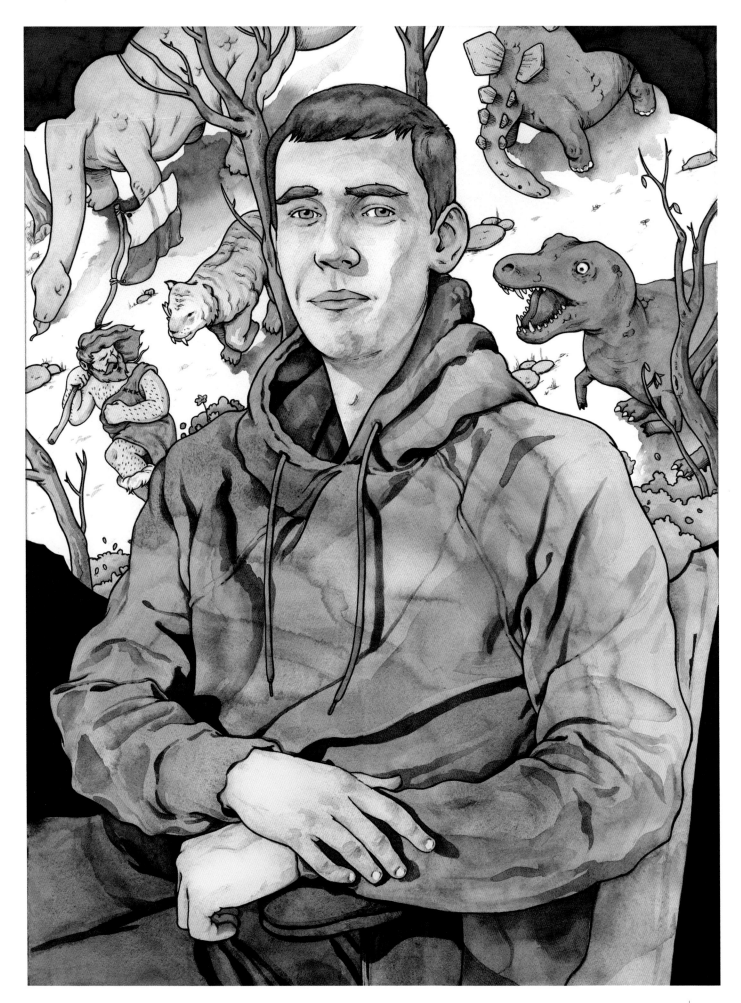

BELOW

Subodh Gupta
Et tu, Duchamp?
Black bronze
88 x 114 x 59 cm, 2009

Initially trained as a painter, New Delhi-based artist Subodh Gupta has gone on to receive acclaim in a wide range of disciplines, including sculpture, installation, photography, performance art, and video. His colossal bronze sculpture *Et tu, Duchamp?* is described as "an appropriation of an appropriation," as it derives its inspiration not from Mona Lisa, but from the numerous mustached parodies created by Marcel Duchamp throughout the first half of the 20th century. The sculpture takes Mr. Duchamp's irreverent gesture and monumentalizes it, effectively laying claim to its inheritance. The larger-than-life size and lasting durability of Mr. Gupta's version are in direct contrast to the artistic sensibilities that Mr. Duchamp had tried to dispel in his own work.

Artwork Courtesy of the artist and Hauser & Wirth

RIGHT

Timothy White
Whoopi as Mona Lisa
Digital photograph taken with a Hasselblad H4 Camera
3600 x 4800 pixels, 2009

Timothy White is one of the most sought-after celebrity photographers in the United States. For over twenty years, he has captured the intimate, playful sides of legendary actors and actresses, as well as the innocence and luminosity of up-and-comers. He has photographed some of the most recognizable movie posters of our time, the covers of countless high-profile publications, and imagery for an extraordinary roster of musicians. In 2009, he was tasked by Poise Brand Absorbent Products to photograph comedienne Whoopi Goldberg portraying famous women throughout history who may have had issues with LBL (light bladder leakage). The series of images depicted Ms. Goldberg as figures such as Cleopatra, Helen of Troy, Joan of Arc, Lady Godiva, the Statue of Liberty, and, of course, Mona Lisa. Using humor to raise awareness of the fact that one out of every three women experience LBL, the popular advertisements sought to reduce the embarrassing stigma associated with the condition so that women would feel empowered to deal with this issue. The Mona Lisa ads were accompanied by a tagline, which read: "There's a 1 in 3 chance that wasn't a smile on Mona Lisa's face."

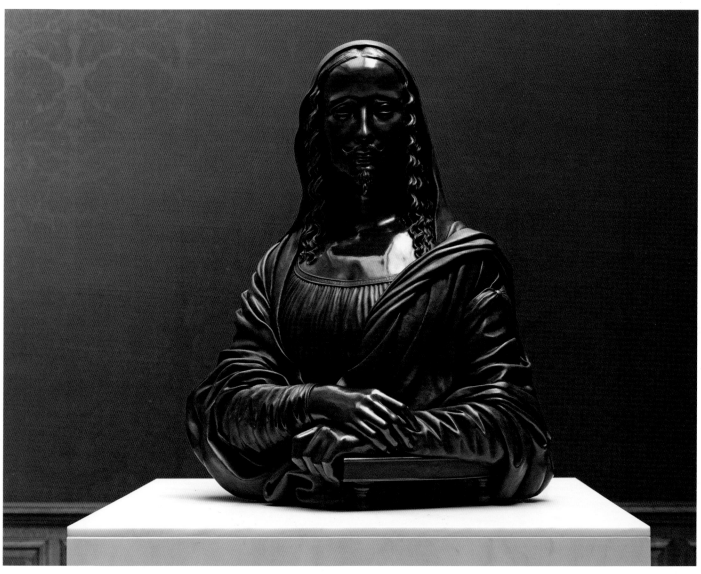

© Subodh Gupta. Photo by Mike Bruce.

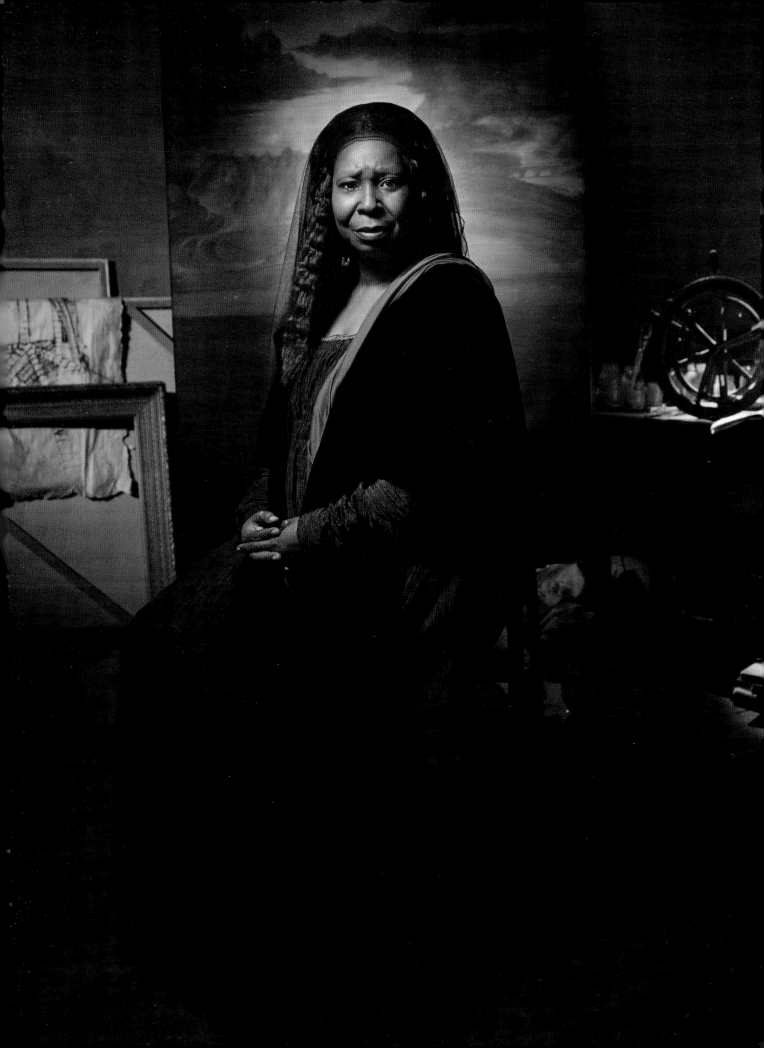

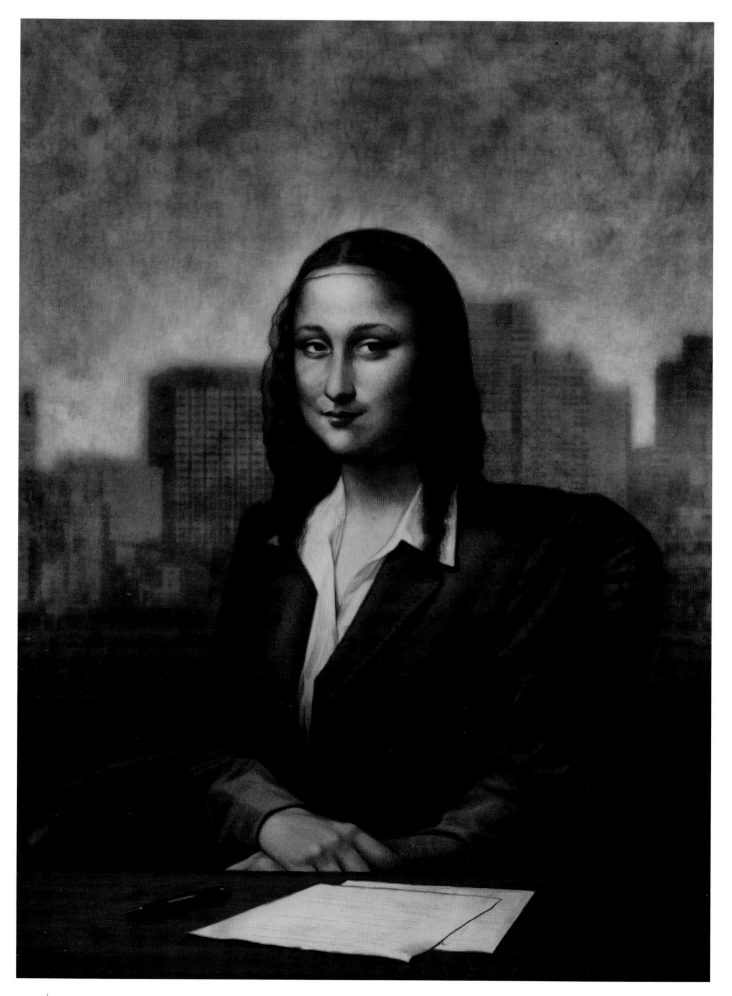

Patrick Faricy
Modern Mona
Acrylic with digital enhancements
26.7 x 33 cm, 2009

In his twenty years as a professional illustrator, Patrick Faricy has worked for an eclectic range of corporations such as Coca-Cola, General Mills, The Walt Disney Company, *Reader's Digest*, Sega, Kellogg's, Mattel, and *USA Today*. His Mona Lisa artwork was commissioned by Real Estate Forum Magazine and used as cover art for 2009's "Women of Influence," an article profiling commercial real estate's most accomplished female professionals.

Barbara Wijnveld
Smile (Heartbroken)
Acrylic and varnish on linen
140 x 190 cm, 2009

Amsterdam visual artist Barbara Wijnveld limits her palette to the three primary colors when creating her paint-dripped double-portraits. Extremely diluted paint is applied in thin layers, one on top of the other, so that the entire spectrum of color is ultimately present in the works. In this painting, the artist's own face is superimposed over the top of Mona Lisa's features, partially obscuring them. This technique generates a unique type of psychological self-portrait, which the artist describes as "an inner portrait."

Nickolas Moustakas
In Taste We Believe
Digital photograph of food collage
2480 x 3508 pixels, 2009

Versatility seems to be the cornerstone throughout the portfolio of Greek art director and graphic designer Nickolas Moustakas. With a tendency toward meticulous production and a stable graphic appearance, his work is ingrained with symbolism and analogy. Approached by Banquet, a prominent Italian restaurant in his native Thessaloniki, to create a series of marketing materials with the theme "The Italian Masterpiece," his goal was to utilize all elements of a great cuisine philosophy to create the perfect piece of art. Using unprocessed raw materials such as spices, herbs, and bits of pasta, he reconstructed Mona Lisa as a collage of ingredients found in the dishes prepared and served at the restaurant.

BELOW, LEFT
David Müller
Mona
Digital, 320 x 480 pixels, 2009

This striking digital illustration was created by German artist David Müller, using only the tip of his index finger on his Apple iPod Touch. The vibrant and expressive background was achieved by utilizing a painting app called "Pollock," enabling Mr. Müller to simulate the unique style of drip painting that had been developed by influential abstract painter Jackson Pollock in the mid-forties. The finely rendered details of the foreground figure were completed using a different painting app known as "Brushes." The entire endeavor required approximately ten hours for Mr. Müller to complete.

BELOW, RIGHT
William Edwards
La Muerta Lisa
Digital, 2700 x 3600 pixels, 2009

California-based illustrator and designer William Edwards creates all of the graphics for his popular line of Skullabee tee-shirts and novelty gifts. A cheerful mix of humor and morbid fascination, many of his images focus on the Mexican holiday "Día de los Muertos." He describes his version of Mona Lisa as "how she would look today if she attended the annual celebration: a skeleton in a dress with neo-propaganda-style rays of shining light."

RIGHT
Dan Parent
Show Me the Monet
Digital, 2774 x 3966 pixels, 2009

A graduate of the prestigious Joe Kubert School of Cartoon and Graphic Art, American illustrator Dan Parent has been an artist and writer for Archie Comics since 1988. His Mona Lisa parody was created as cover artwork for Issue #198 of *Veronica*, a spin-off series focusing on the adventures of popular character and recurrent Archie love interest, Veronica Lodge.

Courtesy of Archie Comic Publications, Inc.

FOLLOWING PAGE, TOP LEFT
Sylvain Lauprêtre
Joconde Troll
Carbon pencil, acrylic, and India ink on paper
26 x 31 cm, 2009

French comic book author and illustrator Sylvain Lauprêtre created *Joconde Troll* for a 2009 Christmas festival in his hometown of Angers. He had been asked to create designs of various troll and hobgoblin characters remade in the image of classic art masterpieces. Ultimately, the design chosen was Mona Lisa, and Mr. Lauprêtre set about his task of recreating her as a mythical Christmas lutin from German folklore.

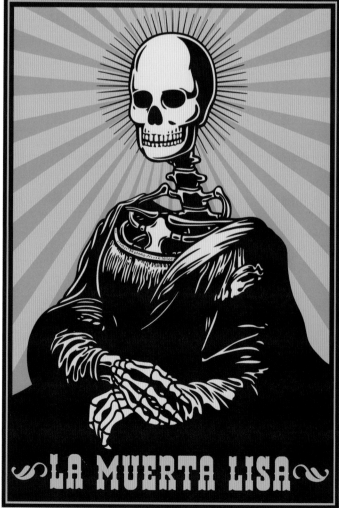

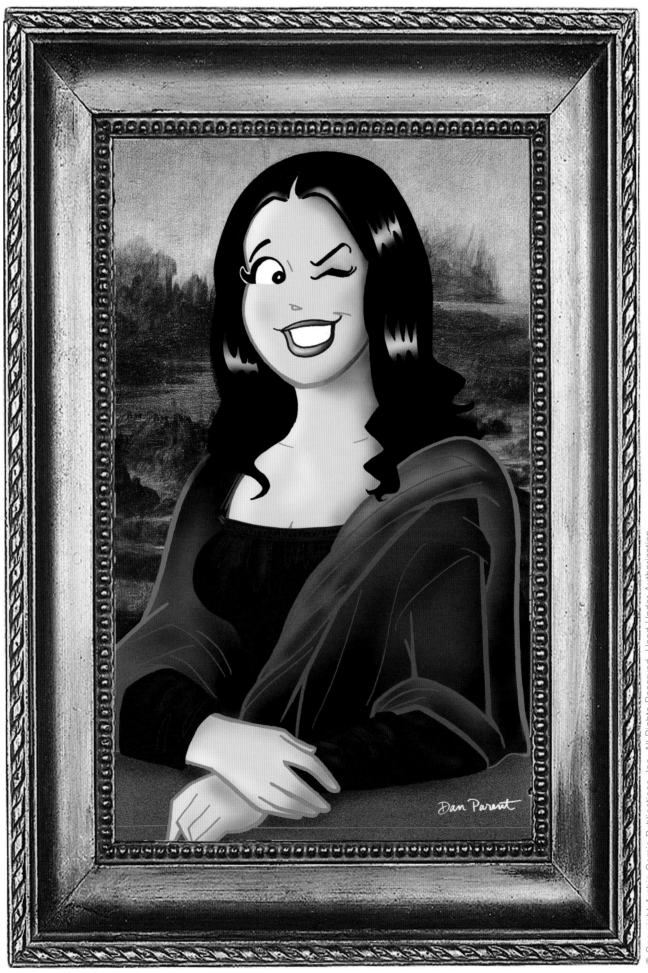

© Copyright Archie Comic Publications, Inc. All Rights Reserved. Used Under Authorization.

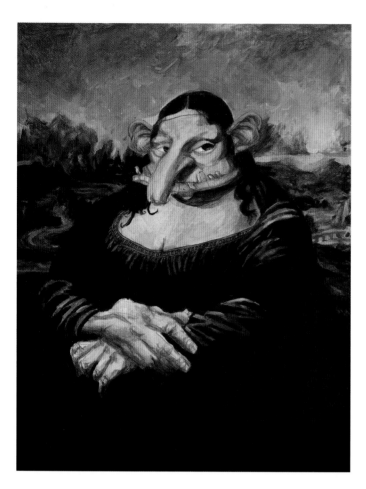

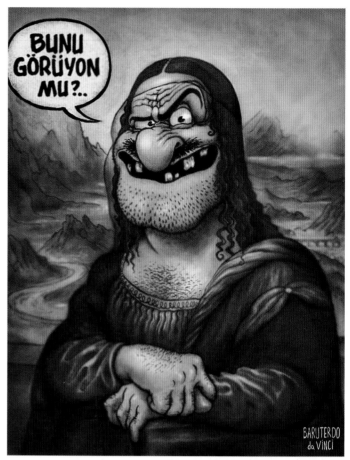

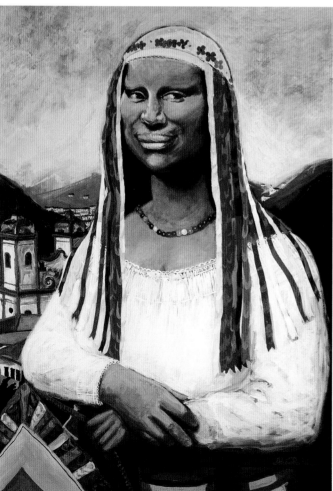

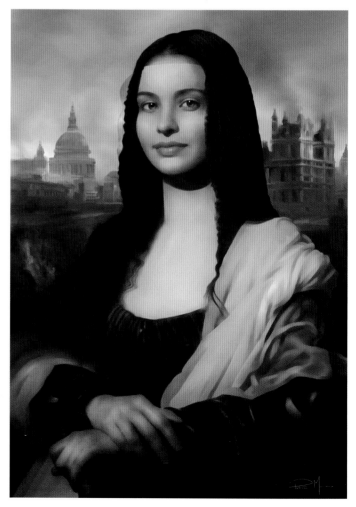

Bahadir Baruter
Mona Riza
Acrylic on paper, 46 x 59 cm, 2009

Turkish cartoonist Bahadir Baruter is one of the most admired and respected artists in Turkey, but also one of the most controversial. He was put on trial in 2011 for illustrating a satirical comic strip depicting the interior of a mosque, with the words "There is no Allah, religion is a lie" hidden within the temple's decorative wall pattern. A lawsuit was filed against the caricaturist after several citizens lodged complaints about the cartoon. His irreverent Mona Lisa recreation has been refashioned as a self-portrait, and features his alter ego making an obscene hand gesture and asking "Bunu görüyon mu?," which translates colloquially to "Are you seeing this?"

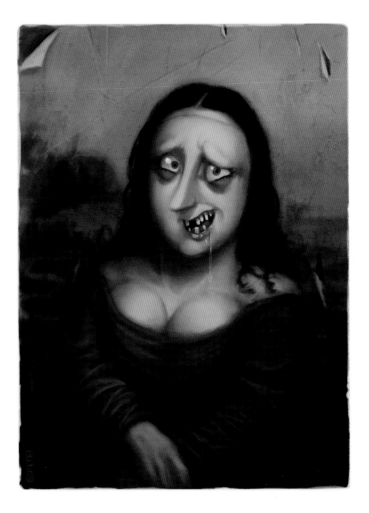

Adão Rodrigues
Gioconda de la Vila Rica
Acrylic on canvas, 80 x 120 cm, 2009

Brazilian artist Adão Rodrigues developed his creative talents working for advertising agencies in Belo Horizonte as an art director, designer, and illustrator. Eventually dedicating himself to the study of painting, he became interested in creating artwork depicting the rich folklore of his culture. "I wanted to tell the story of my people, to represent our colorful heritage and our traditional celebrations of congados, cavalhadas, gang dances, and games. These are all important parts of our history." He began exhibiting his work extensively throughout Brazil, and his *Gioconda de la Vila Rica* was part of a group exhibition in Ouro Preto, which featured ninety-nine additional artists, all reinterpreting Mona Lisa in their own individual style.

Patrice Murciano
Mona Lisa
Digital, 3189 x 4724 pixels, 2009

Mona Lisa makes a return visit in the work of experimental multidisciplinary artist Patrice Murciano, this time in the guise of a digitally manipulated photo of a contemporary French model.

Patri Balanovsky
Mona Lisa Imbecile
Digital, 1528 x 1911 pixels, 2009

Born in Israel and now living in Germany, versatile illustrator Patri Balanovsky works as a video game concept artist and character designer. "One rainy afternoon, I had an abrupt desire to destroy something beautiful, so I created *Mona Lisa Imbecile*. Life is short and horrifying, a sad little joke. Taking it too seriously would be a waste of a good punchline, so why not poke fun at the single most recognizable piece of art ever made?"

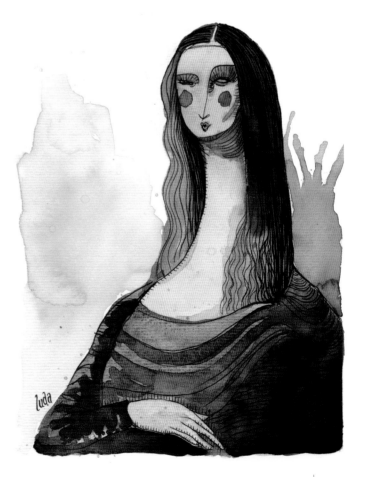

Luda Lima
Monaluda
Watercolor and ink on paper, 21 x 27 cm, 2009

Brazilian illustrator Luda Lima designs and sells a line of colorful stationery products featuring her vibrant, expressive watercolors. *Monaluda* was one of her most popular greeting cards and prompted her to create several more variations for birthday and Christmas cards.

Allen Helbig
Silent Auction
Digital
2700 x 3643 pixels, 2009

American artist Allen Helbig studied to be a veterinarian before eventually ending up with an art degree. His first job was selling fire extinguishers door-to-door, but he has since worked as an art director, animator, children's book illustrator, screen printer, web designer, and comic book artist. He created this simple but effective digital illustration for a poster advertising a fundraising silent auction.

Roberto Gutierrez Garcia
The Moonalisa
Mixed media
28 x 43.2 cm, 2009

Mexican illustrator Roberto Gutierrez Garcia's dreamlike, moon-faced portrait of Mona Lisa conjures the appearance of a celestial body as it directs a calm and ubiquitous gaze upon the spectator. Her face seems to emit a glow from within, just as the moon appears to shine even though it merely has the ability to reflect light, like a mirror. This is symbolic of a mysterious secret that *The Moonalisa* can impart to the viewer, but can provide no resolution to.

Farah Ossouli
Ars Poetica
Gouache on cardboard
55 x 65 cm, 2009

Iranian artist Farah Ossouli's intricate painting represents the conflicting duality of Iranian culture, in that her version of Mona Lisa is still smiling, despite the fact that her throat has been cut. Ms. Ossouli feels that Iranian women always have two contradicting feelings with which they must carry themselves, and they should never complain, even if they are injured. Written within the elaborate border that decorates the artwork are the following words, inspired by a poem composed by Persian writer Ahmad Shamloo: "No suicide was ever more tragic than my life as I live it."

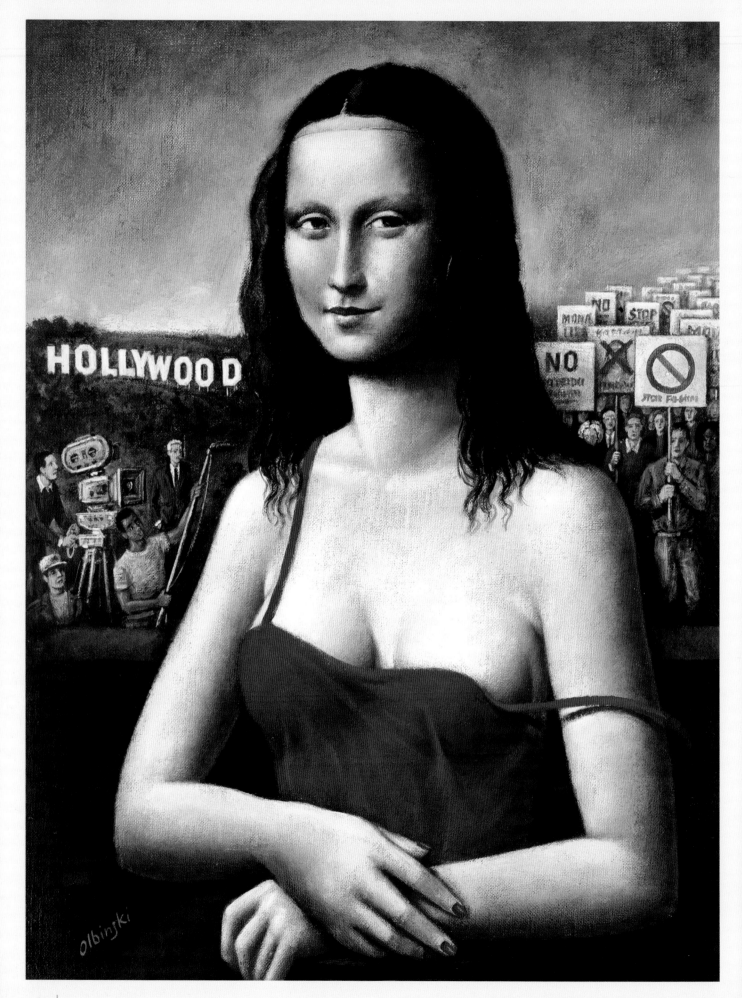

Rafał Olbiński

World-renowned Polish artist Rafal Olbinski initially studied architecture before dedicating himself to painting and design. He graduated from the Architectural Department of Warsaw Politechnical School and immigrated to the United States in 1982, where he quickly established himself as a prominent painter, illustrator, and designer. In 1985, he began teaching at the School of Visual Arts in New York. He has received more than 150 awards during his illustrious career, including Gold and Silver Medals from the Society of Illustrators in New York and Los Angeles, and The Big Crit 2000 award by Critique Magazine in San Francisco. Describing his artistic aesthetic as "poetic surrealism," Mr. Olbinski's lush images are layered with complex psychology. He does not paint the landscape of reality, but rather maps the cryptic interiors of the human consciousness. Like Salvador Dalí and René Magritte before him, Olbinski's work has a poetic resonance; he depicts the mind as a theater of dreams, with new and unexpected attractions around every corner. Well known for his luxurious depictions of women, Mr. Olbinski's nudes are both classical and controversial. He explores the mysterious aura of women who, although often aloof, still manage to entice and beckon to the viewer. Mona Lisa has been a frequent subject of his work because her enigmatic quality is an indisputable compliment to his surrealistic style.

© Copyright Rafal Olbinski
Courtesy of Patinae, Inc. (www.patinae.com)

LEFT
Mona Lisa II
Acrylic and oil on canvas
25.4 x 33 cm, 2006

RIGHT, TOP
Meticulous Scrutiny of Dreams
Acrylic and oil on canvas
38.1 x 48.26 cm, 2009

RIGHT, BOTTOM
Dreamer
Acrylic and oil on canvas
29.85 x 43.18 cm, 2009

FOLLOWING PAGE, TOP
Sentimental Attentiveness
Acrylic and oil on canvas
55.88 x 29.21 cm, 2009

FOLLOWING PAGE, BOTTOM
Mona Lisa in Venice
Acrylic and oil on canvas
30.48 x 22.86 cm, 2009

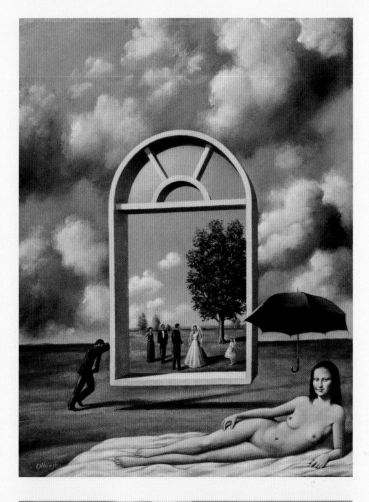

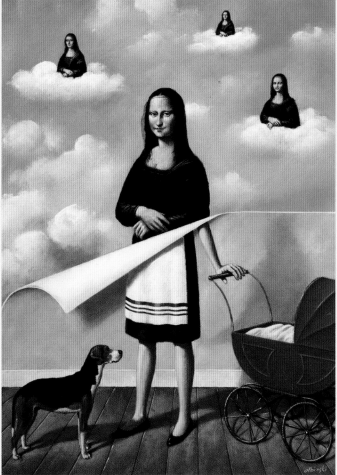

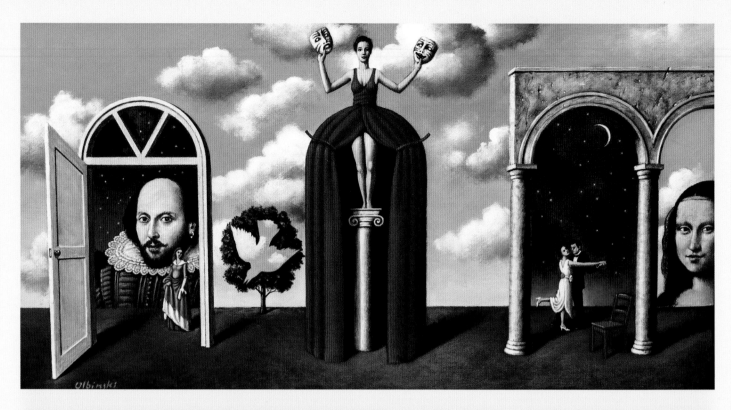

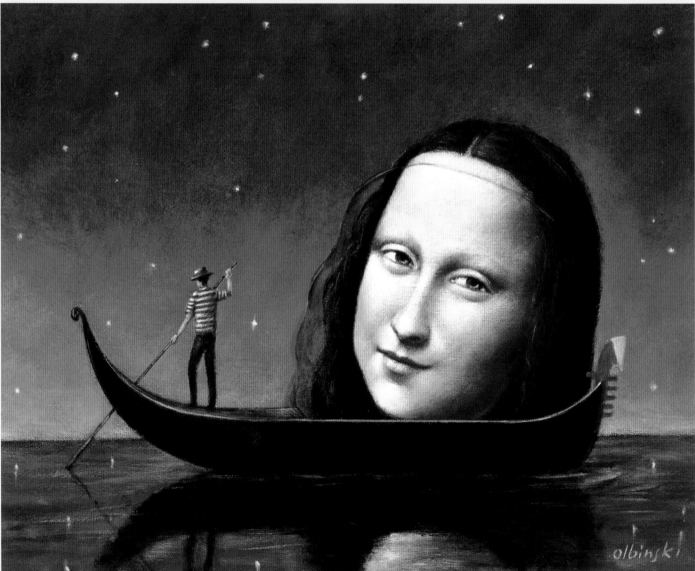

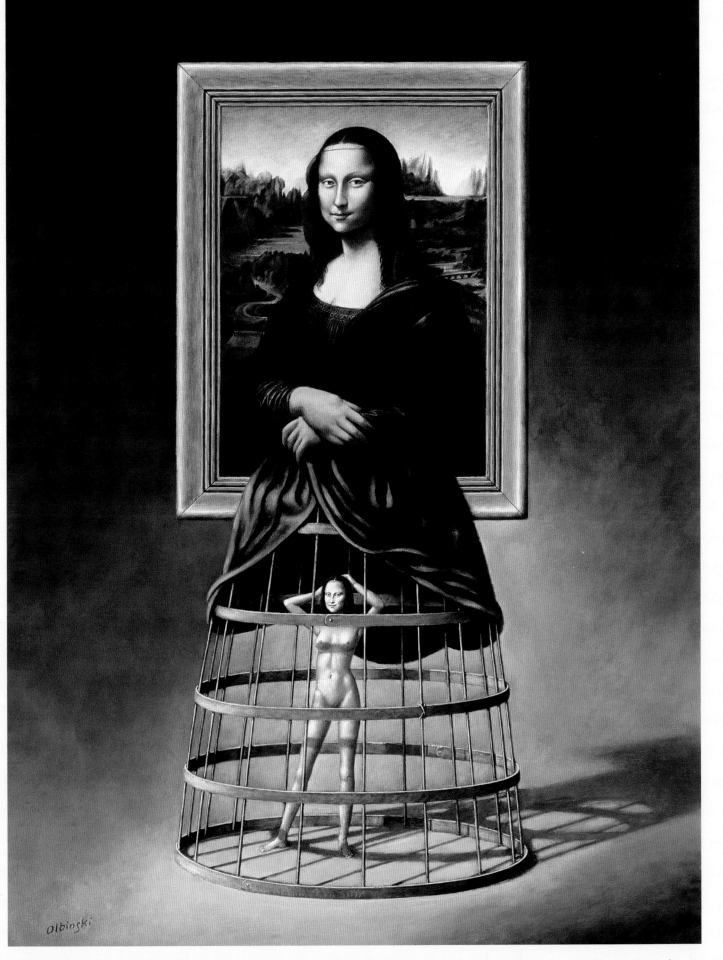

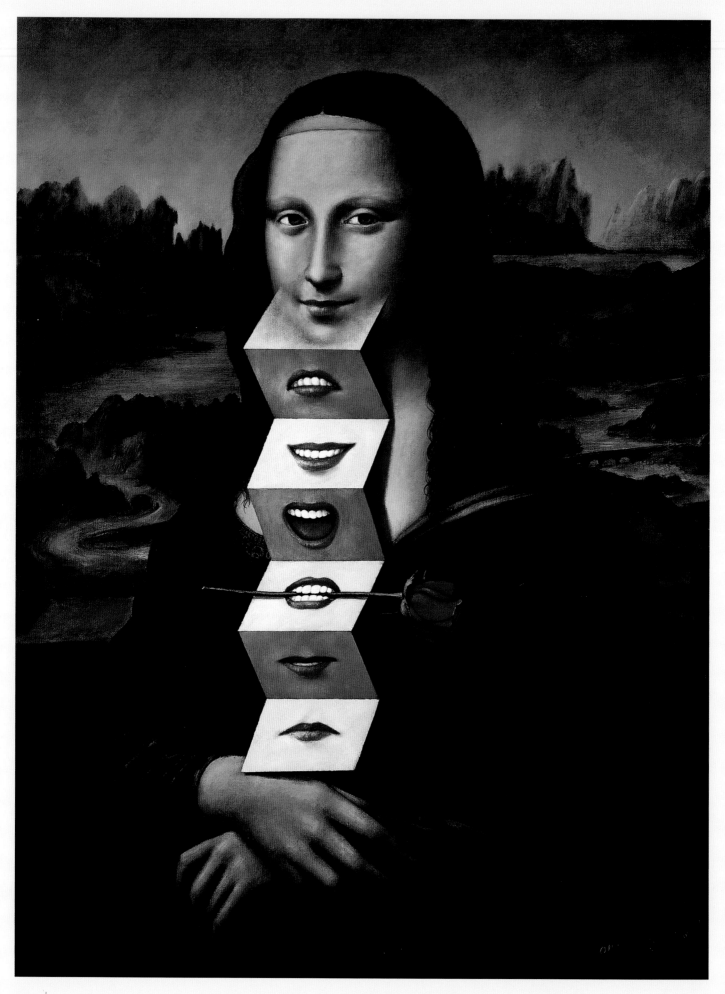

PREVIOUS PAGE
Ambiguous Interpretation of Memory
Acrylic and oil on canvas
68.58 x 93.98 cm, 2009

LEFT
Prohibitive Diversion
Acrylic and oil on canvas
22.86 x 34.29 cm, 2009

RIGHT
Coherent Episode
Acrylic and oil on canvas
54.61 x 91.44 cm, 2009

BELOW
Remembrance of Vapory Fame
Acrylic and oil on canvas
91.44 x 40.64 cm, 2011

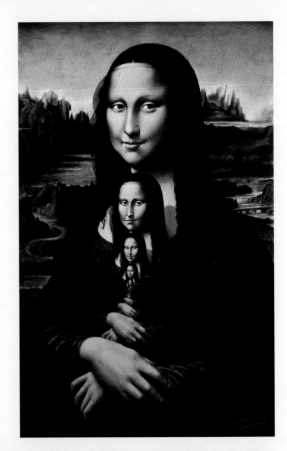

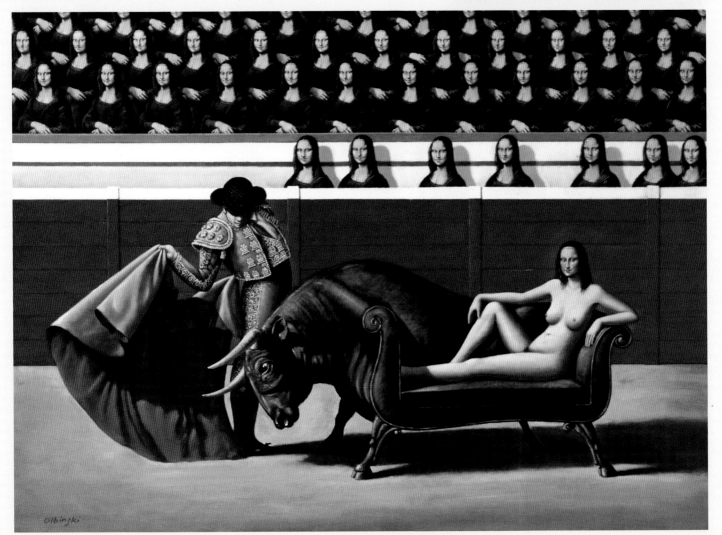

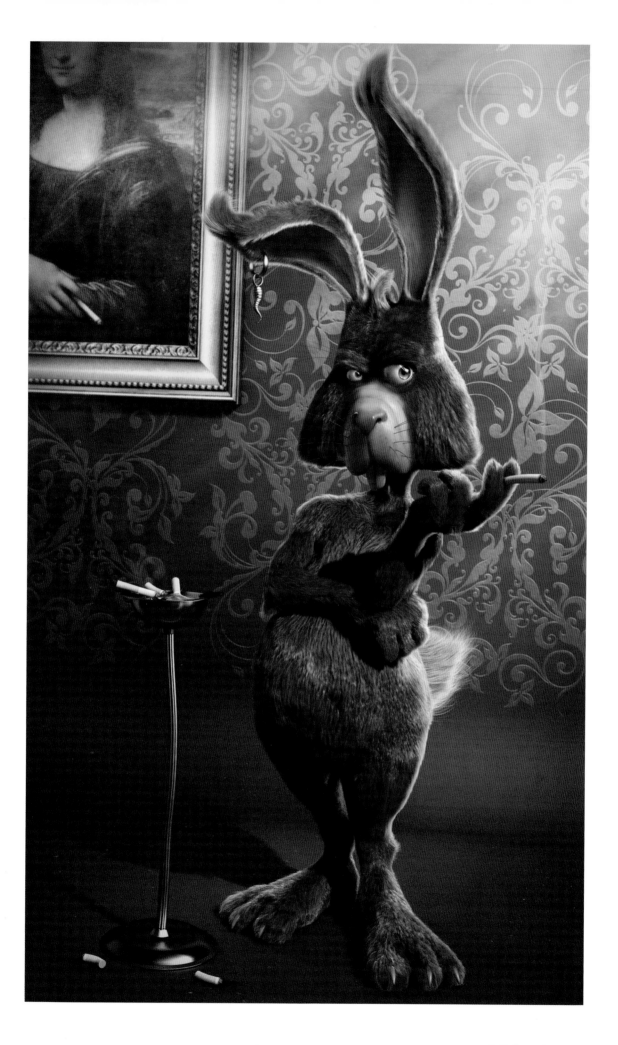

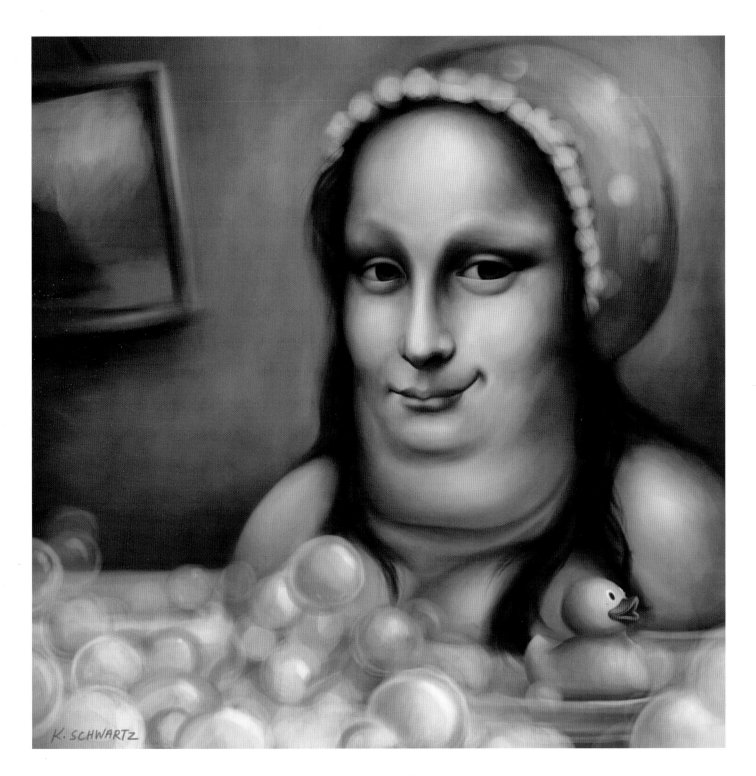

LEFT
José Alves da Silva
Le Rabbit
Digital, 2376 x 3992 pixels, 2009

José Alves da Silva works as a three-dimensional digital character artist in his native Portugal, where he has developed characters in the fields of advertising, video games, and motion pictures. "When creating the rabbit character, I wanted to give him an affected sophistication while defying the viewer's eyes. I imagined him taking a break in the smoking zone of an art museum, and I decided to include Mona Lisa as an Easter Egg after noticing that her hand was perfectly posed to hold a cigarette. The painting is so immediately recognizable that I was able to crop most of it, avoiding the competition between her eyes and the gaze of the rabbit."

ABOVE
Kacey Schwartz
Mona's Cousin
Digital, 3000 x 3000 pixels, 2009

San Francisco-based illustrator Kacey Schwartz specializes in creating original characters and capturing larger-than-life personalities that are playful and amusing. Although her images are created digitally, she likes to maintain a painterly feeling, giving the impression that they were created via traditional methods. *Mona's Cousin* started as a direct caricature and ended up as a whimsical look at an intimate moment with this inexplicably jolly Joconde.

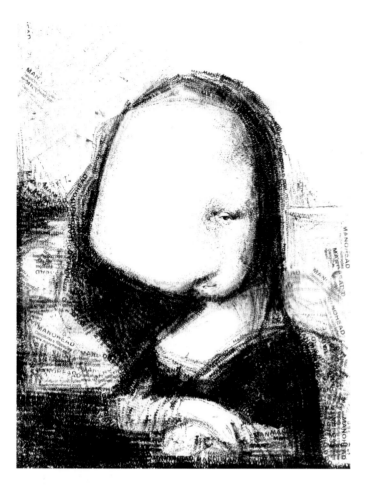

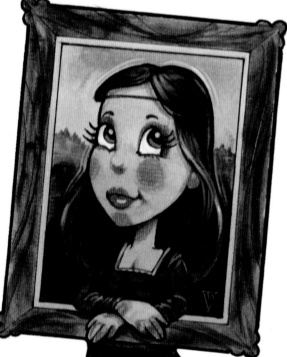

Fabrício R. Garcia
Nouselisa (Nose-a-lisa)
Ink stamp on paper, 29.7 x 42 cm, 2009

Brazilian artist Fabrício R. Garcia, also known as "Manohead," works in a multitude of experimental techniques, combining various disciplines in unexpected and avant-garde ways. The exaggerated proportions of his wistful *Nouselisa* caricature were achieved through the use of a custom-made rubber stamp repeatedly applied to paper.

Don Vernon
Mermaid Mona
Acrylic and Prismacolor pencil on illustration board
20.3 x 25.4 cm, 2010

American illustrator, graphic designer, and painter Don Vernon created this image as one of a proposed series of mermaids for a licensing project that ultimately never materialized. He eventually resurrected it as part of his "Mermaids and Pirates" line of jewelry, stationery, and novelty gifts.

Chan Hwee Chong
One Line Art: Mona Lisa
Faber-Castell artist pen on paper, 51 x 65 cm, 2010

Singapore artist Chan Hwee Chong is accomplished in many areas, including graphic design, art direction, typography, and street installation. Currently an advertising creative director in Beijing, his astonishing "One Line Art" illustrations were commissioned by Faber Castell for a series of advertisements demonstrating the precision and control of their product line of artist pens. Beginning with a blank sheet of paper and one Faber Castell pen, he drew from the center and spiraled outward, using a single continuous line. A video documenting the entire process was produced and is an enduring record of the pen's versatility and the artist's skill and unrivaled draftsmanship.

Mario Klingemann
Mona Lisa Pie Packed
Digital, 1338 x 2016 pixels, 2010

German digital artist Mario Klingemann generated this striking image using a computer algorithm he developed himself. He describes the technique as "Pie Packing," which is a method that combines generative art with data visualization to fill areas of a composition with pie chart circles in such a way that neighboring circles are all touching. Each pie chart shows the distribution of the most dominant colors of the painting under the area of that circle. Explains the artist, "I work a lot with randomness, evolutionary processes, and machine learning in order to find new kinds of imagery that try to incorporate elements that are not directly taking inspiration or ideas from 'natural' sources. The final result is a fancy data visualization that does not really make anyone much smarter but which looks pretty good, just like so many other data visualizations out there."

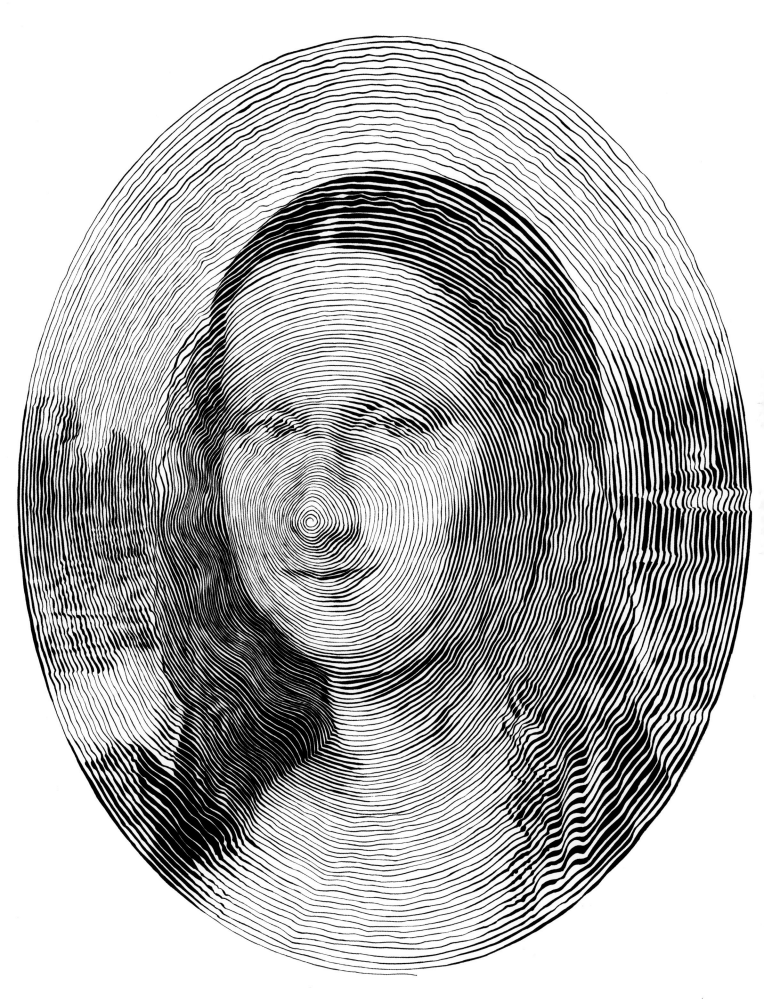

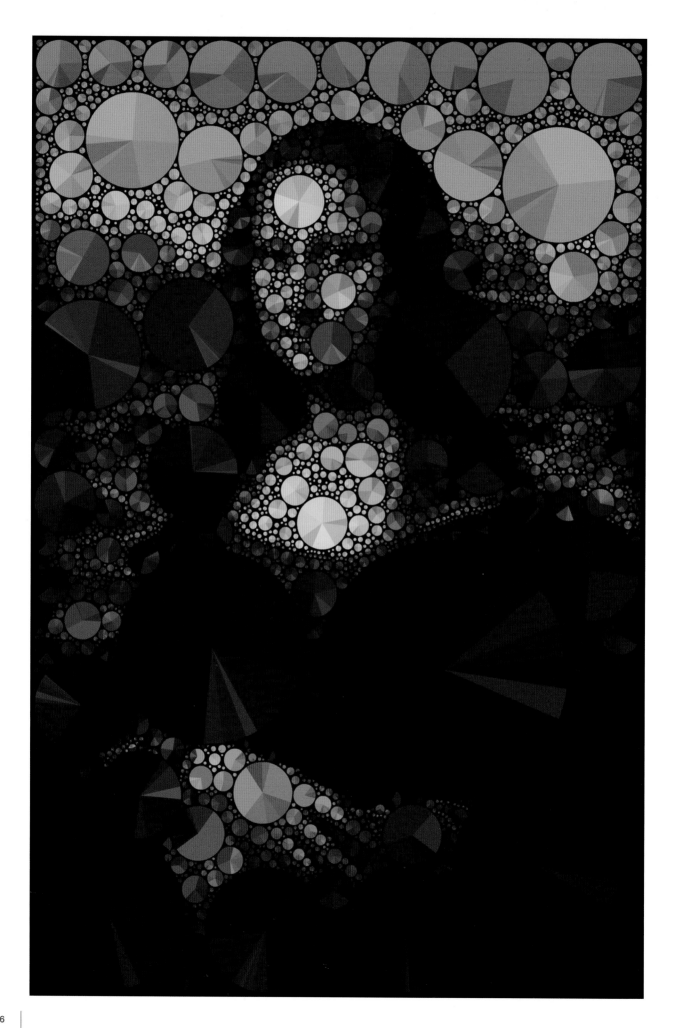

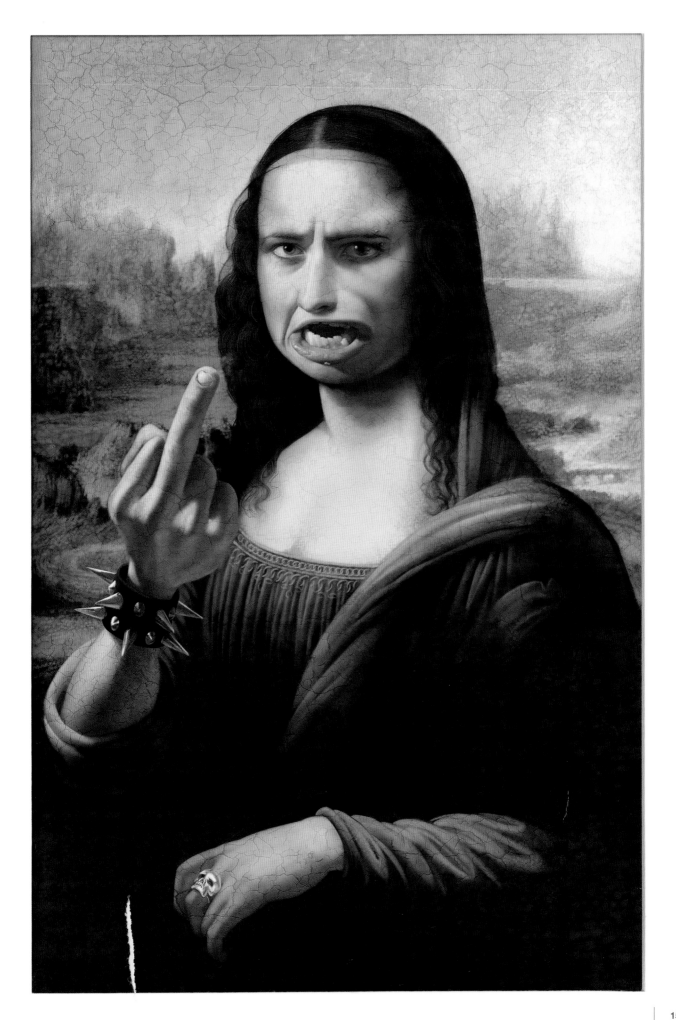

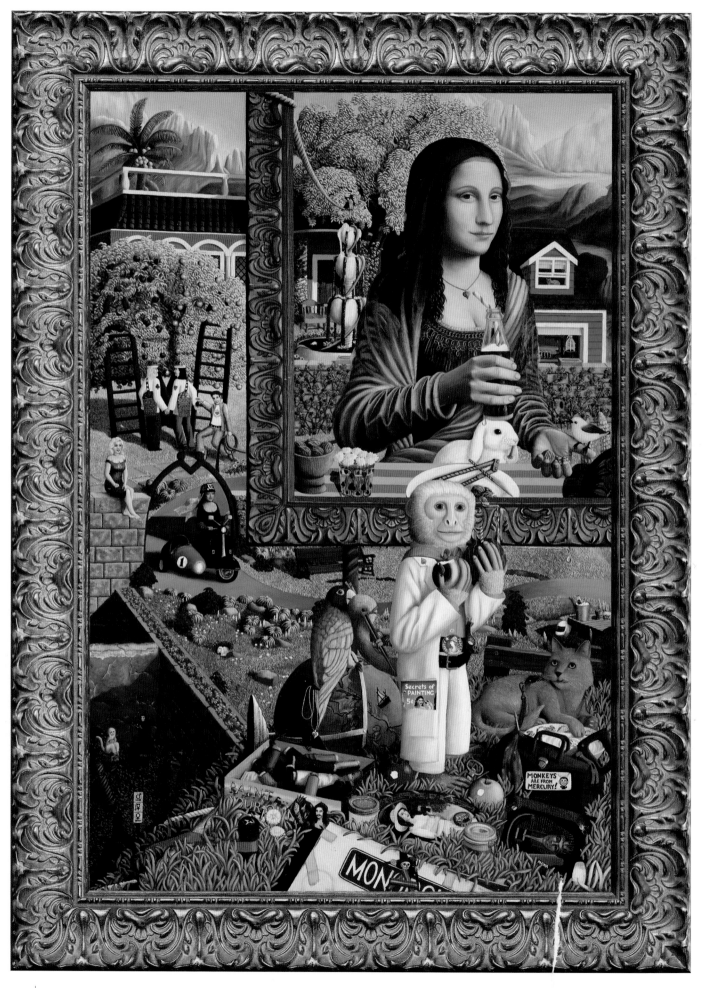

PREVIOUS PAGE
Michel Achard
Joconde
Digital, 6000 x 9000 pixels, 2010

Multi-talented French artist Michel Achard has garnered international acclaim as an oil painter, art instructor, photographer, filmmaker, writer, and digital artist. At age 14, he became the youngest member ever to be admitted to the Association of Painters of Saint-Tropez. Although his career frequently courts controversy due to his outspokenness and frank depictions of celebrities and public figures, he does not consider himself to be a provocateur. He simply claims to hate mediocrity and is attracted to subjects caught in candid, unpretentious moments. "I want people to see themselves as they are," he has said, "and not as they would seem."

LEFT
James Norton
The Restoration of the Mona Lisa
(AKA The Operation of the Sun)
Oil on canvas, 78.74 x 109.22 cm, 2010

In his exquisitely detailed and highly symbolic rendering, Nova Scotia native James Norton has used the "painting within a painting" technique to create two discrete yet disparate time frames. The main portion of the composition containing the monkey and the apple tree

represents the present, while the framed Mona Lisa "portrait" illustrates the eventual future. The work explores various dichotomies through the alchemical mechanism of the age-old mythology of the fountain of youth. The central crisis in the story-line of the painting is that of the Mona Lisa's aged and decrepit condition. The Hero in the story is the monkey, who applies his understanding of the transformational mysteries and methods of alchemy to aid in her revitalization. Mona Lisa's rebirth is accomplished not through the methods of art restoration, but by the elixir of life, which the monkey retrieves from its source at the top of the fountain. It is not the famous painting of Mona Lisa that the monkey has set out to restore, but the lady herself. Meanwhile, the Mona of the present is seen riding a motor scooter. This version is represented in the yellowed and aged state in which we have come to know the actual painting, as she makes her way to her eventual future.

ABOVE
Toni Meisel
Mona Lisa
Digital
3600 x 2700 pixels, 2010

German multimedia artist and graphic designer Toni Meisel (AKA "Tiny") created this geometric-based version of Mona Lisa as a modern tribute to Leonardo da Vinci and as part of his digital cartoon series called *The Tiny Tins*.

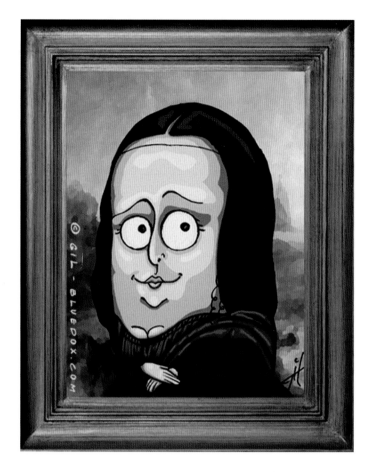

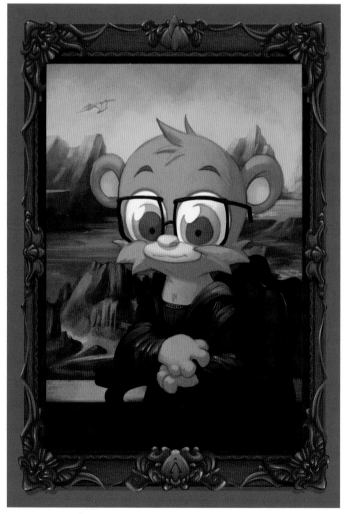

LEFT, TOP

Lucas G. Martin
La Gioconda
Pencil on paper with digital color
416 x 500 pixels, 2010

London-based freelance graphic designer Lucas G. Martin lampoons pop icons both contemporary and classical with his spirited caricatures. Working under the pseudonym "GiL," he authors the popular cartoon blog "Elaborate Mess," a semi-weekly entertainment website posting comics inspired by his life experiences.

LEFT, BOTTOM

Alison Acton
Mona Nerd
Pencil on paper with digital color
1916 x 2720 pixels, 2010

Canadian cartoonist Alison Acton founded Studio DoOomcat with her husband, Jim Charalampidis. Both are freelance artists who together curate BEAR NUTS, an online web comic which chronicles the antics of a group of bears inhabiting the "Discount Zoo." The bears all have very distinctive personalties and names such as Nerd, Prozac, Gimp, Lech, Tanked, and Death. They spend most of their time trying to hide their un-bearlike behavior from the zookeepers who care for them and the people who come to the zoo to gawk at them.

FACING PAGE, TOP

João Belo Jr.
Arte & Invenção (Art and Invention)
Watercolor on paper
47 x 31.5 cm, 2010

The historical scene of Leonardo da Vinci painting Mona Lisa has been imagined numerous times during the past half century, but never quite like this clever cartoon, courtesy of Brazilian artist João Belo Jr. Inspired by the genius of Leonard as an inventor, Mr. Belo has contrived a complicated Rube Goldberg-like contraption to assist him in the creating of his famous portrait.

FACING PAGE, BOTTOM LEFT

Jorge Rendón Alverdi
Dental Health and Cosmetology
Watercolor on cotton paper
21.5 x 27 cm, 2010

Mexican illustrator Jorge Rendon Alverdi was commissioned to create this humorous caricature as an advertisement for the services of the DH&C Dental Health & Cosmetology clinic in Miguel Hidalgo.

FACING PAGE, BOTTOM RIGHT

Diego Jiménez Manzano
Phant Lisa
Watercolor and pencil, with digital enhancements
1400 x 2064 pixels, 2010

Known as "EGO" to his fans, Spanish illustrator Diego Jiménez Manzano created *Phant Lisa* as a humorous tribute to the original painting. He started this artwork using traditional media in 1999, then over a decade later decided to enhance it digitally, finally arriving at this finished version.

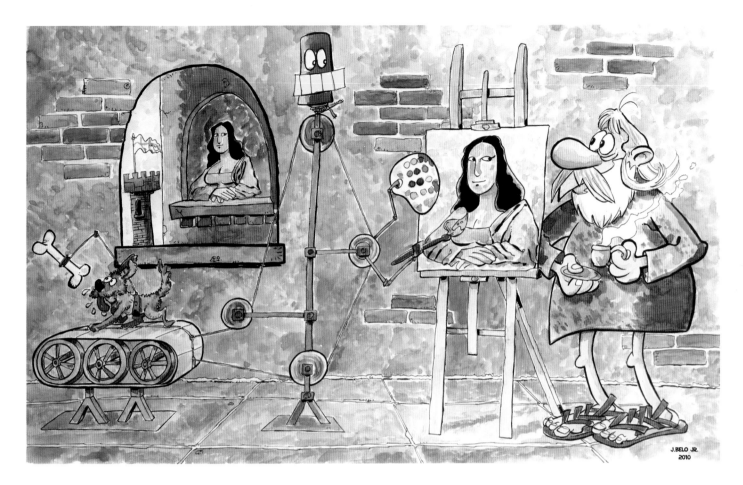

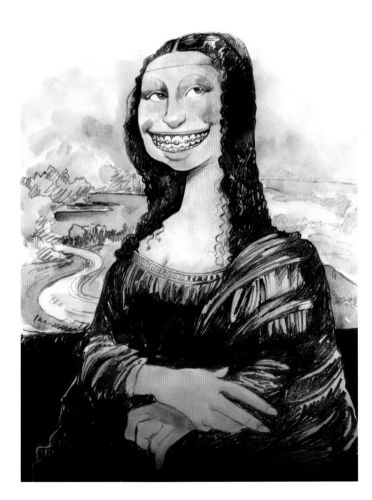

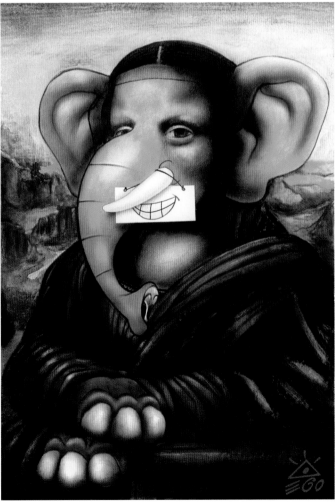

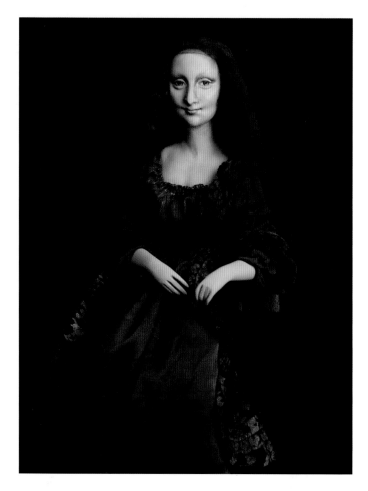

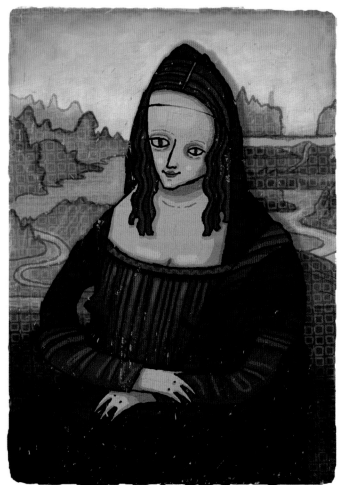

Darya Milova
Mona Lisa
Paperclay, silk, chiffon, acrylic paint
17 x 17 x 27 cm, 2010

There are many types of handicrafts employed by Russian artist Darya Milova during the creation of one of her handmade dolls or puppets. From inception to finished piece, she single-handedly plans, sculpts, and paints every one of her figurines and personally designs and sews the clothing and builds the accessories. She is careful to point out that her dolls are not toys made for children, but works of art created for the discernible collector.

Elly Walton
My Mona Lisa
Digital, 2700 x 3776 pixels, 2010

Beginning her career as an art director at various advertising agencies in the United Kingdom, Elly Walton eventually realized her dream of being a full-time illustrator. Her interpretation of the Mona Lisa was produced as a private commission for a client who requested a series of classic artworks recreated in Ms. Walton's distinctive style.

Fernando Naveiras García
Fernando Naveiras' Version of Mona Lisa
Digital, 3452 x 4965 pixels, 2010

Spanish artist Fernando Naveiras García created this digital illustration for "My Little Museo del Prado," an exhibition for children, composed of recreations of famous paintings from the collection of the Museo Nacional del Prado. The style and colors of his version were inspired not by the Louvre's Mona Lisa, but by the replica owned by the Prado, which is considered to be the earliest known copy of Leonardo's original. The Prado's version is much better preserved than the Louvre's painting and is significantly brighter and more colorful.

FOLLOWING PAGES, LEFT
Jane Perkins
Homage to Leonardo da Vinci
Collage of found objects mounted on wood
71 x 79 cm, 2010

FOLLOWING PAGES, RIGHT
Jane Perkins
There's Something About Mona
Collage of found objects mounted on wood
71 x 79 cm, 2010

Although her background is in textiles, UK-based artist Jane Perkins now works predominantly with plastic. To create her larger-than-life collages, she utilizes any materials of the right size, shape and colour: toys, shells, buttons, plastic cutlery, beads, jewelry, curtain hooks, and springs, among many other objects. No additional color is added, all elements are used exactly as found. Says the artist, "My portraits need to be viewed in two ways: from a distance to recognize the person depicted, and closeup to identify the materials and appreciate the intricacies of how all of the pieces fit together."

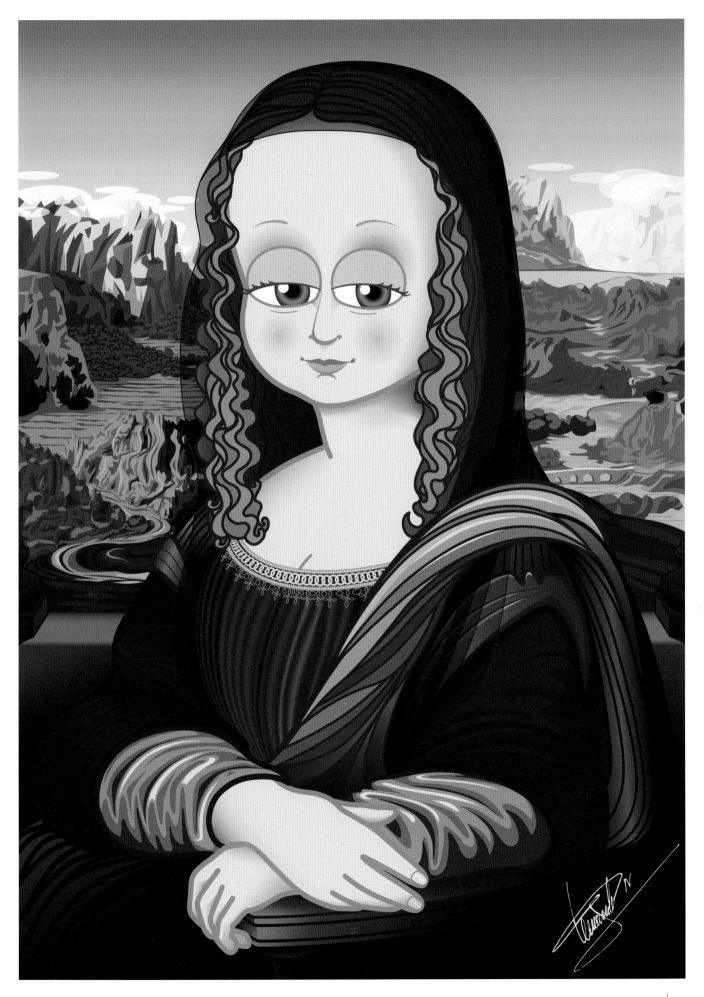

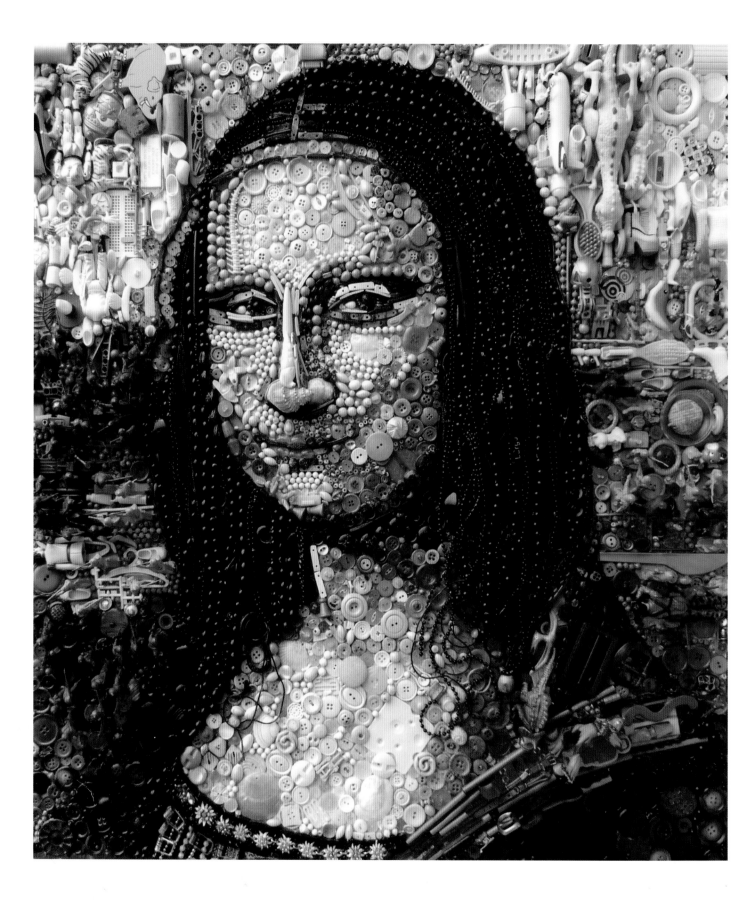

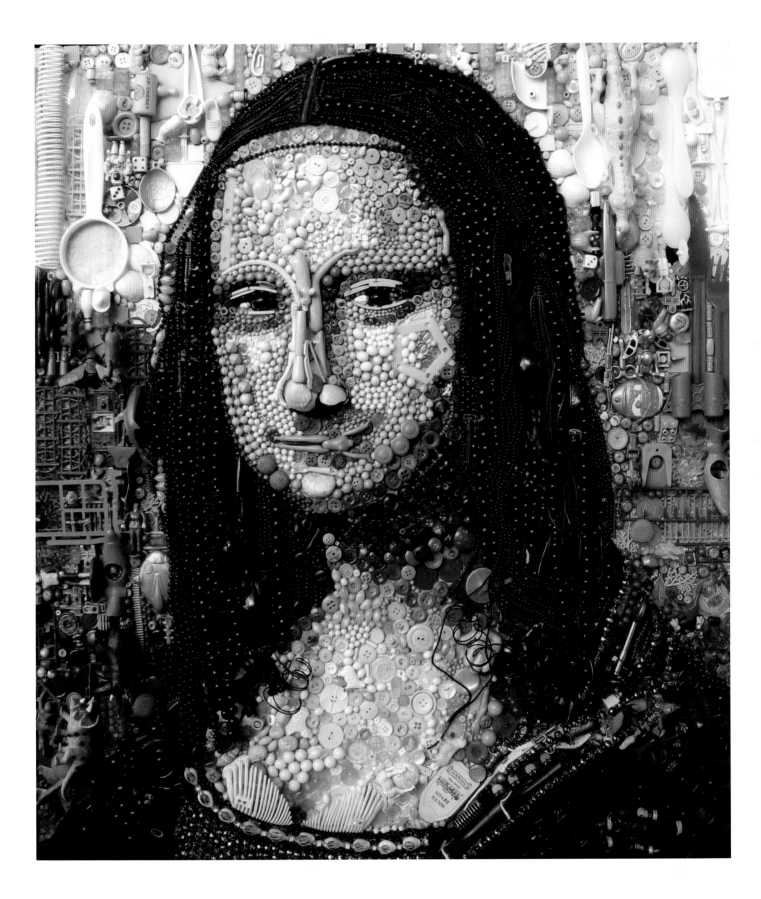

Robert Wolverton Jr.
M and M (Mona and Mickey)
Acrylic on canvas paper
30.5 x 30.5 cm, 2010

Eric Liberge
The Bones of Mona Lisa
Pencil, ink and watercolor on paper
21 x 29.7 cm, 2010

For contemporary American artist Robert Wolverton Jr., painting is all about "following your bliss." He continues to say, "I'm always amazed by the ability art has to effect people in positive and negative ways. The fact that we feel these emotions is what makes art 'art'." Mr. Wolverton takes inspiration from the Neo-Expressionist movement which had developed as a reaction to the Minimalist art of the 1970's, and marked a return to portraying recognizable subject matter in a rough and expressively emotional way using conventional color harmonies.

French comic book writer and illustrator Eric Liberge created this haunting visage of Mona Lisa as one of the illustrations for his 2010 graphic novel *On the Odd Hours*, the third of a four-volume series of highly successful books co-published and sponsored by the Louvre Museum. Each book in the series was written and illustrated by a different artist, with all of the stories being a tale of futuristic or supernatural fantasy involving the Louvre and the artwork contained within its walls.

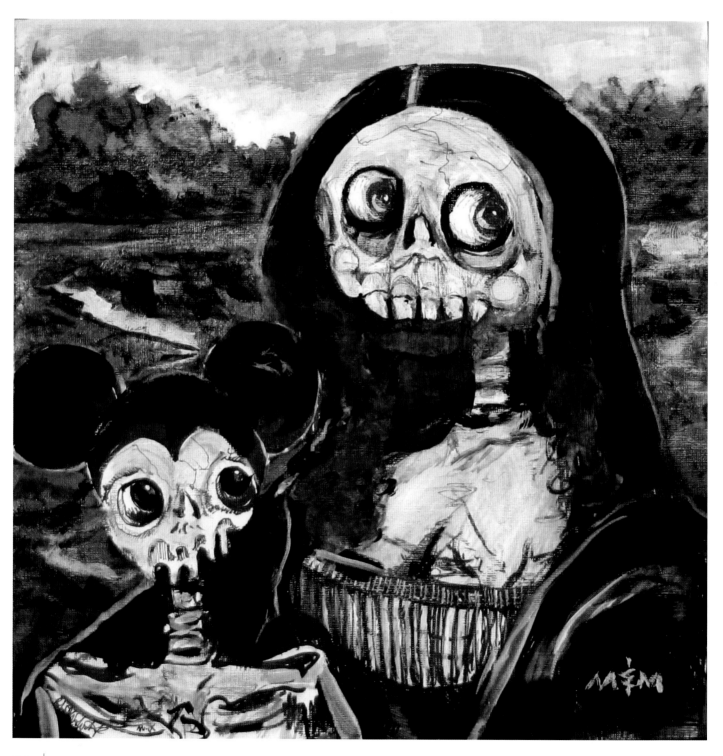

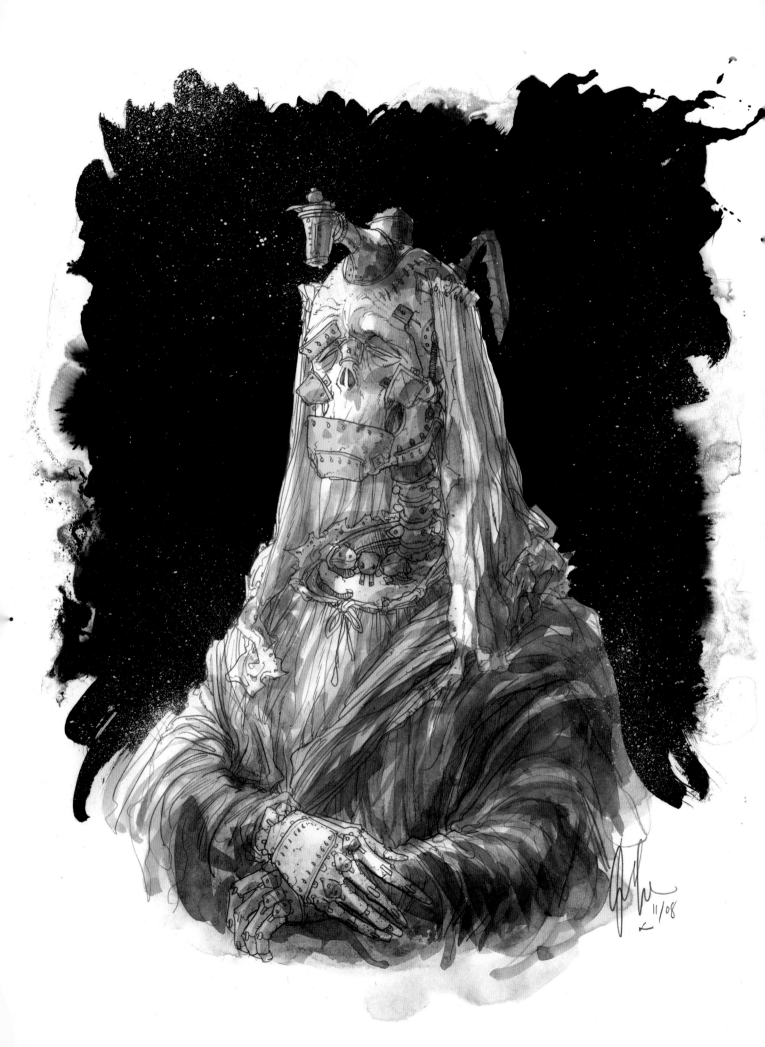

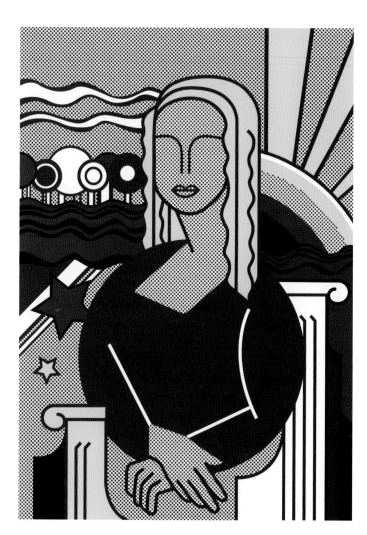

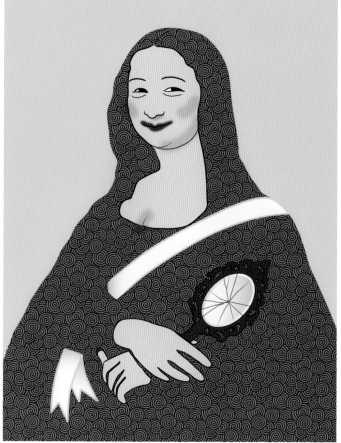

Courtesy of Primus Publishing, Slovenia

LEFT, TOP
Bianca Christoffersen
Mona Lichtenstein
Digital, 3500 x 4950 pixels, 2010

Bianca Christoffersen is a freelance graphic designer from Denmark specializing in typography-based illustrations and logo designs. She created *Mona Lichtenstein* as a personal project contrived to reimagine the Renaissance masterpiece in the comic-strip-inspired Pop Art style that prominent American artist Roy Lichtenstein had made famous during the sixties.

LEFT, BOTTOM
Jaka Modic
Be Happy Without Being Perfect
Digital, 3133 x 3546 pixels, 2010

Slovenian artist Jaka Modic created this ironic digital illustration for the cover of a book entitled *Be Happy Without Being Perfect – How to Get Free from Illusions about Perfection*. The book examines modern society's preoccupation with beauty and perfection, and Mona Lisa is used as a symbol of an archetype that transcends these self-imposed limitations. Says the artist, "No matter if others view us as beautiful or ugly on the outside, from within we can always experience the blissfulness of life which lies at the source of our awareness, and not at the end of our aspirations."

RIGHT
Justin Aerni
Mona Lisa
Acrylic on canvas, 61 x 91.4 cm, 2010

American painter, sculptor, author, photographer, and filmmaker Justin Aerni has garnered global attention for his thought-provoking artwork that combines satire and iconoclasm while examining the great enigmas of our time. As popular as he is prolific, he has sold over 4,000 paintings worldwide within the past decade and written and illustrated five books. His vibrant and expressive interpretation of Mona Lisa presents the icon, and by inference, art itself, as just another product to be packaged and sold in a modern, brand-obsessed consumerist society.

FOLLOWING PAGE, TOP
Loui Jover
Deconstructed Mona
Collage on paper, 30 x 40 cm, 2010

There is an intricate balance of line and form in much of the work of Australian artist Loui Jover, who frequently creates his images on unconventional, delicate materials such as sheets of vintage book paper carefully adhered together. The fragility of the materials used mirror the delicacy of his compositions, creating an image that appears ethereal and fleeting. Explains the artist, "I want my work to appear as though the wind may blow it away at any moment."

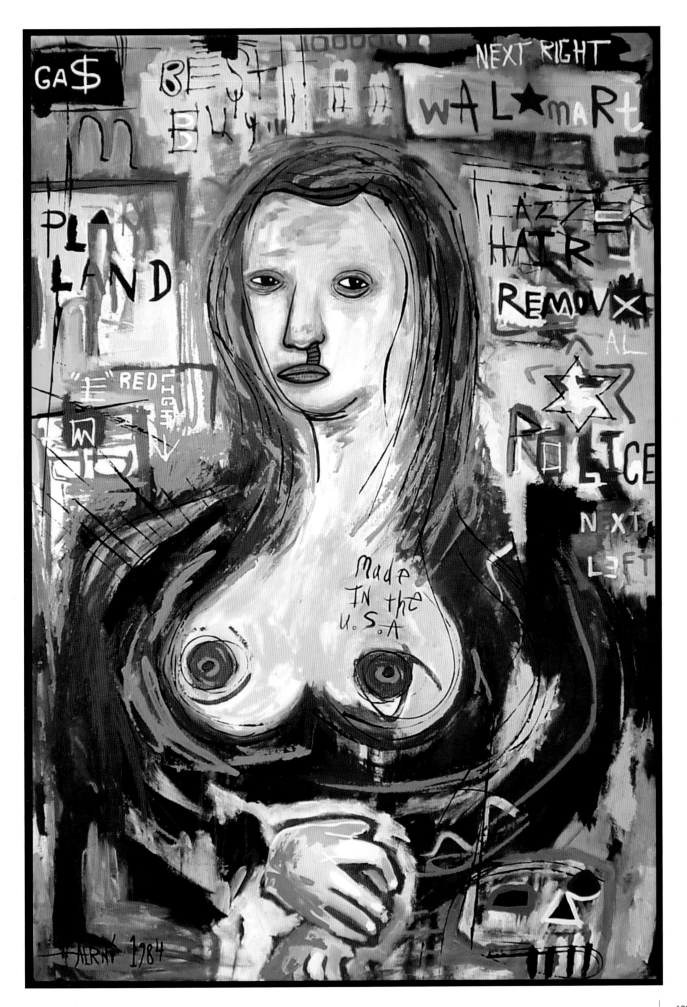

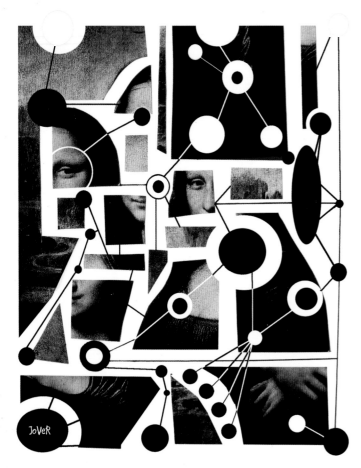

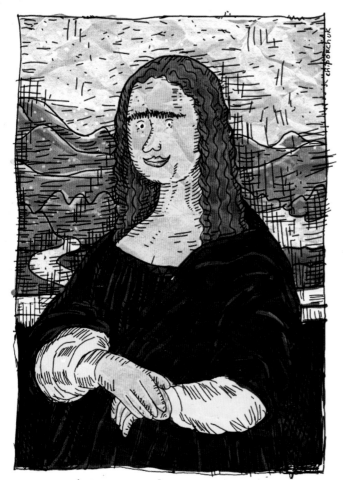

МОНА ЛИЗА И МОНОБРОВI

Eugen Nechiporchuk
Mona Lisa's Unibrow
Digital, 600 x 800 pixels, 2010

Ukrainian designer Eugen Nechiporchuk describes his creative method as a very basic, stream-of-consciousness process. "Something appears in my head, usually quite unexpectedly, and I just go with it. In this case, three simple words suddenly materialized in my imagination out of nowhere: 'Mona Lisa' and 'unibrow.' I thought it would be a funny interpretation of the classic image, and I drew it that same evening."

RIGHT
Enkel Dika
Renaissance Rocks
Digital, 2362 x 3303 pixels, 2010

Reimagining Leonardo da Vinci as a performer in an eighties rock band, Macedonian illustrator Enkel Dika has recreated Mona Lisa as one of his devoted groupies in this popular tee-shirt design.

FOLLOWING PAGE, TOP LEFT
Giovanni Petruzzelli
Invisible Mona Lisa
Digital, 2835 x 4289 pixels, 2010

Known online as "Giopet," Italian graphic designer Giovanni Petruzzelli created a series of digital illustrations called "The Invisibles" in which he erased from existence classic figures from art and pop culture. Ironically, Mona Lisa remains instantly recognizable, even when utterly transparent.

FOLLOWING PAGE, TOP RIGHT
Carolina White
Mona Lisa Wants Your Blood
Digital, 743 x 1155 pixels, 2010

Spanish graphic designer Carolina White offers a supernatural explanation for the eternal youth and immortality embodied by Mona Lisa during the past 500 years: "Obviously she's a bloodsucking vampire, immune to natural death, physical aging, and illnesses."

FOLLOWING PAGE, BOTTOM LEFT
Nata Metlukh
Modern Mona Lisa
Digital, 1748 x 2480 pixels, 2010

Born in Ukraine and now based in San Francisco, children's book illustrator Nata Metlukh created this fashionable digital portrait as a self-promotional piece for the website of Moonsters, a Ukrainian talent agency.

FOLLOWING PAGE, BOTTOM RIGHT
Andrés Lozano
Mona Lisa XD
Digital, 2376 x 3248 pixels, 2010

Spanish illustrator Andrés Lozano reinterprets Mona Lisa's famous smile through the clever use of an emoticon, a facial expression in the form of text characters. When viewed on its side, the letters "XD" represent a laughing face with its eyes shut, and is a commonly used textual portrayal of a writer's mood.

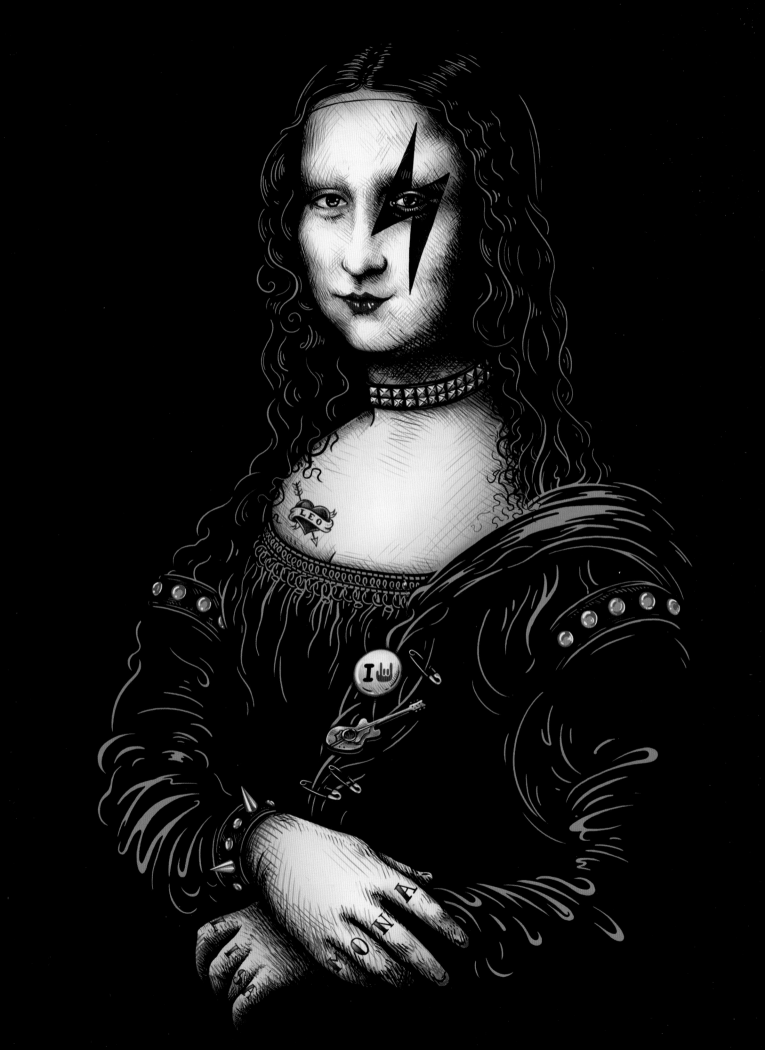

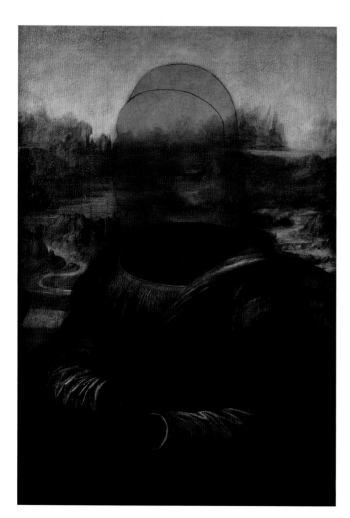

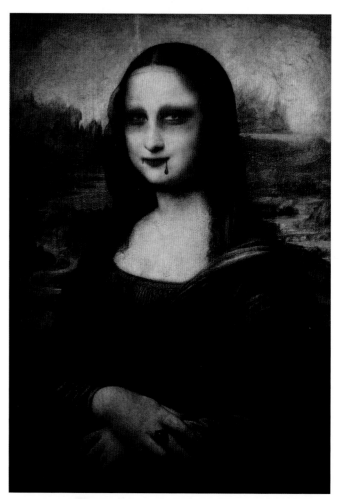

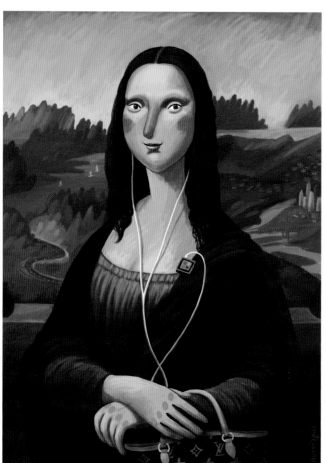

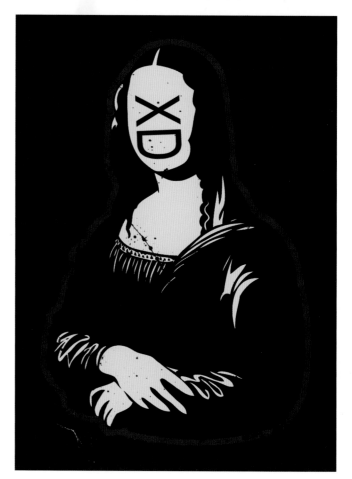

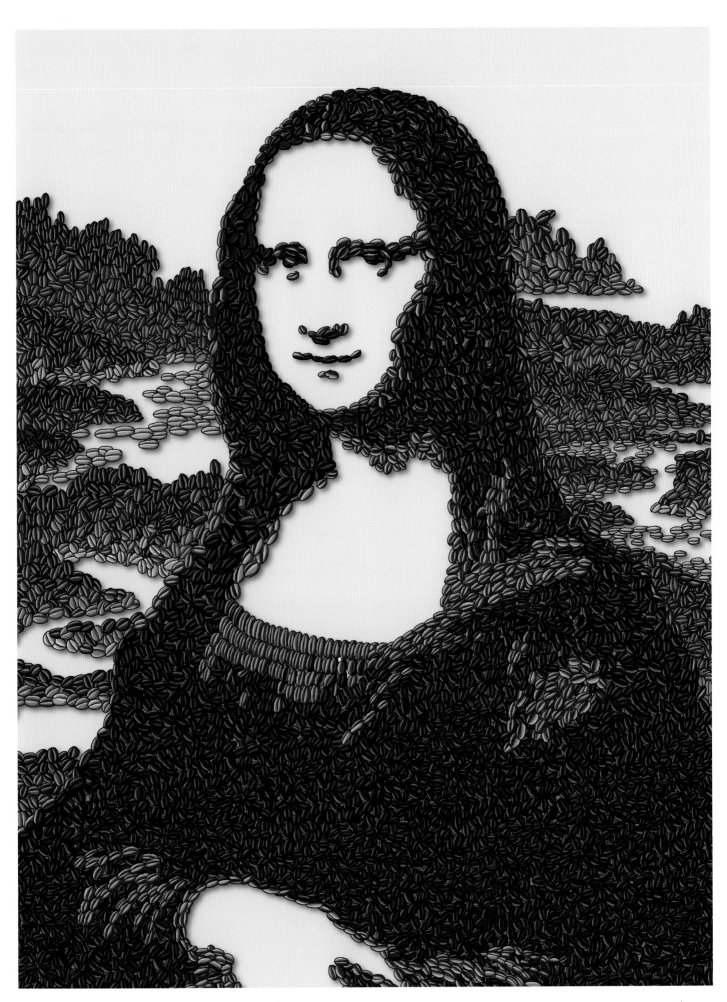

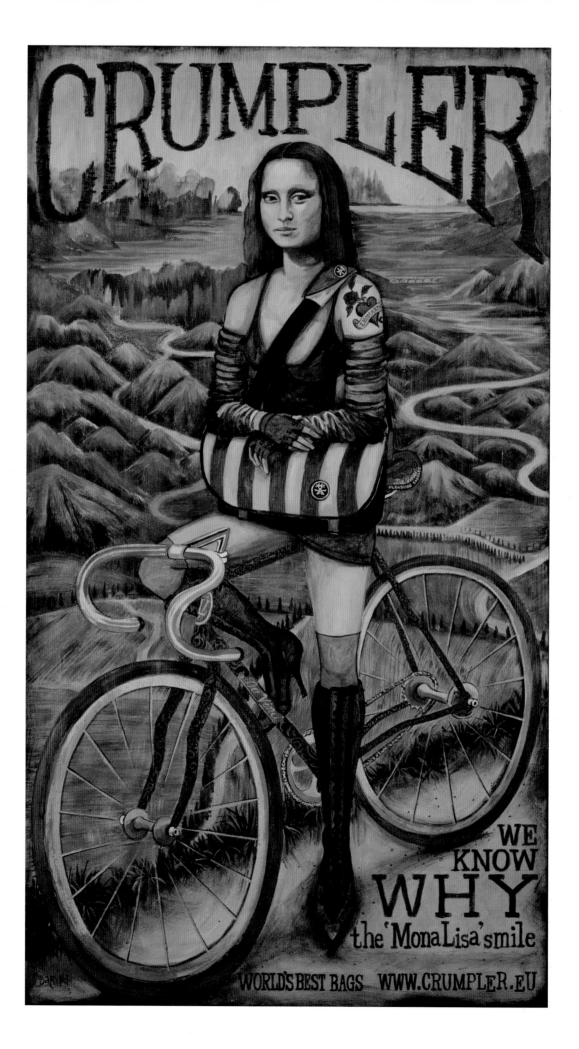

Tony White
Beana Lisa
Pen and ink with digital color, 40.6 x 50.8 cm, 2010

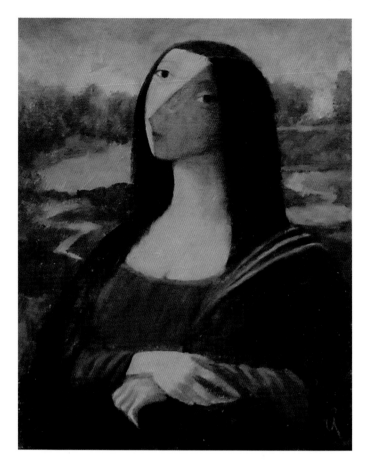

Tony White is a British Academy Award-winning animation director and author of several best-selling books on the art of animation. He is the founder of "DRAWASSIC," a groundbreaking virtual animation studio that seeks to preserve, teach, and evolve the art form of traditional hand-drawn animation in the modern digital age. His deliriously detailed *Beana Lisa* illustration was created for a private display at his local Starbucks coffee shop in Everett, Washington. Explains the artist, "It was not commissioned by Starbucks. I had been so frustrated by the barren, lifeless, diaper-brown wall I had to contend with while drinking my coffee there that I volunteered to create, frame, and hang the illustration at my own expense. The ink drawing took two days to complete, with the digital scanning/coloring requiring a further few hours. It was met with much local acclaim and appreciation! I'm crazy enough to think of animating it now of course but I've not yet found the time or public outlet to be able to do that!"

LEFT
Sarina Tomchin
Single Speed Mona
Oil and acrylic polymer on canvas, 75 x 137 cm, 2010

A longtime cycling enthusiast, Australian artist Sarina Tomchin creates images for Cycology, a clothing brand based around her graphic designs. In 2010, when commissioned to create a series of illustrations advertising Crumpler brand messenger bags, she knew instantly that she wanted to include Mona Lisa as part of the artwork. "I wanted to make a painting of her looking totally badass, complete with tattoos, a skimpy skirt, and high-heeled boots, riding an ornate single speed fixed gear bike (by Da Vinci Designs) through the hilly Italian countryside. She's uber tough and stylish, just like her Crumpler bag." The original painting is embellished with gold leaf and has boot laces actually stitched through the canvas.

RIGHT, TOP
Glenn Quist
The Mona Lisa Next Door
Acrylic on canvas, 35.5 x 45.7 cm, 2010

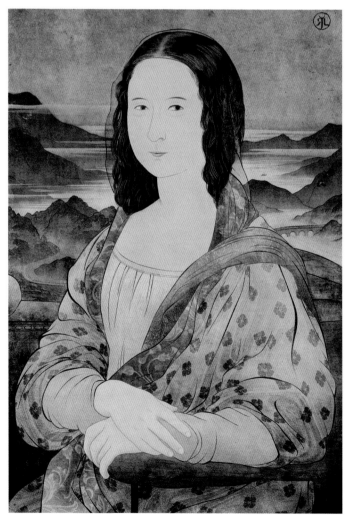

The dreamlike figurative paintings of Minnesota-based artist Glenn Quist are mostly derived from memory and imagination, with a strong emphasis on form and composition. His *Mona Lisa Next Door* was created as part of a series of paintings loosely based on the Cubist work of Pablo Picasso.

RIGHT, BOTTOM
Romain Jacquet-Lagréze
Lisa Sama
Digital, 2953 x 4488 pixels, 2010

French photographer Romain Jacquet-Lagréze began his career as a graphic designer, traveling from his native Paris to work in various cities throughout Asia. Inspired by Japanese visual arts such as Ukiyo-e woodblock prints, as well as more modern styles like anime and manga, he started to develop a new visual approach blending characteristics of Western and Eastern art. His *Lisa Sama* illustration was one of the results of this period of experimentation and mixes European methods of composition with Asian influences on color, linework, and technique. Eventually his interest in cityscape photography started to prevail after moving to Hong Kong, and he has since mounted international exhibitions of his photographic works and seen them published in two books.

BELOW, LEFT
Matthias Kringe
Mona T'Lil
Digital
1853 x 2726 pixels, 2010

BELOW, RIGHT
Matthias Kringe
Mona Vesa
Digital
1853 x 2726 pixels, 2010

RIGHT
Matthias Kringe
Mona Neanderthal
Digital
1853 x 2726 pixels, 2010

German artist Matthias Kringe has been able to put his satirical wit to effective use during his many years freelancing as an illustrator, writer, and political cartoonist. His topical commentaries and incisive parodies have become legendary and earned him a position on the permanent staff of the German Edition of *MAD Magazine*. His clever digital triptych of Mona Lisa spoofs are fitting examples of the irreverent humor that the publication has become known for.

FOLLOWING PAGES, LEFT
Ibrahim Chaffardet Rosas
Mo Na'vi sa
Digital, 4800 x 7200 pixels, 2010

Venezuelan digital illustrator Ibrahim Chaffardet Rosas specializes in character animation and three-dimensional modeling. Created as a personal portfolio piece, his *Mo Na'vi' sa* was inspired by the blockbuster movie *Avatar*. In the futuristic science fiction epic, the "Na'vi" are an alien tribe of blue-skinned humanoids who inhabit a distant moon called Pandora.

FOLLOWING PAGES, RIGHT
Marek Dolata
Boba Lisa
Digital, 3508 x 4961 pixels, 2010

French illustrator Marek Dolata created this Mona Lisa replica after attending an exhibition at the Cité des Sciences et de l'Industrie museum in Paris. The show was titled "Bob l'éponge comme vous ne l'avez jamais vu" ("Spongebob like you've never seen") and featured the subaquatic sea sponge in variations of classic art scenarios. "Being an avid fan of the Spongebob universe, I enjoyed the exhibit very much. There were lots of paintings satirized, like Dali's *Persistence of Memory*, Van Gogh's *Self-Portrait* and Michaelangelo's *Creation of Adam*, but I was a little disappointed because I expected a Mona Lisa parody and there wasn't one. So when I got home, I decided to create one myself for fun."

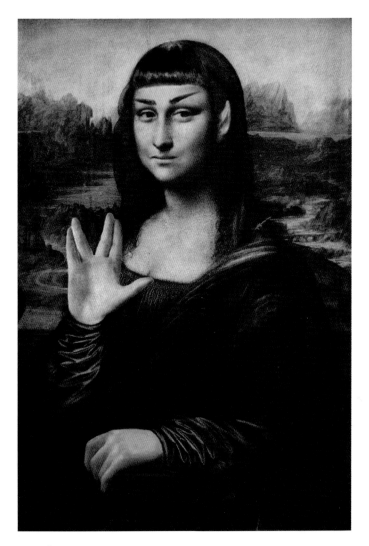

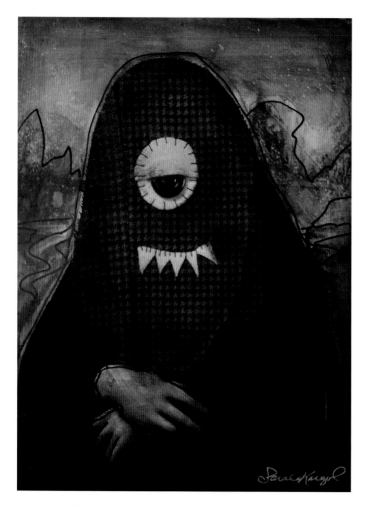

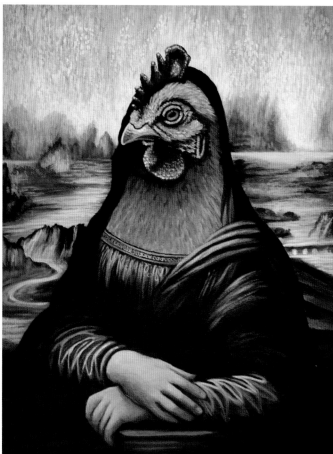

LEFT, TOP
Sarah Kargol
Mona Monster
Mixed media on paper, 61 x 91.4 cm, 2010

The monsters portrayed in the work of American mixed media artist Sarah Kargol evolve from materials that had past lives. Buttons, fabric, and collaged images bring a sense of nostalgia to her illustrations. She gives these recycled components a new, unexpected, and often humorous life, one more exciting and interesting than was originally intended.

LEFT, BOTTOM
Jacki Yorke
La Chiconda
Acrylic on canvas, 45 x 60 cm, 2011

The paintings of Wales-based artist Jacki Yorke are often inspired by her love of nature and animals. *La Chiconda* was the result of a college course in wildlife and botanical illustration. "Our assignment was to create studies of something we see everyday, and then to design a set of cards featuring our chosen subject. I chose my chickens. I thought the shape and colours of Mona Lisa matched perfectly with my hen, and she echoed the same look of composed contentment."

FACING PAGE, TOP LEFT
Francisco Munguía Villalta
Menstruating Mona Lisa (Monalisa Menstruante)
Ink drawing with digital color, 42 x 53 cm, 2010

FACING PAGE, TOP RIGHT
Francisco Munguía Villalta
Stand-Up Comedy
Ink drawing with digital color, 21.6 x 28 cm, 2011

Francisco Munguía Villalta had studied ceramics at the University of Costa Rica before refocusing his attention on cartooning. Explains the artist, "Art is a state of mind and a way to break the ice. It's also a direct way to reach the public. Spicing something with humor, I can bring a host of other messages." His digital comics encompass a wide variety of genres, sometimes political, sometimes scatalogical, but always reliable in their ability to produce a smile.

FACING PAGE, BOTTOM LEFT
Dima Je
Mana-mana Lisa
Digital (Illustrator, Photoshop), 2598 x 3543 pixels, 2011

Moscow-based graphic designer Dima Je specializes in corporate branding and logo design. His simple but engaging illustrations have been seen on packaging, invitations, and limited edition posters all throughout Europe.

FACING PAGE, BOTTOM RIGHT
Randy Burns
Monkey Lisa
Acrylic on canvas, 50.8 x 61 cm, 2011

American artist Randy Burns began his popular series of sock monkey paintings following the death of his sister, Felicia. "She always believed in my art and encouraged me to pursue it. The sock monkey was her favorite toy, and I started these paintings to honor her. Most are spoofs on famous paintings, like Van Gogh's *Potato Eaters*, Michelangelo's *The Creation of Man*, and Whistler's Mother."

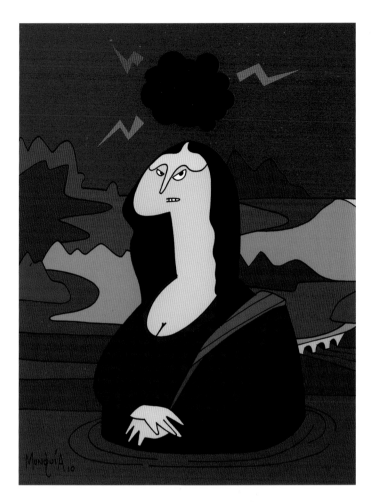

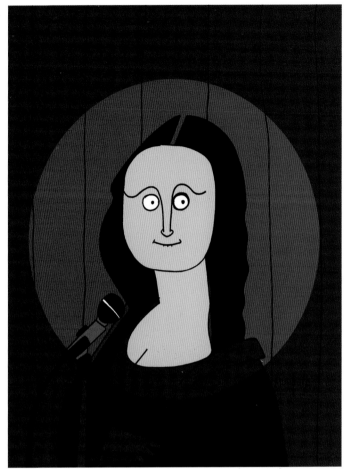

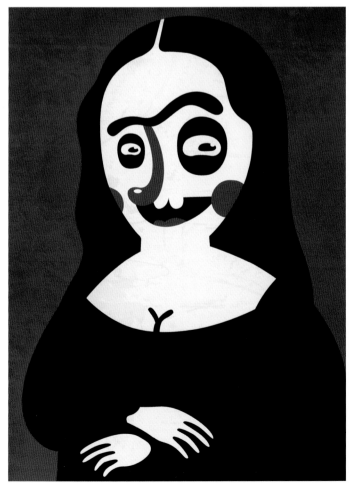

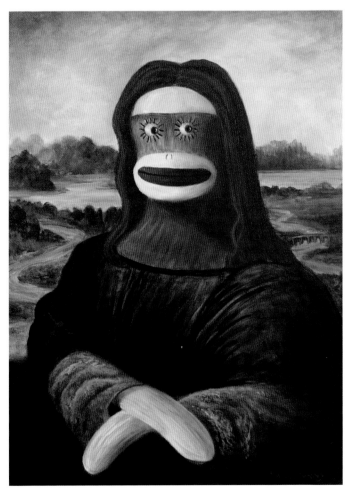

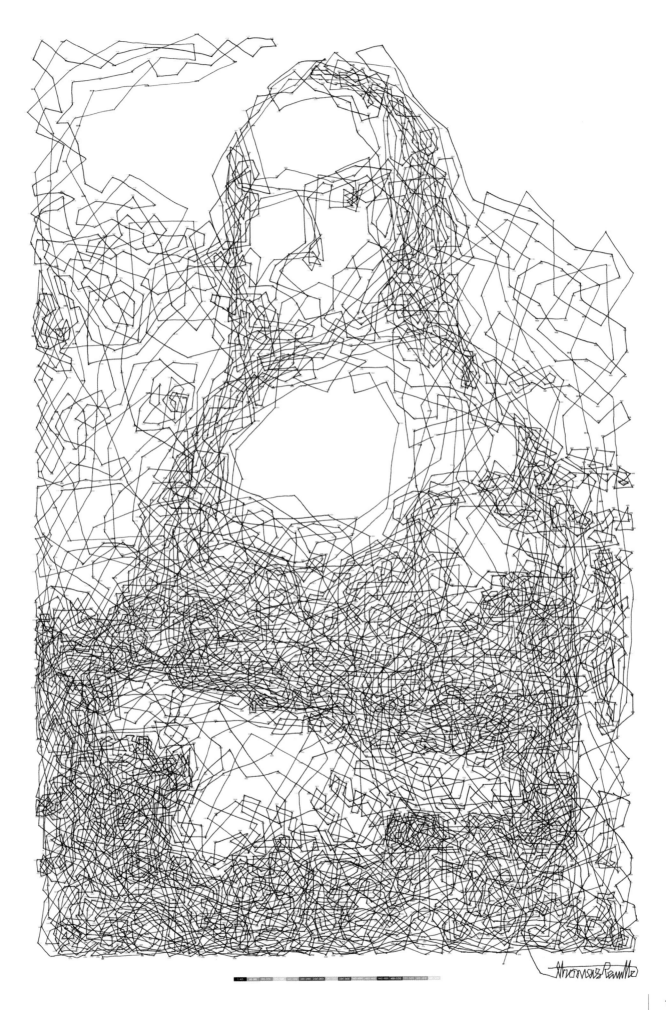

183

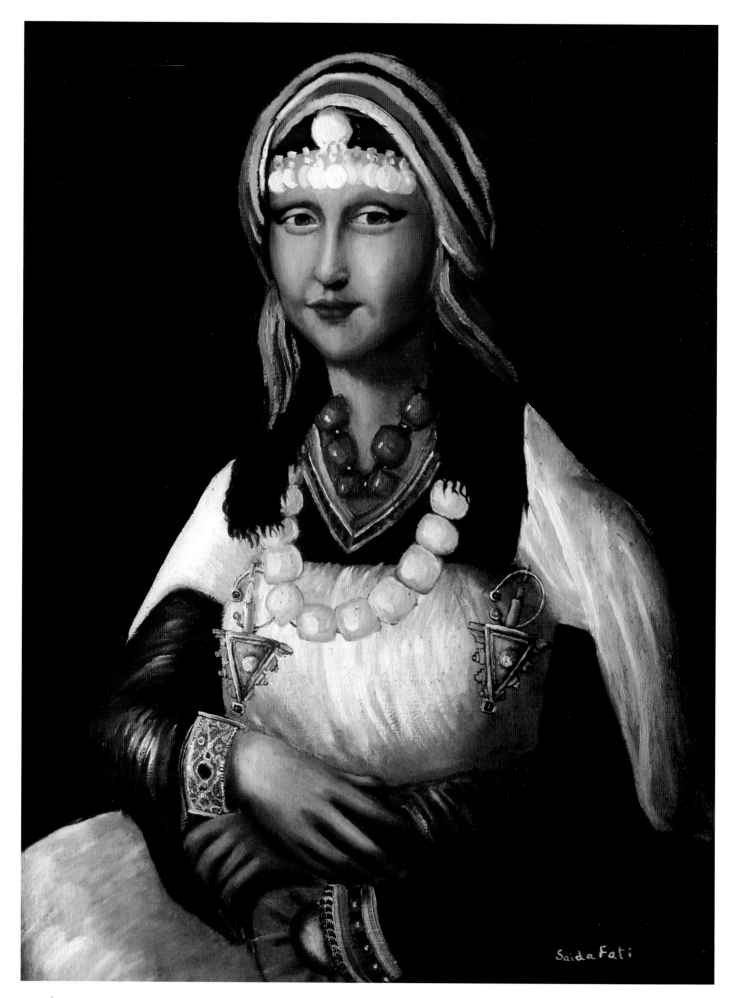

Saida Fati

Thomas Pavitte
Mona Lisa 6,239
Dots created digitally,
lines drawn by hand using 0.3 mm ink pen
841 x 1189 mm, 2011

When New Zealand graphic designer Thomas Pavitte set out to create the world's largest and most complex dot-to-dot drawing in history, he could think of no subject matter more appropriate than Mona Lisa. Comprised of 6,239 dots, it took him over nine hours to complete the entire drawing. Several books have since been published of his dot-to-dot drawings, and a modified version of his Mona Lisa (containing 3,000 dots) is currently being produced as a poster.

LEFT
Saida Fati
Mona Lisa Moroccan Berber
Oil on canvas, 40 x 60 cm, 2011

Moroccan painter Saida Fati chose to paint her homage to Leonardo da Vinci after consulting a biography on the Renaissance polymath and being deeply moved by his passion and insatiable curiosity. It was only after her painting was finished that she became aware of the startling, yet unintended, resemblance to Kahina, the Berber Queen who had led an indigenous resistance to Arab Islamic expansion in Northwest Africa during the 7th century.

RIGHT, TOP
Dóra Zsófia Kovács
Let's Cartoonize Mona ...
Brush marker on paper with digital enhancements
2700 x 3675 pixels, 2011

Hungarian artist Dio Kovács is primarily known for her lively and vivid animations. Influenced by a childhood spent watching cartoons, she has recreated Mona Lisa in the style of a classic Walt Disney heroine.

RIGHT, BOTTOM
Alexandros Chamilakis
Mona Lisa
Digital, 2700 x 3600 pixels, 2011

Originally from Greece and now living in Sydney, Australia, digital designer Alexandros Chamilakis has illustrated children's books and magazines in addition to designing greeting cards, tee-shirts and comic strips. He brings an eerie, unsettling quality to his version of Mona Lisa, which manages to be at once innocent and unassuming, while simultaneously exuding a sinister, fiendish vibe.

FOLLOWING PAGE
Daniel Mena Calavia
Smile of Smileys
Digital, 1467 x 2226 pixels, 2011

Spanish illustrator, photographer, and app designer Daniel Mena Calavia utilizes the iconic smiley face originated in the early sixties to form the foundation of his clever visual pun. Like Mona Lisa, the classic yellow smiley holds an important position in popular culture, and similarly, it has continued to evolve and change over time, with each new generation taking a turn at creating their own variations. Only the passage of time will eventually reveal if the smiley has the same staying power as Mona Lisa to sustain reinvention for centuries to come.

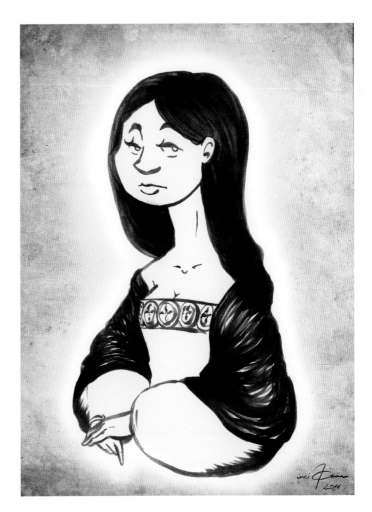

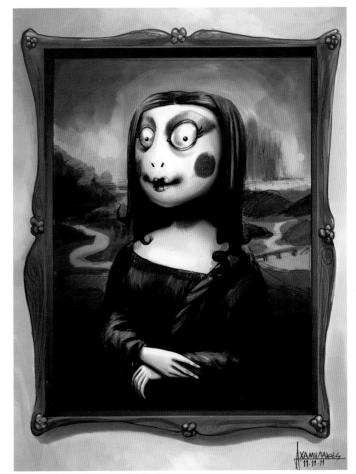

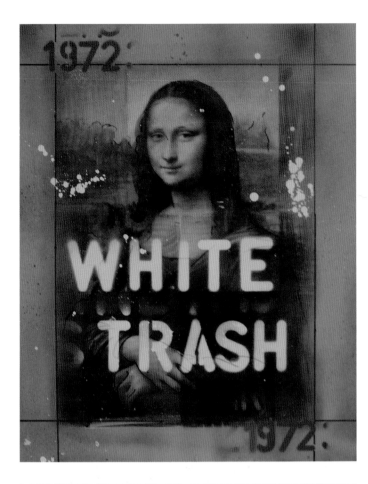

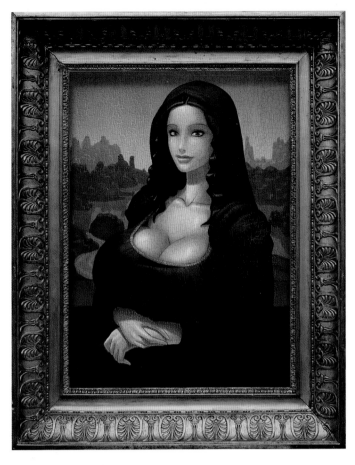

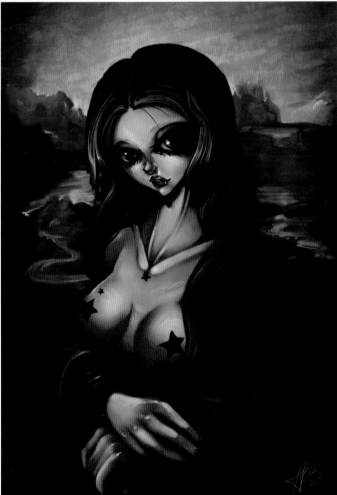

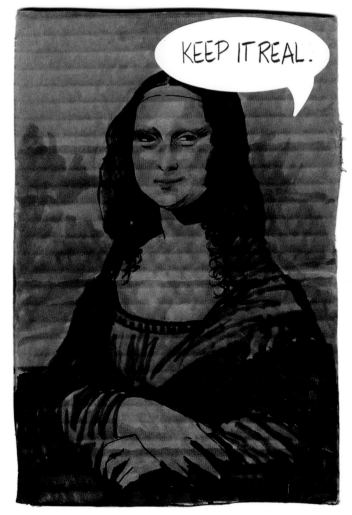

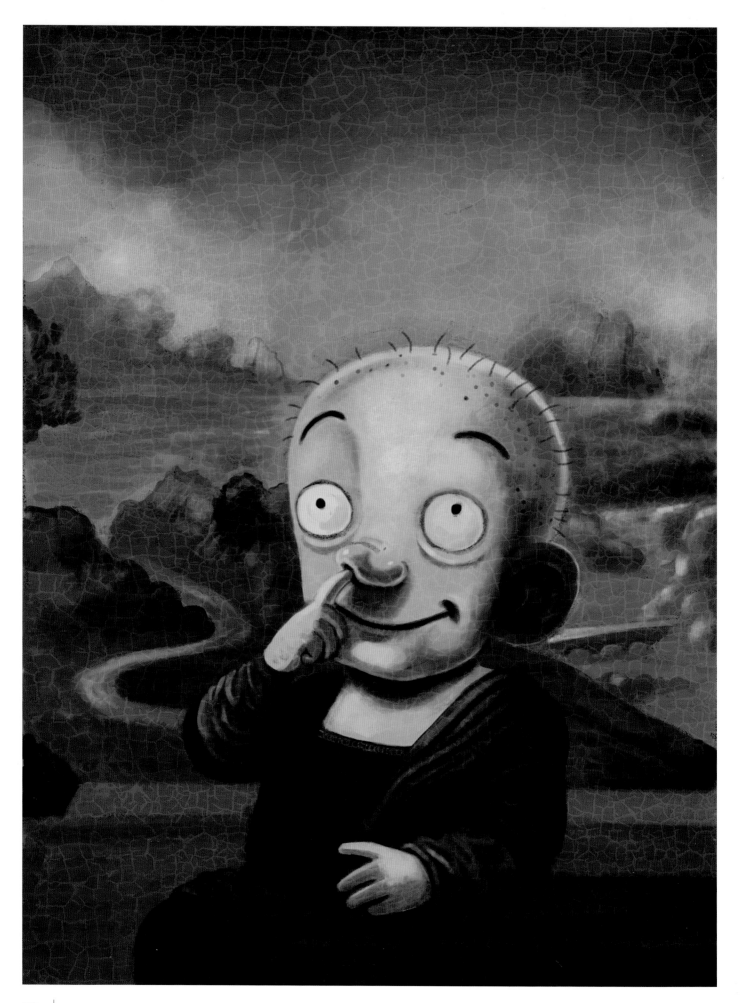

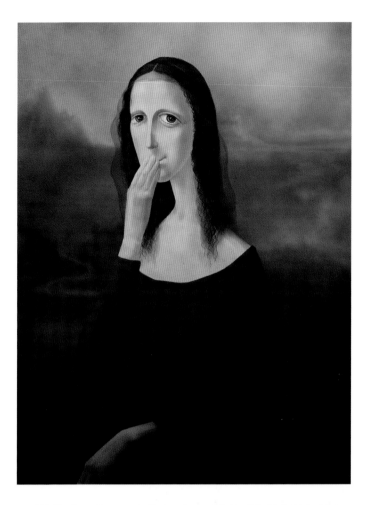

Roberta Marrero
White Trash
Mixed media on paper, 35 x 44 cm, 2011

Much of the work of Denmark-based Spanish artist Roberta Marrero is based on the use of iconic imagery, with the artist reconstructing and deconstructing familiar images to infuse them with new meaning. She doesn't just borrow images, she builds shrines to them, reliquaries of glamor and sex appeal. Confesses the artist, "Mona Lisa is not one of my favorite paintings at all, but it is a very powerful image that everybody recognizes. My ideas come to me in a flash and I complete the work swiftly without trying to interpret why I'm doing it. I find it more interesting for the viewer to try to decipher what it means. Through this process, the art becomes alive."

David Goujard
Mona Lisa
Digital, 1790 x 2250 pixels, 2011

A recurring augmentation of proportion seems to permeate the work of French illustrator David Goujard's portfolio, and he could not resist bringing his ample-bosomed aesthetics to the Renaissance period, creating a cosmetically-enhanced heroine that is unmistakably anachronistic for the era. Jokes the artist, "If you put mine and Leonardo's version side-by-side, obviously the primary difference you notice is that my Mona Lisa has eyebrows!"

Andrea Boddam
Mona Lisa after Valérie Bastille
Digital, 2264 x 3300 pixels, 2011

Assigned to recreate Mona Lisa in the style of another illustrator for a college art history course, digital artist Andrea Boddam chose the provocative artwork of fellow Canadian Valérie Bastille as her inspiration.

Carly Hwang
Keep it Real
Markers on cardboard, 16.5 x 24.1 cm, 2011

California-based graphic designer Carly Hwang's *Keep it Real* recalls the aesthetics and techniques of Outsider Art or Folk Art. The laid-back, straightforward attitude of her decidedly unpretentious take on Mona Lisa is echoed in her simple and unconventional choices of media and the use of a rough-edged, uneven piece of corrugated cardboard as her "canvas."

Caroline Kintzel
Mona What
Digital, 1424 x 1952 pixels, 2011

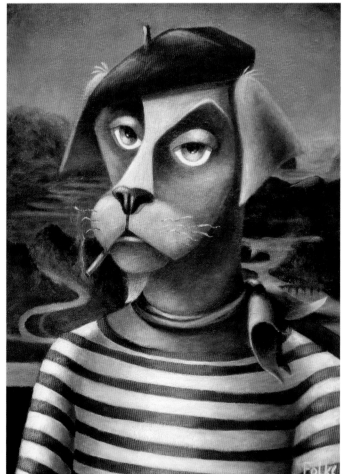

The inspiration for German illustrator Caroline Kintzel's *Mona What* came from *The Witcher*, a series of medieval role-playing video games based on the books of the same name by Polish author Andrzej Sapkowski. Explains the artist, "I had created several illustrations derived from characters from the game, but instead of trying to replicate the dark and sinister tone of the source material, I reimagined them as children in a light-hearted, humorous manner. At this point, apart from the characters' names, the recreations do not have much in common with their violent adult counterparts."

PREVIOUS PAGE, TOP RIGHT
Liza Andreyeva
Giggling Mona Lisa
Digital, 21 x 30 cm, 2011

PREVIOUS PAGE, BOTTOM RIGHT
Eva Folks
Francois the Forger
Acrylic on canvas, 22.86 x 40.64 cm, 2011

Ukrainian illustrator and graphic designer Liza Andreyeva has enjoyed a varied career as a book illustrator, website designer, poster artist, and corporate logo designer. In her personal projects, she creates stylized characters who are regularly portrayed with exaggerated and elongated proportions. Here she conceives of an alternate reality in which Mona Lisa has fallen under the spell of an unexpected and uncontrollable giggle fit.

Expectations are often subverted in the artwork of self-taught Canadian painter Eva Folks. Buildings topple, animals drive cars, and the art counterfeiter himself is depicted in his own forgery in place of the painting's intended subject. A whimsical twist on the classic image which recalls the myriad of times Mona Lisa has been forged, reappropriated, and reimagined, *Francois the Forger* is part of Ms. Folks' "Family Portrait Series," where nothing is as it should be.

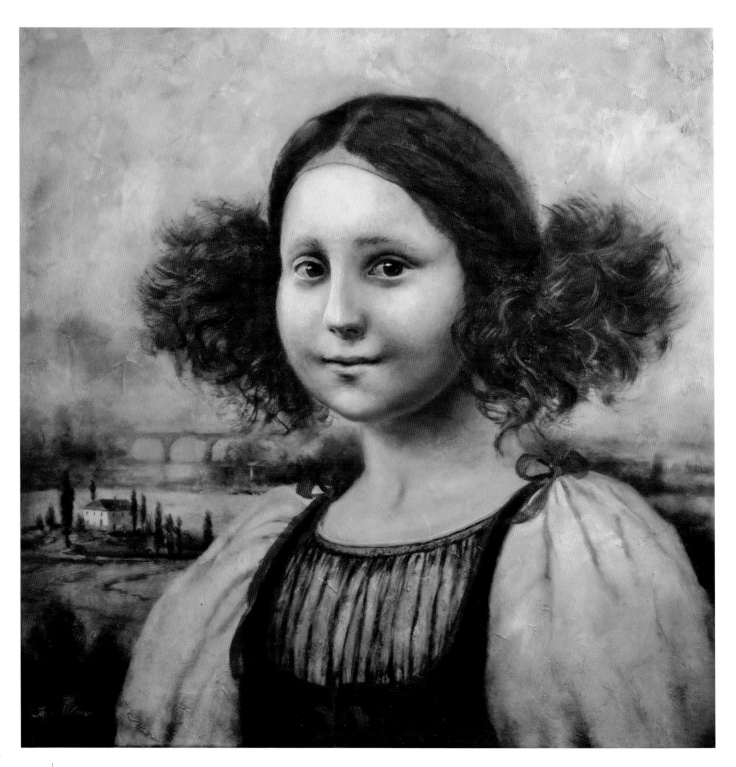

Liza Andreyeva
Giggling Mona Lisa

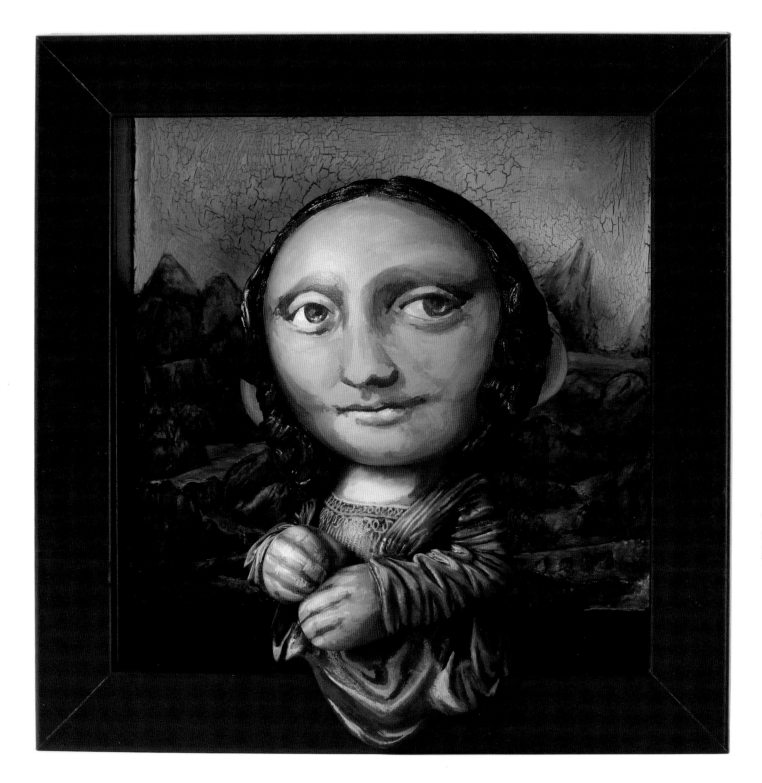

LEFT
Ira Volkova
When Mona Lisa Was a Girl ...
Oil on canvas
127 x 127 cm, 2011

Mona Lisa's delicate smile is perfectly epitomized as Ukrainian painter Ira Volkova imagines what the iconic portrait model may have looked like as a youngster. Ms. Volkova's paintings are characterized by her expressive, lively brushwork and ethereal use of light that gives a celestial glow to all of the characters who inhabit her canvases. Says the artist, "In my paintings I want to tell simple stories about lovely, ordinary humans, but as if in slow motion. My artwork is not theatrical or monumental. I'm interested in telling stories that are intimate, simple, and honest. This is my creative tuning fork."

ABOVE
Michal Miszta
Munny Lisa
Vinyl toy, polimer clay, acrylic paint, wooden frame
12 x 12 cm, 2011

Polish architect and modelmaker Michal Miszta is best known for his customized toy designs featuring likenesses of celebrities and characters from popular culture. His ingenious three-dimensional relief sculpture *Munny Lisa* was created using a Kidrobot Mini Munny Vinyl DIY toy, resculpted with polymer clay and painted with deft precision. An acrylic-painted relief background and black frame from IKEA tie everything together and complete the charming scene.

J. Leo
Camelisa
Acrylic on canvas, 90 x 90 cm, 2011

Michael Knight
M0na1za-582
Digital, 2514 x 3585 pixels, 2011

Born in Portugal and raised in Angola, J. Leo had worked as a matte artist, package designer, fashion designer, and interior designer before turning his attention to painting and sculpting. He cites Salvador Dalí as a major influence on his eccentric style, crediting the surrealist's life and work with giving him the assurance to continue painting. "Art has always been, and still is, my solace," explains the artist, "a place where I gain a certain peace and satisfaction from the uncertainly and insensitivity of human relationships." Mona Lisa has been a recurrent subject of his work, as in *Camelisa* where she has inexplicably started to adopt the characteristics of a nearby pair of inquisitive chameleons.

Canadian graphic designer Michael Knight began his career building props and miniatures for low budget film companies in Winnipeg. When computers started to take over the industry, he realized it was time to enter the digital world, and he taught himself the skills he needed to remain competitive. While he mostly creates his art using traditional tools, he does continue to produce the occasional digital masterwork as well. *M0na1za-582* is the first of a series of planned illustrations in which he has recast classic Renaissance paintings with mechanical figures, to be followed next by a robot-inhabited version of Leonardo da Vinci's famous religious mural *The Last Supper*.

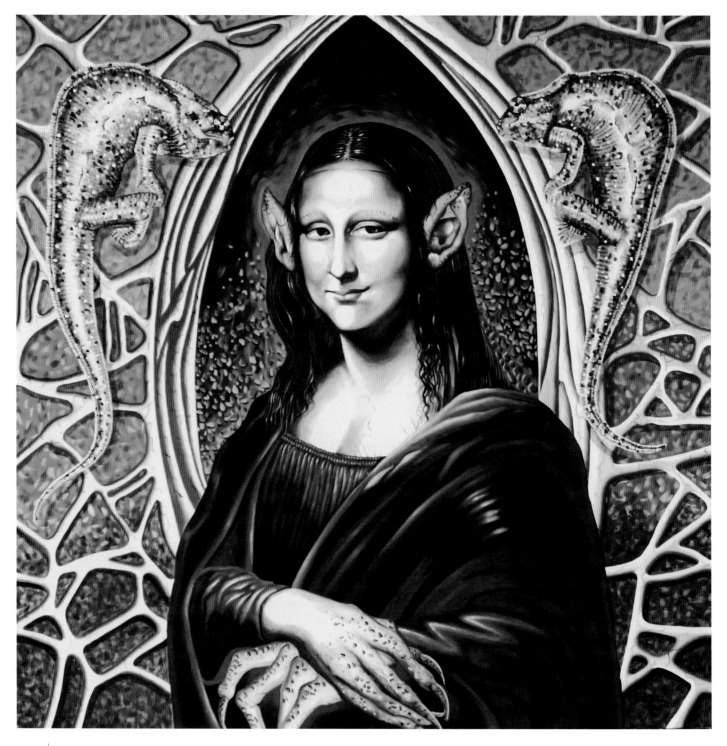

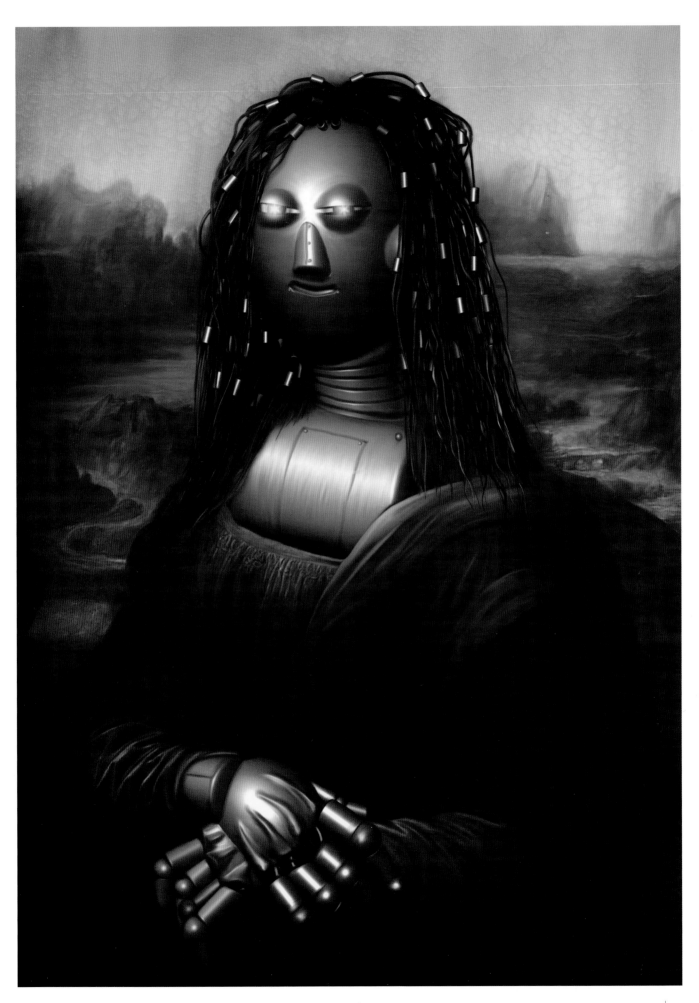

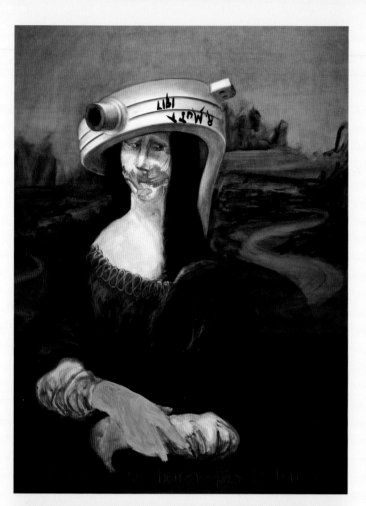

Gaël Davrinche

A graduate of the distinguished École des Beaux-Arts in Paris, noted French artist Gaël Davrinche brings an honest, spontaneous naturalism to all of his work. With his series of paintings called "Des Revisités" ("The Revisited Series"), he sought to reinterpret the works of the Old Masters in an exaggerated style reminiscent of a child's art. Famous works by painters such as Leonardo da Vinci, Diego Velázquez, Johannes Vermeer, and Jan van Eyck were all appropriated in a gesture oscillating somewhere between reverence and ridicule, with the artist questioning each painting's historical and cultural significance. Through a collection of seven canvases, Mr. Davrinche desecrates Mona Lisa and reduces the painting to scrawled renditions, subjecting this incarnation of beauty to all manner of outrages and indignities. Accompanying his images, in a clever nod of the hat to the famous *L.H.O.O.Q.* parodies of Marcel Duchamp, are acronyms such as *L.A.P.T. - L.A.R.* and *L.C.K.C.I.R.* The former is a scatological remark, which remains in line with the adolescent nature of his renderings, and the latter is presumably a reference to the painting having been famously stolen in 1911, providing an explanation for the painting's disappearance to disappointed Louvre visitors frustrated by not being able to see it, as though the painting were an amusement park attraction that was not operating on that particular day.

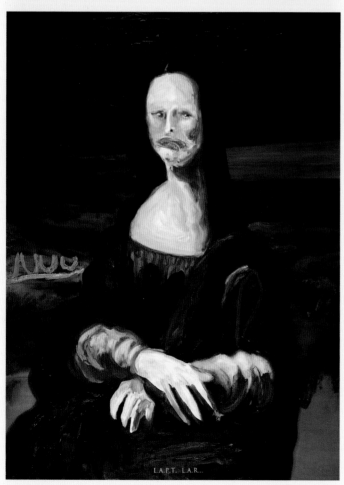

LEFT, TOP
Fontaine, Je ne boirai pas de ton eau
(Fountain, I Will Not Drink Your Water)
Mixed media on canvas, 160 x 200 cm, 2011

LEFT, BOTTOM
L.A.P.T. - L.A.R. (Elle a pété, elle aére)
(She has Farted, It Airs)
Mixed media on canvas, 160 x 200 cm, 2011

RIGHT
She Suddenly Felt the Terrible Desire to be Somebody Else
Mixed media on canvas, 160 x 200 cm, 2011

FOLLOWING PAGE, TOP LEFT
L.C.K.C.I.R. (Elle s'est cassé hier)
(She Broke Yesterday)
Mixed media on canvas, 160 x 200 cm, 2011

FOLLOWING PAGE, TOP RIGHT
Triste Figure
Mixed media on canvas, 160 x 200 cm, 2011

FOLLOWING PAGE, BOTTOM LEFT
L.A.F.A.C. (Elle a éffacé)
(She is Erased)
Mixed media on canvas, 160 x 200 cm, 2011

FOLLOWING PAGE, BOTTOM RIGHT
Sale
Mixed media on canvas, 160 x 200 cm, 2011

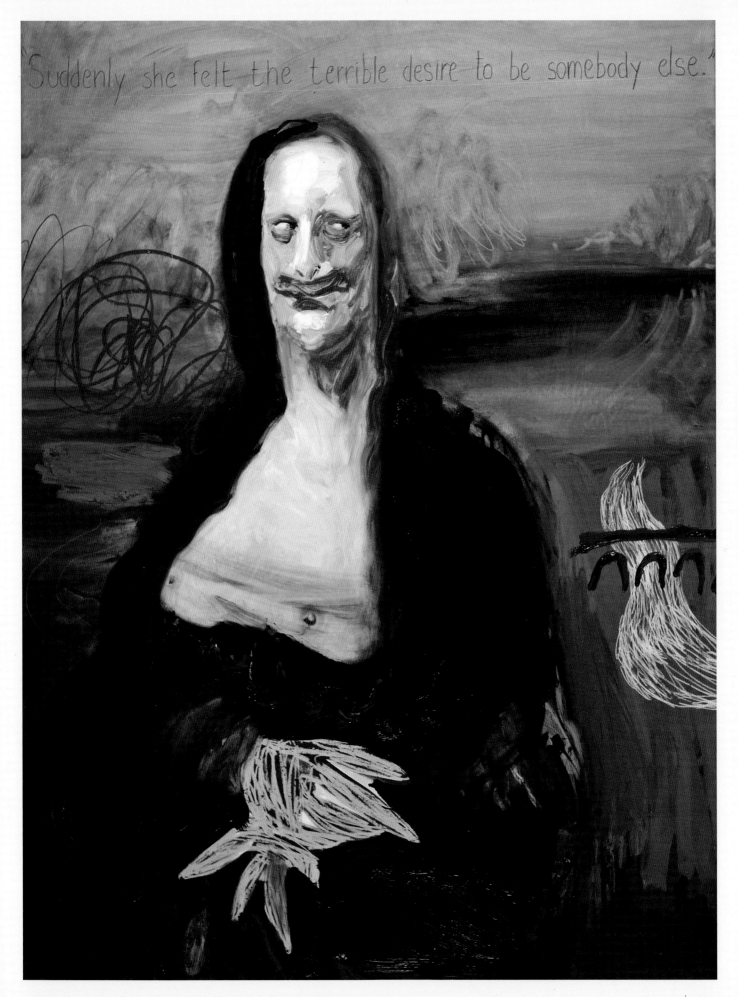

"Suddenly she felt the terrible desire to be somebody else."

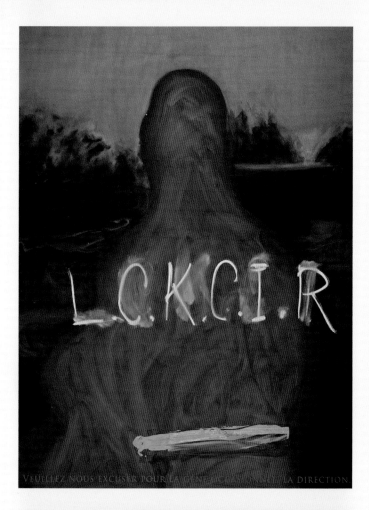

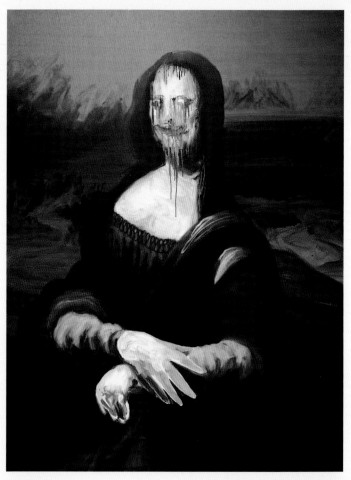

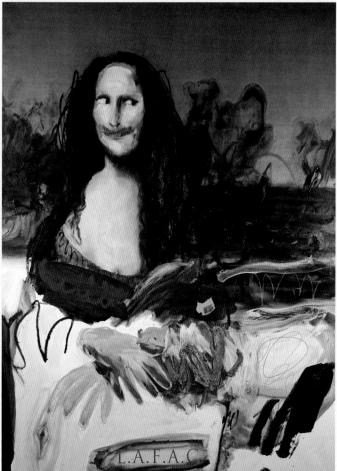

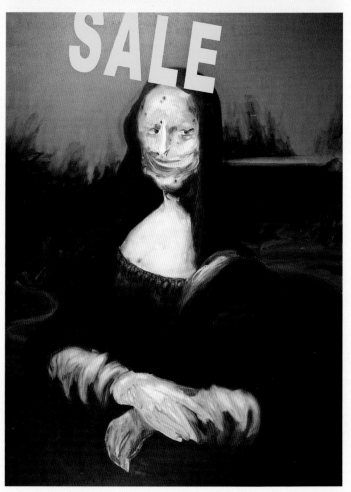

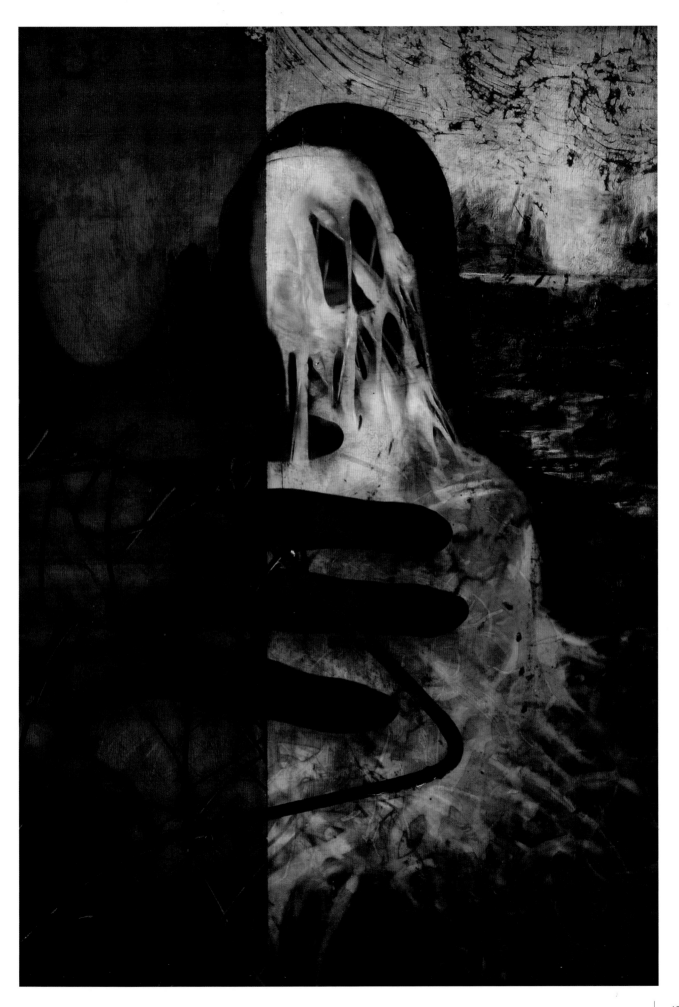

Sho Imai
Wastepaper
Digital
2000 x 2984 pixels, 2011

Diagnosed with schizophrenia while still a teenager, Japanese graphic designer Sho Imai has said that his disorder causes him to experience extended periods of inactivity, during which time he feels unable to create any artwork. These periods of suspended creativity are usually followed by a stage of explosively prolific productivity. The artist admits that it is an inevitability that his work be influenced by his health issues, and that the inspiration for his haunting images frequently comes from his dreams and hallucinations. Regardless of his intermittent output, the stunning craftsmanship and disquieting beauty of his digital illustrations are undeniable.

BELOW, LEFT
Xi Ding
The Real Face of la Gioconda
Digital
1042 x 1440 pixels, 2011

Chinese illustrator and cartoonist Xi Ding has a sharp intuition and strong analytical skills, elements that are crucial to the craft of portrait caricature. He has twice been awarded first prize at the prestigious ISCA (International Society of Caricature Artists) European convention as well as the Eurocature convention. Of the demanding discipline of caricature, the artist comments, "One can either choose to emphasize the 'benefits' of a person's face, or instead focus on the 'disadvantages.' The trick is to recognize that freedom and put it to good use, adapting to the personality of the subject and empathizing with his or her own self-assurance."

BELOW, RIGHT
Panyawat B. Silp
Lady LISA
Digital
2400 x 3600 pixels, 2011

Panyawat B. Silp, a graphic designer from Bangkok, Thailand, created this hypnotic digital image as an homage to the gratuitously sentimental saucer-eyed kitsch paintings made popular in the fifties and sixties by Walter and Margaret Keane. While the subjects of those vintage paintings were usually waifs, kittens, and puppy dogs, here Mona Lisa appears to have the otherworldly characteristics of an alien visitor from another planet.

RIGHT
Dimitar Bochukov
The Little Mona Lisa
Traditional, Digital
2000 x 4000 cm, 2011

Bulgarian illustrator Dimitar Bochukov created this portrait of a childhood Mona Lisa as a commission for a large-scale print advertisement which was displayed at infant clothing retailer Babytoria in Tsarigradsko Mall, the largest shopping mall in the Balkans.

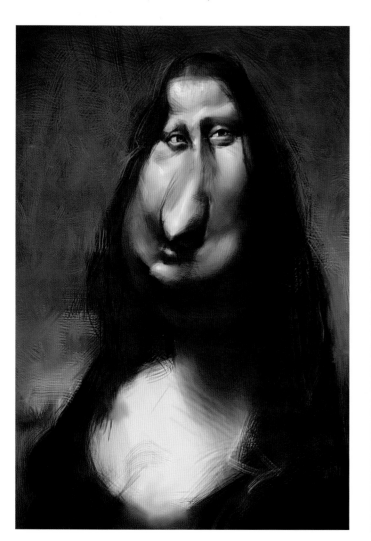

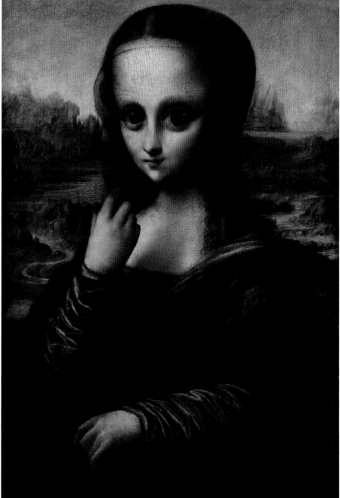

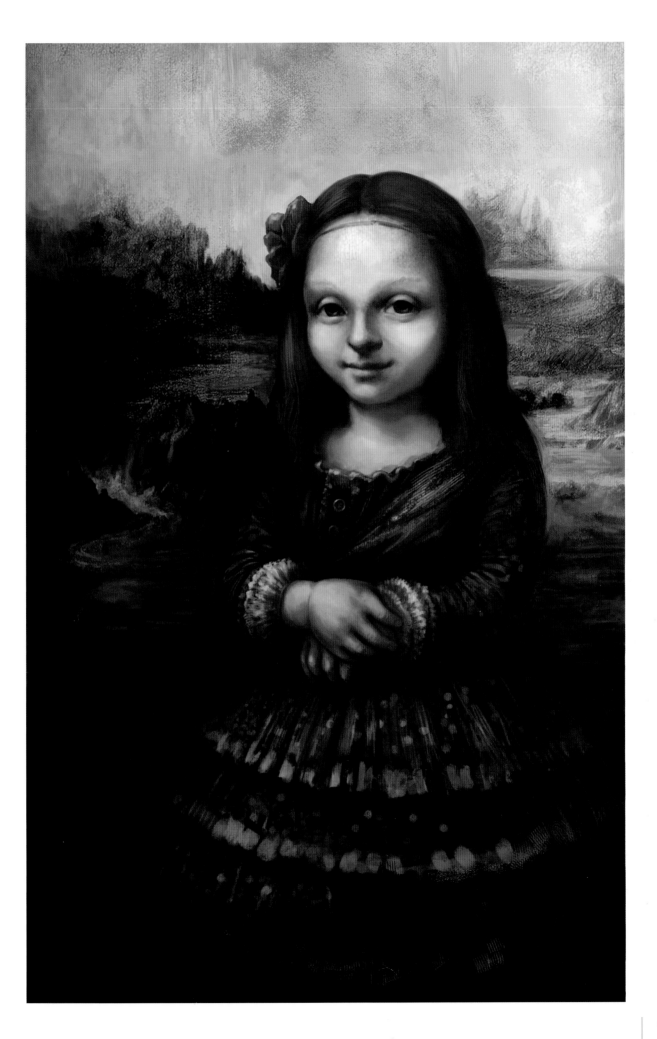

Maurice Bennett
Mona Lisa with Ice Cream: K11 Mall, Hong Kong
Over 6,000 slices of toasted bread, of varying sizes
4.8 x 4.8 meters, 2011

Tatiana Soteropoulos
Once Upon a Time
Mixed media on canvas
50 x 70 cm, 2011

Known across the globe as "The Toastman," New Zealand artist Maurice Bennett has never been afraid of experimenting with untried techniques and nontraditional media while developing his unmistakably unique style. He had some minor success early on with an unusual format best described as "sculptural canvas," and later began creating works of art constructed from the charred remains of found objects. Eventually he achieved worldwide recognition after utilizing toast as his source material. With the success and notoriety generated by his creations, he continues to push the boundaries in his use of toast as a medium, adding collage to his work and creating three-dimensional images that never fail to delight and astound.

Esteemed Cypriot artist Tatiana Soteropoulos has exhibited her artwork in galleries across the United States and in Europe, establishing herself securely in the international art community as one of the most innovative voices of contemporary art. She explains the meaning behind her extraordinary *Once Upon a Time* by saying, "The painting symbolizes life itself, as everything that exists will ultimately age and deteriorate. Nothing, not even Mona Lisa, is immune to this. No matter how much precaution is taken, and how much effort is expended to preserve and protect her, time eventually takes its toll. It's an inevitability that is beyond our control."

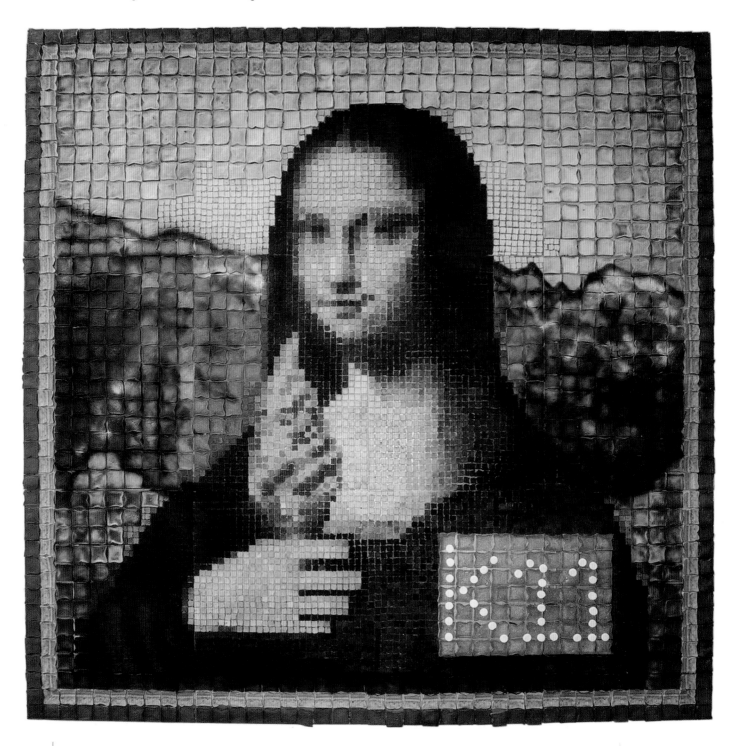

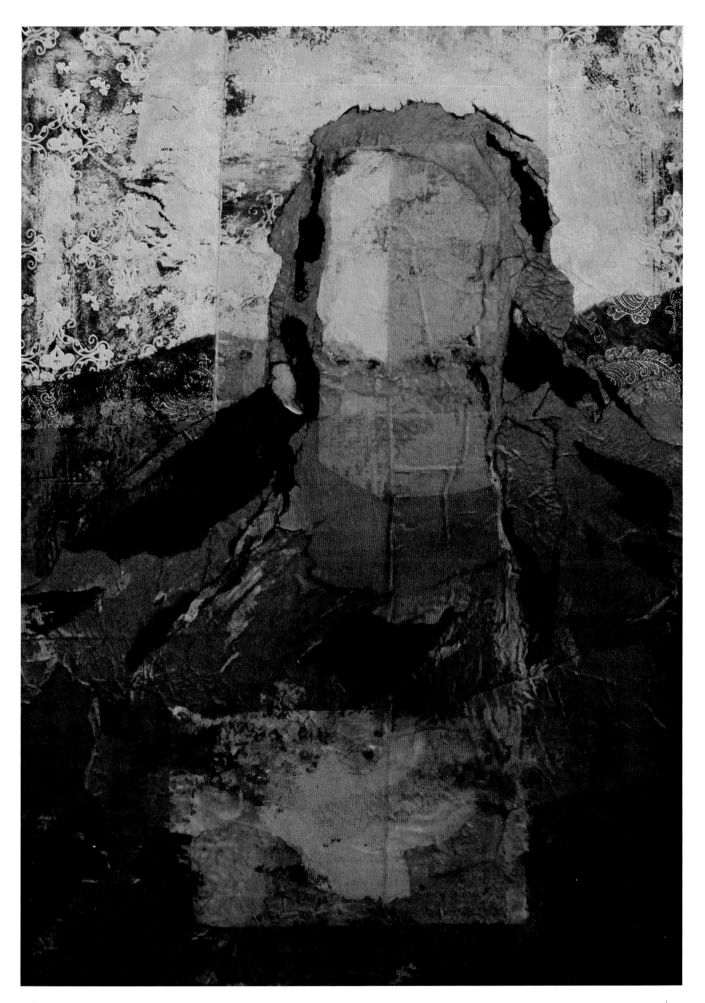

LEFT, TOP
Felipe Castaño
La Mona Isa
Ink on paper with digital color
13.97 x 21.59 cm, 2011

A native of Colombia, Illustrator Felipe Castaño shares his graphic designs on the internet under the pseudonym "Pargorojo." Says the artist, "I'm always trying to arouse curiosity in spectators with my work. In each of my illustrations, I impose a series of perfectly planned and accented details to make people wish to revisit and continue learning about my work."

LEFT, BOTTOM
Artem Bizyaev Pavlovich
Hippie Lisa
Digital
3508 x 4961 pixels, 2011

Russian illustrator Artem Bizyaev Pavlovich has worked as an animator, concept designer, and comic book artist. He is known for his strong compositional skills, energetic use of line, and dynamic treatment of color. Here his lively style perfectly encapsulates the spirit of the psychedelic hippie subculture youth movement which was prevalent in the 1960's.

RIGHT
Ron English
TMNT da Vinci
Oil on canvas
61 x 91.4 cm, 2012

One of the most prolific and recognizable artists working today, Texas-born Ron English has bombed the global landscape with his unforgettable images. He coined the term "POPaganda" to describe his signature mash-up of high and low cultural touchstones, from superhero mythology to totems of art history, often populated with a vast and constantly growing arsenal of original characters of his own creation. His street art techniques blend stunning visuals with biting political, consumerist, and surrealist statements and have earned him the nickname "The Godfather of Street Art." He has appeared as himself in an episode of *The Simpsons*, and his artwork has been featured in motion pictures such as *This is the End* and *Movie 43*. His painting of Leonardo, the blue-masked leader of the Teenage Mutant Ninja Turtles, was created as a limited edition print sold exclusively at the 2012 San Diego Comic Con.

© 2012 Viacom International Inc. All rights reserved.

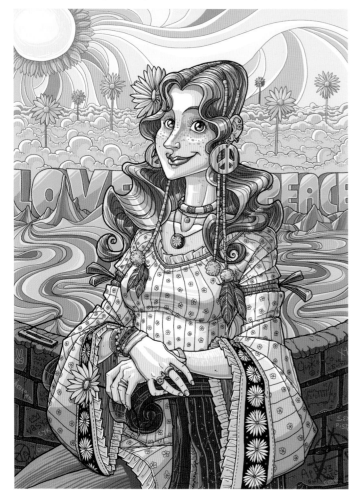

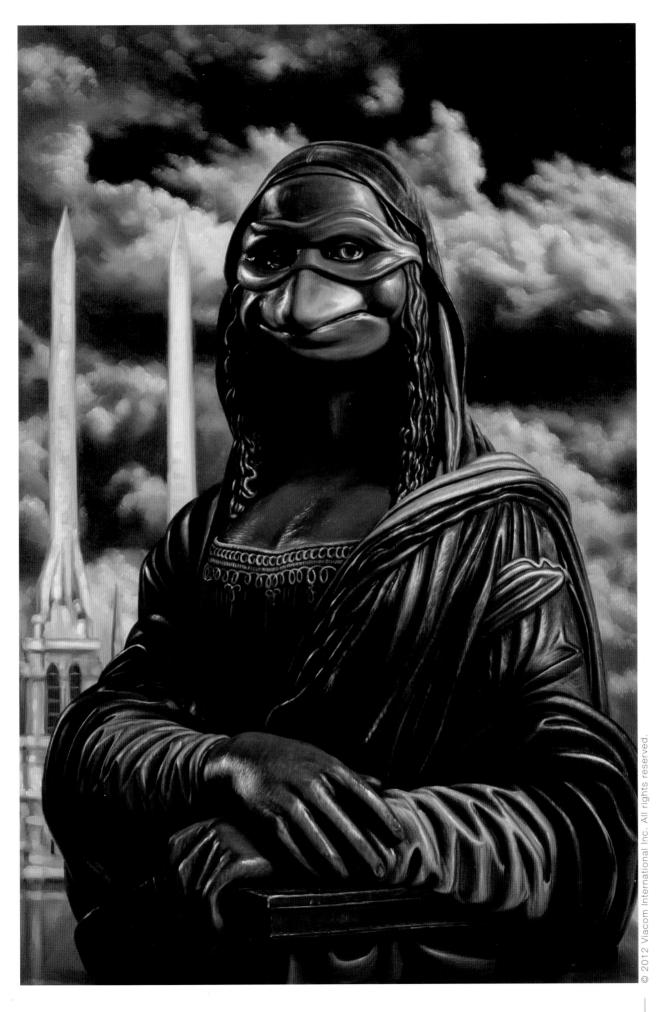

© 2012 Viacom International Inc. All rights reserved.

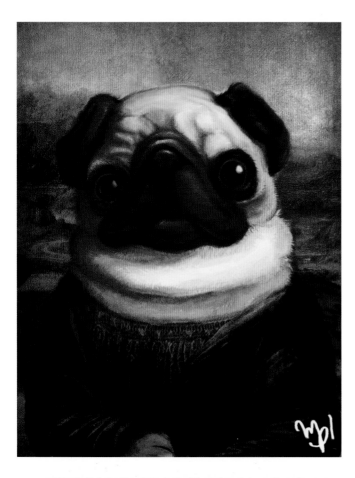

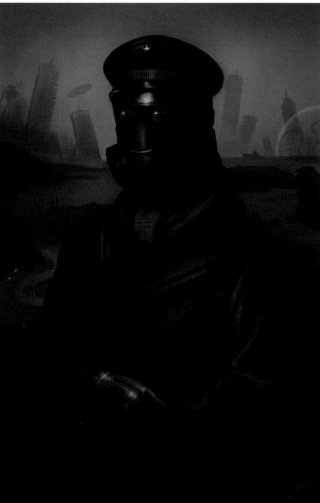



Copyright © 2014 Vitaly S Alexius. All Rights Reserved. Used Under Authorization.

Mario Pimenta
La Pugalisa
Digital
3130 x 4119 pixels, 2012

Brazilian illustrator and graphic designer Mario Pimenta loves to experiment with digital art. His interest lies in showing the world his point of view through a quirky aesthetic and playful approach to his work. Of *La Pugalisa*, the artist says, "I tried to create a humorous twist on the idea that even though dogs aren't able to do the iconic Mona Lisa smile, they can still convey complicated emotions with their big, expressive eyes."

Jade P. Nadales Guamán
Mona Lisa Captain
Digital
2700 x 4045 pixels, 2012

Born in Malaga, Spain, illustrator Jade Nadales began selling her watercolor paintings when she was just ten years old. She continued to gain professional experience through her teen years, creating commissioned oil painting portraits before eventually concentrating on digital artwork. The Captain, or Zee Captein, is the main character of the online webcomic *Romantically Apocalyptic*, written by Vitaly S. Alexius and set in a post-apocalyptic dystopia where humanity has been tragically copyrighted out of existence, and a sexy search engine now runs the planet. Explains Ms. Nadales, "Mona Lisa was the perfect choice to embody The Captain. Both have a mysterious background with their true identities unknown, and while Mona Lisa is famous for her inexplicable smile, The Captain's ever-present gas mask manages to create the impression of a smile which is very eerie and unsettling."

Erik Maell
Gioconda Amidala
Watercolor, acrylic, ink and Copic markers on paper
35.5 x 50.8 cm, 2012

Erik Maell is an American artist who received his Bachelor of Fine Arts Degree from the Columbus College of Art and Design with a double major in Fine Arts and Illustration. As a painter, he has shown his artwork in many solo and group exhibitions across the United States and in Europe. As an illustrator and graphic designer, he has enjoyed an extremely diverse career working in a wide variety of areas, including book and magazine illustration, advertising design, fashion illustration, mural painting, logo design, and website design. His work in the fashion industry included a four-year period employed as a visual consultant in the marketing department of Victoria's Secret Beauty Corporation in New York City. He has collaborated with the Central Bank of Cyprus to create the designs for that country's national currency, which became the first Euro ever issued for the Republic of Cyprus. He currently creates artwork for such internationally prevalent corporations as Lucasfilm Ltd., The Walt Disney Company, Universal Studios, Marvel Comics, DC Comics, and Topps Trading Card Company. His *Gioconda Amidala* illustration was created as a limited edition print sold at "Star Wars Celebration VI," a convention held in Orlando, Florida during the summer of 2012.

Courtesy of Lucasfilm Ltd.

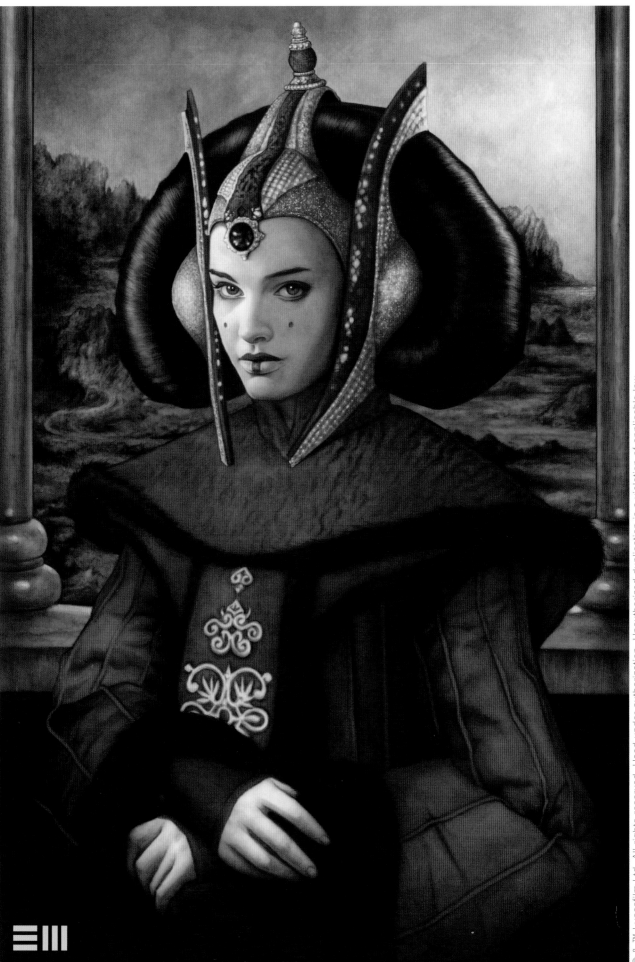

© & ™ Lucasfilm Ltd. All rights reserved. Used under authorization. Unauthorized duplication is a violation of applicable law.

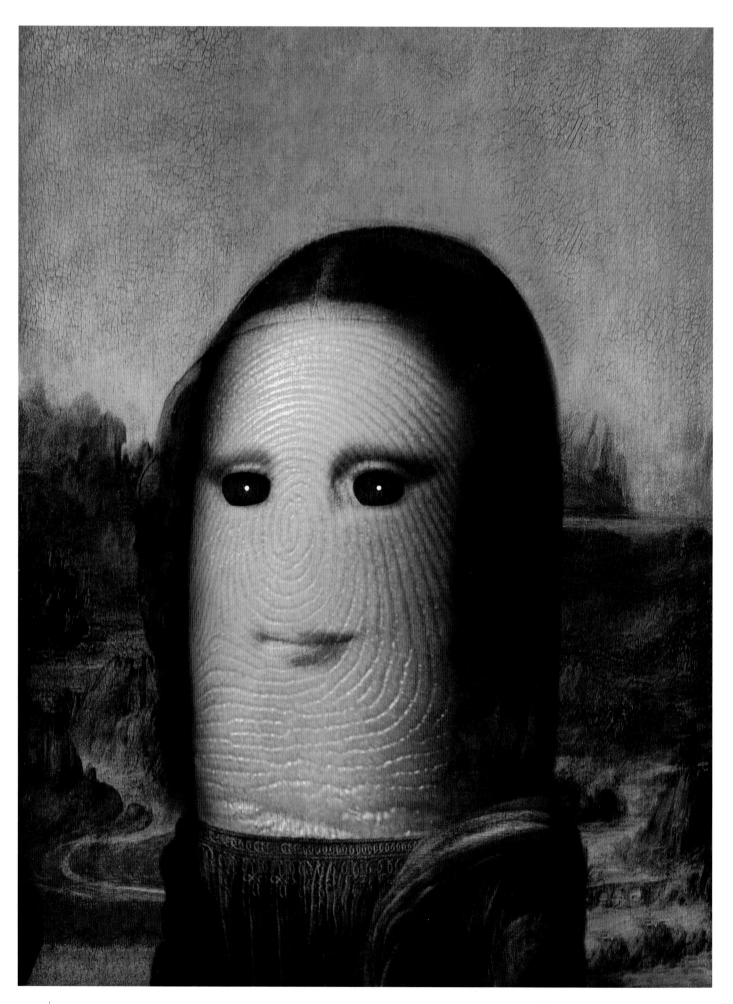

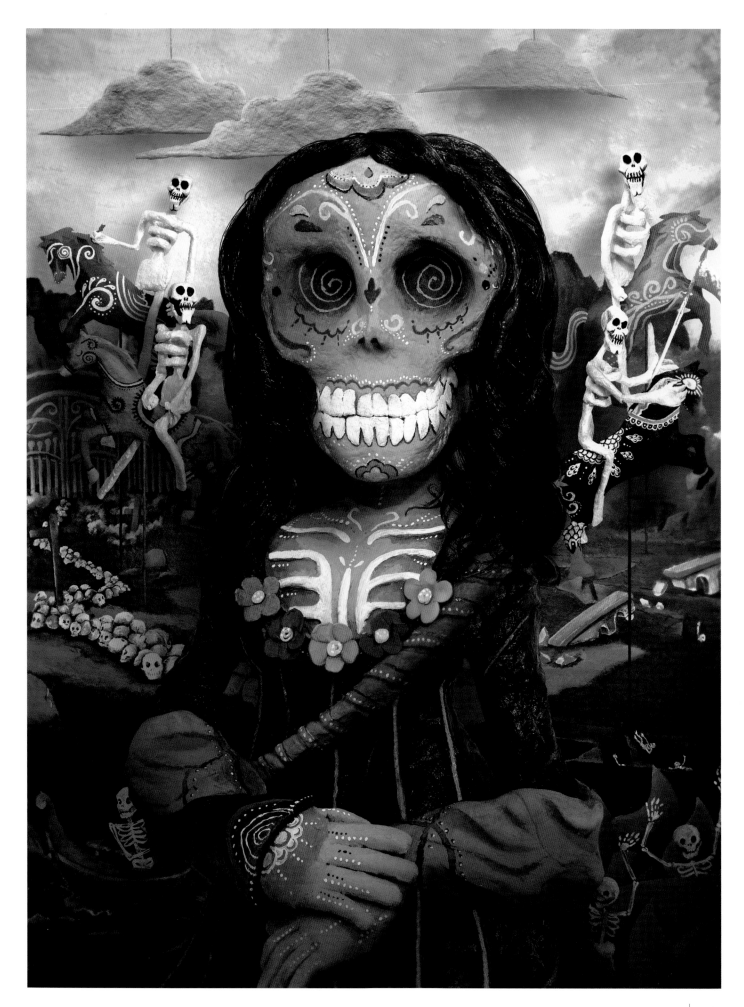

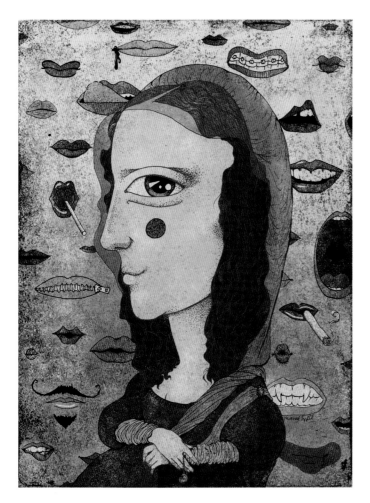

Dito Von Tease
Dito Mona Lisa
Digital
2481 x 3507 pixels, 2012

Hiding behind a pseudonym, which was inspired by the queen of burlesque, Italian artist Dito Von Tease (or simply "il Dito") creates his unique finger portraits as a commentary on social identity in the modern digital era. The apparent playfulness of his work disguises a deeper reflection on the complexity of postmodern existence and the mystery of personal identity. Explains the artist, "In the contemporary digital age, our fingers are the tools we use to handle touch screens, mouse devices, and keyboards, connecting us with the world. Thus, in a sense, each of us are hiding behind our finger while surfing the internet or communicating online. The finger is the image we project of ourselves, the mask we wear, even in real life." His Ditology project began in 2009, when the artist began creating finger-portraits of famous celebrities and cultural figures. "Ditology invites everyone to look beyond the masks we wear in our daily lives, and go deeper to find our own unique fingerprint."

PREVIOUS PAGES, RIGHT
Alopra Estúdio
La Catrina
Paper mache with digital enhancements
29.7 x 42 cm, 2012

Alopra Estúdio is a Brazilian design firm, specializing in two-dimensional and three-dimensional animation as well as illustrations both printed and electronic. Inspiration for *La Catrina* came from Dia De Los Muertos, a traditional Mexican celebration during which paper mache sculptures and skulls are decorated as Catrinas, satirical representations of upper class society ladies. A skull posing as Mona Lisa appears in front of an apocalyptic facade representing judgment day. The main character and all background elements were sculpted, painted, and mounted in place to be photographed. The resulting image was later refined and enhanced with digital tools in post-production, and then submitted for a contest launched by Urban Arts Gallery, in which artists from all around Brazil were invited to recreate their own versions of Mona Lisa.

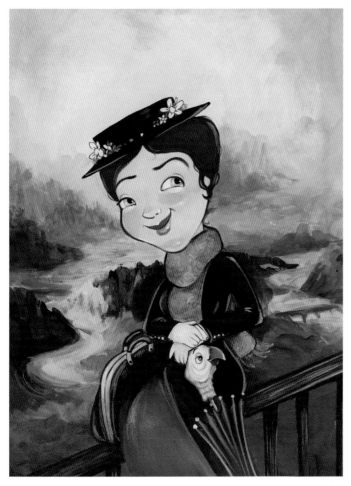

LEFT, TOP
Michael Ezzell
Mona Lisa Smile
Ink drawing with digital colors
21.6 x 28 cm, 2012

Michael Ezzell is an illustrator and printmaker from Elkhart, Indiana. His artwork combines elements of traditional printmaking methods with digital applications in order to create a printed effect without an actual press involved. His aesthetic draws inspiration from vintage styles, with heavy influences from fairy tales and folklore.

LEFT, BOTTOM
Summer Morrison
Mona Poppins
Acrylic on illustration board
22.86 x 27.94 cm, 2012

For American cartoonist and caricaturist Summer Morrison, the notion of combining Mona Lisa with Mary Poppins was a no-brainer, as she says, "Mona Lisa is a masterpiece, no one can dispute that, and while some may think of it as the perfect painting, others have a slightly different definition of perfect. The British Nanny and all of her delightful demeanor is a contemporary masterpiece. Proclaiming

herself to be 'Practically Perfect in Every Way,' Mary Poppins has a way with words and a propensity to persuade people to see the world her way. Our influences come from many different sources, and our heroes echo our unique range of experiences in life. 'Mona Poppins' seems like an obvious match for the modern artist seeking success, perhaps perfection, in a very hectic world."

RIGHT
Mary Spring
6% Fearful
Pencil and acrylic on wood panel
17.78 x 50.8 cm, 2012

The figurative paintings of American artist Mary Spring are both self-portraits of the present and projections of an internal hope for the future. In her work, she explores the range of mental, emotional, and physical conditions experienced in a mere snapshot of time, enabling the observer to merge silently into the psyche of the artist. From ultimate pleasure to unbearable sadness, each expression communicates profound casualties of insight. The title of this painting references a study conducted in 2005 by Dutch researchers at the University of Amsterdam. An image of Leonardo da Vinci's original painting was scanned into a computer and, using "emotion recognition" software, which had been developed in collaboration with the University of Illinois, the image was analyzed to determine exactly what emotions were being registered by that famous enigmatic smile. The resulting data concluded that her expression is 83% happy, 9% disgusted, 6% fearful, 2% angry, less than 1% neutral, and 0% surprised.

FOLLOWING PAGE, TOP LEFT
Marko Köppe
Mona Lisa 1a Blue Shining
Digital, 4000 x 6051 pixels, 2012

FOLLOWING PAGE, TOP RIGHT
Marko Köppe
Mona Lisa 1c2 DigitalFace
Digital, 4000 x 6051 pixels, 2012

FOLLOWING PAGE, BOTTOM LEFT
Marko Köppe
Mona Lisa 1c2b DrakDigitalFace
Digital, 4000 x 6051 pixels, 2012

FOLLOWING PAGE, BOTTOM RIGHT
Marko Köppe
Mona Lisa 1c DigitalFace
Digital, 4000 x 6051 pixels, 2012

German artist and graphic designer Marko Köppe explains that he draws much of the inspiration for his digital collages from nature. "I am at my most relaxed and creative away from the urban landscape, in a natural environment. I love the sea, the forest, the wind. I want my art to have an abstract quality, so that gives me the freedom to mix and match different elements to build something unexpected. With all of the elements I have at hand, I play a little bit with the eyes and the mind to trigger the audience's imagination. My work adheres strongly to the German proverb 'Das Auge sieht weit, der Verstand noch weiter' or 'It is the eye that looks, but it is the mind that sees.'"

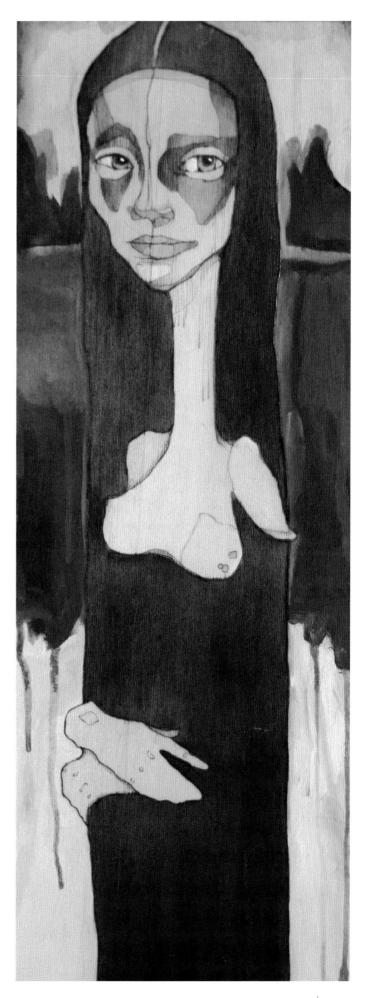

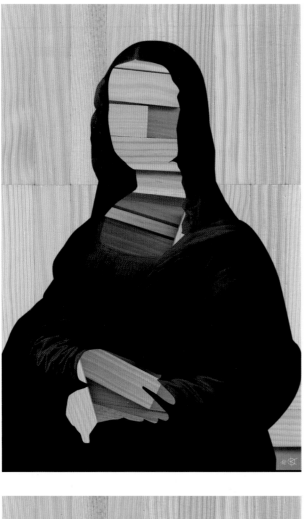

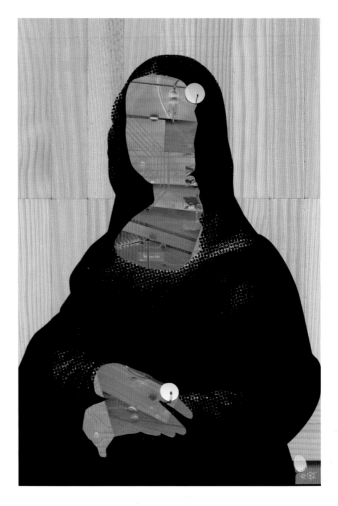

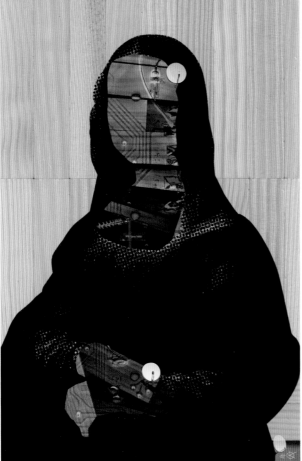

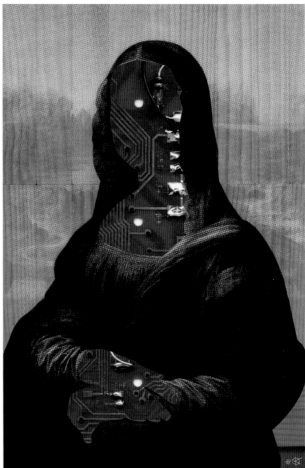

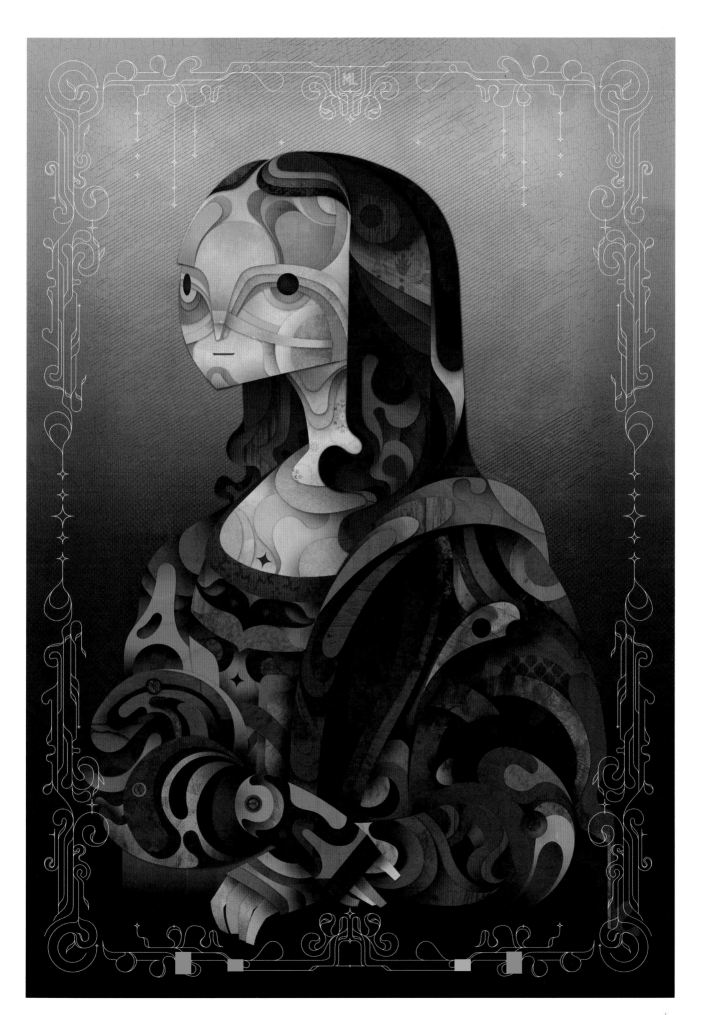

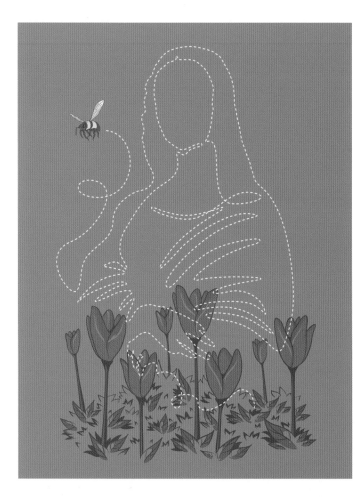

PREVIOUS PAGE
Renato Faccini
Untitled
Digital
7795 x 11,339 pixels, 2012

Brazilian designer and illustrator Renato Faccini has created cutting-edge digital images for clients around the world. His visually complex and ornately detailed rendition of Mona Lisa was commissioned by Gráfica Monalisa, a printing company in Curitiba, who had requested an intricate and sophisticated image that could effectively demonstrate their superior printing techniques.

LEFT, TOP
Chow Hon Lam
I Love Art
Digital
2700 x 3600 pixels, 2012

LEFT, BOTTOM
Chow Hon Lam
Wink
Digital
2700 x 3600 pixels, 2012

Chow Hon Lam, also known on the internet as "Flying Mouse," is an illustrator and tee-shirt designer from Malaysia. His whimsical designs and clever lampoonery are quirky, unpredictable, and frequently uproarious. Says the artist of his unconventional creations, "I just hope to bring some smiles to the world."

RIGHT
J.T. Morrow
Mona Lisa Screams
Acrylic
26.67 x 41.91 cm, 2012

Multi-talented American illustrator J.T. Morrow has acquired a reputation for his special ability to mimic the styles of famous artists, creating parodies of some of the world's greatest art and most recognizable cultural icons. "This is one of three parodies I've done of Mona Lisa over the years. Although it has a distinct *Home Alone* vibe, it was actually created as a reaction to the price paid for 'The Scream' in 2012." Edvard Munch's iconic painting had sold for $119,922,500 at Sotheby's, setting a world record for the highest amount ever paid for a work of art at auction.

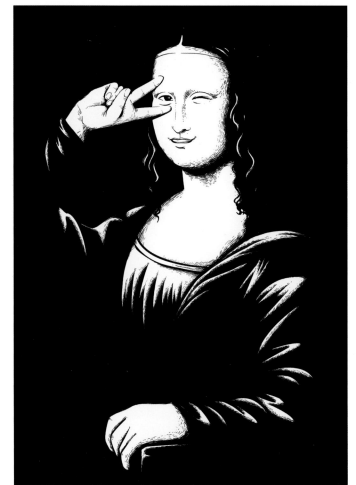

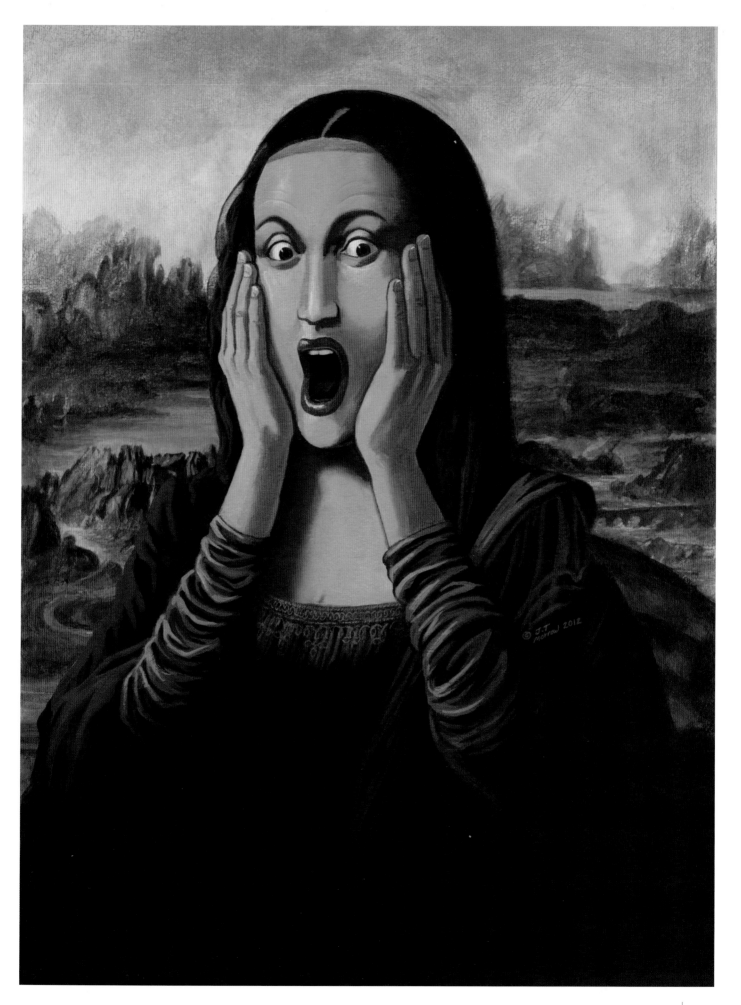

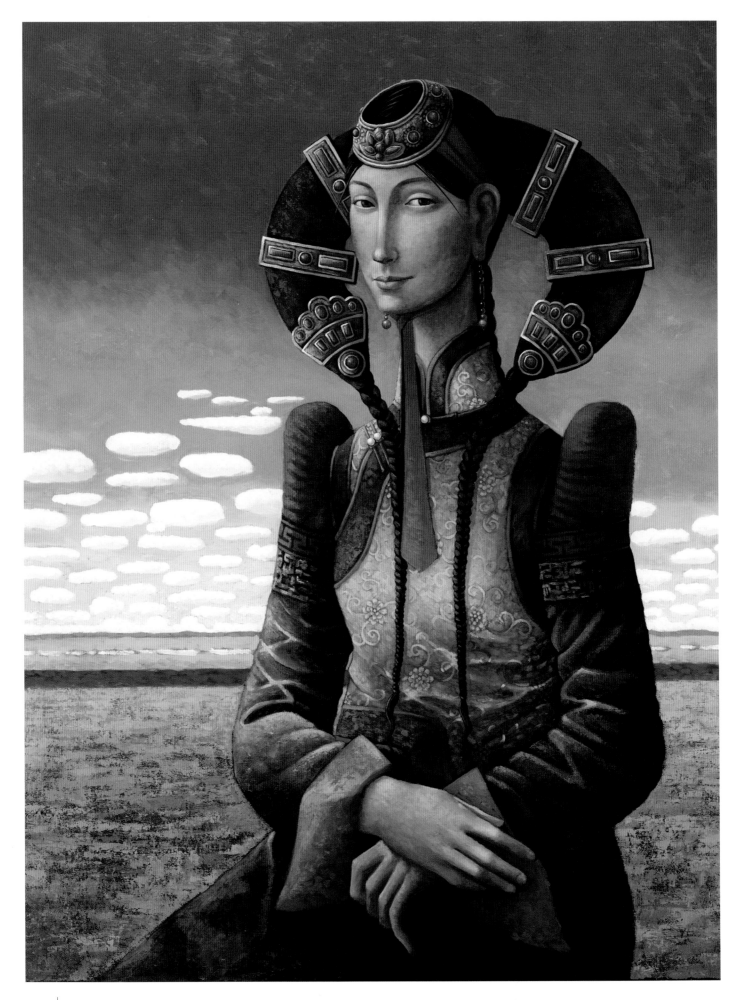

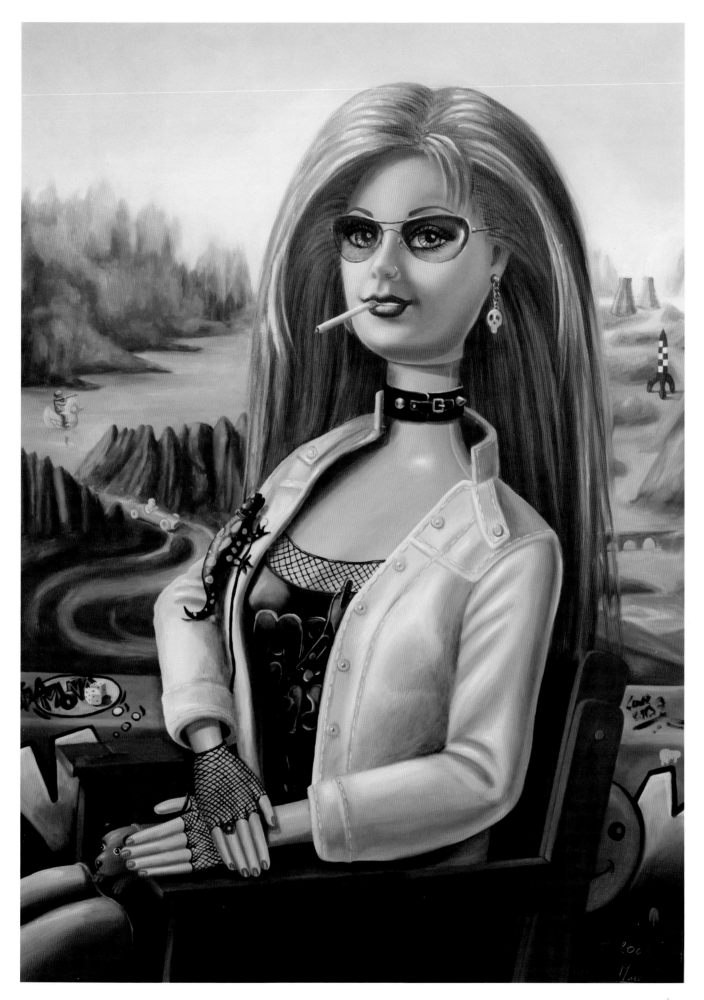

Zayasaikhan Sambuu
Reincarnation
Oil on canvas, 70 x 90 cm, 2012

Known around the world as "Zaya," Mongolian artist Zayasaikhan Sambuu grew up in Baatsagaan, a small, isolated town of about one hundred households. During his teenage years, as the oppression and censorship of communism began to fade away, growing nationalism allowed for the re-emergence of forgotten Mongolian culture, and newfound religious freedom enabled many Mongolians to practice Buddhism, which had been forbidden under the communist regime for over a decade. It was through this religion that Zaya was first introduced to art. Today, Zaya has achieved global acclaim with celebrated exhibitions in Germany, Australia, Japan, and the United States.

Caroline Maurel
Mona Lisa
Oil on canvas, 53 x 77 cm, 2013

French painter Caroline Maurel has always been fascinated by toys and she sees in them a heightened reflection of all the best and worst things that society is responsible for. The plastic figures she paints are infused with human emotions, and breathe with a life that is further enhanced by her hyper-realistic technique. The frozen poses of her brightly colored subjects are amusing, absurd, and at times, deeply unsettling.

Catalin Lartist
My Girlfriend's Got Blue Tooth
Digital, 3200 x 4600 pixels, 2013

Romanian artist Catalin Lartist created an entire series of images reappropriating the subjects of classic paintings and either transporting them to modern settings or outfitting them with anachronistic technology. Here, rather than simply transposing the modern Bluetooth wireless technology to the Renaissance period, Mr. Lartist has taken a more literal approach, choosing to illustrate "bluetooth" as some kind of dental affliction. The follow-up image is a cautionary warning showing in gruesome detail the deadly results when someone stricken with "bluetooth" fails to receive proper medical attention.

Mina Anton
Copic Mona Lisa
Ink and Copic markers on paper, 2700 x 3819 pixels, 2013

As a storyboard artist, children's book illustrator, comic book artist and conceptual draftsman, Egyptian designer Mina Anton's work is constantly shaped by a broad knowledge of classical art. "I've been influenced by the culture of the old civilizations (Egyptian, Greco-Roman, Byzantine) and I am also fascinated by Neoclassical styles, Renaissance Art, and Pop Art. I've tried to mix all of this together in developing my own independent style." Mr. Anton currently works for the international TBWA Advertising Agency and as a teaching assistant at Art Education Faculty in Cairo, Egypt.

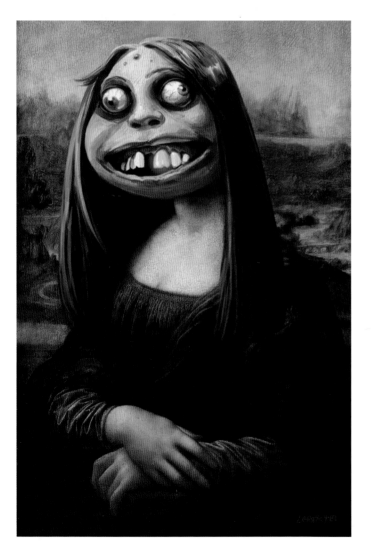

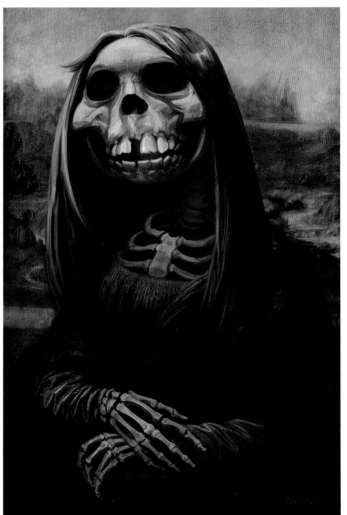

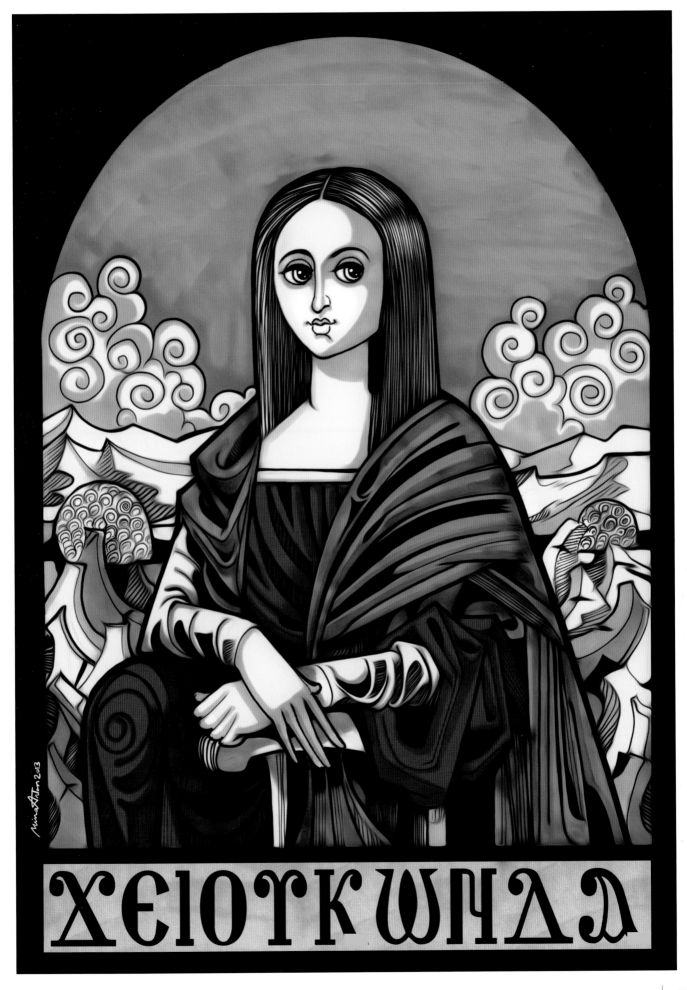

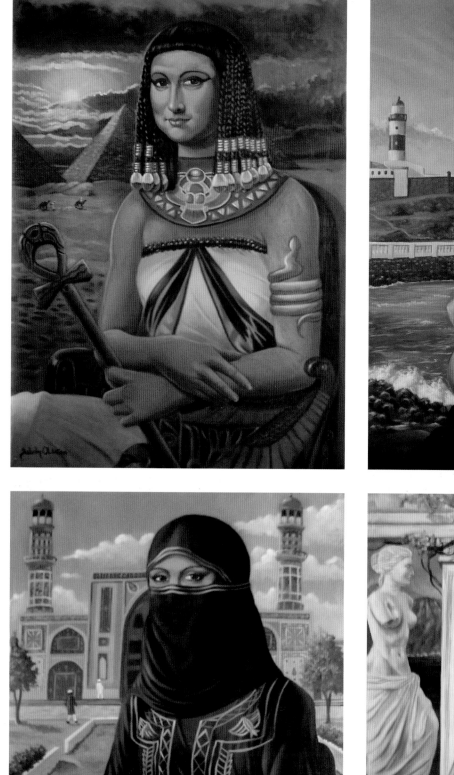

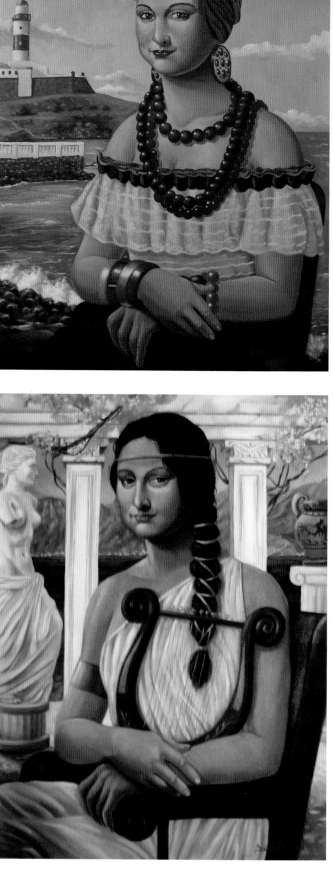

FACING PAGE, TOP LEFT
Fabiano Oliveira
Egyptian Mona
Oil on canvas, 50 x 70 cm, 2013

FACING PAGE, TOP RIGHT
Fabiano Oliveira
Brazilian Mona
Oil on canvas, 50 x 70 cm, 2013

FACING PAGE, BOTTOM LEFT
Fabiano Oliveira
Muslim Mona
Oil on canvas, 50 x 70 cm, 2013

FACING PAGE, BOTTOM RIGHT
Fabiano Oliveira
Greek Mona
Oil on canvas, 50 x 70 cm, 2013

Brazilian-born artist Fabiano Oliveira has always been curious to know what Mona Lisa would have looked like had she been born in another country. In addition to the four variations reproduced here, he has also created Native American, Spanish, Japanese, and Thai versions, among others, and he still has many more depictions in mind to paint in the future.

RIGHT, TOP
Lacey Bryant
Too Many Eyes
Oil on panel
22.86 x 30.48 cm, 2013

In the dreamlike paintings of San Francisco Bay Area artist Lacey Bryant, the artist explores the erosion of memory and the movement of time by presenting a mishmash of real and imagined places with discarded remnants of lives and stories scattered about. Contrasting cute with creepy, familiar with odd, Ms. Bryant manages to quietly captivate and unnerve her viewers through the underlying tension of her work. For *Too Many Eyes*, she presents a unique perspective on a familiar classic by portraying the understandable feeling of frustration that one would experience after 500 years of being stared at. "I couldn't help but think about what it might feel like to be constantly looked at by mobs of people. I could see her getting tired from so much attention. For all of the staring, no one is really able to see who she is as a person. All she'll ever be to them is a mysterious stranger."

RIGHT, BOTTOM
Oksana Grivina
Gioconda, 59
Digital
35 x 49.5 cm, 2013

The work of Portuguese illustrator and mobile applications developer Oksana Grivina has been published internationally in magazines such as *Playboy*, *GQ*, and *Forbes*. Several of the children's books she has written and illustrated have been reproduced in interactive editions for the iPad. Though attention is often focused on Mona Lisa's famous smile, Ms. Grivina has chosen instead to emphasize the eyes of her subject. She characterizes her captivating portrait of an older, world-weary Gioconda by saying, "Although she has aged, she is still beautiful because of her magnetic eyes."

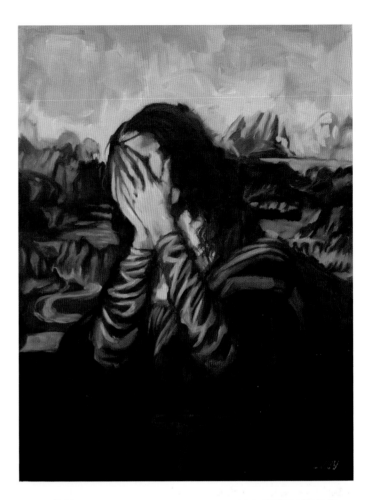

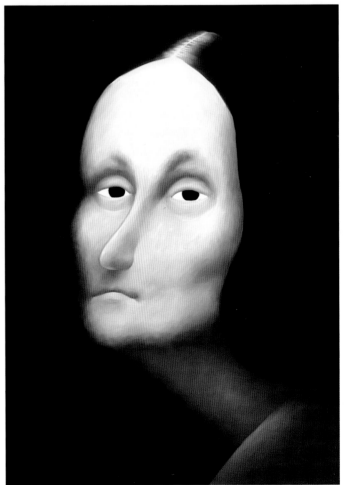

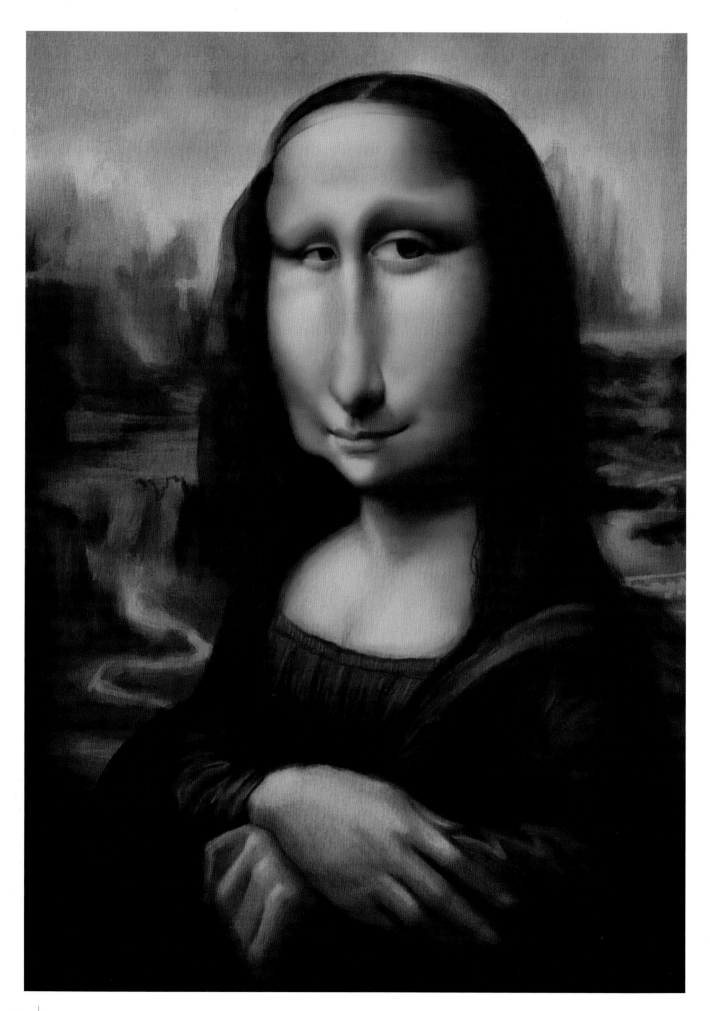

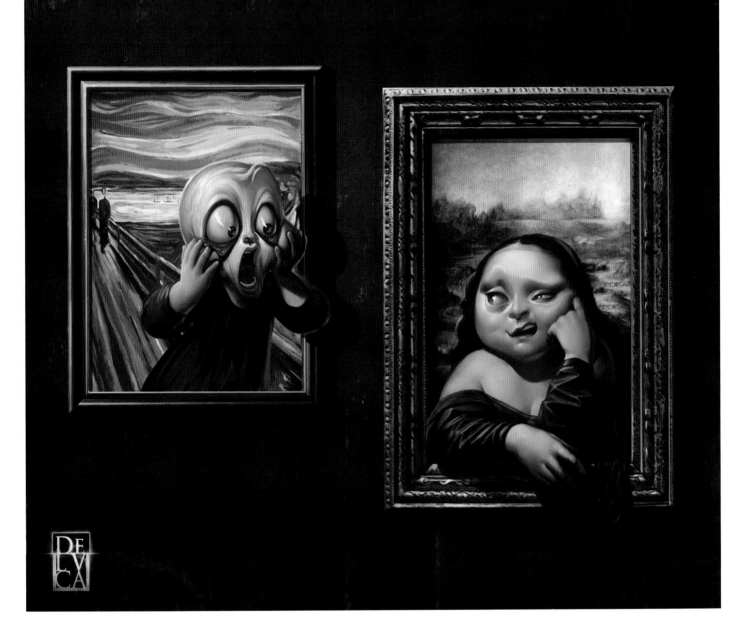

LEFT
Alexander Novoseltsev
Caricature of la Gioconda
Digital
5000 x 7562 pixels, 2013

Although Russian illustrator Alexander Novoseltsev is perhaps best known for his celebrity caricatures, his varied and prolific career has encompassed a wide range of disparate projects, including children's book illustration, conceptual design, logo design, and traditional portraiture. Despite the fact that he's only been working professionally for a few years, he has already developed a reputation in the industry due to his extraordinary work ethic and his bold, unique style. Many have noted that his Mona Lisa interpretation bears more than a passing resemblance to Russian President Vladimir Putin, though Mr. Novoseltsev maintains that this coincidence was unintentional.

ABOVE
Antonio De Luca
The Scream vs. Mona Lisa
Digital
5023 x 3854 pixels, 2013

Versatile Italian artist Antonio De Luca was born in Sicily and graduated with a degree in Painting and Architecture from the Academy of Fine Arts in Rome. Among his diverse accomplishments, he has achieved international recognition as a comic book illustrator, storyboard artist, production designer, video game developer, filmmaker, and fine artist. In *The Scream vs. Mona Lisa*, Mr. De Luca has juxtaposed two colossal icons of art history and presented them as uneasy companions on a gallery wall, with Mona Lisa a spectator to the howling character from Expressionist artist Edvard Munch's painting *Der Schrei der Natur (The Scream of Nature)*. Says Mr. De Luca of his creations, "My friends tell me that I physically resemble both of these characters!"

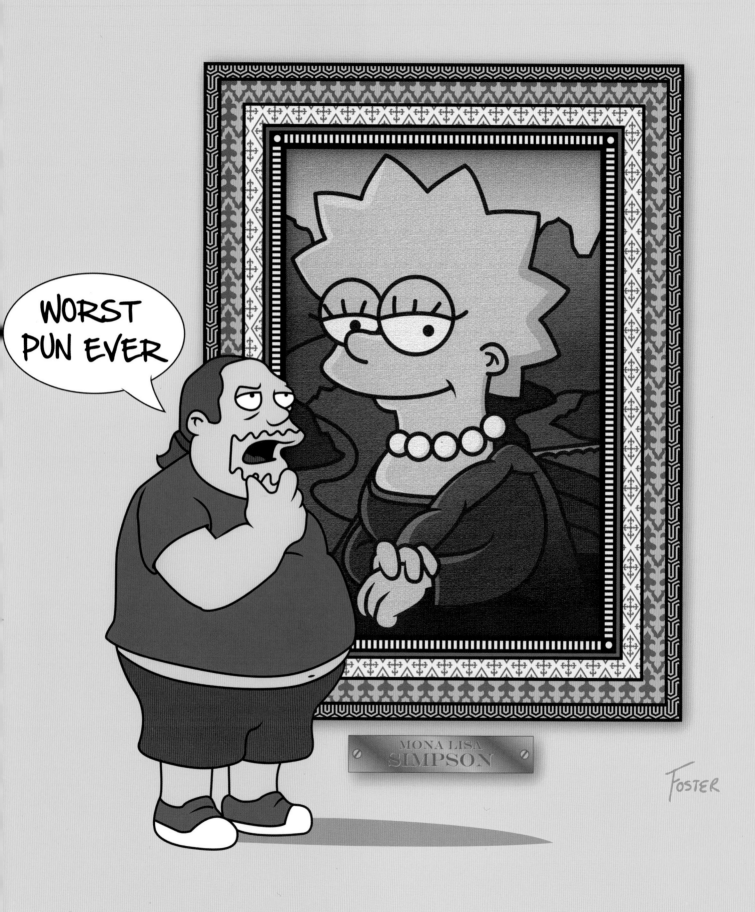

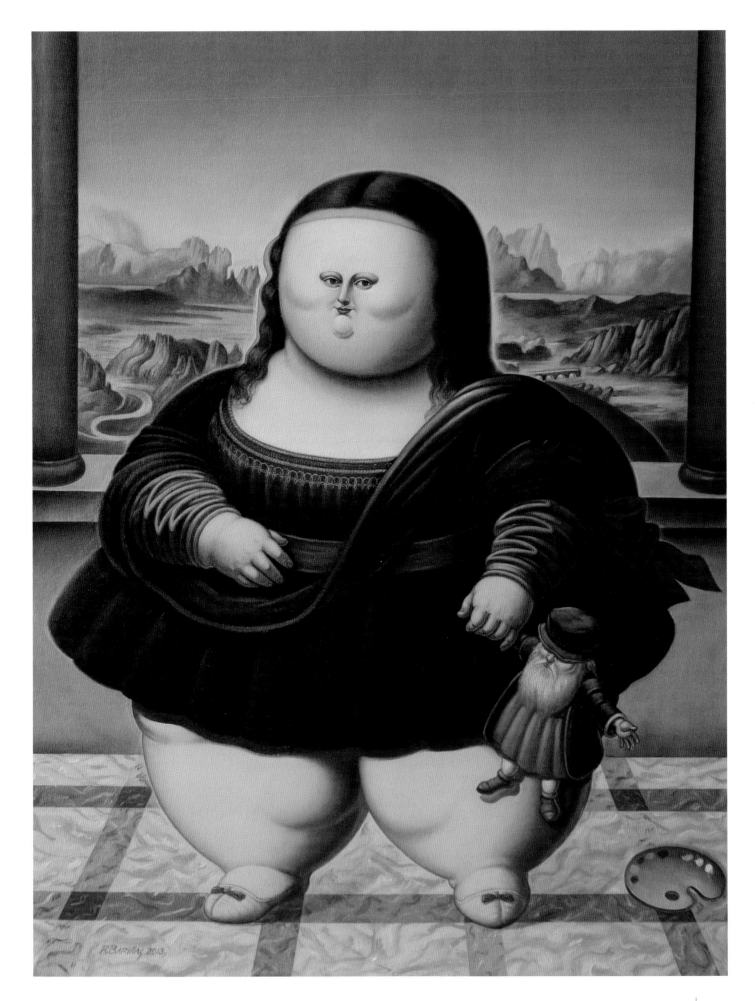

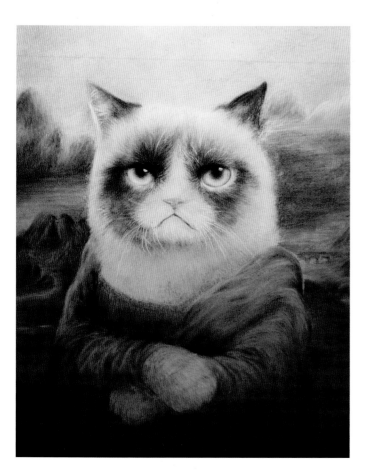

Andrew Foster
Mona Lisa Simpson
Digital
12000 x 12429 pixels, 2013

Massachusetts native Andrew Foster says he enjoys the challenges associated with creating illustrations that attempt to combine atypical elements. "It's difficult because you're taking two completely different styles and trying to make them mesh together, but it's intriguing because you start noticing things about the two subjects you never noticed before. As a result of working on this image, I ended up doing more research on Mona Lisa in one night (just out of curiosity) than I ever did during college. It also led me to rewatching a lot of old Simpsons episodes as well, which I also enjoyed."

Rogelio Barillas
La Gioconda Niña
Oil on canvas
54.61 x 68.58 cm, 2013

The work of Guatemalan-born painter Rogelio Barillas is notorious for his robust, extravagantly proportioned figures. Mona Lisa, whom he views as "the Queen of all models," has been a muse for his work on several occasions. Explains the artist, "She represents all the women in the world and at the same time she is none of them. Her smile attracts and at the same time rebuffs. She is inspiration, she is light, she is the one and only with the cosmos and infinity. But above all considerations, she is the most remembered and the most beloved."

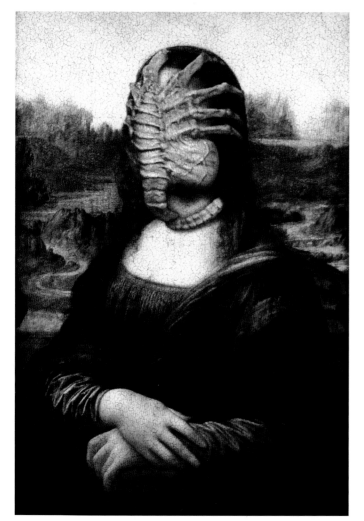

Clare Zhao
Mona No Lisa
Colored pencil on paper
28 x 35.5 cm, 2013

Originally from China and now based in Vancouver, Canada, Clare Zhao is a full-time Chartered Accountant working in Corporate Finance by day, and a full-fledged hobbyist artist by night. In *Mona No Lisa*, the popular internet meme Grumpy Cat is referenced to remind the viewer that even Mona Lisa can have a bad day.

Richard Soppet
Mona with Facehugger
Digital
2388 x 3600 pixels, 2013

New York native Richard Soppet, more popularly known on the internet as "Rabittooth," is always searching for ways to add a bit of geeky humor to famous works of art. Whether reappropriating a Norman Rockwell painting as an Indiana Jones parody, or recasting Golden-Era Hollywood stars in contemporary movie roles, Mr. Soppet consistently manages to surprise with his innovative and unusual digital mash-ups. Here he has brought his nerdy flair to the Renaissance period by illustrating Mona Lisa as the victim of a facehugging Xenomorph from the popular *Alien* movie franchise.

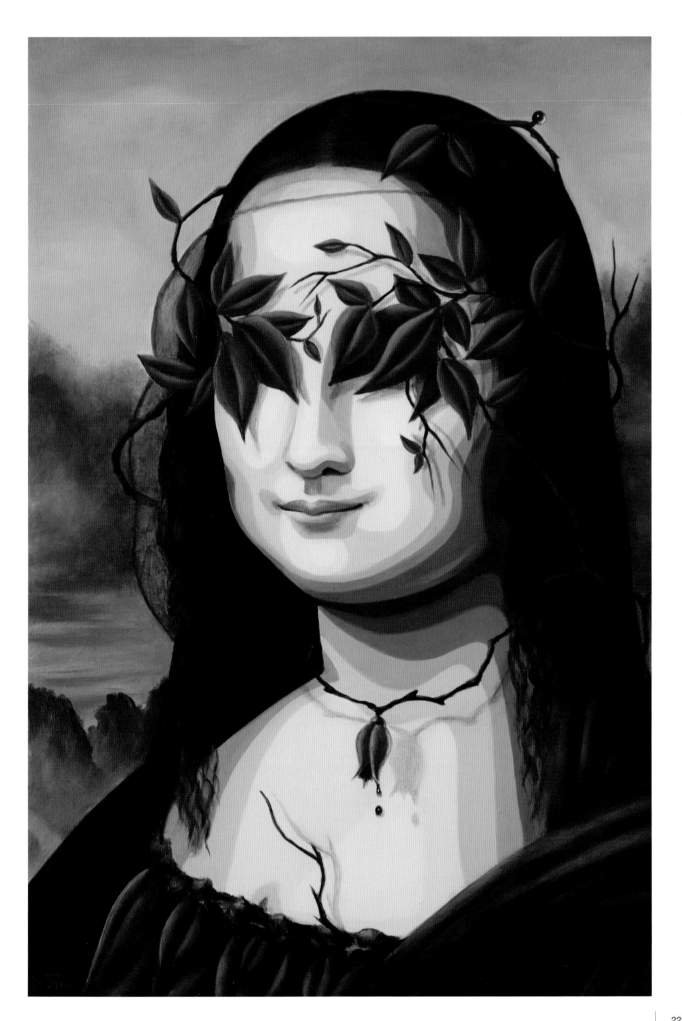

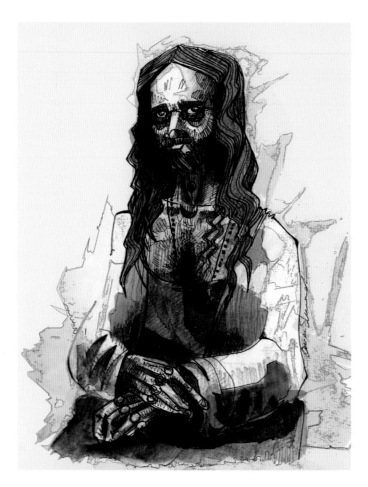

Duma
Mona Leaf
Oil on wood
20 x 30 cm, 2013

Duma is a Portuguese artist, living and working in Lisbon. Her work focuses primarily on the female form, depicting various facets of womanhood in a mysterious and anonymous way, never revealing the entire figure, and frequently mixing her characters with elements from nature. Explains the artist, "The idea is to show that we do not really get to know anyone deeply, not even ourselves. There is always an unknown part of the whole." Her style is inspired by digital art and vector illustrations, but created entirely with traditional means, utilizing oil paints on either canvas or wood.

LEFT, TOP
Omar Shammah
Self Portrait
Charcoal, ink, watercolor on paper, digital enhancements
21 x 29.7 cm, 2013

Syrian artist Omar Shammah studied at the Visual Communications department in the Faculty of Fine Arts in Damascus, where he graduated with a degree in Graphic Design. Drawing inspiration for his work from every conceivable source surounding him, he developed his concept for this self-portrait from a theory that Leonardo da Vinci had actually patterned Mona Lisa after his own likeness.

LEFT, BOTTOM
Afsoon Shahriari
The Dream of Freedom
Digital
2067 x 2923 pixels, 2013

Iranian artist Afsoon Shahriari aspired to represent her own life in Tehran while creating her politically-fueled rendition of Mona Lisa. While the women's rights movement in Iran continues its attempts at influencing reforms, progress sometimes seems unattainable. Similarly, although Ms. Shahriari's seated figure has a wish of freedom and a desire to move beyond the reality of her life, she ultimately feels shackled helplessly in her chair, unable to move.

RIGHT
Nicolás Castell
The Monumentality of a Picture
Ink on paper with digital colors
29.7 x 42 cm, 2013

Born in Argentina and now based in Spain, graphic designer Nicolás Castell earned his Master's Degree from the University of Granada. His Mona Lisa reinterpretation is a sly meditation on how the simple portrait ultimately became the most famous painting in history. According to the artist, "Mona Lisa already has an intrinsic monumentality. My illustration reflects the huge sensation caused by the mass media and how the painting has been built up as a cultural icon, a monument to art itself."

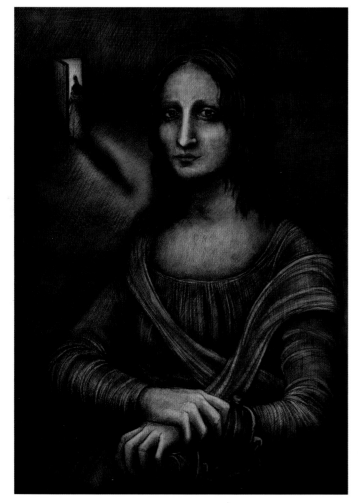

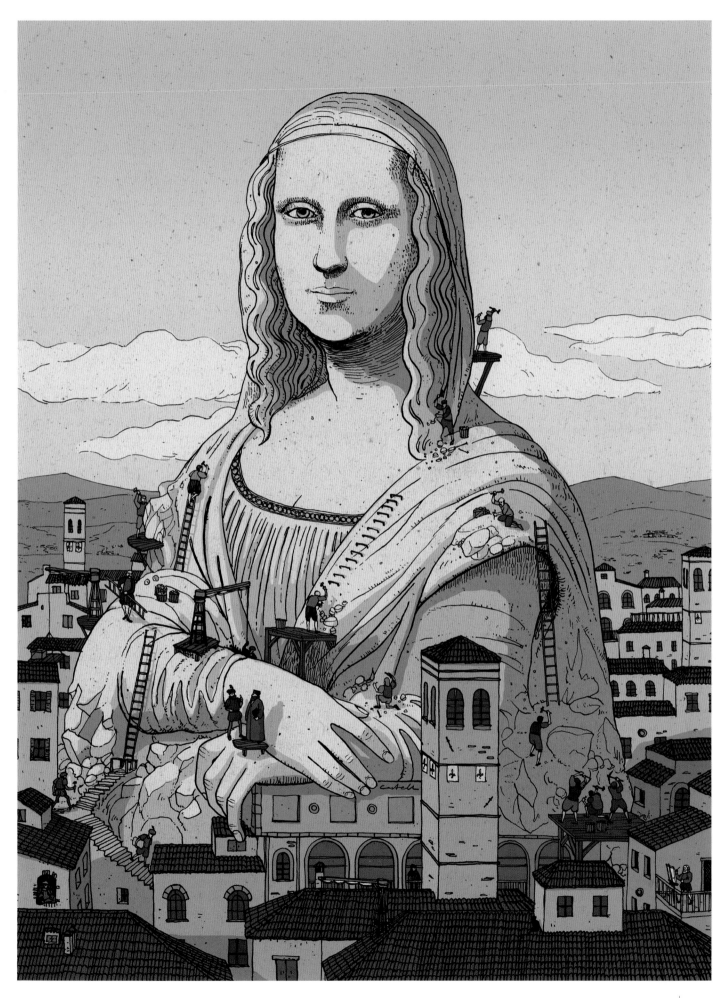

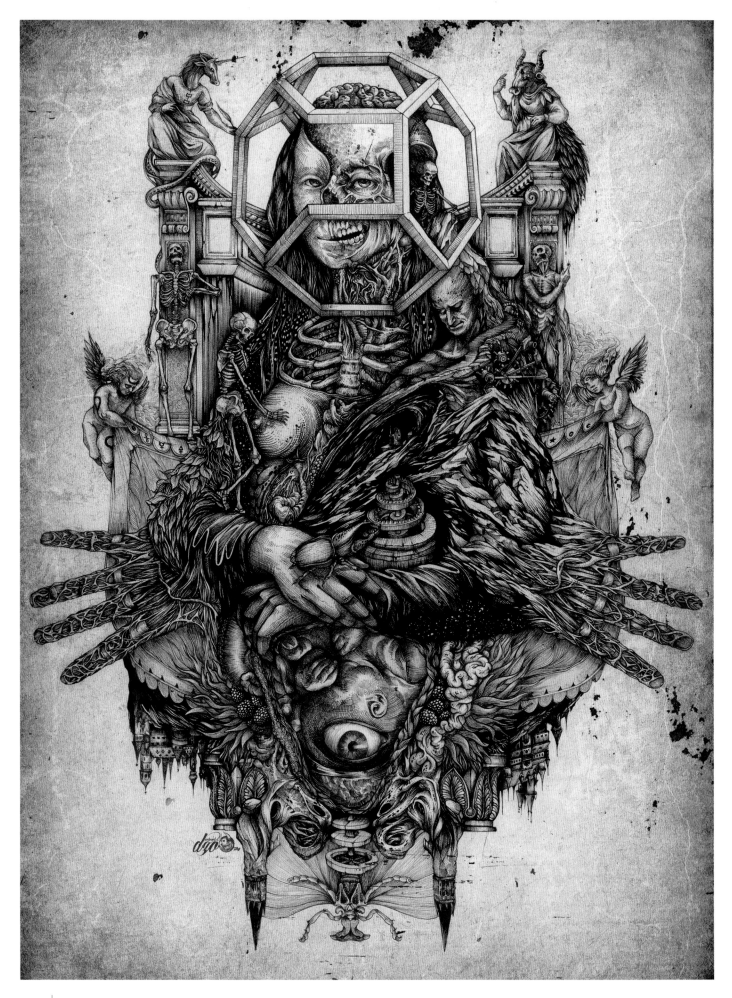

DZO-O
Giocondanatomy
Mixed media, digital
101.6 x 152.4 cm, 2013

French illustrator and designer DZO-O creates his sensual pen-and-ink drawings without the assistance of pencils and erasers, committing himself to accepting and even embracing the mistakes that often accompany working in such an unforgiving medium. His painstakingly detailed textures mimic the biological formations of nature, echoing the patterns found in tree roots, bird feathers, and the organs of the human body.

Débora Cabral
Gioconda
Digital, 1196 x 1714 pixels, 2013

Brazilian native Débora Cabral created her unconventional version of Mona Lisa especially for "Gioconda Project," an exhibition at W3 Gallery in London, which showcased both established and emerging artists from all over the world, each interpreting the classic portrait in their own individual style.

Teresa Guido
Joconda
Digital, 2067 x 2923 pixels, 2013

Italian illustrator and caricaturist Teresa Guido specializes in creating art for children's books. Her work is agile, free-spirited, and invites the viewer to reflect upon the the absurdity of certain aspects of human behavior. Here she has restyled Mona Lisa as an enthusiast of heavy metal music.

Stanley Chow
Mona Lisa (a Damsel in Distress)
Digital, 42 x 59.4 cm, 2013

Mona Lisa had cast a spell over celebrated British illustrator Stanley Chow ever since he first saw the painting in the Louvre when he was 10 years old. His striking retro depiction was created for his 2013 "Damsels in Distress" gallery show at Kosmonaut in Manchester, England. The exhibition featured stylized renditions of fairytale characters such as Snow White and Rapunzel, cartoon heroine Olive Oil, and real-life songstress Whitney Houston. With the lively history that the painting has (including its theft in 1911), Mr. Chow felt that Mona Lisa could also be categorized as a damsel in distress.

Melody T. Newcomb
Saints & Sinners La Gioconda
Watercolor and ink mounted on paper, 35.5 x 45.7 cm, 2013

Born in Tulsa, Oklahoma, Melody Newcomb received her BFA in Illustration from New York's School of Visual Arts and is now a freelance illustrator in Brooklyn. Her distinctly intricate work is rich with detail and symbolism. *Saints and Sinners: La Gioconda* focuses on the mysterious allure of Mona Lisa as a woman who has enraptured generations. Male garter snakes fight one another to mate with the larger female, entangling themselves in their frenzy. The orchid flower represents virility, while Mona Lisa herself holds a red-breasted Robin, which symbolizes divine sacrifice and the rebirth of the spirit.

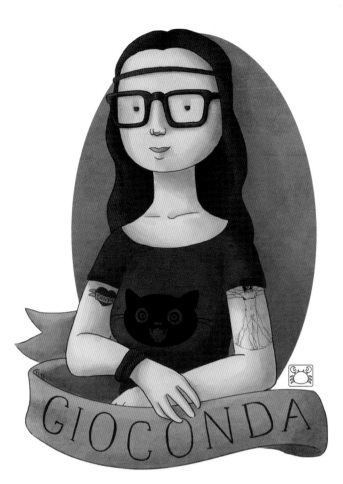

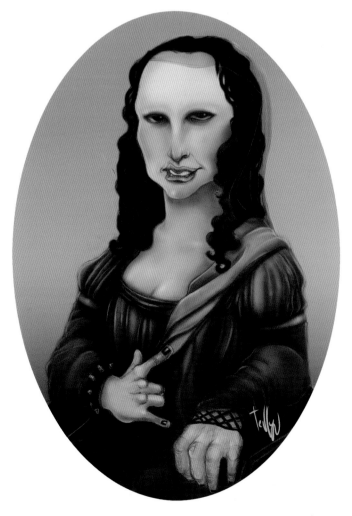

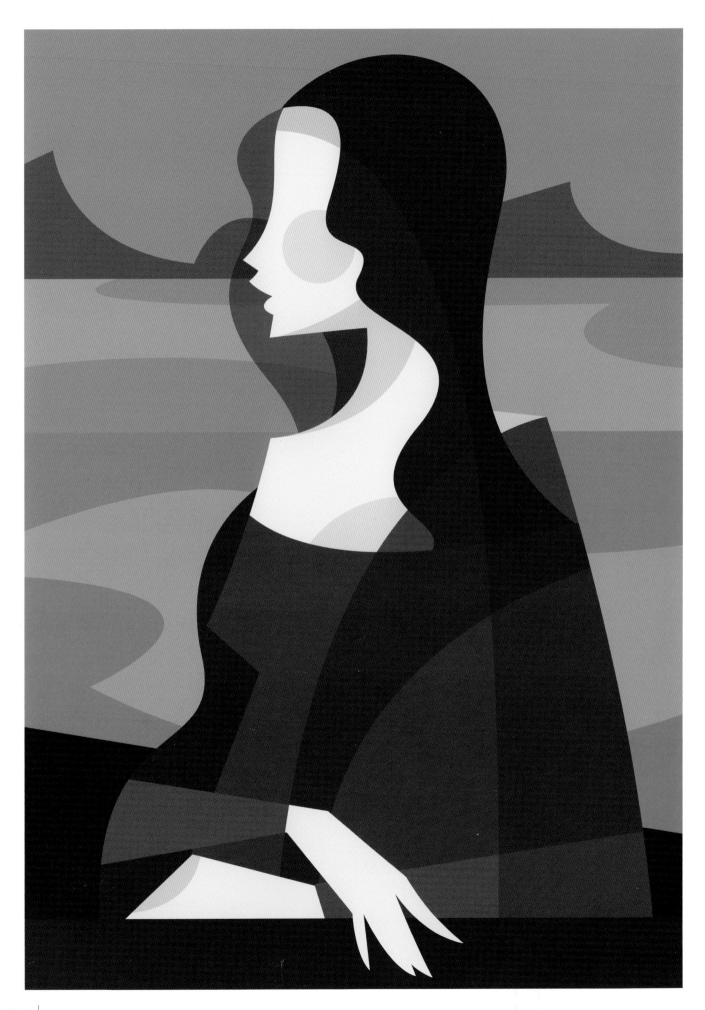

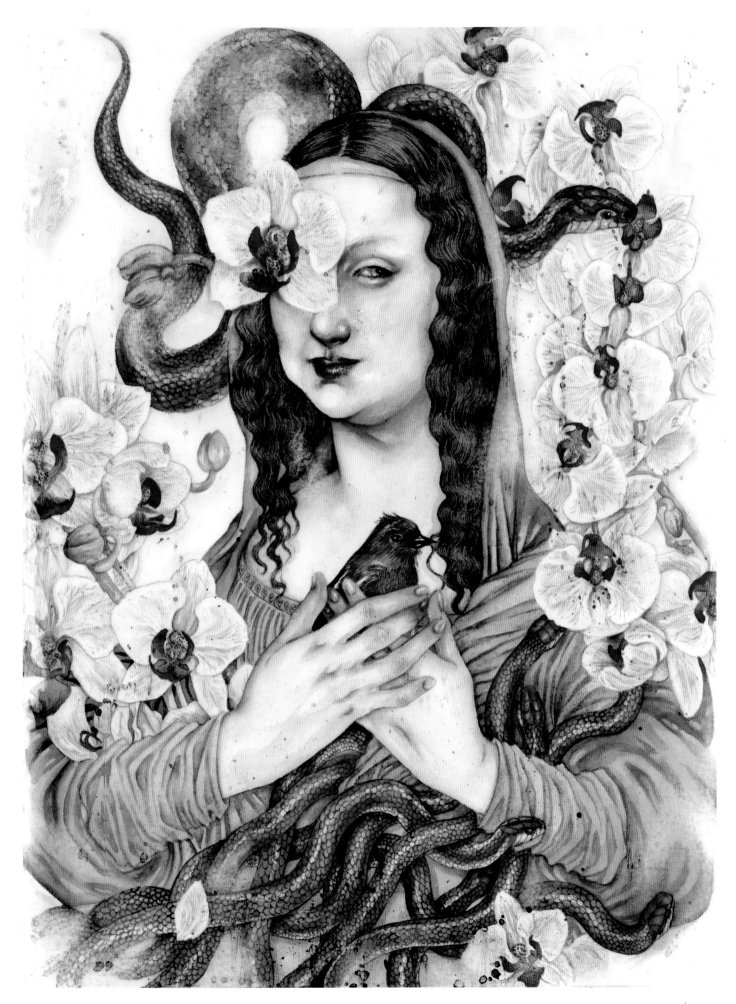

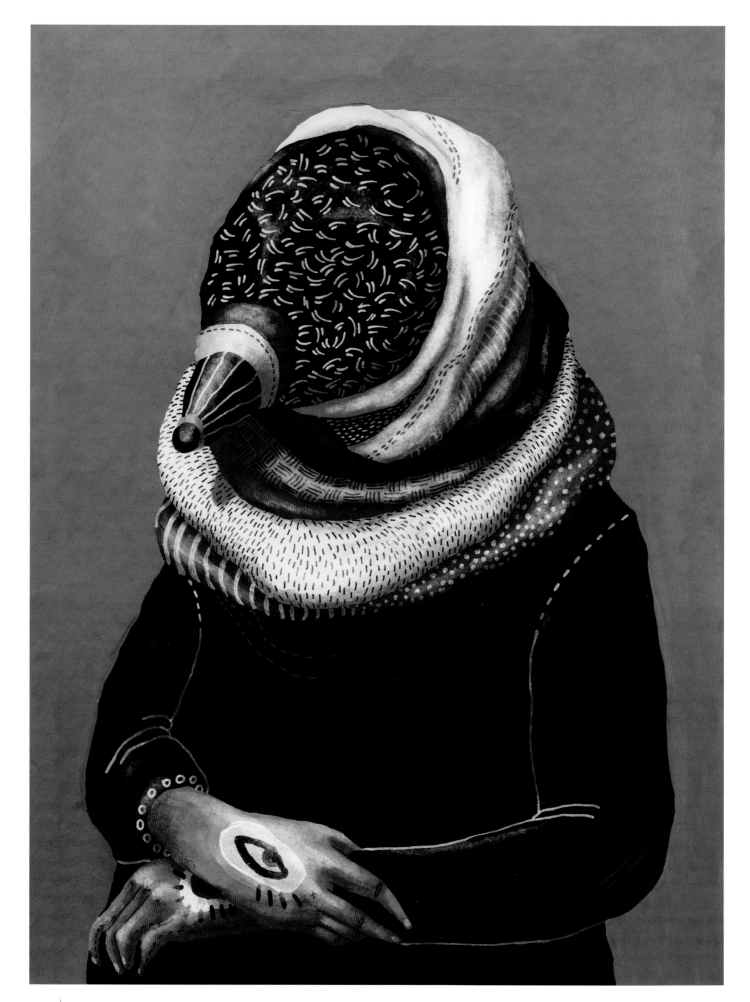

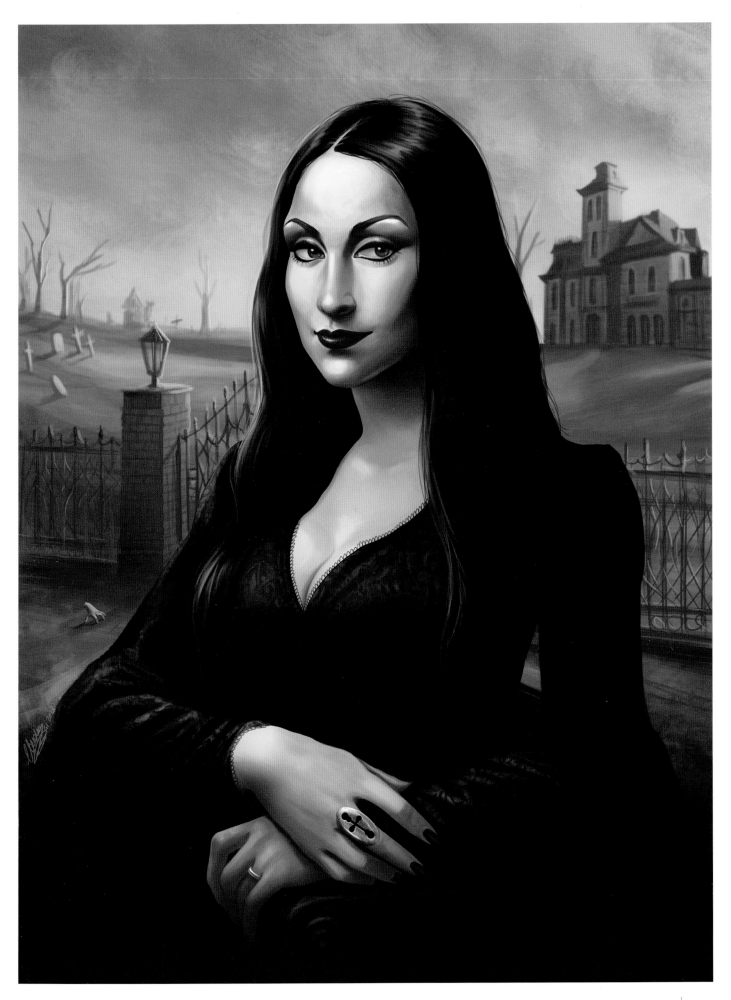

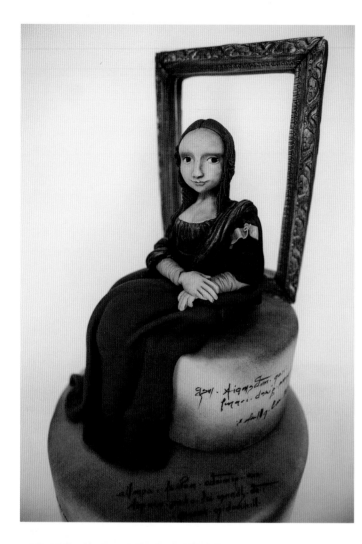

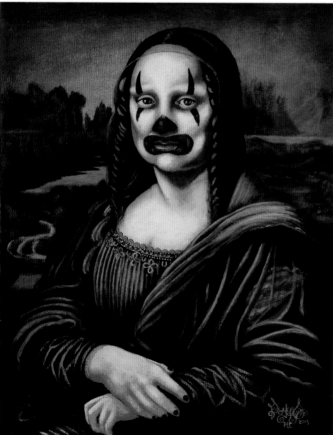

Ilona Partanen
Kinkmole Mona Lisa
Gouache and Photoshop, 23 x 31.5 cm, 2013

Double meanings, irreverent humor, rich color intensity, and a touch of naughtiness are the usual ingredients of Finnish illustrator Ilona Partanen's work. Kinkmoles are frequently used as subject matter, as they are often mischievous and inscrutable. Although *Kinkmole Mona Lisa* doesn't have an actual face in the traditional sense, her posture still manages to reflect the same enigmatic flirtatiousness of the original painting.

Claudia Ianniciello
Monatisia
Digital, 5216 x 7476 pixels, 2013

Better known on the internet as "ScarletGothica," Italian artist Claudia Ianniciello has worked as a digital colorist for comic book juggernauts such as Marvel, Image, and IDW. Influenced by Gothic and Pre-Raphaelite styles, she created this illustration as a tribute not only to Leonardo's classic painting, but also to the macabre fictional character Morticia Addams, whom she describes as the perfect woman: calm, composed, and every bit as mysterious as Mona Lisa.

Barbara Regini
Sugar Lisa
Sugar paste, 40 x 60 cm, 2013

Italian cake designer and self-described "sugar artist" Barbara Regini (also known as Barbie Lo Schiaccianoci) loves Mona Lisa, in all her various forms, and even named her son Leonardo. She has received numerous international awards for the originality of her confectionery creations, and has been featured on the television show *The Italian Kitchen* and in publications such as *Corriere della Sera*, *Modern Woman* and *Vogue*.

Pascal Leo Cormier
Mona Pagliaccio
Acrylic on wood panel, 20.3 x 25.4 cm, 2013

Pascal Leo Cormier (or "Payazo") is a self-taught artist, writer, and musician originally from New Brunswick, Canada. Characterizing himself as an "independent student of world history, religion and sciences" and a "proud high school dropout," Mr. Cormier has spent the last decade exhibiting his paintings in galleries across North America. *Mona Pagliaccio* was created for the Modern Eden Gallery in San Francisco as part of an international group exhibition in 2013 which featured contemporary adaptations of Mona Lisa.

Nguyễn Thanh Nhàn
Monalisa Caricature
Digital, 2700 x 3830 pixels, 2014

Known for his captivating children's book illustrations, Vietnamese illustrator and graphic designer Nguyễn Thanh Nhàn creates kaleidoscopic worlds filled with bright colors and whimsical characters. Here, for the first time, he has created a caricature based on an already well-known and established portrait and has subdued the vibrancy of his usual palette to more closely replicate the paintings of the Renaissance.

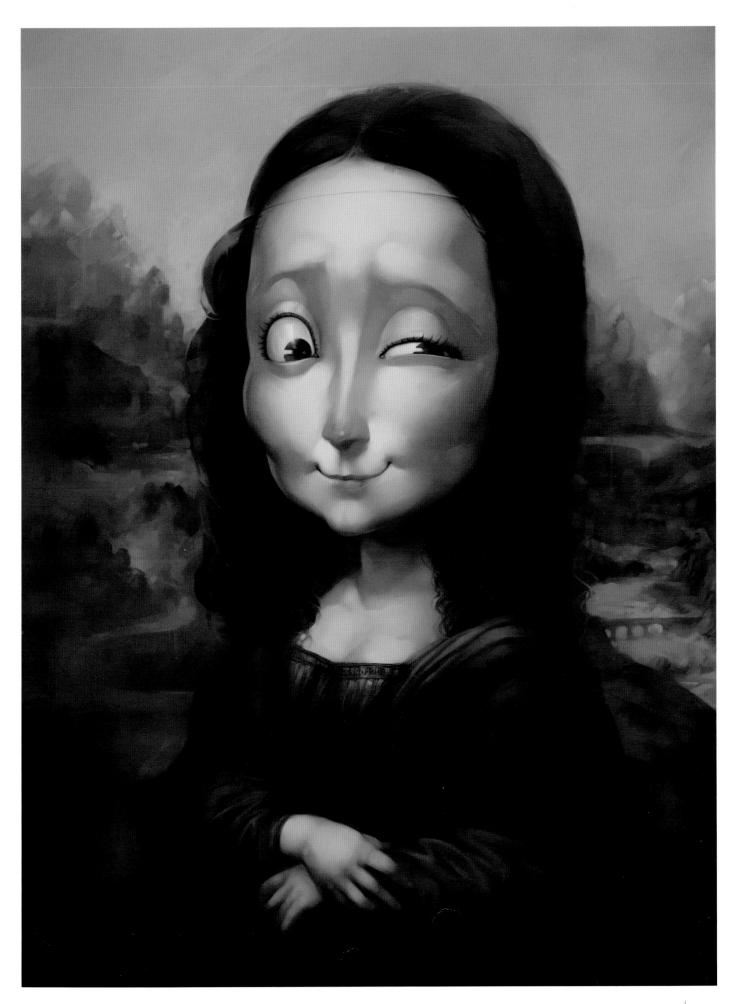

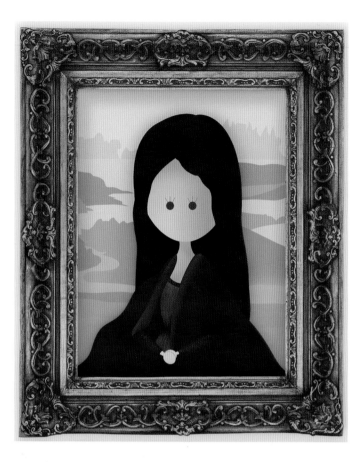

Elsa García Torrens
1911-08-21
Digital, 2700 x 3233 pixels, 2014

The work of Spanish graphic designer Elsa García Torrens is infused with a sprightly innocence and childlike sense of wonder. The simple yet elegant shapes of her stylized illustrations appear at first glance to have been created via the traditional technique of cut paper collage, when in fact her work is realized entirely via digital means. The title *1911-8-21* makes reference to the date that the original painting was stolen from the Louvre, which may be the reason that the smile in this particular rendition is conspicuously absent.

Walid Bensafidine
The Mona Leesi
Digital, 2000 x 3109 pixels, 2014

French graphic designer Walid Bensafidine based his digital illustration of Mona Lisa on the character of Daenerys Targaryen from the popular television series *Game of Thrones*, adapted from George R. R. Martin's wildly successful fantasy novels. Says the artist, "I really enjoy the series, especially this character in particular. She is an inspiration and muse for a lot of fans. Mona Lisa is part of the collective national pride of our country and she was, is, and always will remain a source of inspiration for artists, so of course I was eager to create artwork combining these two women." The name "Mona Leesi" is a pun which refers to the character's designation of "Khaleesi," a Dothraki title which is the equivalent of a queen. She has numerous other sobriquets as well, alternately referred to as "Stormborn," "Khaleesi of the Great Grass Sea," and "Mother of Dragons."

Dixie Leota
The Mysterious Smile of Mona Lisa
Digital, 2700 x 3600 pixels, 2014

Polish illustrator and cartoonist Dixie Leota has produced an entire series of images spoofing some of the most recognizable pieces of art ever created. From Sandro Botticelli to Gustav Klimt, no artist is off limits to Ms. Leota's penetrating sense of humor, and of course she could not resist lampooning Mona Lisa, despite the trepidation she felt in attempting to satirize the most oft-parodied painting in history. Explains the artist, "I decided to make that the theme of my version: that she's been reproduced so many times, she surely would have grown tired of it by now. I'd come to the conclusion that she'd be bored with all of the attention and after 500 years her attitude would be, 'Seriously? You want to paint my portrait? Again?' So my Mona Lisa is impatient, and perhaps a little annoyed."

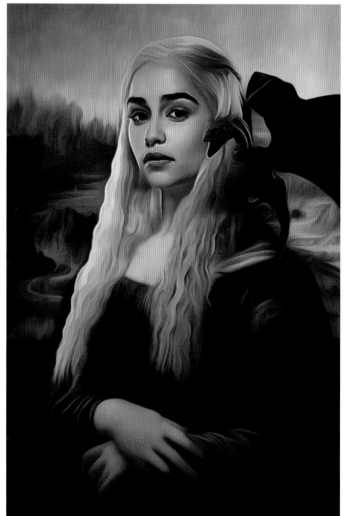

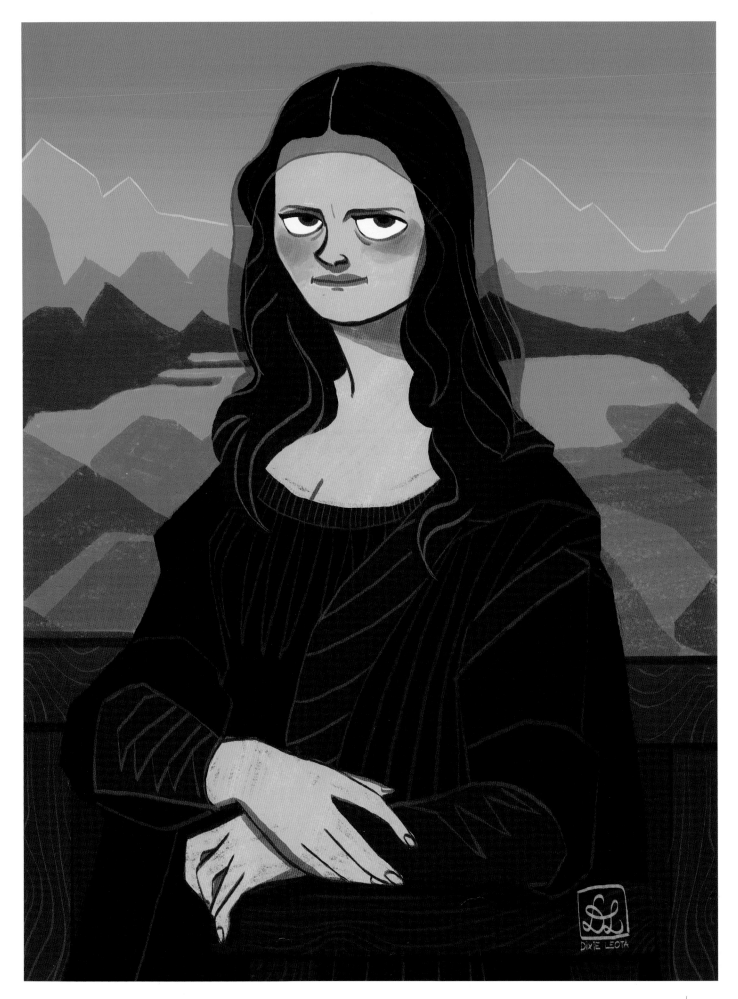

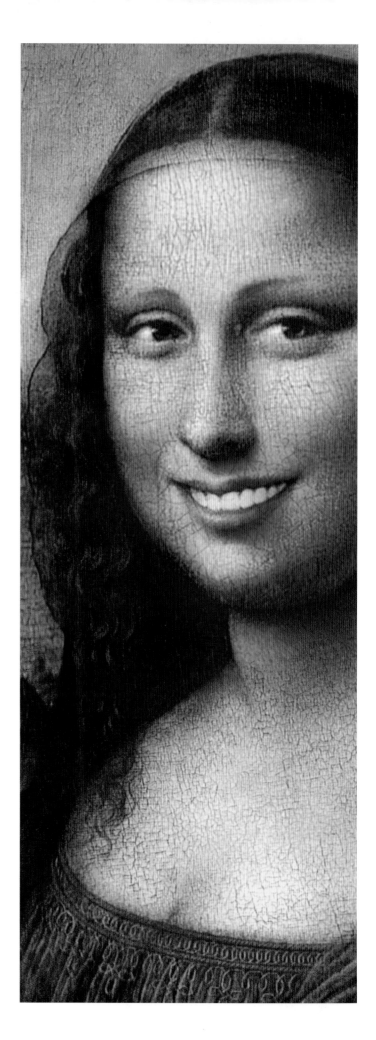

ACKNOWLEDGMENTS

Erik Maell would like to thank
Tatiana, Andreas, and Thessalia
for their love and patience,
Janis and Bill
for their encouragement and support,
Koula and Andros
for their faith and prayers,
all of his family and friends
for their interest and enthusiasm,
Gordon Goff and the entire staff at Goff Books
for their diligence and extreme professionalism,
and each of the remarkably gifted artists
who have contributed their work to this book;
without their talent and generosity,
this entire endeavor would not have been possible.